TUSCANY·ARTISTS·HOMES

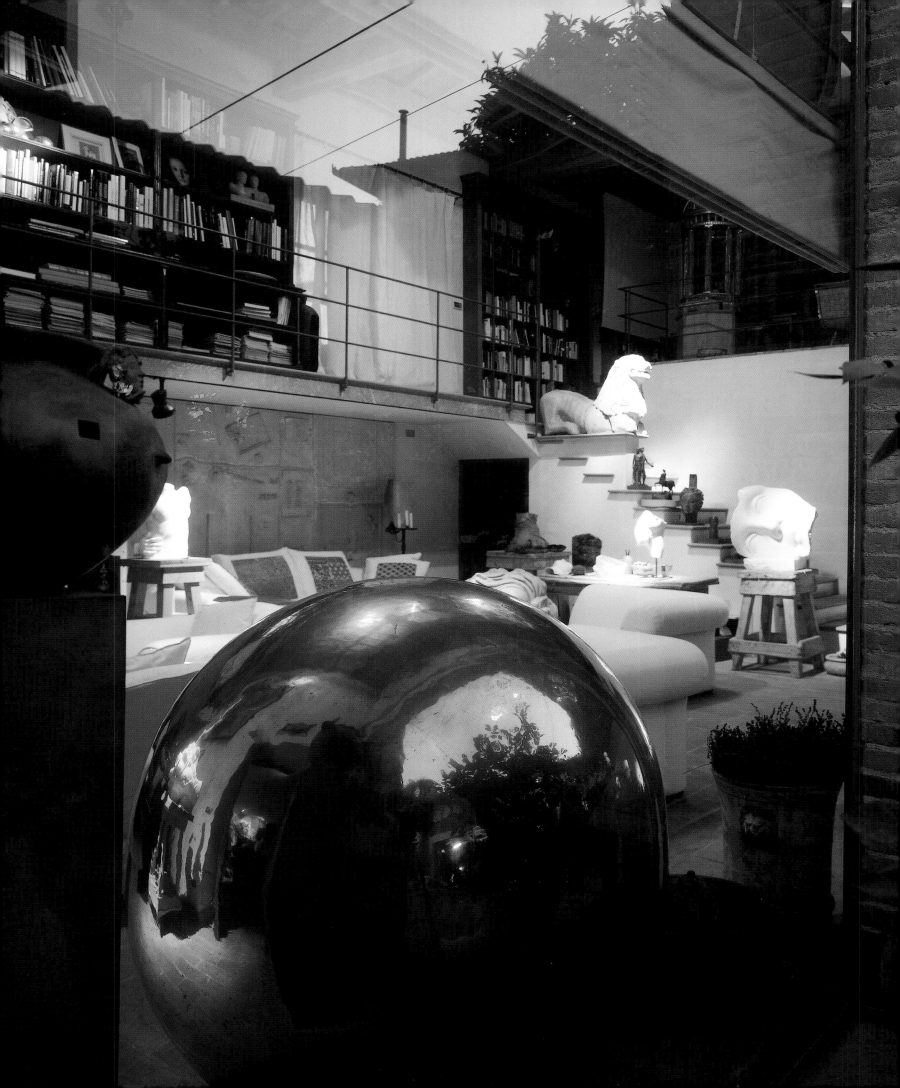

TUSCANY

MARIELLA SGARAVATTI

ARTISTS

PHOTOGRAPHS BY MARIO CIAMPI

HOMES

Thames & Hudson

Pages 2 and 6: from the home of Igor Mitoraj
Pages 238 and 240: from the home of Isanna Generali

First published in the United Kingdom in 2005 by
Thames & Hudson Ltd,
181A High Holborn, London WC1V 7QX

www.thamesandhudson.com

© 2005 Verba Volant Ltd.

This project was originated by Verba Volant Ltd.
Translation from the Italian: William Larson
Biographical research: Eleonora Tolu

British Library Cataloguing-in-Publication Data
A catalogue record for this book is available from the British Library

ISBN-13: 978-0-500-51263-0

ISBN-10: 0-500-51263-9

Printed and bound in Hong Kong

Contents

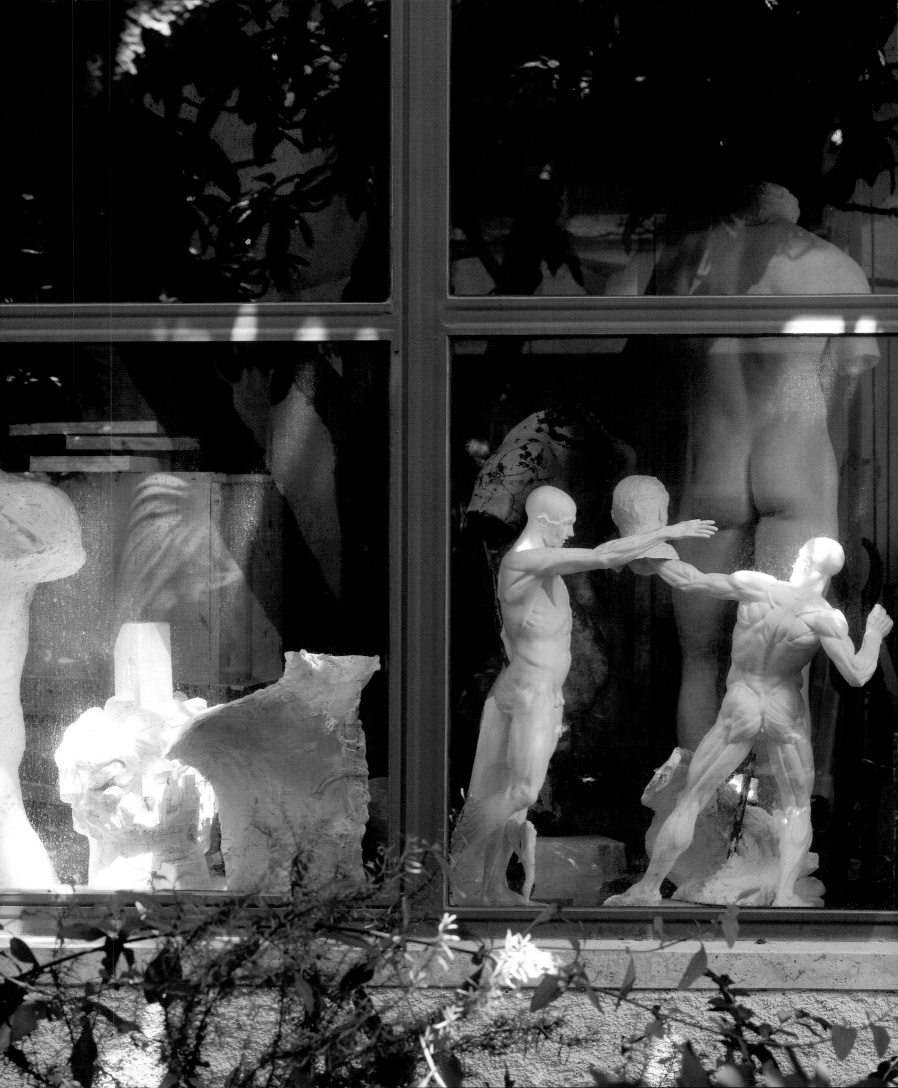

Introduction

This book, conceived as a companion volume to *Tuscany • Artists • Gardens*, takes the reader into twenty-five homes and studios of artists who have chosen to live in Tuscany. The places, settings, and situations described are varied, however all of them are vivid, original experiences that are closely bound with each artist's creative spirit. Some of the homes are castles that have been turned into studios, others are farmhouses brought to new life with masterly transformations that have left their true essence unaltered. Some of the structures were originally intended for use as industrial buildings, middle-class dwellings, or villas. While others were workshops that remain imbued with the lively spirit of historic urban quarters formerly inhabited by craftsmen. The ample size, richness of the furnishings, and unique artwork found inside cause some of these residences to be impressive. Others are distinguished by their minimal decor and by their uncompromising essential nature. A few artists in this volume have reworked their homes in a modern key and others have left the structure of their home intact making only minor changes necessary for living in. All of these original residences have a special charm that arises from the presence of art and from the respect and loving care lavished on the pre-existing architecture and settings.

The artists living in these homes do not share a common style, medium, or direction; each follows his or her individual quest for a personal artistic language that is self-representative. In an effort to harmonize their homes with their individual personalities, the artists have made changes and additions that borrow from their own cultural backgrounds. The outcome may vary widely, but if one looks carefully there is a common thread to all of them, a desire to distance themselves from the usual schemes of architectural planning, interior decoration, and design in favor of an organic relationship between artistic production and living space. Also, however varied these homes may be, they are all located in Tuscany. In each of them something of the region's familiar history, culture, and art is to be found—along with other, more obscure aspects.

Igor Mitoraj

Like many sculptors, Igor Mitoraj came to live in Versilia because he was attracted to this extraordinary region's unique working environment. The variety of materials available and the ability of the local craftsmen, particularly stonecutters and foundry workers, make the area a perfect place to pursue art. "Naturally I came here to sculpt, nothing is lacking. First of all, the availability of many materials that cannot be found in Paris gives me a great opportunity. Being in contact with the foundries and the people who work there is extremely important. By now we have known each other for years, so our relations are not limited to just the execution of a piece of sculpture; I exchange ideas with them. When I first arrived, some of the workers were youngsters, now they know what has to be done with my work without my having to say anything."

Mitoraj came to Pietrasanta for the first time twenty years ago, and has experienced all the changes that have since taken place in the city. Early on he would come by train and stay in a little boarding house. At the time the city was gray and oppressed, now it has been completely restored with brighter colors. But the spirit of the town is less vital and original. "It has become a place for VIPs—and this is terrible because the old shops, such as my favorite delicatessen and the greengrocer who used to be in Piazza del Duomo, have been replaced by jeans stores, restaurants, and art galleries. Now there are twenty-five galleries, some artists are still here and directors of museums, critics, and collectors come, but the market is elsewhere—Paris, London, New York. Maybe it was our being here that involuntarily caused the change, the town was certainly not made for mass tourism. There are no more young artists around, so the small marble shops are out of work. Walking through town you used to hear the sounds of sculpting being done, now you smell the odor of fried food."

In the mid-twentieth century Mitoraj's house was the atelier of a sculptor who made large statues for churches and monuments to Evita Peron. It then became a workshop, later abandoned. When restoring it, Mitoraj took pains not to change it other than what was necessary to make it suitable as living quarters. The two rectangular parts of the building that are now the house and studio have maintained their basic configuration. Their red brick façades still have the large original arched arched openings. The space that separates the two structures has become a large courtyard which is shaded by flowing hangings in the summer, creating unity between life and work without distinction between indoors and out.

The layout of the rooms follows the structure of the atelier, particularly the living quarters, where a great deal of space is left free; it has a wood ceiling with exposed trusses and beams and two lofts connected by a long balcony. The artist chose to use old, preferably inexpensive materials, thus he was able to create a lived-in atmosphere that is extremely warm and inviting. Mitoraj has sculpted only two permanent works for the house. One is a small fountain in the living room featuring the head of a medusa issuing a jet of water. The other, located in the courtyard, is a hollow head that

Opposite: *Portrait of Mitoraj with* Ikaria.

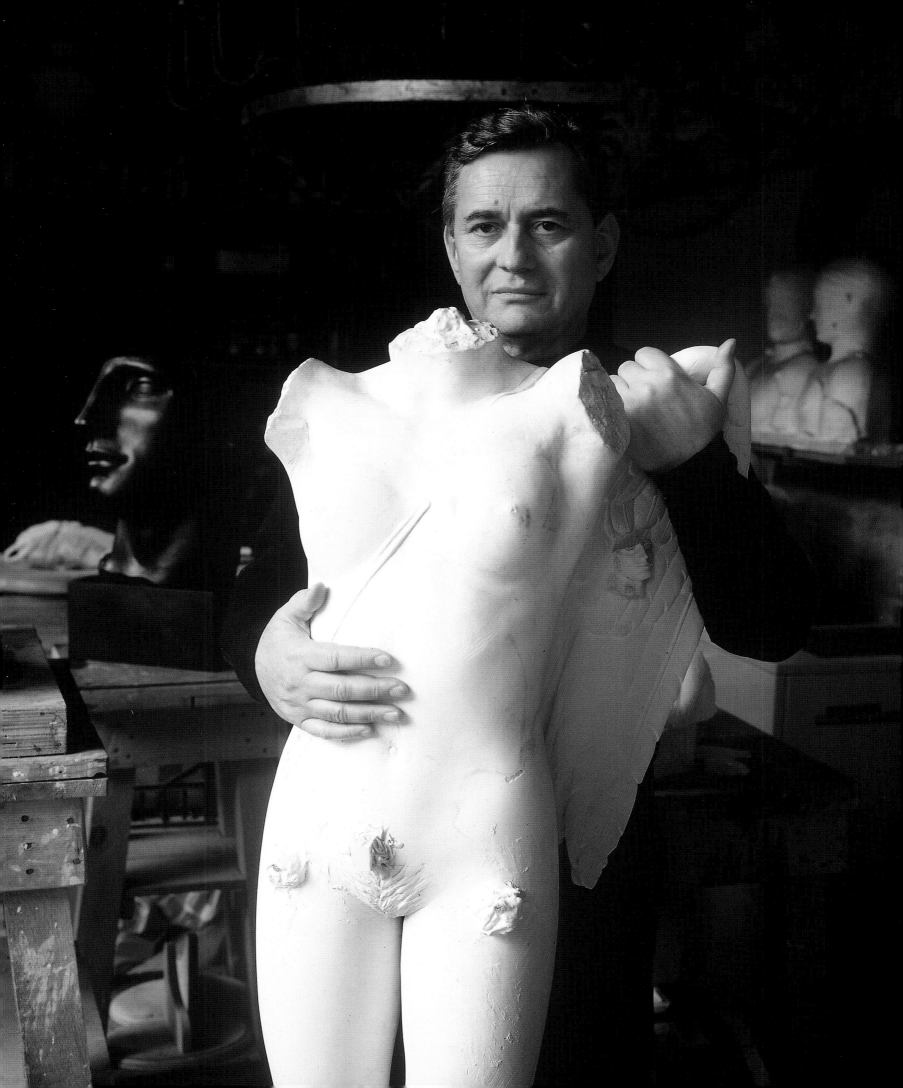

spills water into a pool. Additional pieces are added on a temporary basis only, not unlike a gallery where objects come and go. Other statues and potted citrus decorate the patio and blend in with the creepers that cover the walls, creating continuity with the garden.

The house has a wealth beautiful objects, including sculptures and paintings, all the product of a highly refined aesthetic quest. "These are things that one collects, sometimes not knowingly. I remember when I was much younger in Paris I used to buy things for my house before I even knew where I would put them. It is important for me to surround myself with my objects, and if I ever change houses they are going to come along with me…The place where I live influences my art. I love this house with its old-fashioned look and the way it is separated from the studio by a courtyard. I do not care if it does not have a view of the sea; the light here is so diffused that it helps me in my work. It is essential for me to have my studio nearby because wherever I go the only place I really feel at home is where I work." The impression one gets when one passes through the outer gate leading to Mitoraj's house and studio is that of entering a small self-sufficient world—a microcosm of beauty and classicism where there is no room for the anxious haste of our times. Here artistic creativity is at the center of every phase of life.

Above and opposite: *An old workshop has been turned into a large living room with a wall of windows that face a courtyard. The large blue artwork near the window is by Niki de Saint Phalle, and the large bronze sphere is by Greek artist Takis. A marble sculpture by Mitoraj titled* Le mani *rests on a stand with wheels. The smaller bronze sphere suspended from the ceiling is also by Mitoraj.*

Overleaf, left: *A carpenter's table placed at the foot of the stairs that lead to a loft space has a variety of artworks, including a small collection of African sculptures and three marble works by Mitoraj.*

Overleaf, right: *A sculpture in Carrara marble by the artist.*

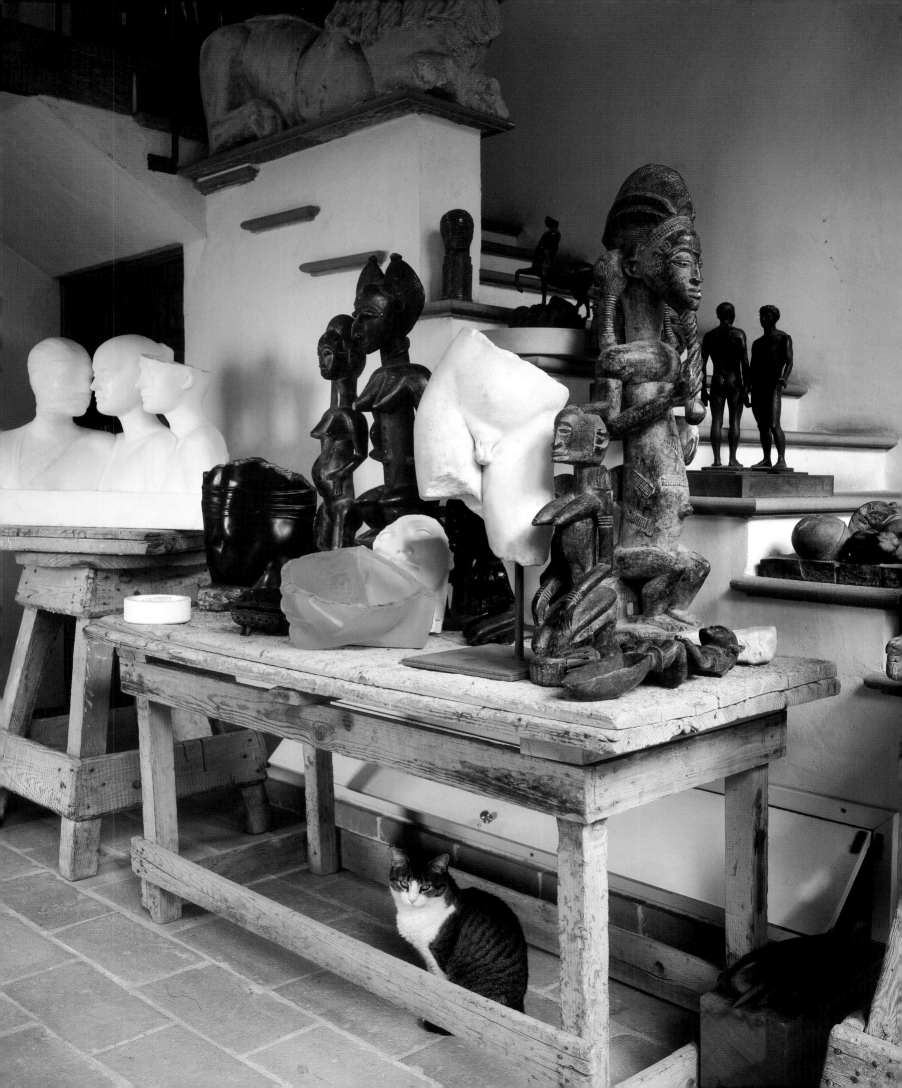

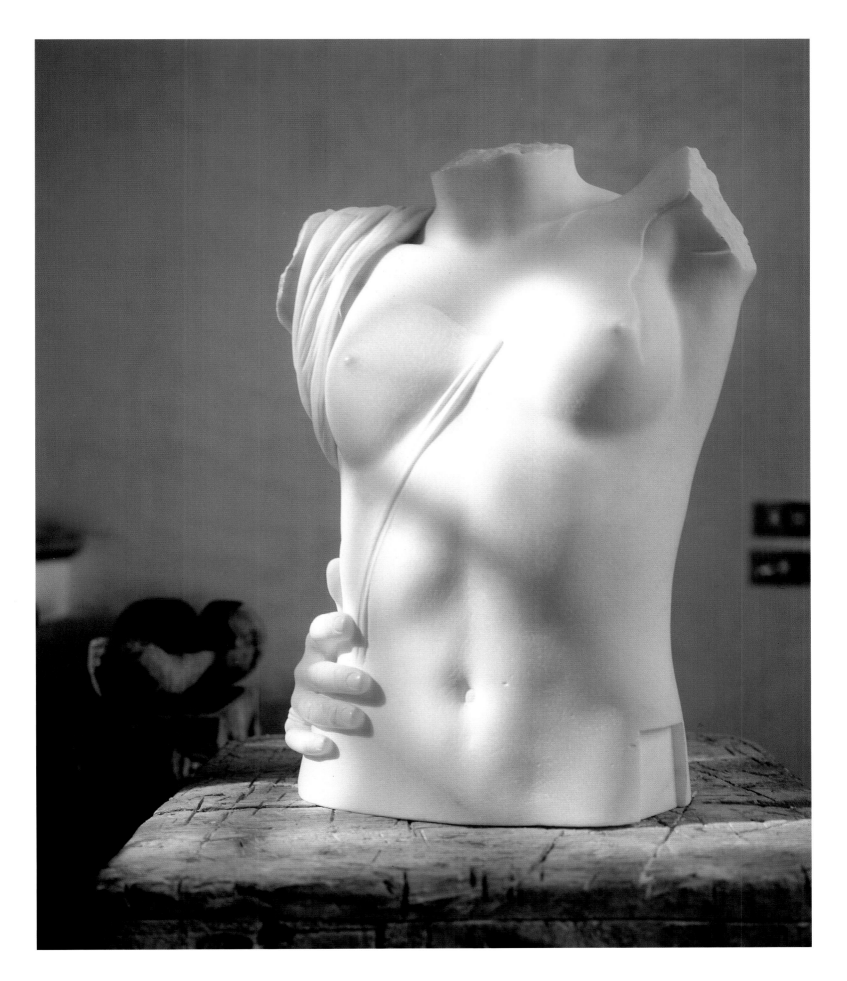

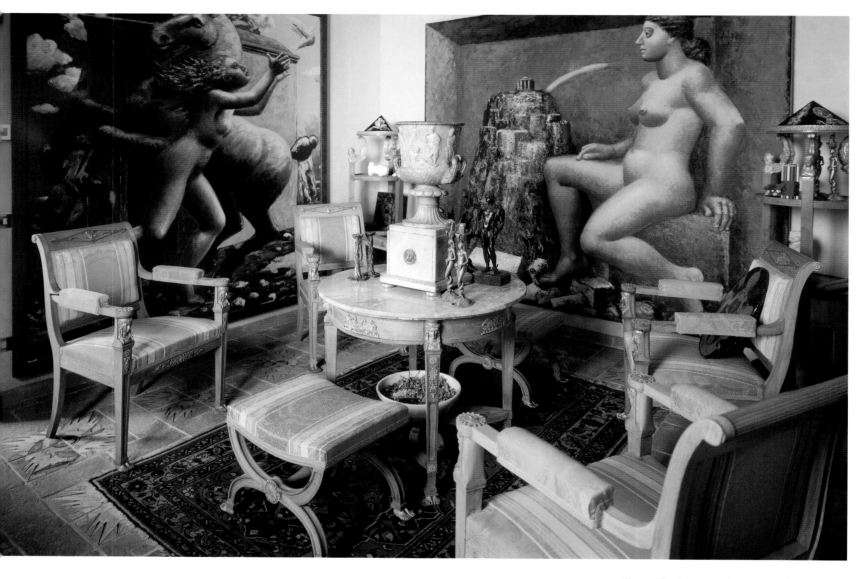

Above: *The doorway in the photograph on page 10 leads to a small drawing room that features Russian Empire style furniture. The large paintings on the walls are by Herman Albert.*

Opposite: *The doorway seen on page 11 leads to a more intimate combination living and dining room. A small blue sculpture by Niki de Saint Phalle rests on a table with a marble mosaic top designed by Mitoraj. The wood used for the floorboards comes from old railroad ties.*

Overleaf, left: *The same room has a large pietra serena fireplace with a cast-iron sculpture by Mitoraj placed inside.*

Overleaf, right: *A Daum crystal rests on a small bronze table by artist Dô Vasilakis.*

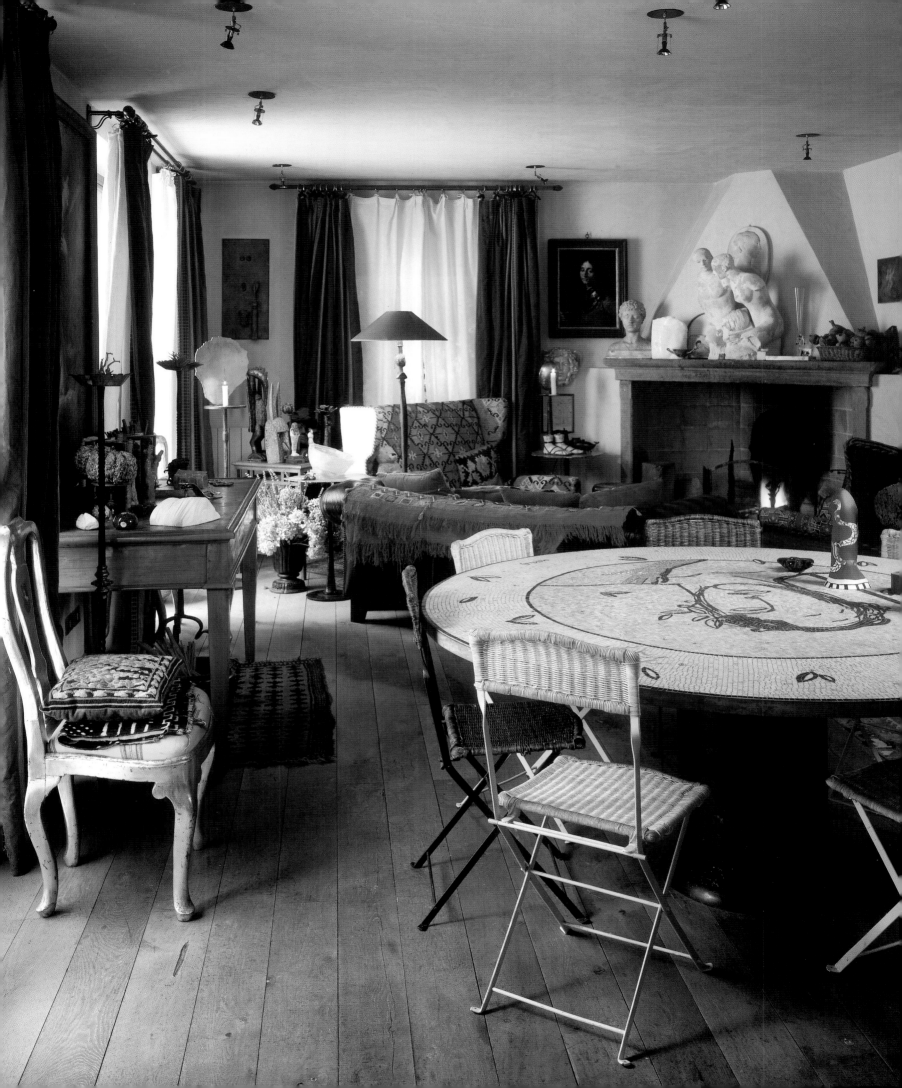

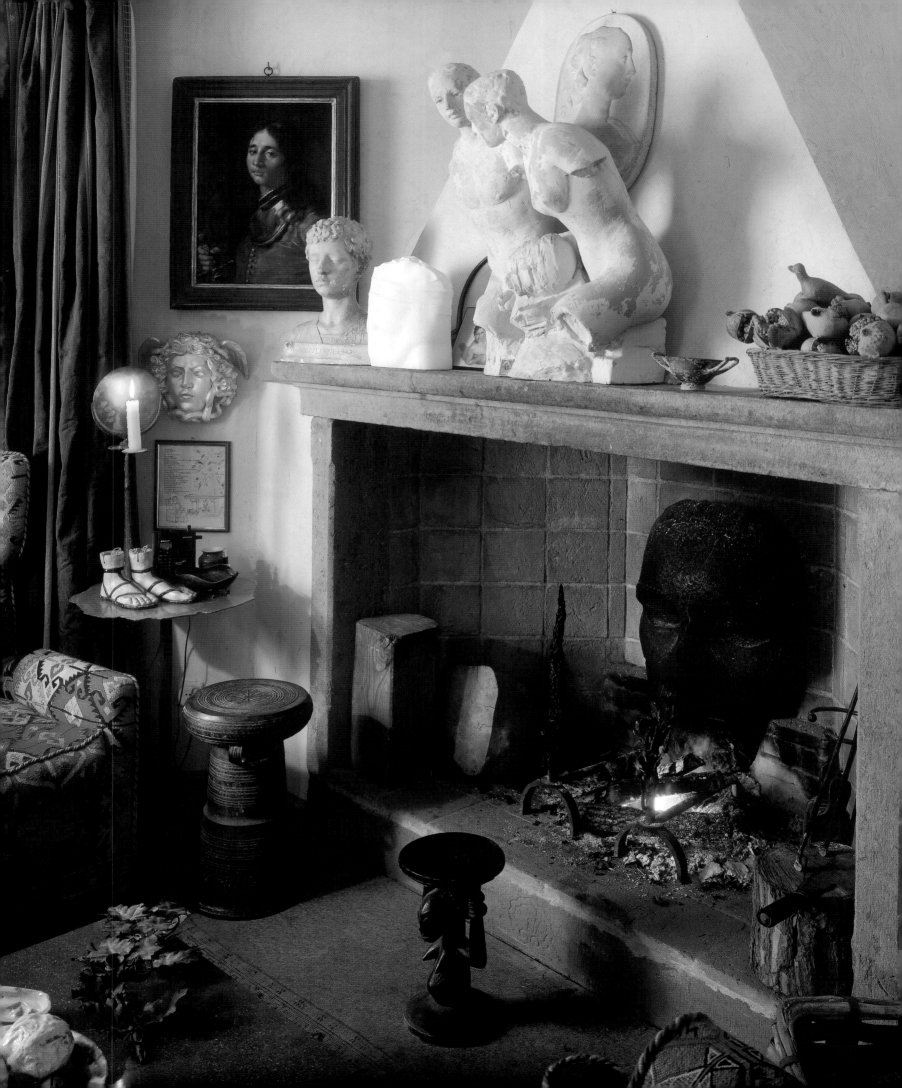

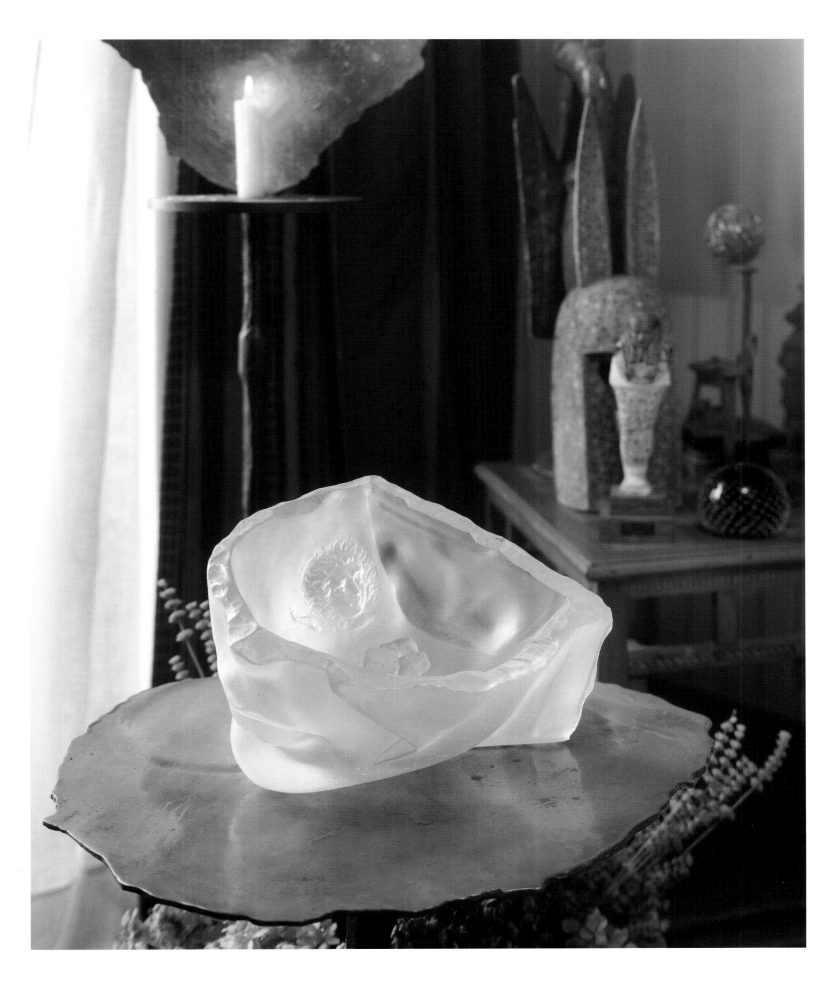

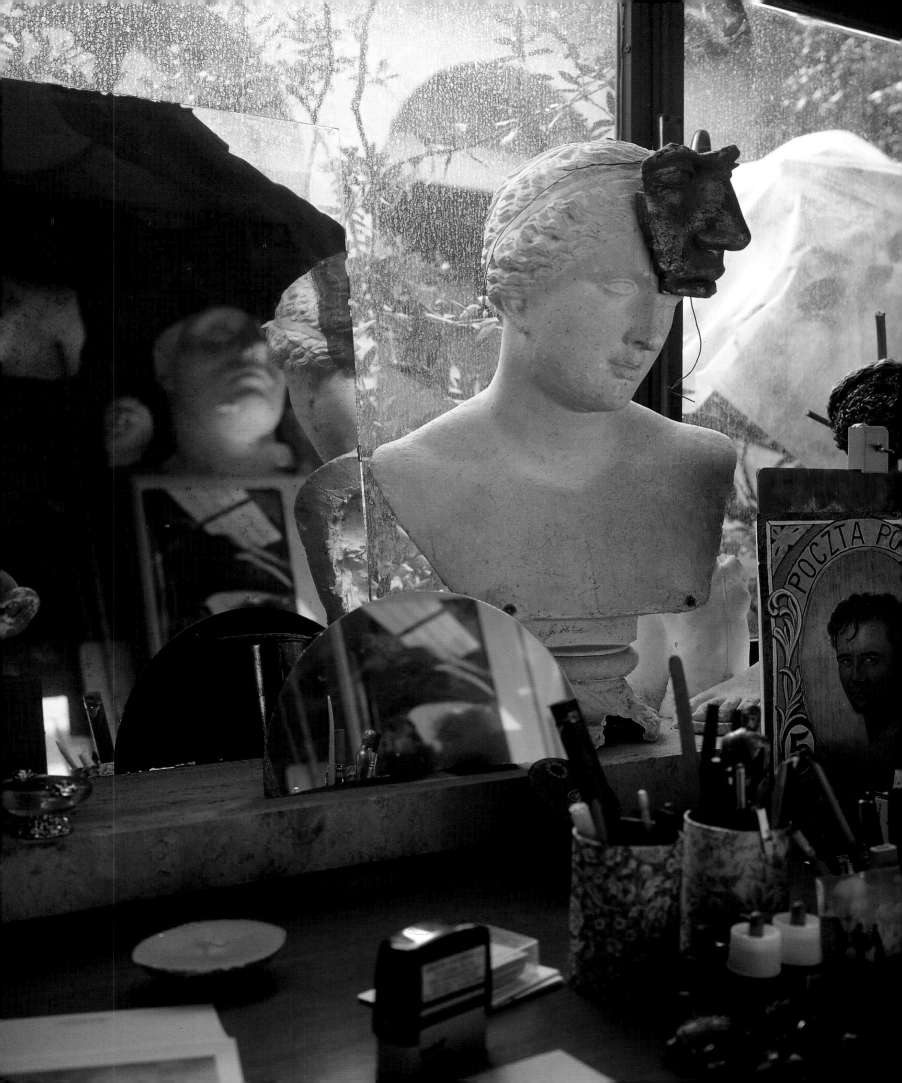

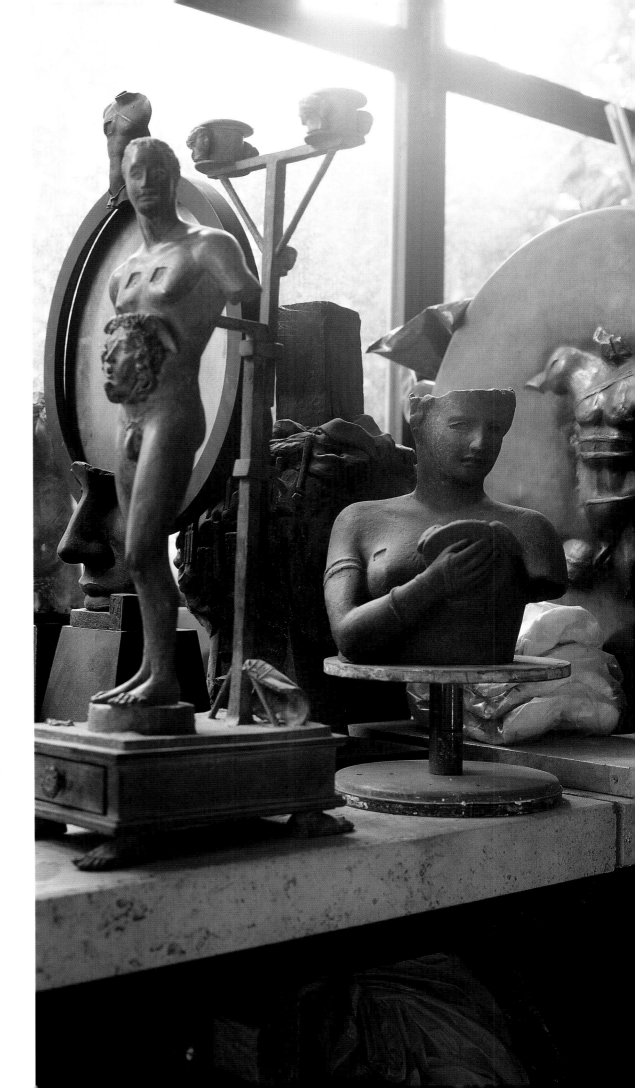

Previous pages, left: *One corner of the living room has objects collected by the artist including antique books and Oriental corals. The picture on the wall is a Herald Angel of the Bologna school.*

Previous pages, right: *In the same room is a painted music box dating from the eighteenth century. A collection of plaster cameos from the nineteenth century sits on top.*

Opposite and right: *The windowsills in Mitoraj's studio hold collections of artworks, sketches, and tools.*

Sandro Chia

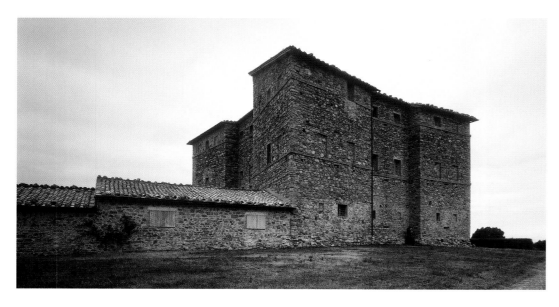

For Sandro Chia, the purchase of the castle of Romitorio in the small town of Montalcino, in the province of Siena, was the occasion for his return to Tuscany. He had left in 1968 upon graduation from the Florence Academy of Fine Arts with no clear plan in mind. As it turned out, life and art took him to Rome, New York, and other cities for many years.

Chia relates the story of how he came to his sudden decision to purchase the house one day while he was in the process of painting a huge canvas (measuring over 400 square feet) in the middle of a torrid New York summer. "I remembered a castle that some time ago a friend had suggested that I buy, describing it as something that would suit me. At the time I had declined without giving it a second thought, but that day I felt an urgent need to see the place. I made a phone call and then caught a flight to Italy. The castle, which had been vacant for sixty years, was covered with vegetation and had been turned into a sheepfold. The enormous stone structure overlooked a valley. Severe and unattractive as it was, it immediately aroused my enthusiasm. In one afternoon I bought it and headed back home."

Insisting that the original structure not be altered, three years of work was required just to repair the walls and replace the roof. Chia personally supervised the work and also scavenged for old building materials to use. To the amazement of the workmen, he even slept in the castle before there was running water or electricity. While this restoration work was taking place the adjoining vineyard, planted with varieties that allow different types of wine to be produced, was becoming an increasingly serious matter, growing in size from a little more than seven acres to almost ninety.

Above: *The site of the castle was chosen for its commanding position. The huge square building with four corner towers, now used as a country house by Sandro Chia, was originally a sixteenth-century Sienese military fortress, later converted into a convent and hermitage. The low structure on the left, which encloses an inner courtyard, is now used as wine a cellar for the artist's wine production.*

Opposite: *A small private chapel is adjacent to the main entrance to the castle.*

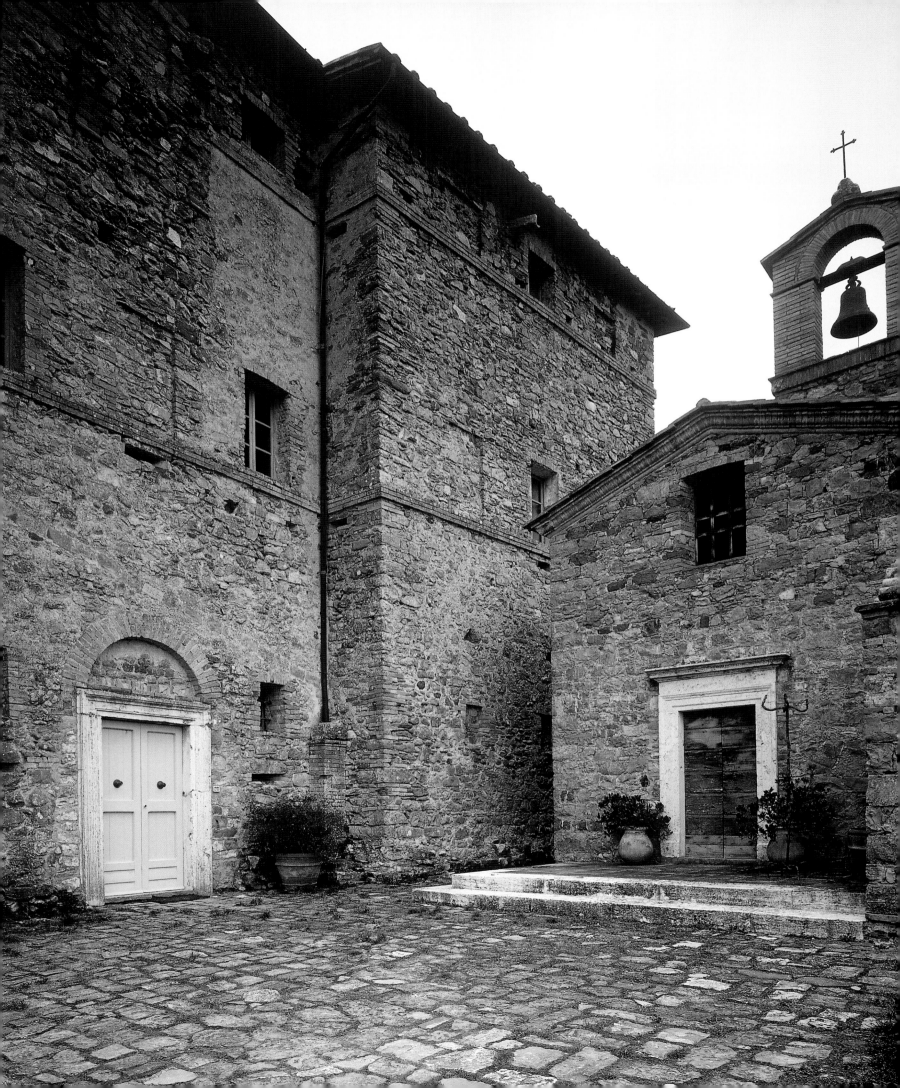

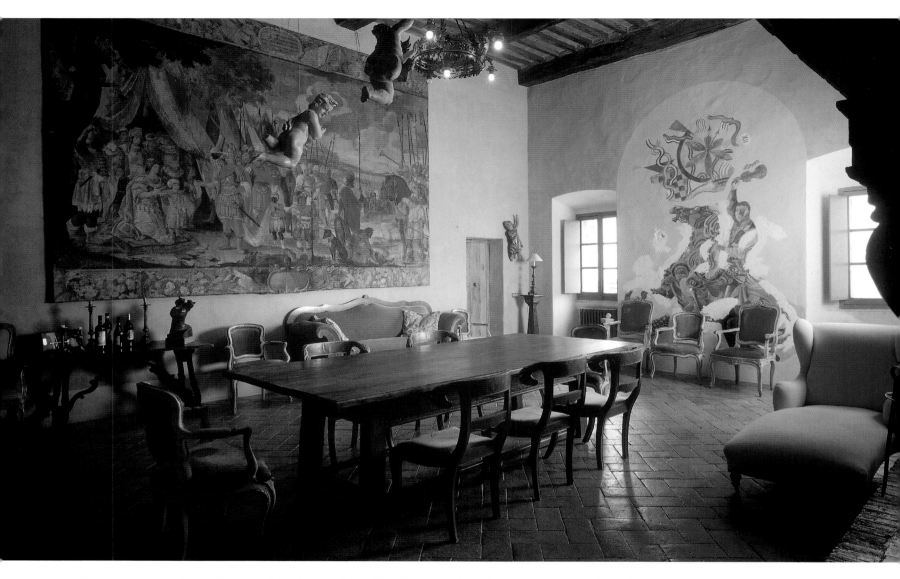

"Wine is a passion of mine. I dreamed the dream of the old-style winemaker who wanted to control the fermentation process, something only advanced technology is able to do today. So I went to California to learn how it is done. In the process, I discovered many analogies between the art of winemaking and art in a strict sense of the word. Winemaking requires skills applied to a product of the earth that is mainly dependent on chance, independent of our will even if we pretend to be guiding its course. The end product is something that is alive, in the sense that it changes over time, and kindles bonhomie, truth. It takes you out of yourself, like when you stand in front of a work of art that can change your way of being or your life."

Chia believes the decision to purchase the property was fate. During the Middle Ages it was a fortress, the last bastion of Siena in its perpetual strife with Florence. Even today the four squat, angular towers stand witness to its defensive function. During Siena's final act of resistance against Florence, the French troops allied with Siena were quartered here. The battle resulted in a massacre. Later the castle was used by the Curia as a prison for disobedient priests. For these reasons, it is said that the castle is haunted; no one from the town slept in it when it was vacant. "I sensed that this property is somehow alive and that you have to gain its confidence and win its friendship. I was sure the castle would never become comfortable and accommodating. It is impossible to cultivate the hard, rocky land other than for growing grapes. The environment is hostile and does not lend itself to pleasant, pretty changes. One would not even think of putting up a pergola or anything of the sort."

Above: *General view of the reception hall on the first floor. The large mural of a rider on horseback on the rear wall was painted by Chia during the eighties.*

Opposite: *A partial view of the hall includes small eighteenth-century armchairs of various provenance and an eighteenth-century wooden putto from Tuscany on the wall. Through the doorway one catches a glimpse of the bookcases in the study.*

Overleaf, left: *Above Chia, and Leo, his faithful Jack Russell terrier, is a late eighteenth-century painting that depicts Charlemagne's meeting with the Persian Princess Roxane. The putto hanging from the ceiling is a seventeenth-century product of the Neapolitan school. The winged head sculpture on the table behind Chia was made by the artist during the eighties.*

Overleaf, right: *The large sixteenth-century stone fireplace from Umbria bears the coat of arms of an unknown family. An anonymous Roman painting, on the left, depicting the Trinity dates from the seventeenth century, while various eighteenth-century portraits line the mantelpiece.*

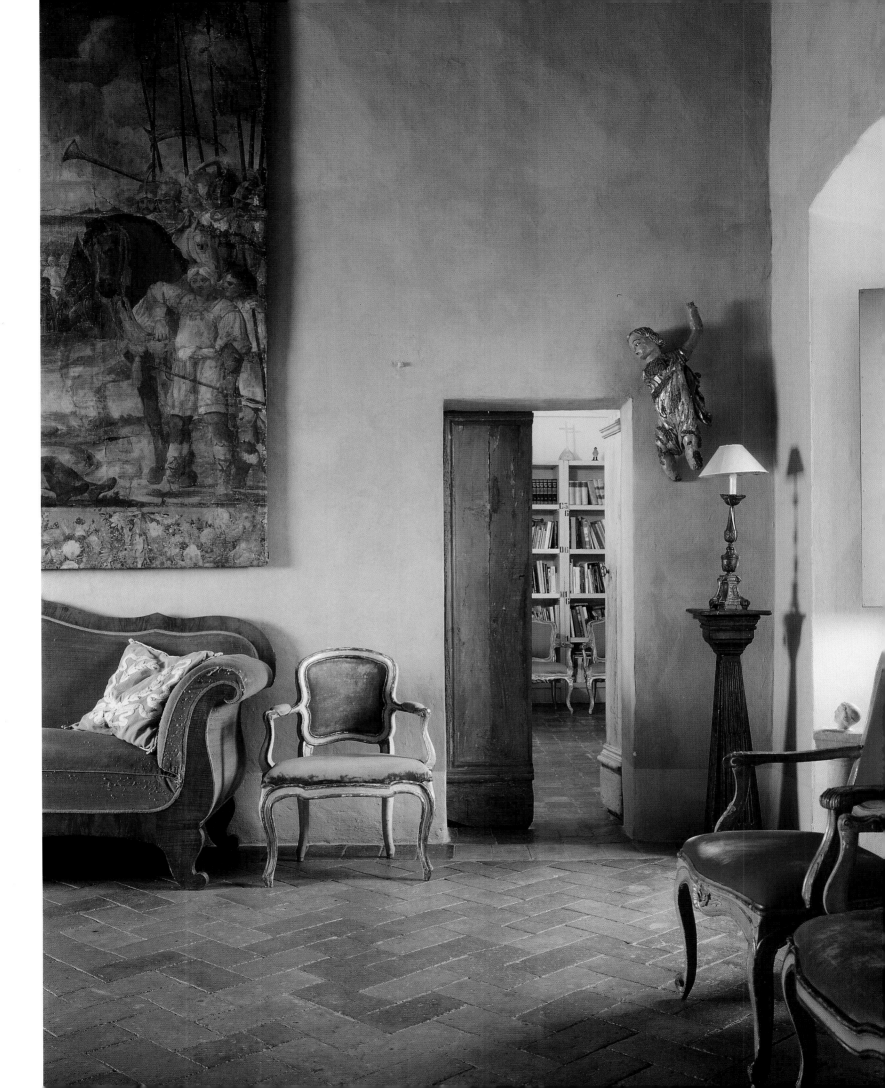

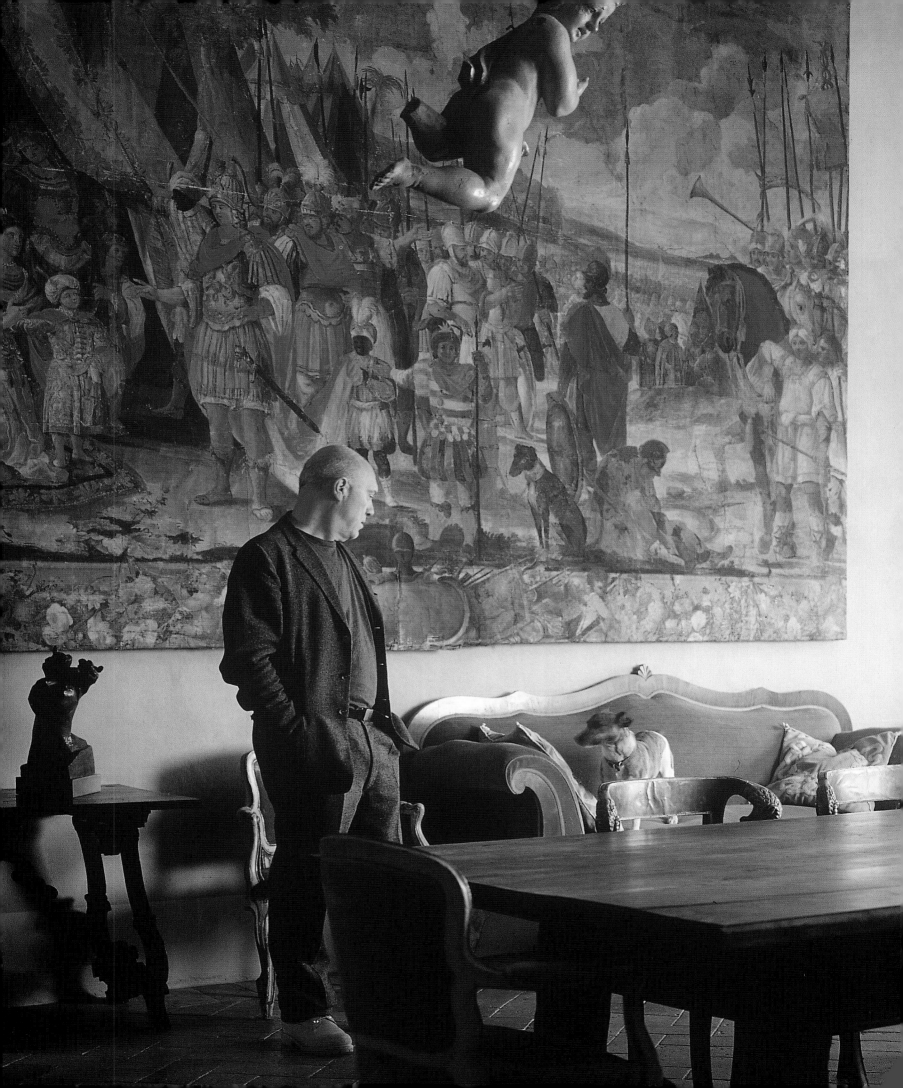

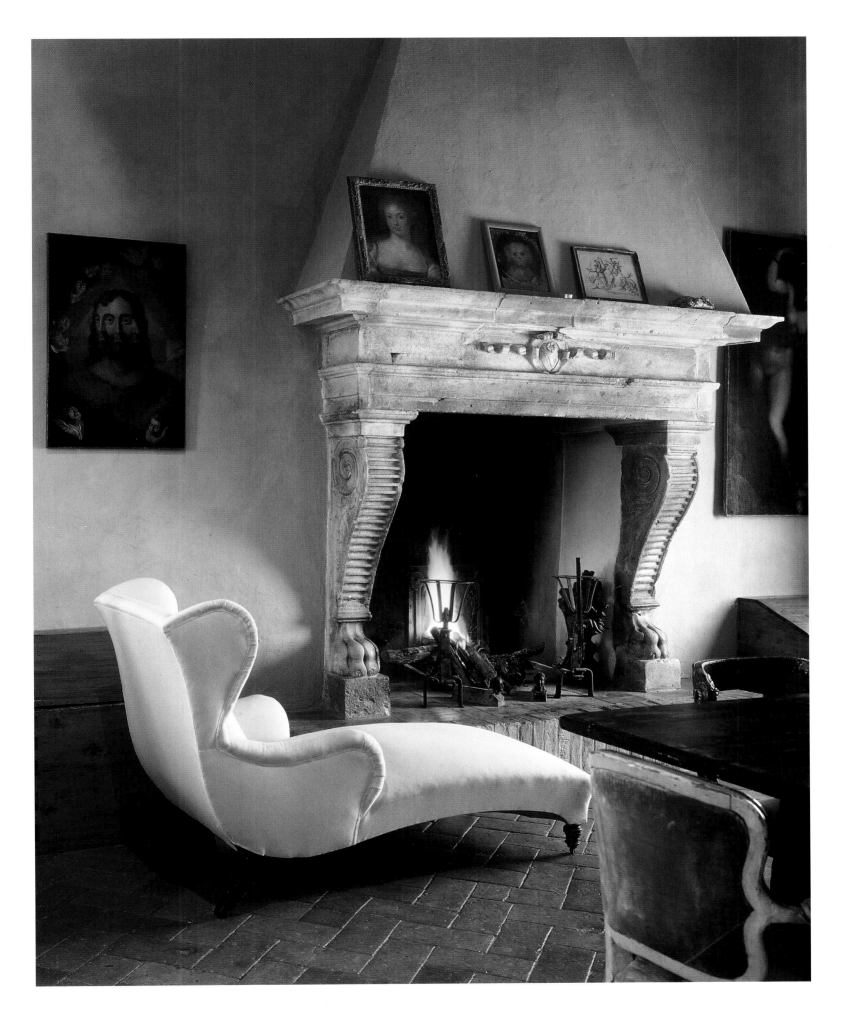

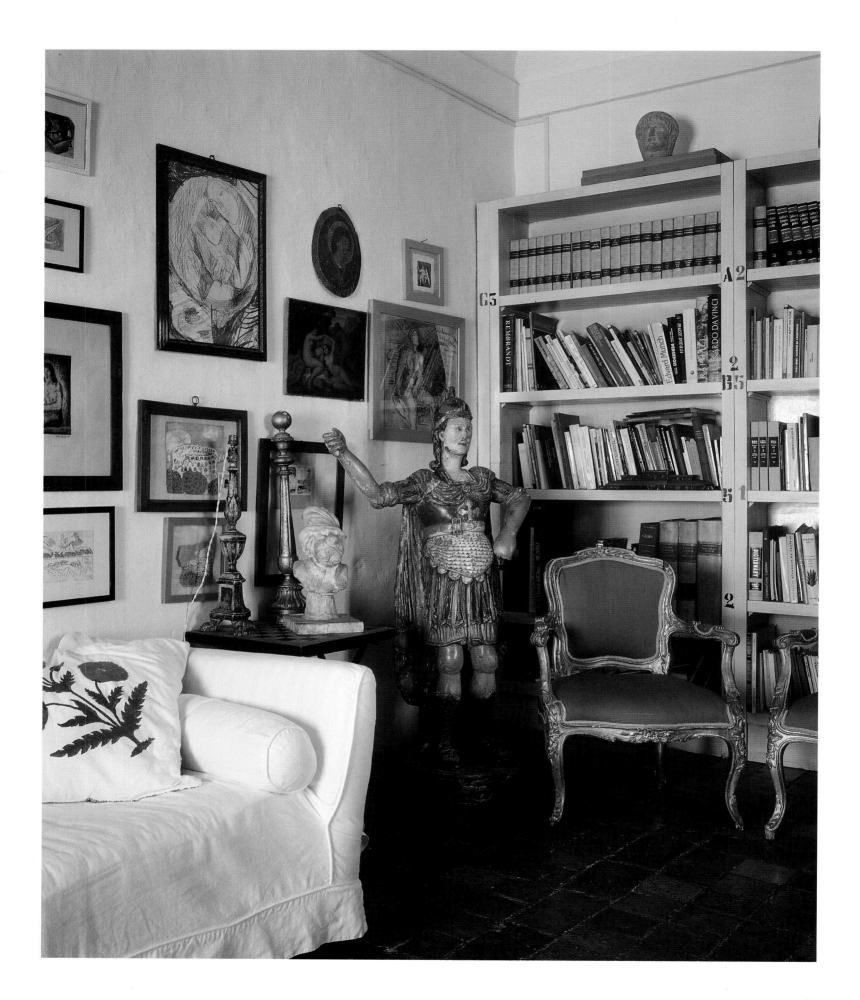

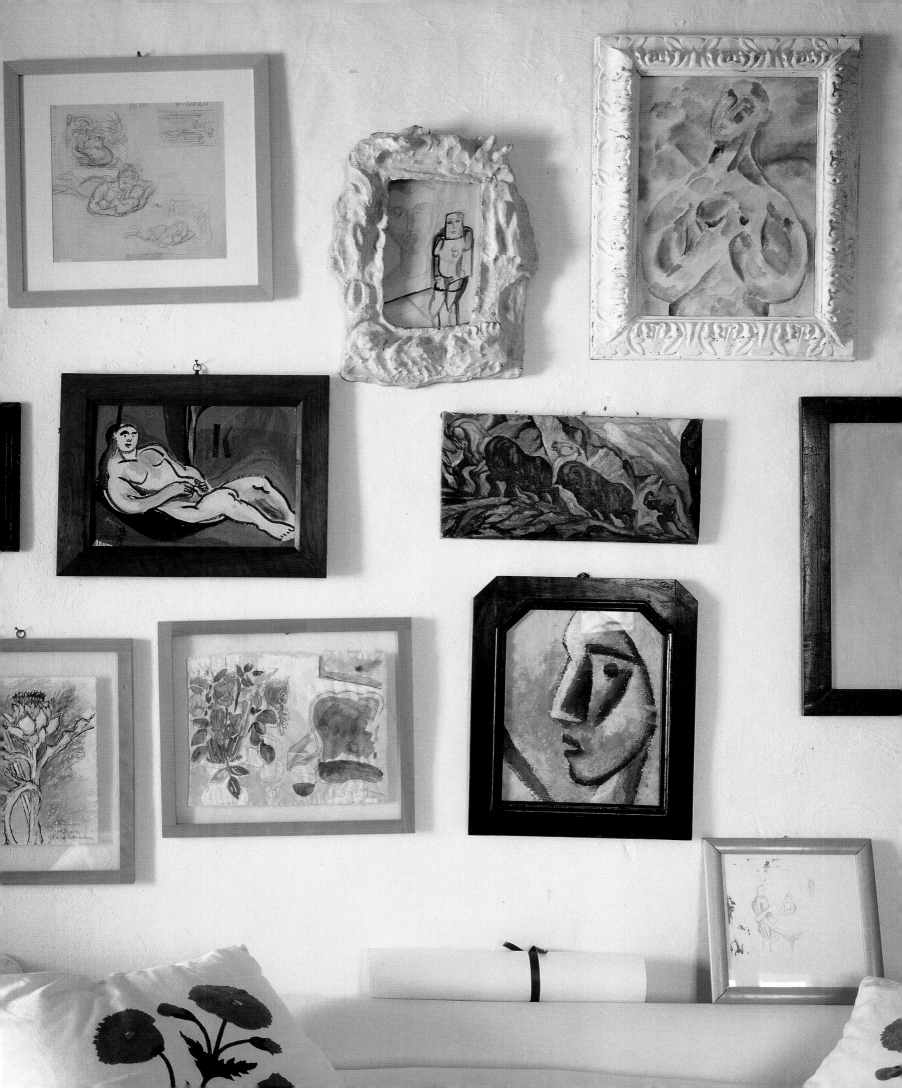

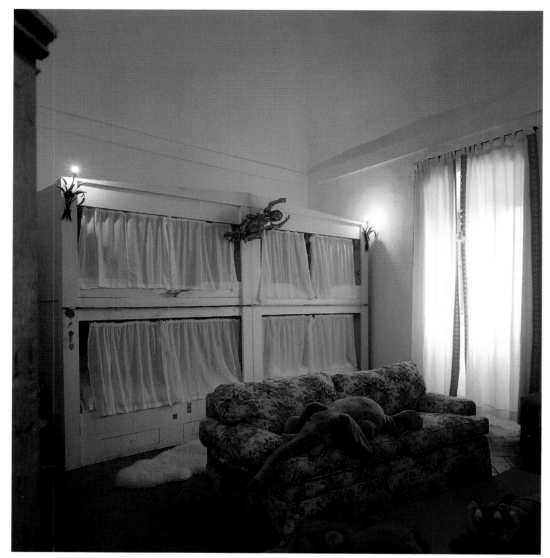

The large rooms are furnished with plain furniture that seems to have always been there. In reality the furnishings are the fruit of many years of accumulating objects that have very different histories. One does not detect the hand of a professional interior decorator. Chia explains that the furnishings practically showed up on their own: "During the restoration work, a junk dealer would come around, each time with a truckload of different items. Usually, I would buy the whole lot, and when the work was finished every piece fit into place, including the billiard table I had always wanted, since it reminded me of my childhood." The artist spends extended periods of time in the castle with his wife and daughters. The vineyard, grape harvests, new wines, and the work of building a large wine cellar attract much of his attention. Chia intends to decorate the wine cellar with mosaics and sculptures that will attest to his work and way of interpreting this land with his art.

For Chia, Romitorio has become a much larger and more complex project than the one he was working on in New York when he remembered the ancient abandoned castle in Tuscany. Chia states, "I love this place, but it is not my true home, perhaps because I have no true home. I like to buy old houses in different places, including New York, London, Rome, Venice…I have remodeled them to make them my own without ever favoring one over another. Homes have to come from the heart. When I am in the process of restoring them, I feel that they belong to me, to the point that I am actually sorry when the work is over, afterwards I feel no special attachment to them. Perhaps things will be different this time, one never knows."

Previous pages: *The study off the main hall features plain bookcases and a collection of prints and drawings by the artist dating from the eighties and nineties. The large eighteenth-century polychrome wooden marionette is from Sicily.*

Above left: *The bedroom shared by Chia's daughters is characterized by bunk beds that accommodate four. It was fashioned according to Chia's design by a craftsman in Montalcino.*

Above right: *The billiard room, off the opposite side of the hall from the study, is decorated with a red ink etching made by Chia in the eighties and a nineteenth-century French tapestry.*

Opposite: *The kitchen is furnished with nineteenth-century rustic pieces from Tuscany. The large corner fireplace is an original feature of the house. Chia's lithographs from the nineties adorn the walls.*

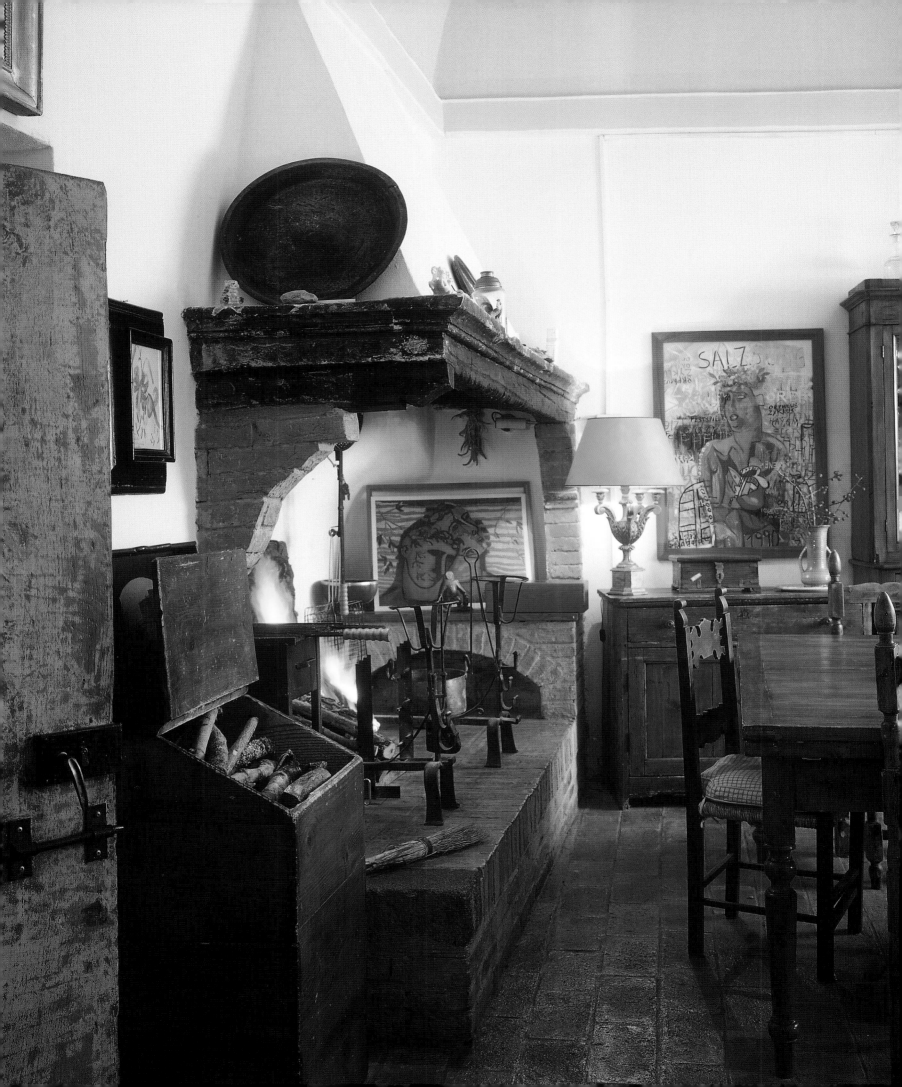

Ivan Theimer

Ivan Theimer's house is reached by foot up a narrow cobbled mule-track that climbs the hill leading to the medieval village of Monteggiori in Pietrasanta, located in the province of Lucca. The house is built on walls formerly used to defend the ancient fortress that once belonged to the early fourteenth-century lord of Lucca, Castruccio Castracani. All the rooms in this three-story building overlook the valley and sea beyond. The view, which also encompasses the islands of Elba and Capraia, was a decisive factor in the artist's decision to purchase the property.

His love for Tuscany in general, and the area around Lucca in particular, began in the seventies, a time when he was still a student in Paris after leaving his native Czechoslovakia in 1968. Theimer's first visit here was prompted by César's accounts, which described it as a fantastic place conducive to an artistic life. Later, when Theimer began exhibiting his work in Italy, he returned many times for extended stays. An important factor in his decision to live and work in Monteggiori was the presence of marble quarries. Marble is an element that has played a leading role in the entire history of the area beginning in Roman times, continuing through the Middle Ages and Renaissance, and all through the twentieth century. The presence of so many artists during the last century can be attributed to the availability of marble and skilled craftsmen.

Theimer left his native Czechoslovakia at a very early age, and his career as an artist has led him to work in different countries. Now his chosen place of residence is changing. "When I first came here, the area was full of artists, including great sculptors, but also a great many young people who chose to live on this coast wedged between the mountains and the sea. They tended to bring their friends along, so a diverse, cosmopolitan scene sprang up. Now young people do not come anymore. Life here has become too difficult and expensive, which is why I fear that my whole familiar world is destined to come to an end."

The birth of his children was the key factor leading to Theimer's decision to purchase the house, which he then remodeled to make it more practical for a family's needs. The restoration work was a considerable commitment that kept the artist shuttling between Pietrasanta and Paris (at the time he was working on a monument for Champs-de-Mars). This situation caused his sculptural contribution to the house itself to be limited to the fireplace and a balustrade. Even so, the entire house and studio bear Theimer's imprint. Bright, white rooms provide a backdrop for his works. His sketches, sculptures, and drawings fill the walls and shelves; they are illuminated by the light from windows that face the sea. The rooms are small and plain, but in them one experiences a blend of several cultures expressed at different moments in time. Ancient rooms, filled memories of a simple existence dedicated to work, have been turned into a home. These rooms are true reflections of this great artist's life and work.

Above: *View of the house and studio from a small garden that runs along the fifteenth-century walls of Monteggiori.*

Opposite: *Portrait of Ivan Theimer with one of his works.*

Overleaf, left: *The entrance to the house is filled with a collection of plaster and wax models for Theimer's* Monument to the Declaration of Human Rights *on the Champs-des-Mars.*

Overleaf, right: *View of the living room and the stairs that lead down to the entrance. The artist sculpted the balustrade and fireplace in stone. Theimer's paintings and drawings adorn the walls.*

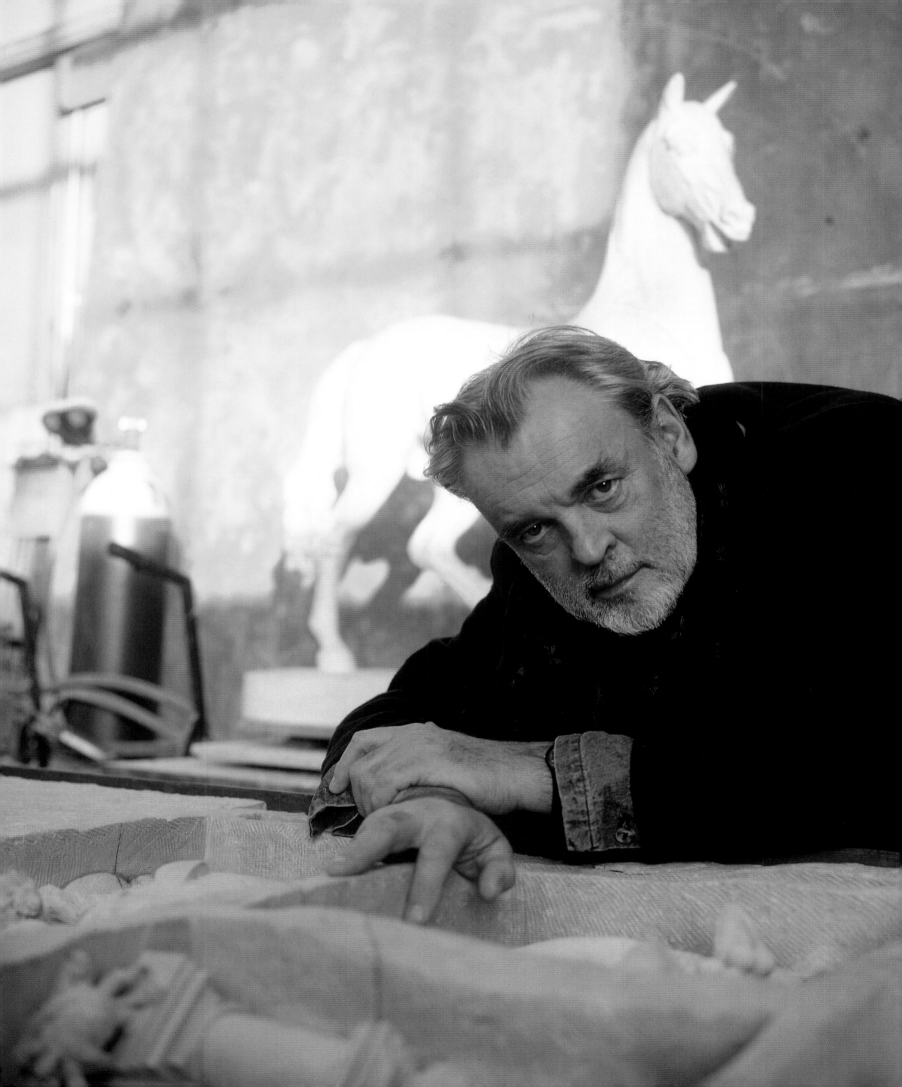

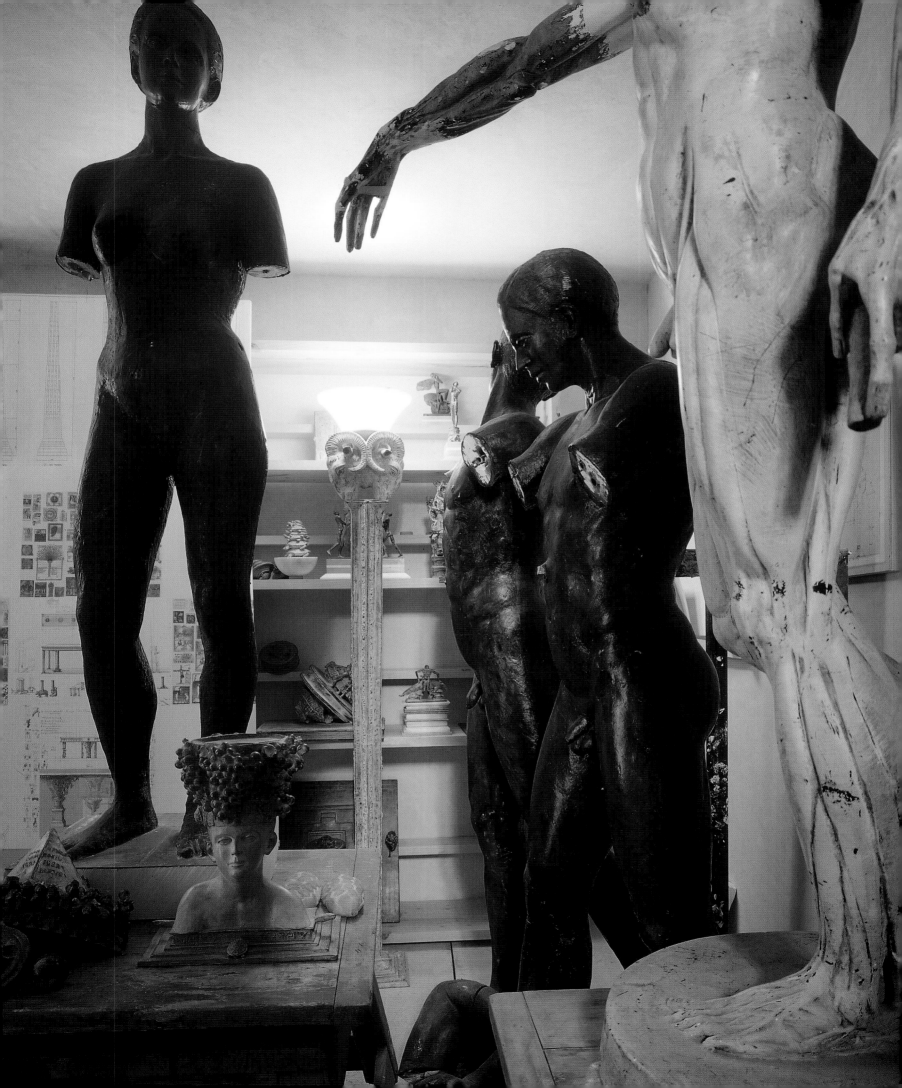

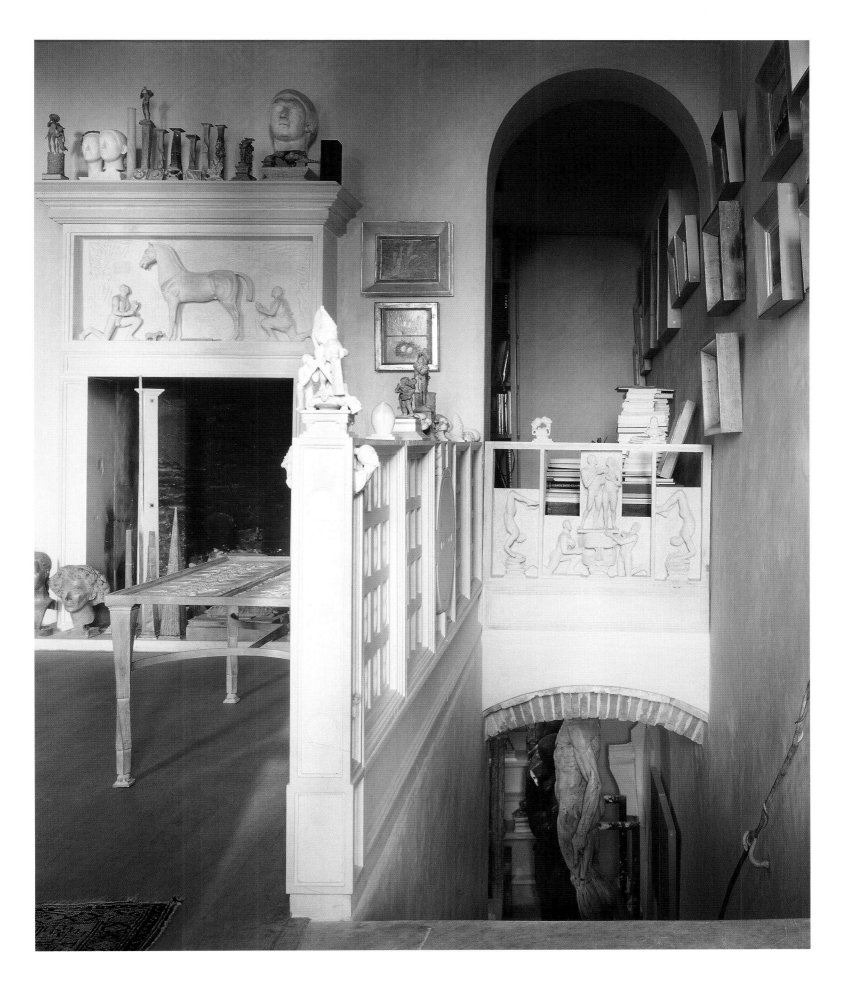

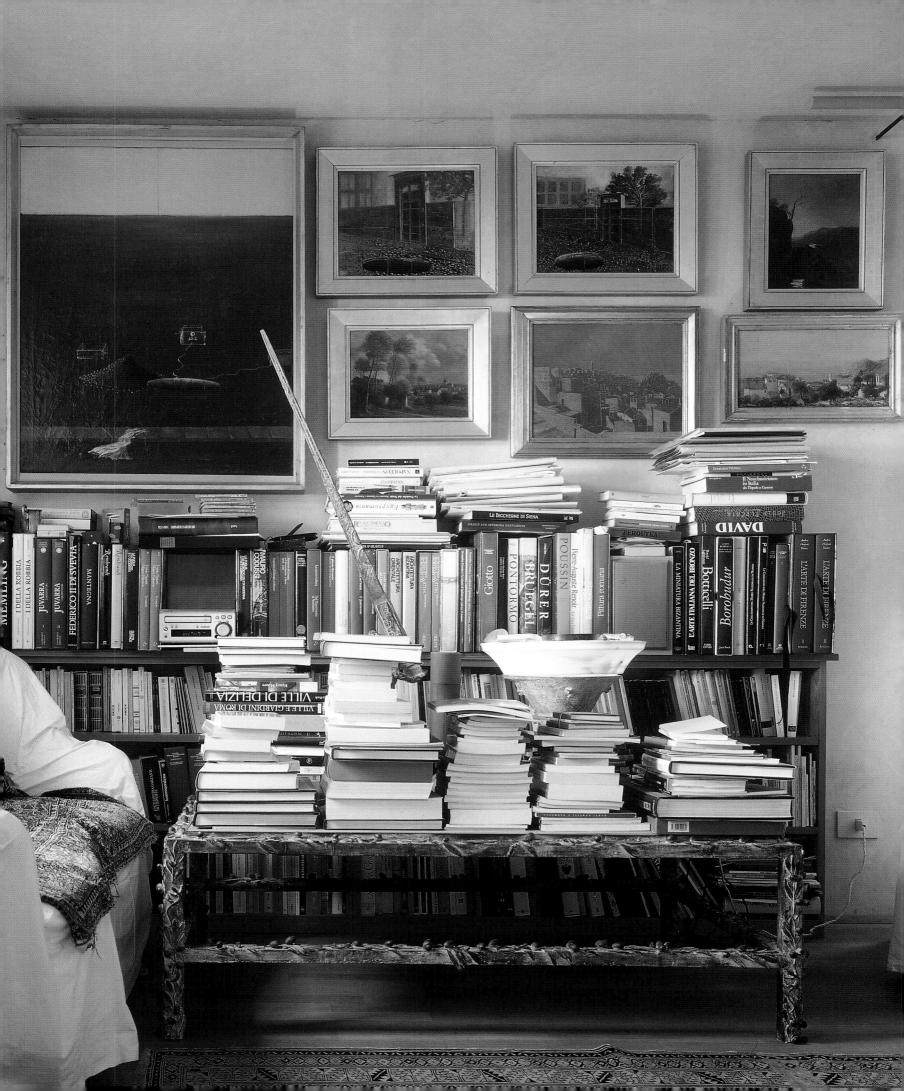

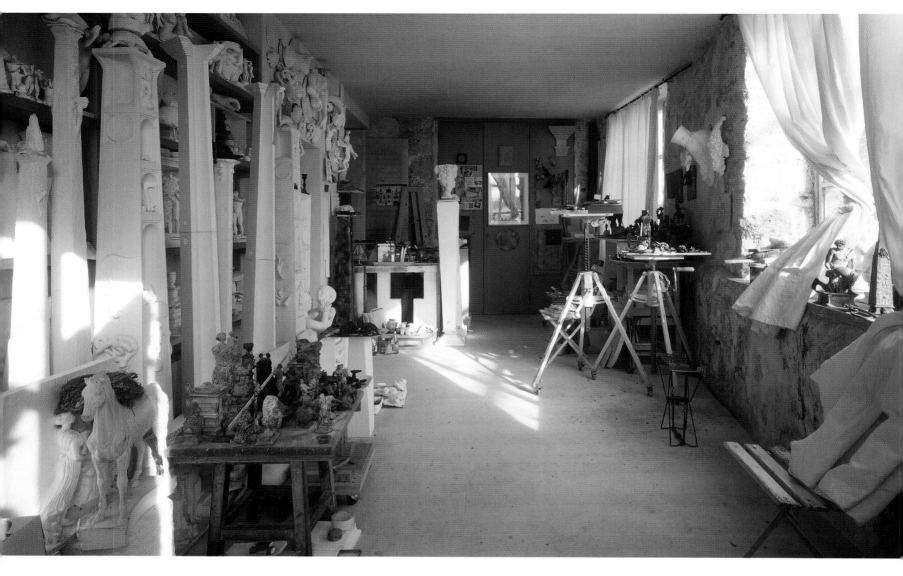

Previous pages, left: *In a corner of the second-floor living room is a bronze table, with an olive branch motif, designed by the artist. Behind piles of books on the table is a bronze and marble lamp, also designed by Theimer.*

Previous pages, right: *On the walls of the same room are paintings by the artist and on the balustrade are some of his small bronze studies.*

Above and opposite: *Theimer's studio overflows with sketches, finished works, and objects collected by the artist.*

Overleaf, left: *On the wall are plaster casts of acrobats and a tortoise leg—thematic elements in Theimer's work.*

Overleaf, right: *A windowsill in the studio has works and projects in progress, including a red wax study for a column (Monument to Wine) that will be built in Bordeaux, a child's head with shells, and two tortoises carrying mountains.*

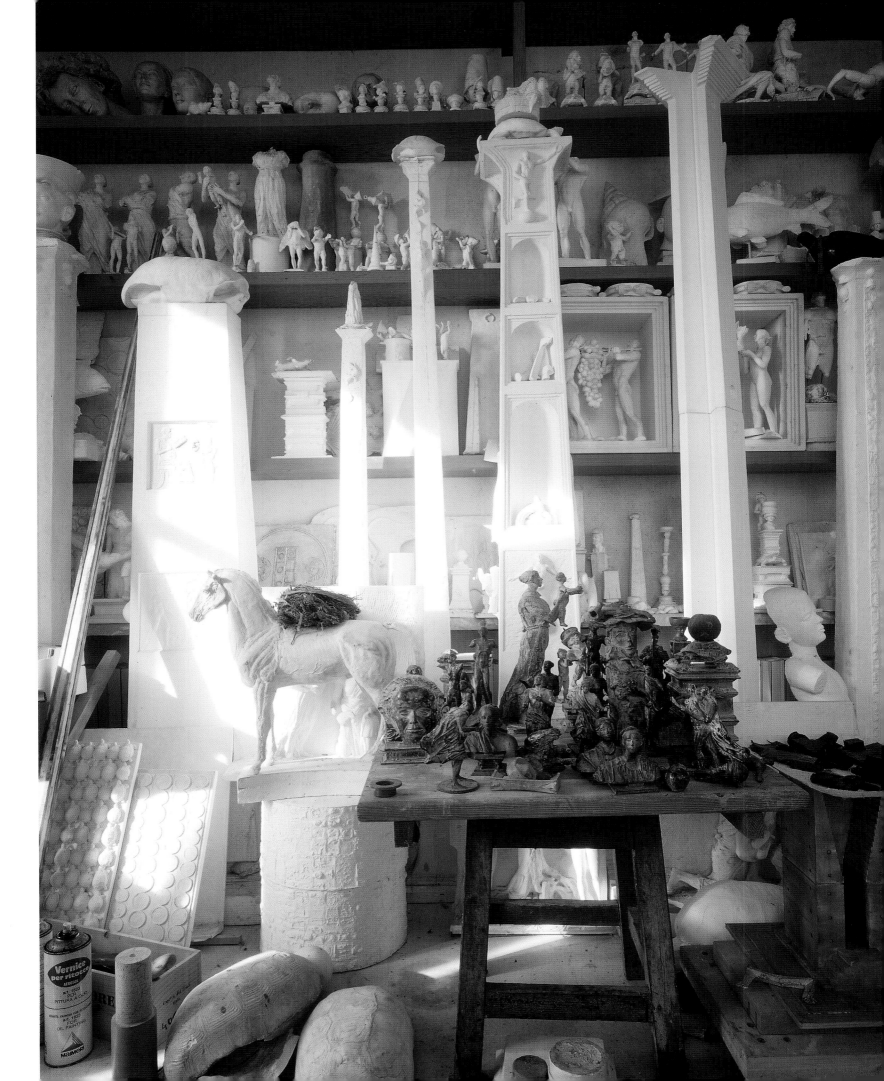

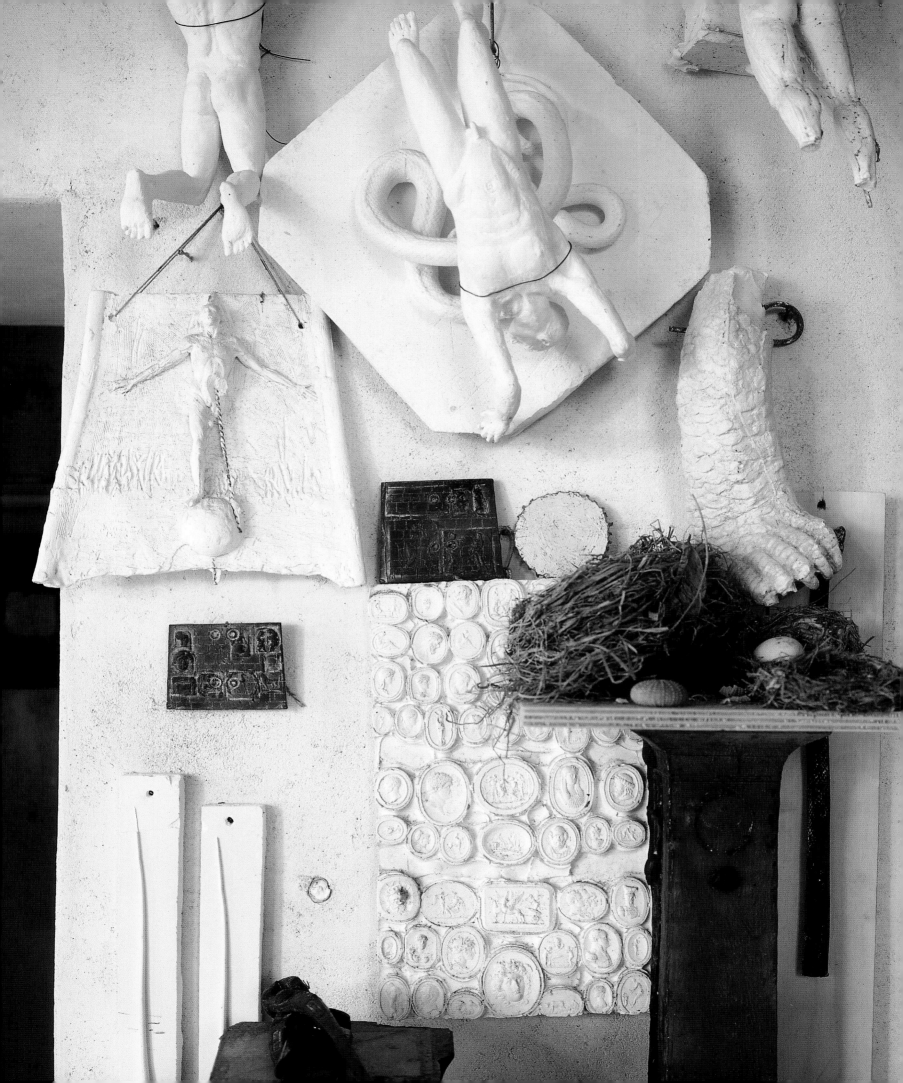

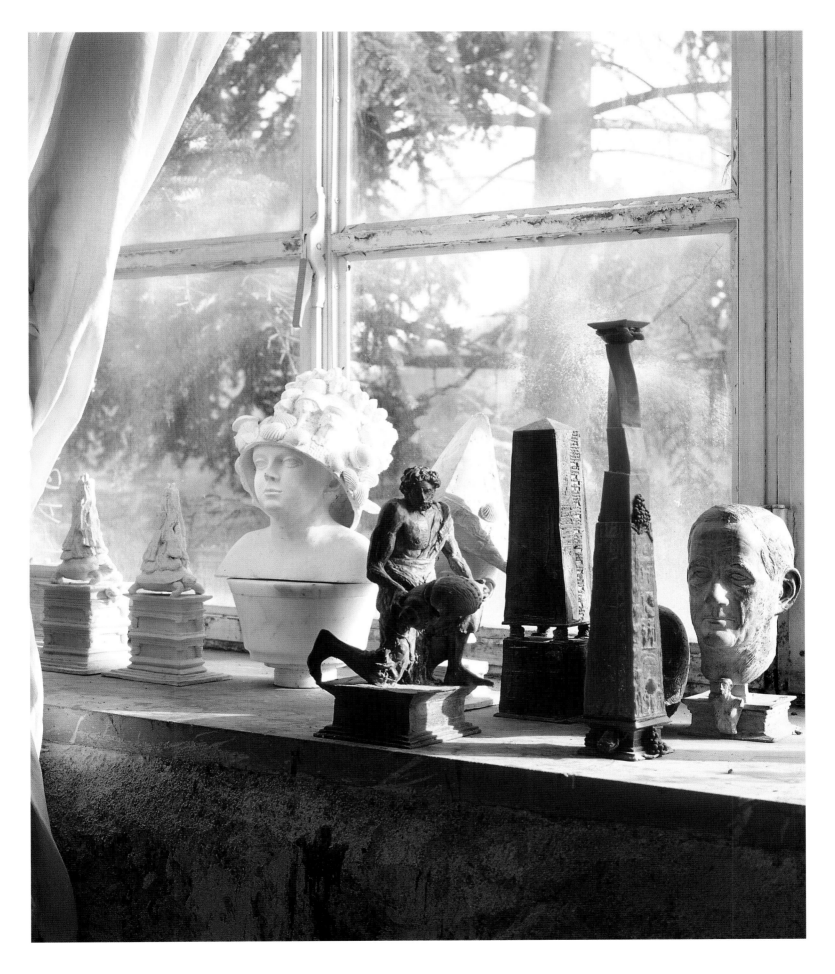

Massimo Lippi

Between Siena and Buonconvento, along an ancient Roman road called Via Cassia, one comes across a fortress-like complex. Unlike typical defensive structures, which are usually located in strategic and elevated locations, this fortification is positioned next to a road, in a plain. It is one of the most unique and fascinating buildings in the Sienese countryside—the Grancia di More di Cuna, a fortified farm built in fourteenth century by the religious congregation of the Spedale di Santa Maria della Scala. The old granary, originally built to store grain for the Republic of Siena, is divided into separate large spaces and is like a small village enclosed by walls.

This is the context where Massimo Lippi carries out his work as a sculptor and poet. He passes much of his time meditating and trying to capture the sensations emitted by this historic building. The artist is keenly aware that the materials, light, and silence of this edifice give him the vital energy he needs for his creative work and therefore he has carefully avoided transforming the spacious rooms and their stone column supported vaulted ceilings. Lippi describes his relationship with the places that are important to him: "In my opinion, there is no such thing as a perfect house and yet, I would not trade my home, my lot, my vital space, or my sorrowful people—now white as bone—for anything in the world. It is here that in the tumult of these days my dead are housed. It is here that I try to make poetry out of anything that I lay hands on.

"When I was fourteen years old I wrote a poem about my father and my first home, a cry of joy and prophecy, a drop of nectar that drips in my heart without end. Dear family members and the constant flow of the people in my village, Ponte a Tressa in the province of Siena, as well as lands and legends, were all swept away by a slow, inexorable hurricane. Our house was always open to the whole town; it had the flavor and voices of my people, and each individual left something of himself or herself there.

"The long voyage of Ulysses with all its hardships seems made for the sole purpose of going back to the beginning, back home where he set out from on a human adventure that ends in the myth of legend. It was no different with the farmers and artisans from whom I learned the ancient craft of portraying every bit of life. These wonderful men and women deserve hymns of praise. Instead, their homes, land, and their personal and collective stories are no longer handed down. The legends are as dead as the air in a sulfur pit. What happened to the need and pleasure of keeping company? It used to be that the fireplace was a sacred place in the winter—where we cooked, where I learned to read and colored, and where the *Befana* came down the chimney on the Epiphany. Even now I revive these customs that are in my blood, but everything is a flash of memory and this house is a lopsided imitation of the original.

Above: *The Grancia di More di Cuna is a rare example of a fortified agricultural complex that has survived to the present day in good condition. Built in the fourteenth century to store grain for the congregation of the Spedale of Santa Maria della Scala in Siena, it is surrounded by strong walls and defensive towers. Ramps enabled carts of grain to reach the upper levels of the granary.*

Opposite: *A portrait of Massimo Lippi in his studio.*

Overleaf, left: *Part of an eighteenth-century stucco relief depicting the Annunciation remains on the wall of a landing between two ramps.*

Overleaf, right: *Gently sloping ramps are paved with terracotta bricks and have raised, rounded striations that provide braking points for the carts that were once pulled to the top of the edifice by draft animals. The ramp is illuminated by a series of arched openings that overlook a courtyard.*

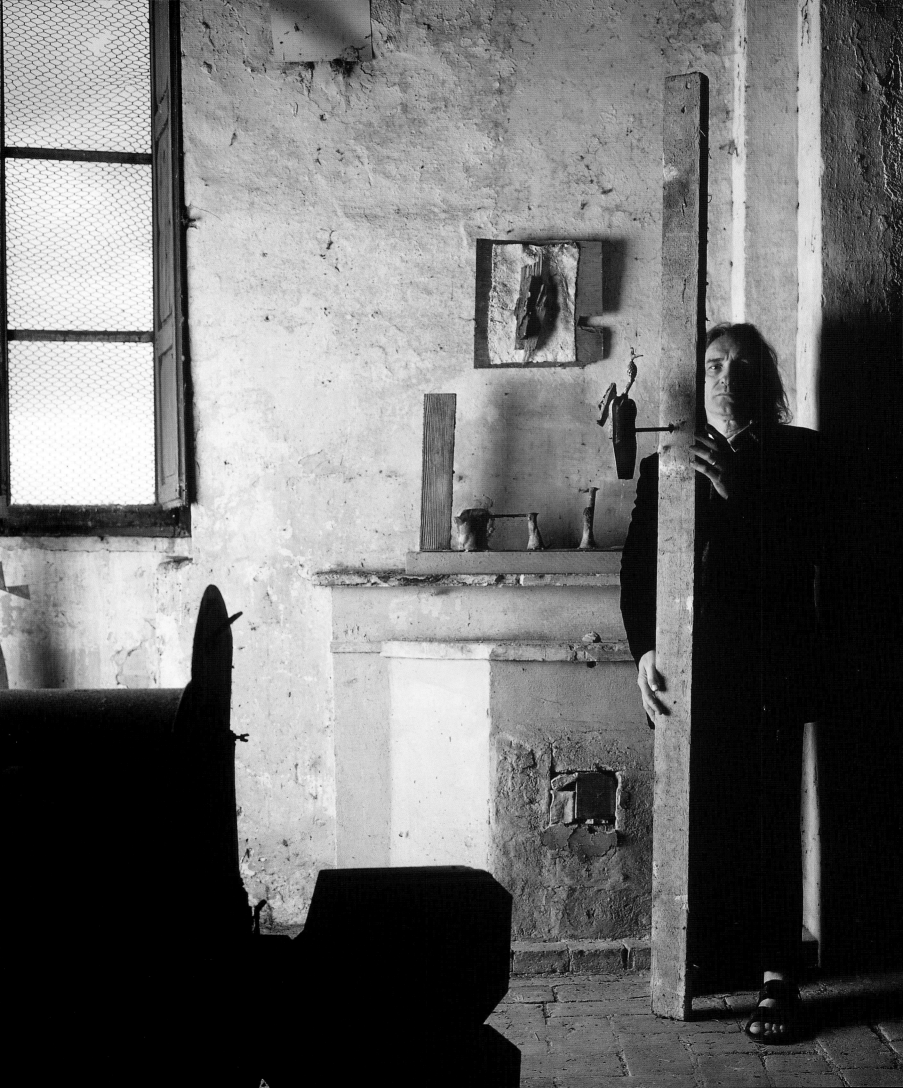

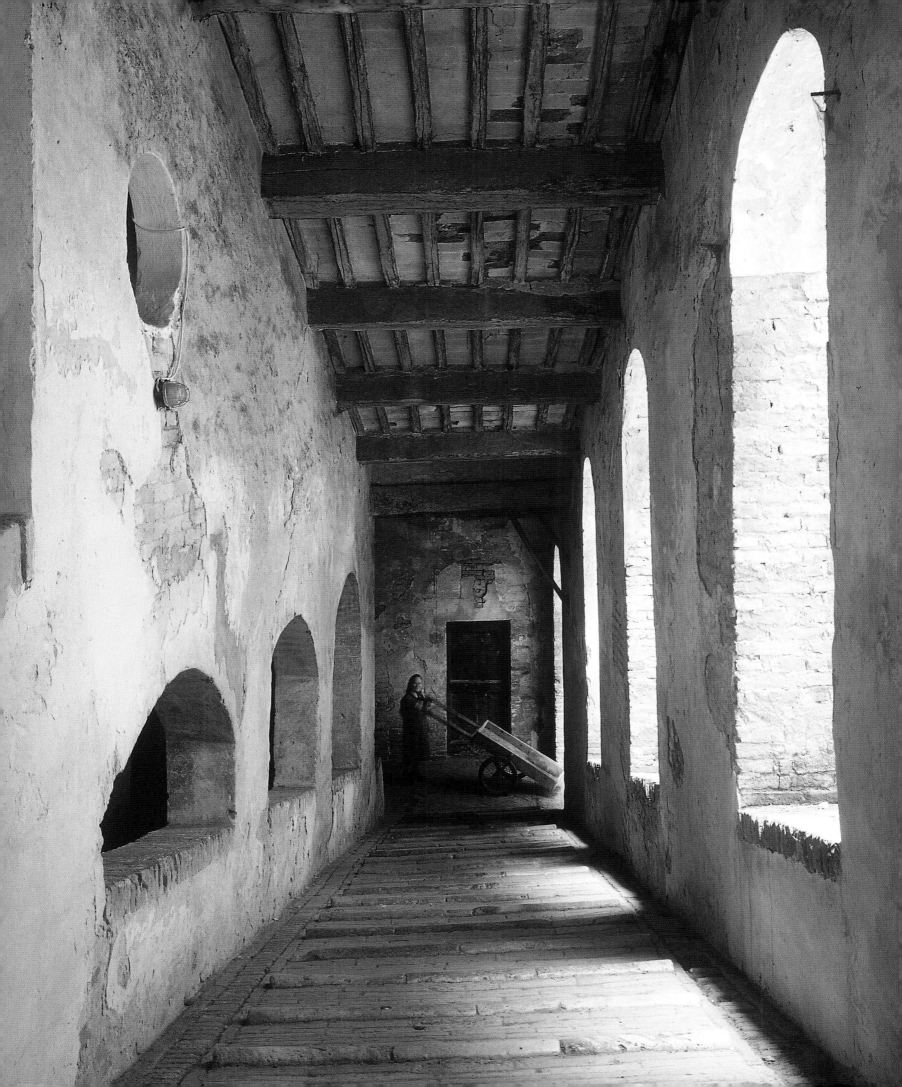

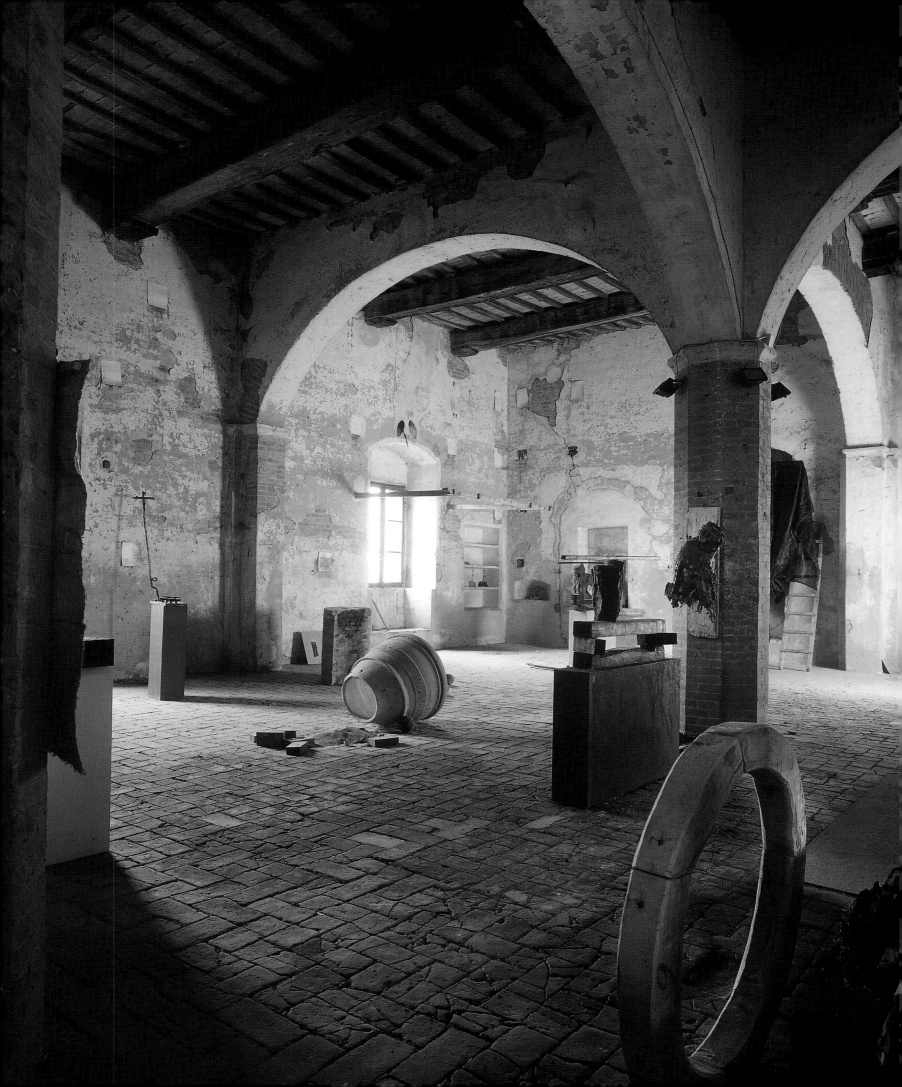

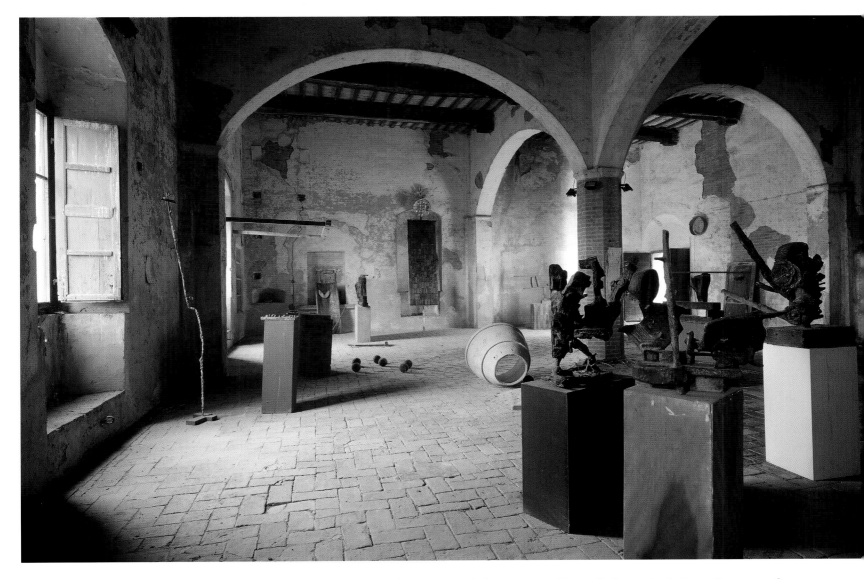

Opposite: Lippi uses the granary's huge rooms for his studio. Octagonal brick columns support arches that in turn support wooden ceiling beams. In the center of the room on the floor: Memorie d'infanzia (1996), terracotta, ashes, and eggshells.

Above: *The artist's sculptures bring new life to the old rooms.*

Overleaf: *The tall assemblage: L'angelo del granaio di Cuna (1977), wood, stone, metals, and plaster.*

"I love my home and studio. It is a good place to eat and have a little rest in the heat of summer after having busied myself with the tools of the trade. I am comforted by the maternal shade of summer and the warmth of winter. These friendly walls patiently await me like a nest up in the blue awaits a boy to find it. The house and studio are stuck together like bread and marmalade.

"I do not care for having objects around, at times I would be tempted to get rid of all my work because seeing it all the time gets in the way of my inner visions. I would like to have only the best African sculptures on the walls, along with a few old cast-off utensils from my childhood, and postcards of classic artworks. My home dips its hands in the landscape and inscribes it in my heart and in my artwork.

"No one should have a fixation with the ruin brought on by having too many needs—transforming an artist's house, or any house, into silly little comfortable living quarters or hostels without candor or a healthy irregularity—this is an effective antidote to interior decorators."

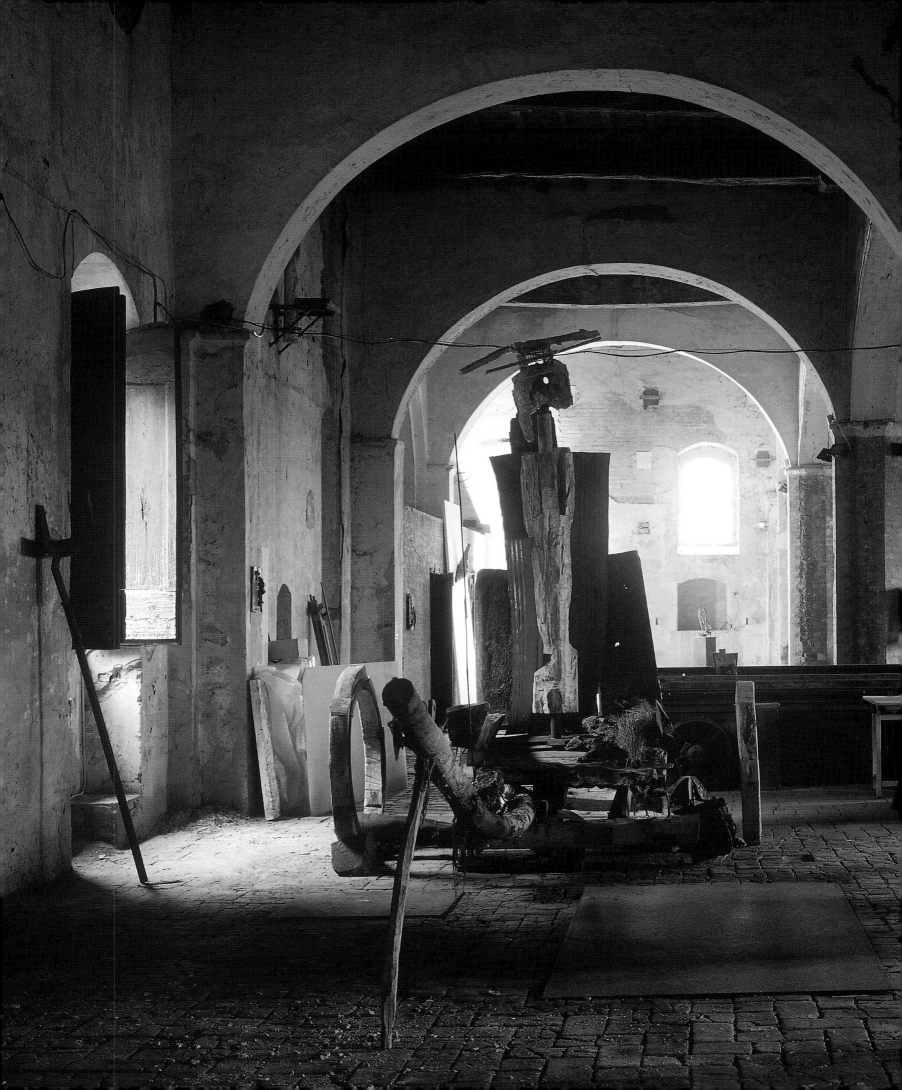

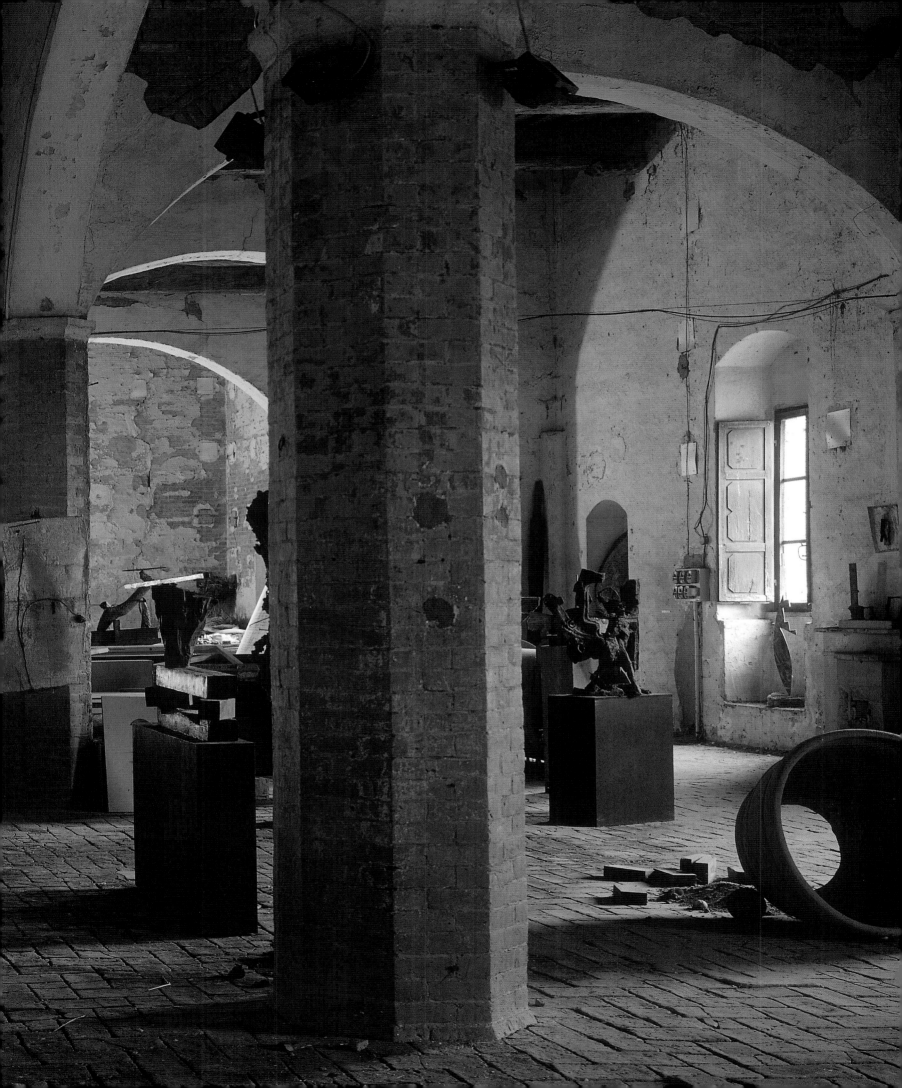

Daniel Spoerri

Daniel Spoerri's studio is found on the ground floor of a building originally used as a hayloft on a large farm in the neighborhood of Seggiano on Mount Amiata, in the province of Grosseto. It is also where his foundation, Fondazione Spoerri, has its office. The spacious room acts as a sort of container for the material result of his passion for collecting objects found during visits to markets all around the world. Models for new sculptures fill the studio and front walk, ready to be transported to foundries. Ever since he was child, Spoerri has collected many different kinds of objects. When he was living in Paris he devoted three days a week to visiting flea markets, where he would purchase items that he would later arrange and classify. When he relocated to Tuscany three trucks were needed to carry his finds, which in turn filled three cellars in his new residence. Among his collections is a group of tools that have identical functions. The tools have various forms that are tied not so much to aesthetics as to time and place. Their subtle differences reveal the history of each particular object. Other items are related to one another by nothing more than having been chosen by the artist. His finds are so varied that one comes to think of Spoerri more as a gatherer than a collector. This whole variegated set of samples of different realities strewn along the path of life becomes the subject of his artwork. "I have never created objects," he reflects, "but merely assembled them. I have used one to contaminate another." The best example of this facet of his creativity is *The Genetic Chain of the Flea Market*, a work comprised of forty panels that has a total length of more than 300 feet. The assembled work represents almost literally the total sum of the artist's long-standing interest in collecting.

An old stairway made of a local stone, *pietra serena*, leads up to the living quarters above the studio. The spacious rooms, the kitchen, living room, and bedroom, all have wooden ceiling beams. But most notable feature is a large fireplace and the collection of old plowshares that hangs above it. The furniture is plain and basic. The bareness of the rooms, lacking any hint of accumulation, gives one the impression that this is no longer the artist's true home and in fact, after dedicating a decade of work to his foundation, Spoerri no longer lives in this house on a regular basis. The poetics of Spoerri's art lies in bringing abandoned objects back to life. These objects are fragments of life that accompany him for a period of time, only to be left by the wayside down the road. Both the house and the garden are the fruit of his labor, yet having brought them back to life, the artist has now left them to their fate. One day perhaps it will be someone else's task to revive them.

Spoerri first came to Tuscany almost by chance: "I did not come here looking for Tuscany, or this particular place. Instead, everything came out of the blue, almost like a trap. In much the same way, I created 'trap images' by chance, I was not searching for them, I merely stumbled across them. I did not trust Tuscany because many people there trying to escape the world, the city, and time. They are convinced that they have found a shelter all their problems...The thing that really made me head off

Above: *Spoerri's house and studio are reworked buildings that are part of a large farm on the slopes of Monte Amiata. The farm is now managed by the Spoerri Foundation. The foundation's motto,* Hic terminus haeret, *is from Virgil's Aeneid.*

Opposite: *Outside the studio recently completed pieces by the artist wait to be transported to one of the many foundries in Versilia.*

Overleaf, left: *The artist in his studio.*

Overleaf, right: *Detail of the studio with objects organized by the artist. Seen are collections of tripods (in the foreground), wooden hat blocks (on the table), tools, and unfinished works (in the background).*

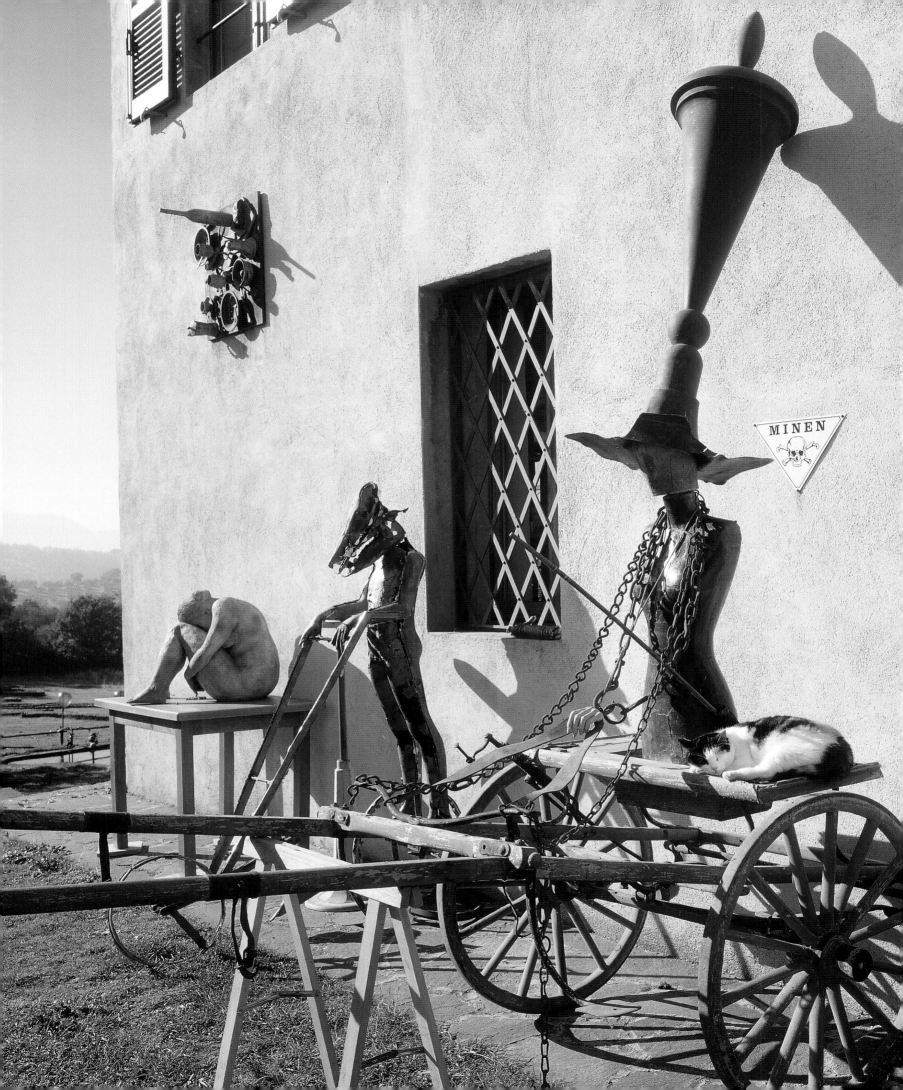

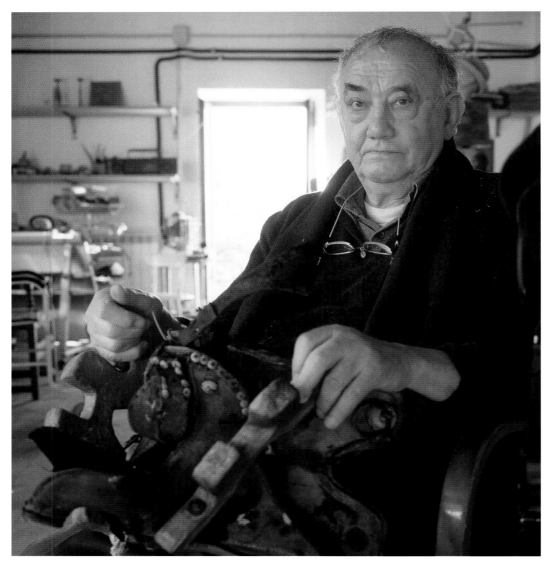

to Tuscany was a ramshackle house that was said to be slowing sliding down a hill. I found the idea attractive. At the time, I had already lived in a mill that flooded once a year. The crooked tower that I imagined turned out to be nothing more than a miserable little house good only for vacations. It was poorly constructed with no foundation and sat in the middle of a dull meadow on a slope. But the trap had already sprung, they wanted to show me other houses…" Spoerri purchased his farm with the idea of turning its buildings into a large house and studio. Initially, all his efforts were concentrated on restoring the structures until he was approached by a man who asked if he could harvest the olives. Spoerri recalls that moment, "It was the first time it dawned on me that I had any."

From that point forward, the artist's interests shifted to the outdoors—specifically, to the exhibition space now known as "The Garden." Spoerri's relation to nature changed and he began to observe plants with the same interest that he observed sculpture and paintings in museums. Though he had not included an outdoor exhibition space in his original plans, he began to place his sculptures, as well as those of friends, in the park. In 1997 he was struck by the idea of creating a foundation. He succeeded in doing so despite many difficulties, not the least of which was the bureaucracy involved. In the beginning it was difficult for the small town administrators to appreciate the potential of the initiative. Today the foundation is self-sufficient and draws increasing numbers of visitors because of its uniqueness. It is Spoerri's greatest accomplishment, summing up all his values and views on life and death expressed in his previous work.

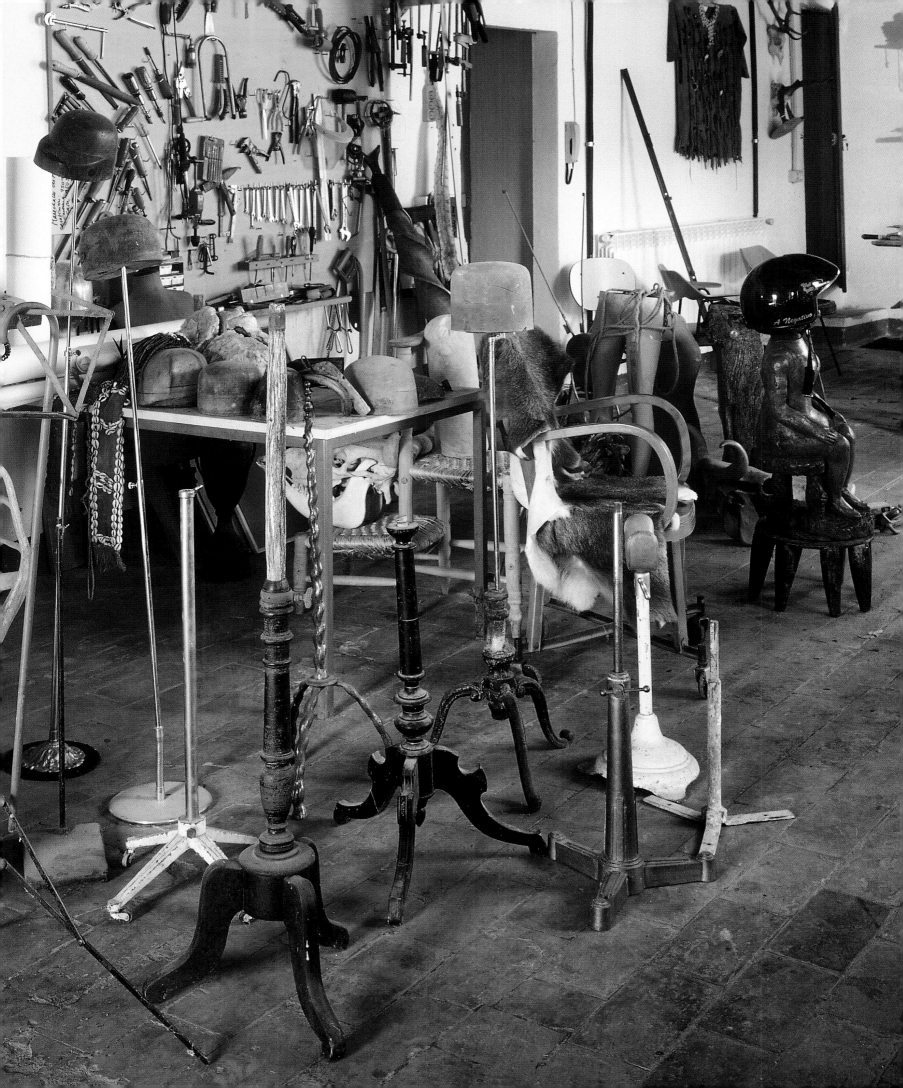

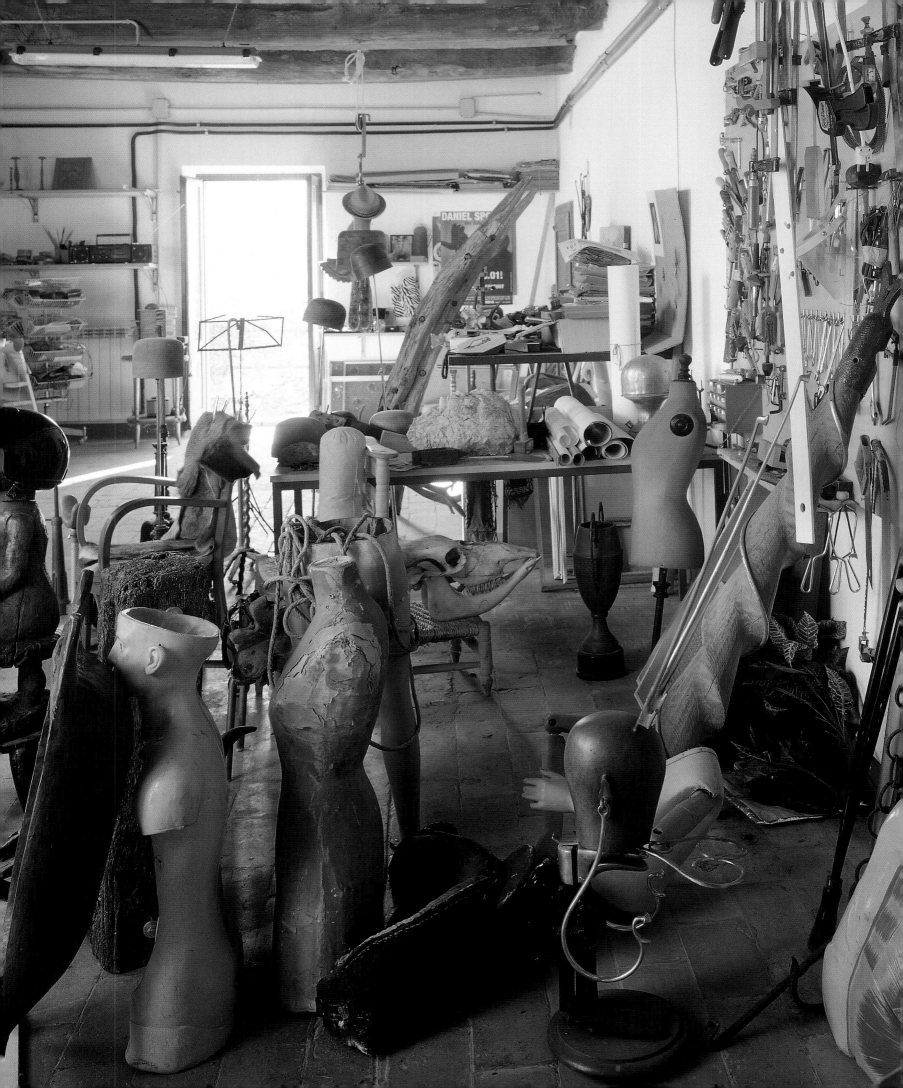

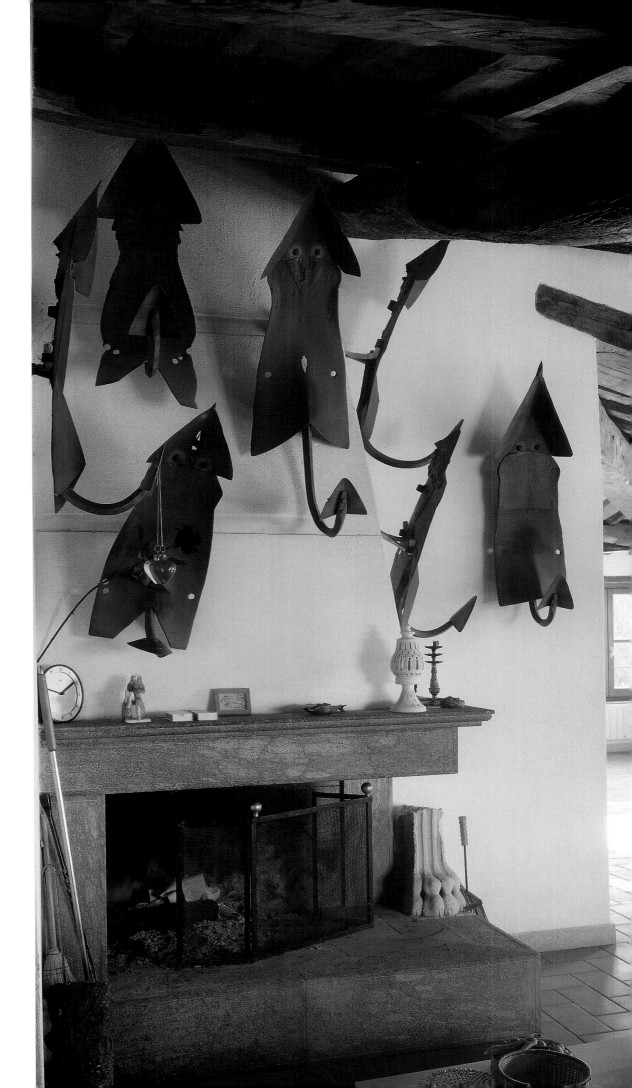

Opposite: *A collection of mannequins in the artist's studio.*

Right: *The living room and kitchen area, in a space created by joining two smaller spaces that were once used as a hayloft, has a stone fireplace and a collection of old plowshares.*

Gigi Guadagnucci

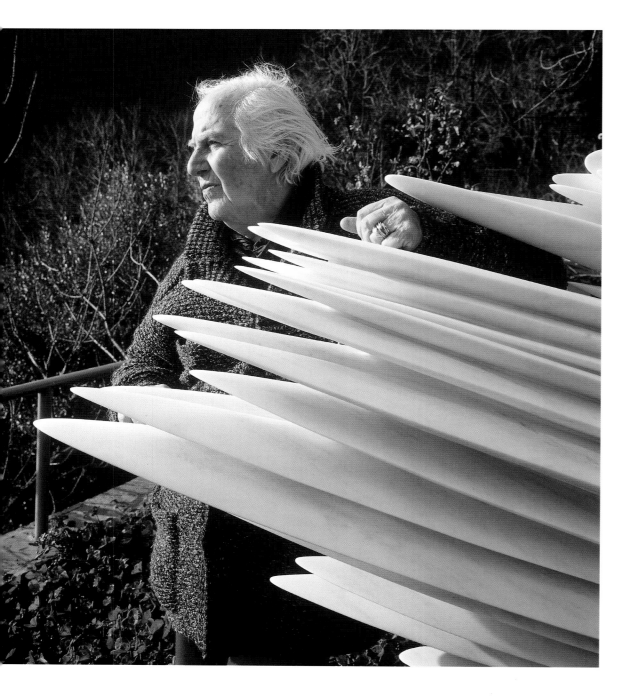

Left: *Portrait of Gigi Guadagnucci by one of his marble sculptures.*

Above: *View of the interior of the artist's workshop with materials, and both finished and unfinished works.*

Opposite: *An unfinished work and a few of the artist's tools.*

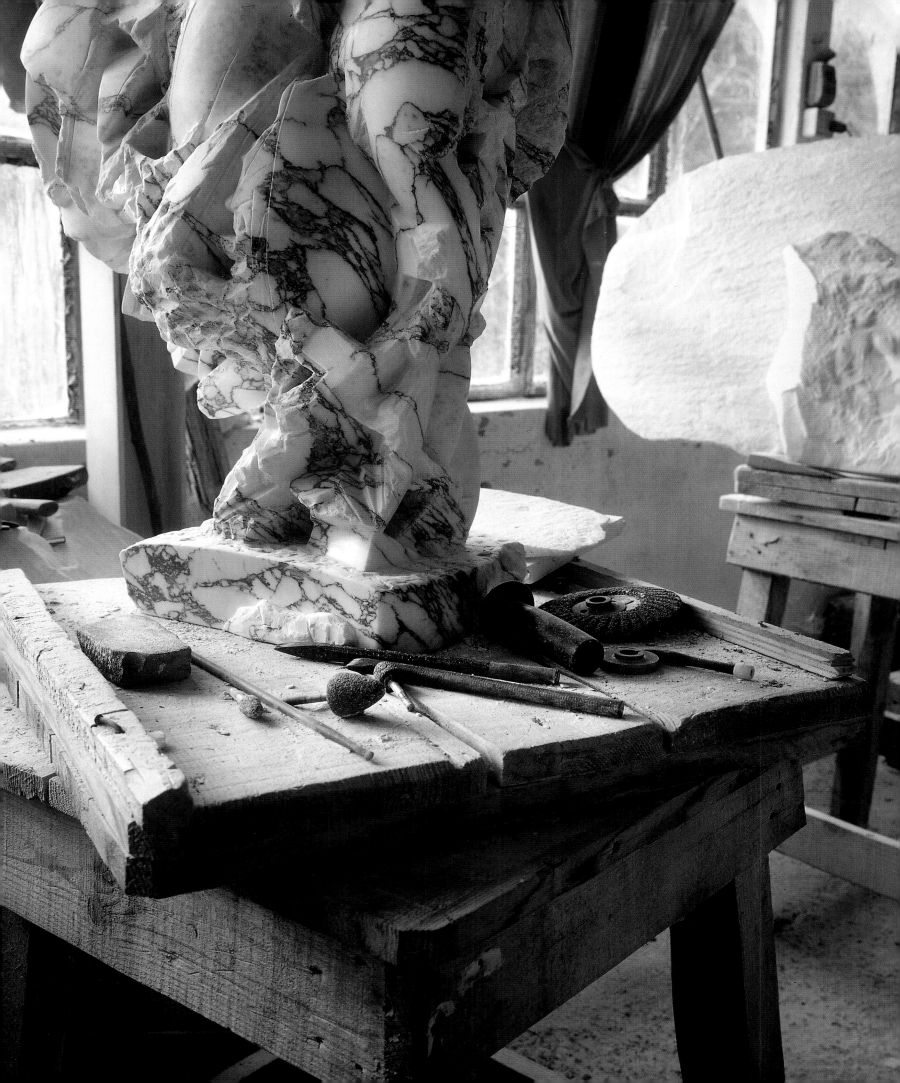

Gigi Guadagnucci has spent his life between the hills of Tuscany and France. He was little more than a boy when he fled Italy during the Fascist regime, and returned following a stint in the Foreign Legion and as a partisan in the French resistance movement. By then, however, his artistic life was tied to France, particularly Paris, where he worked as a sculptor in contact with the greatest artists there. Only much later did his stays in his native territory, between the Apuan Alps and the sea, become more frequent. He explains that two factors led to his permanent return: the plentiful marble and the international artistic life that made this area such an exciting place to be during the seventies. In fact, at that time many of his old friends from Paris were also in Tuscany, including Emile Gilioli and César, in addition to other great sculptors, such as Henry Moore, Isamu Noguchi, Marino Marini, and Ossip Zadkine.

He purchased land in the Bergiola area, in the province of Massa-Carrara, near the house where he was born. "I liked the idea because there was a vineyard, a spring, and a view of the sea; there were no buildings and the only way to get there was by a goat path. The house was built by the man who used to farm the land, which I later enlarged and converted into a studio. I let the land that was previously

Above: *Guadagnucci exhibits of few of his works on the grounds in front of his house. The house overlooks a plain that leads to the Tyrrhenian Sea (seen in the distance).*

Left: *The artist's house is not far from the town of Carrara and is situated in the hills that lead up to the Apuan Alps, the chain of mountains that runs along Tuscany's Versilia coast.*

cultivated go back to its natural verdant state. I love the natural growth of the vegetation that has taken over. I love living here surrounded by nature in absolute silence."

A number of his works are placed in the area in front of the simple house at the foot of a hill; the white marble stands in stark contrast to the blue of the sea and sky. "These days in my line of work it is possible to do things that could not be done before by using diamond saws, but I continue to work with just my own two hands, even though the work is long and hard. I do not use a clay models, since I don't care for clay. I don't like adding and subtracting; with marble you can only subtract. It is a one-on-one struggle. When you begin a work you are forced to enter into a dialogue with the material. Before I begin working, I stand in front of the block and study it at length. It is like having an inspiring angel suggesting the form to me. Marble is living matter, it is like nature—if you don't know what you are doing, you end up destroying it. It is a wonderful thing to be able to create a work on your own. When I am working I feel that I have to make the marble soar. Mechanical aids can do technical things and nothing more. When creating an artwork, poetry is an indispensable ingredient."

Renato Ranaldi

Renato Ranaldi's house, outside Florence, was built in the early twentieth century during the aftermath of the changes that resulted from a new building campaign initiated during the brief period when Florence was the capital of Italy. The artist took residence in 1980. "Previously, I had lived in a succession of studios where there were no boundaries between my daily life and my artwork. Being immersed in my work meant that my latest piece was the last thing I saw when I went to bed at night and the first thing I saw when I woke up in the morning. It gave a sense of continuity to my existence and put me in a state of creative tension that has always sustained me. Even though there were times when I succeeded in detaching myself from my work and managed to think about something in the outside world, I basically lived in seclusion. And this helped me. I felt as though my only calling was to represent myself in my creative work."

Ever since he moved to this house his life has changed; his living quarters and studio became two separate spaces. "I did not choose to live here. My mother thought of me as a son that needed to be defended and protected, while my brothers were better at coping with everyday life. I was an artist, and she understood that an artist needs to be defended. She sensed my inability to deal with practical matters according to the rules of the world, so she left this place to me when she died. I felt it was almost my duty to her to live here out of a sense of gratitude."

The plain rooms, arranged on either side of a long hallway, have maintained their basic features and original function, but they have filled up with Ranaldi's works. The artist repeatedly returns to his work using a process of continuous stratification that reflects new situations and outside influences. "I like to think of my work as a sort of unstoppable flow. I like the fact that one does not notice the difference between my earliest and latest work. In my most recent work there is a return to my recollection of a very early work that I come back to again and again. For me, to work means performing a sort of survey of what I have already done before. I am nothing but memory, which is to say what I was yesterday and the day before yesterday, not what I will be tomorrow. I am memory at work."

Above: *A view of the guest room.*

Opposite: *Portrait of Renato Ranaldi.*

Overleaf, left: *The walls of the guest room exhibit both early and recent works by the artist. Ranaldi believes that there should not be any difference between work completed during disparate periods.*

Overleaf, right: *Among other objects collected on the artist's writing desk is an Indian lingam (on the far right). All of the works on the wall are by Ranaldi.*

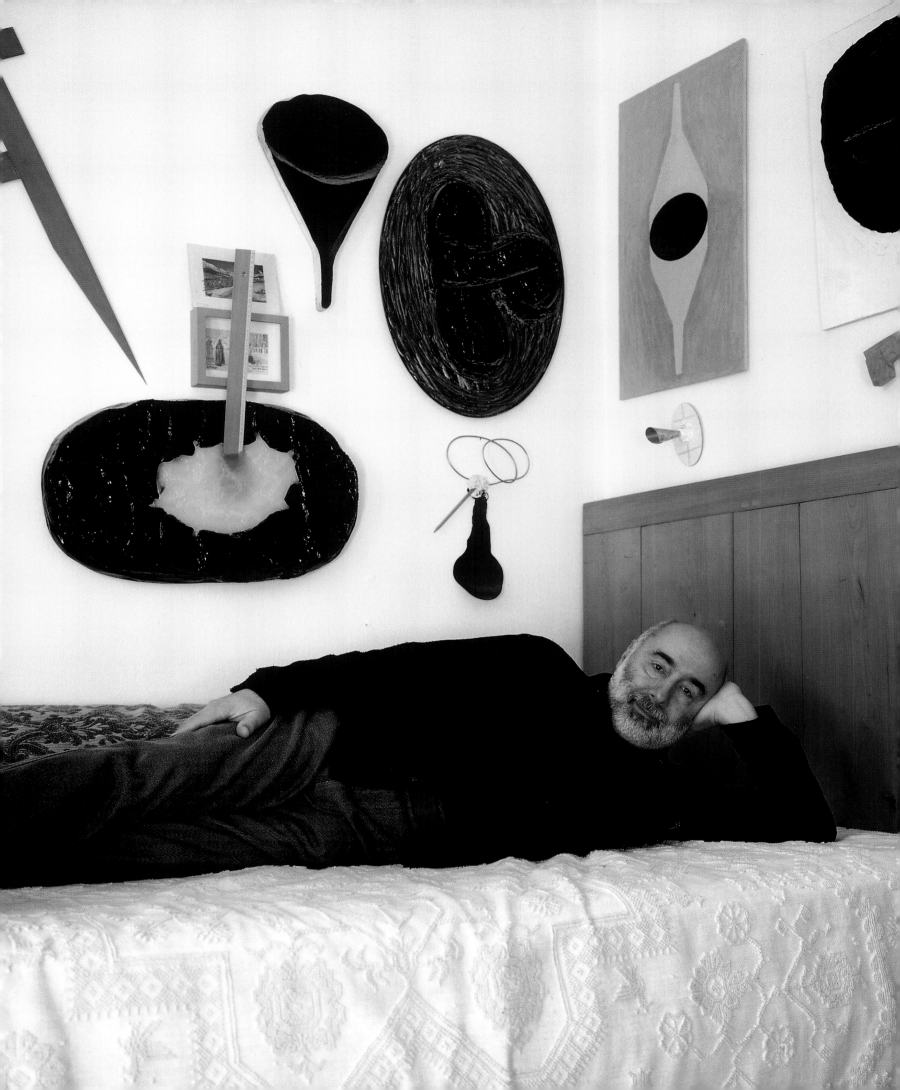

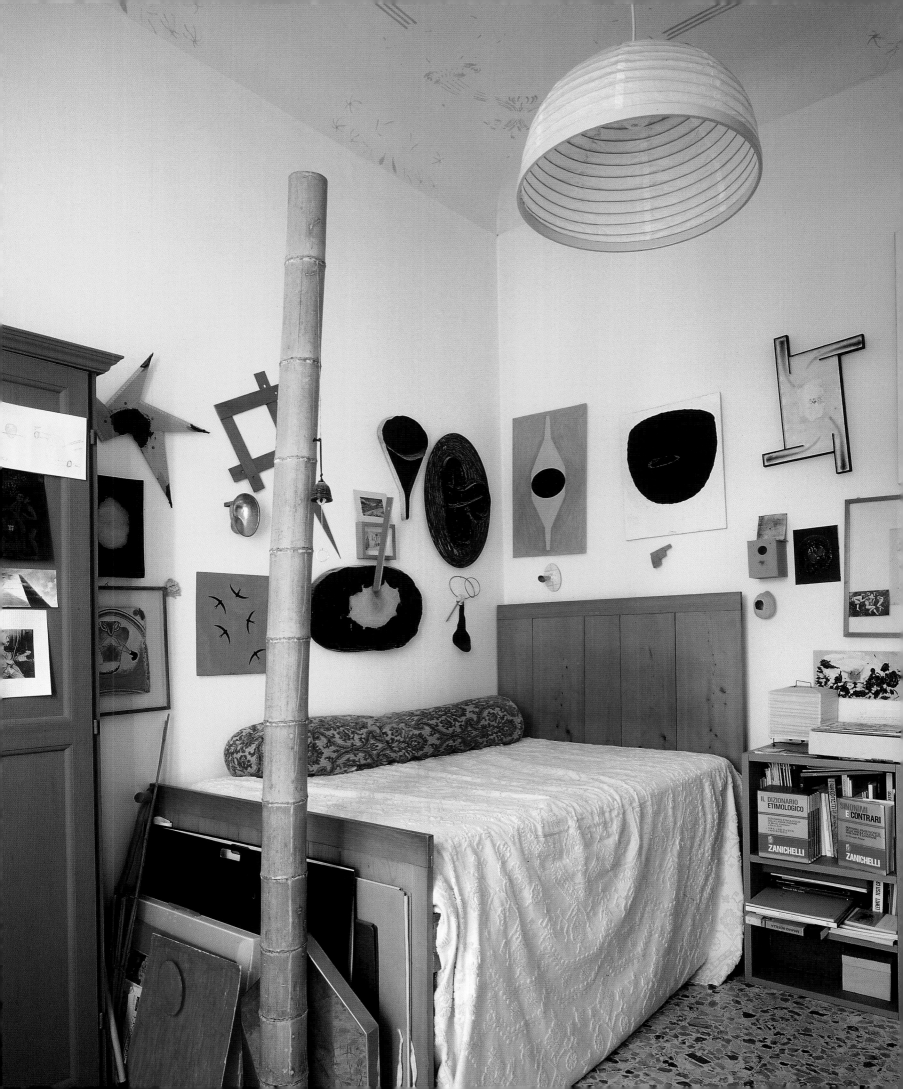

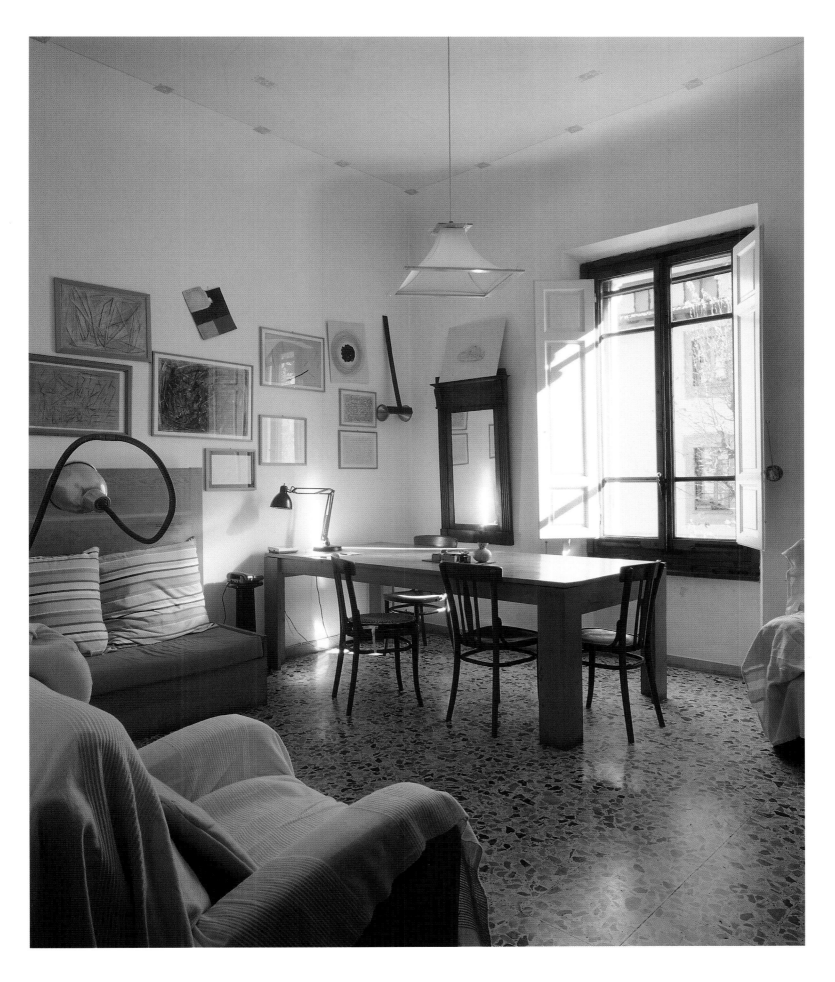

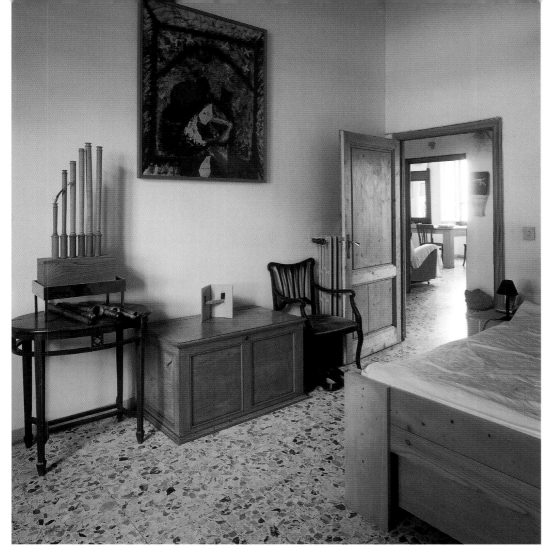

Previous pages, left: *A work by Ranaldi that he describes as an "assembly put together at different times with tatters of memory."*

Previous pages, right: *A corner of the living room with a table where the artist makes a new drawing every morning. These drawings have been collected in a catalogue titled* Parusie.

Above: *The oil painting on the bedroom wall, titled* Figura alla finestra, *was completed by the artist in 1965. Ranaldi defines the small work on the chest as a "sculptured painting" because he used pigment as though it were clay to create a three-dimensional form.*

Left: *A corridor has become a picture gallery that includes an early work by Catelani (the large painting on the left).*

Opposite: *On the right is a plaster copy of the Venus de Milo that the artist has kept since his youth. A sculpture by Carla Montemerli hangs from the ceiling.*

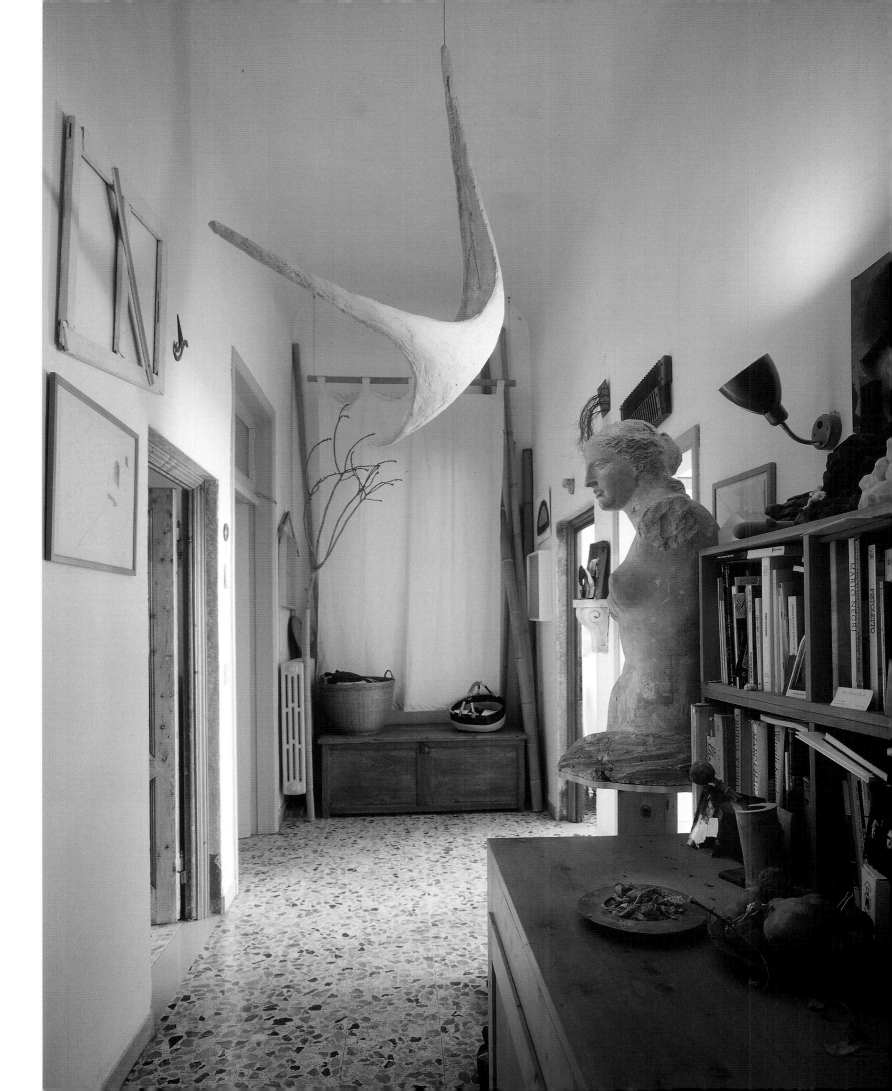

Luciana Majoni

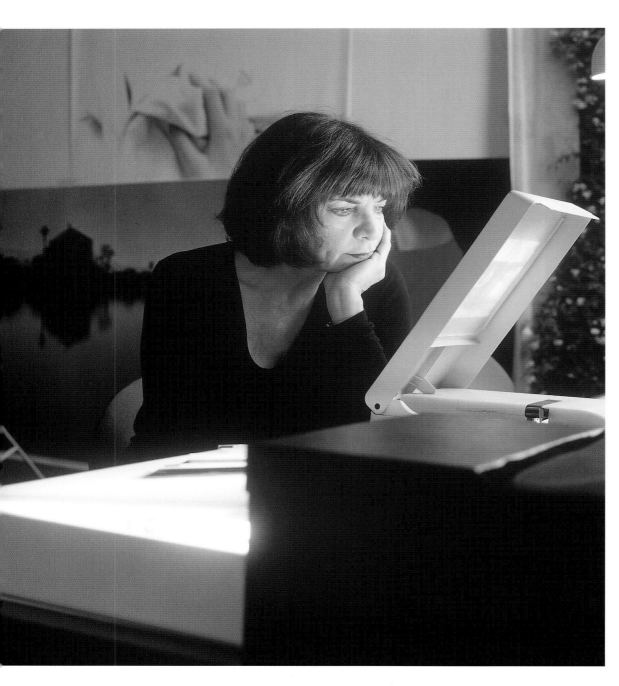

Left: *Portrait of Luciana Majoni in her studio.*

Opposite: *During the remodeling of the artist's nineteenth-century residence adjacent rooms were joined by a doorway to create a two-level studio space. A desk in the portrait studio is visible through the doorway. The image on the wall, titled* Volto, *is a photograph printed on cotton fiber paper.*

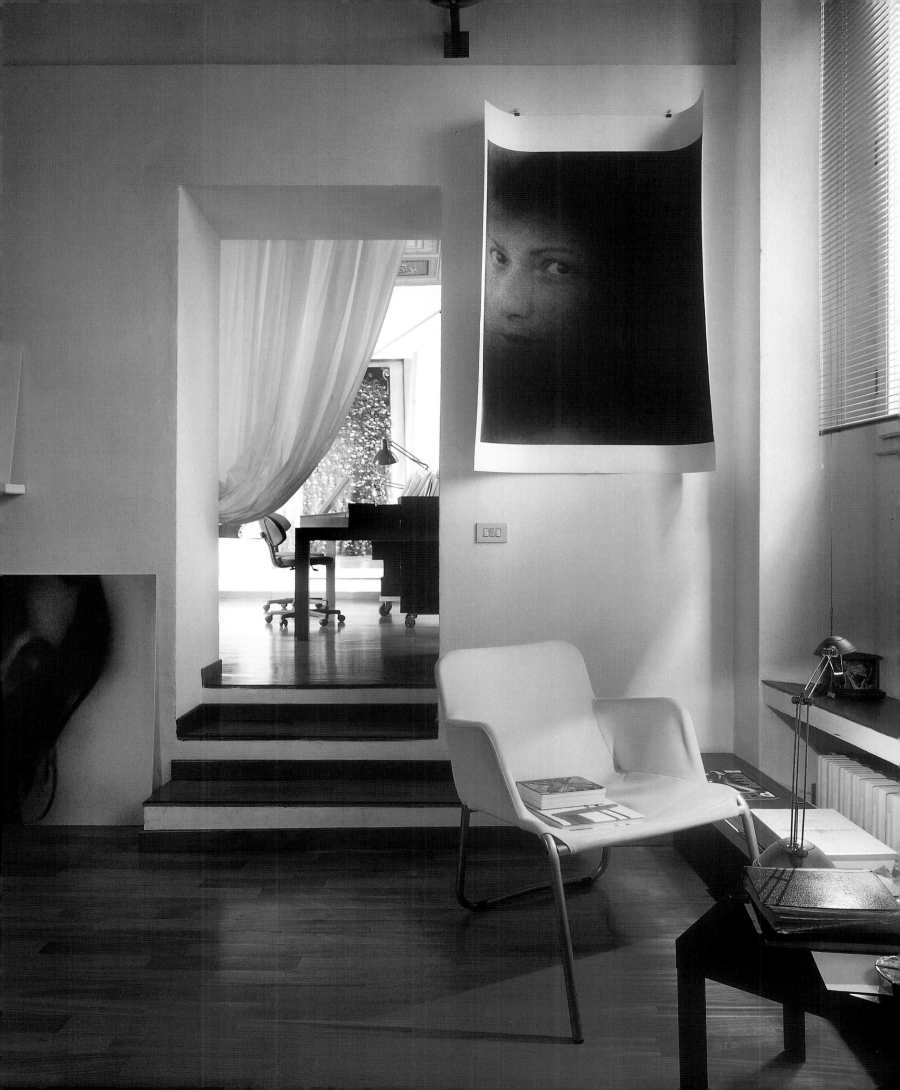

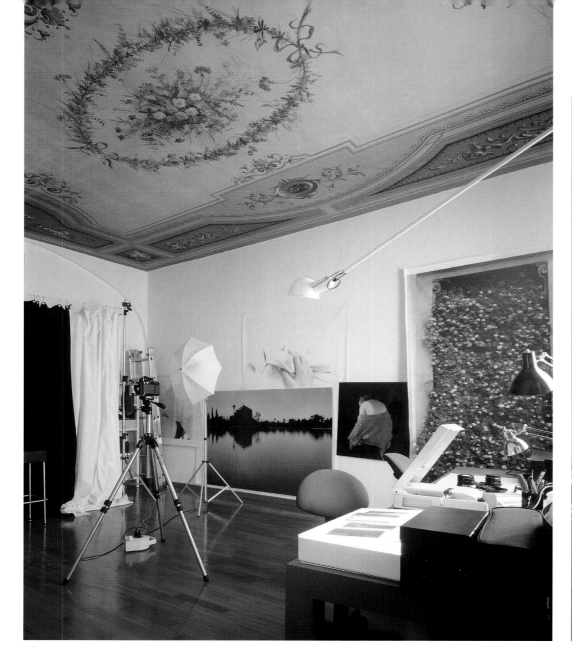

Luciana Majoni first came to Florence in the seventies to complete her education in art and photography. For the past twenty years she and her husband have worked together to transform the rooms of this apartment in central Florence. These rooms are typical of the historic fabric of Florence; they have been transformed through the centuries by overlapping layers of architectural interventions. By eliminating partition walls, one large uninterrupted space was created leaving an area for living and working that easily blend while remaining separate. The geometrical design of the white walls and the severe cut of the openings are accentuated by the use of plain materials. According to Majoni the wooden floors are "a reminder of the warmth of my childhood home." While the overall look is very contemporary, care has been taken to preserve and restore obvious traces of the house's past history, the frescoed and coffered ceilings for example. They have also selected modern furnishings, favoring pieces that are starkly linear. The furniture is carefully arranged so as not to interfere with the Majoni's large photographs on the walls.

The artist reveals the extent to which she identifies with her home and workplace: "This apartment provides me with a variety of spaces according to my needs at any given moment. It is my refuge, an 'ivory tower' for thoughts that need to lie dormant, for impulses to be deciphered and transformed on film, for negative moments to be elaborated and resolved. It is the destination of my ideas, the place where they continuously take shape and are subjected to verification. The stimulus for my work comes from a variety of outside sources, from my way of seeing and perceiving situations, visions, and instants in time that I then transform in the privacy of my home and studio."

Above left: *The ceiling of the portrait studio has nineteenth-century frescos restored by the artist.*

Above: *A large opening in the wall between the portrait studio and the bedroom helps to illuminate the otherwise windowless bedroom.*

Opposite: *The apartment is open plan; the rooms flow from one to the next allowing living and working spaces to mix.*

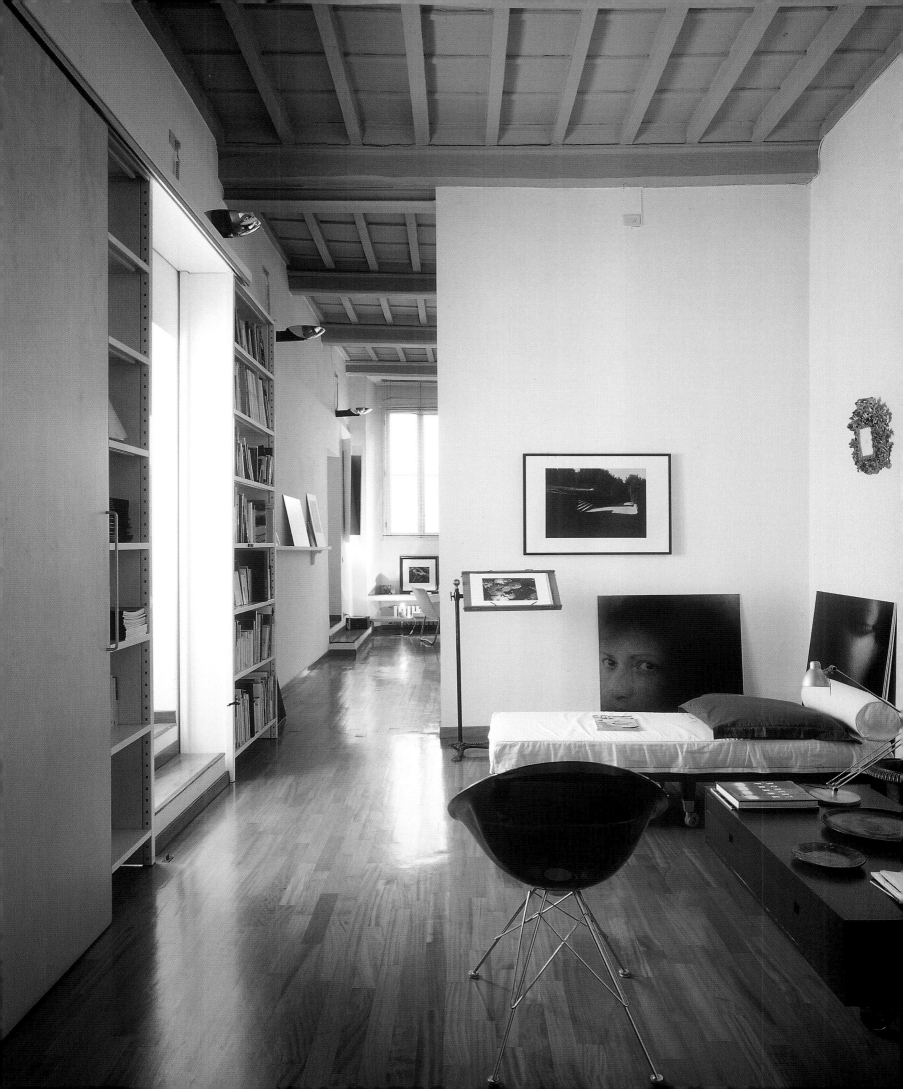

Leone Contini Bonacossi

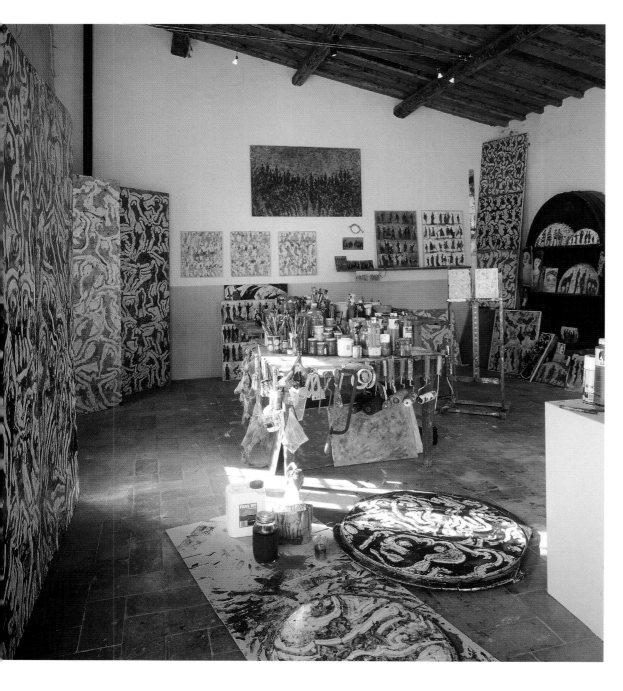

Left: *Leone Contini Bonacossi's studio is in a building adjacent to his family's villa, the Villa of Capezzana. This space was once used for storing the yields of the vineyards that surround the villa.*

Opposite: *Portrait of the artist in his studio. To paint the large polyptych (in the background) the artist used a mixture of pigment and marc, the dense, normally discarded, residue of wine grapes after they have been pressed.*

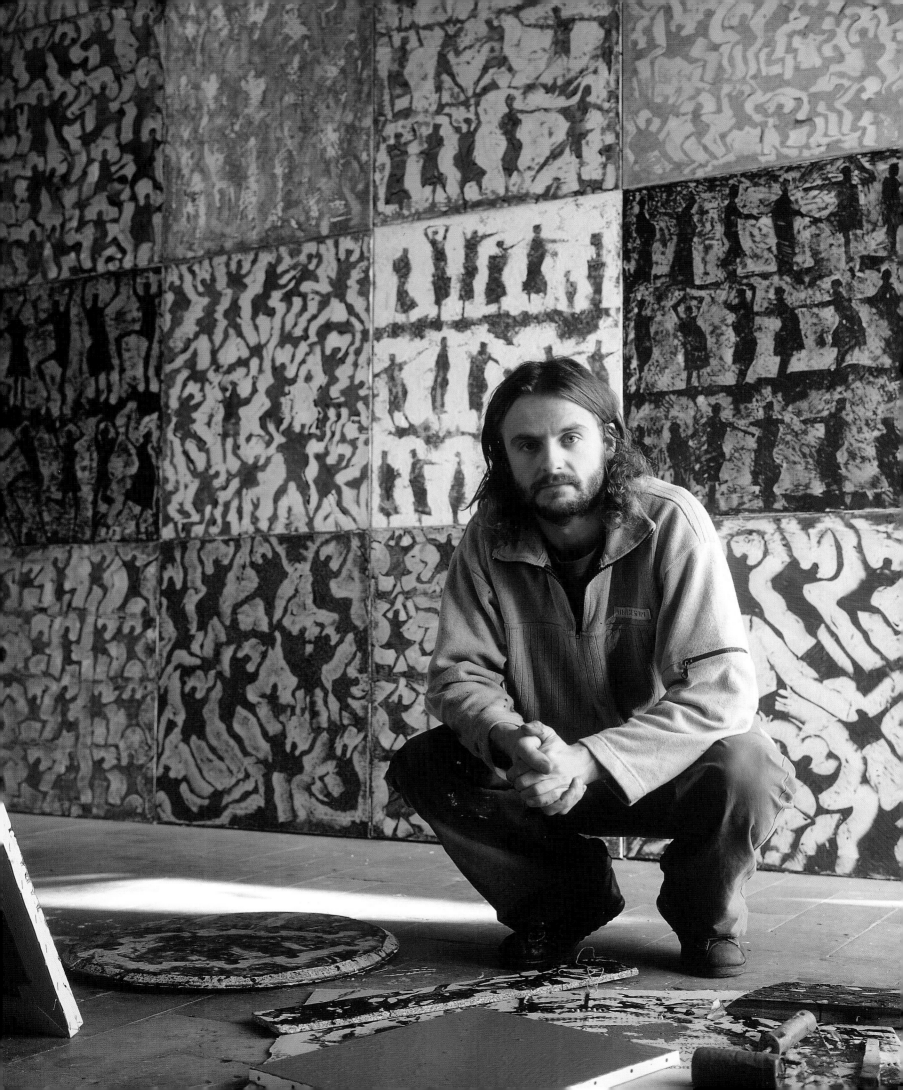

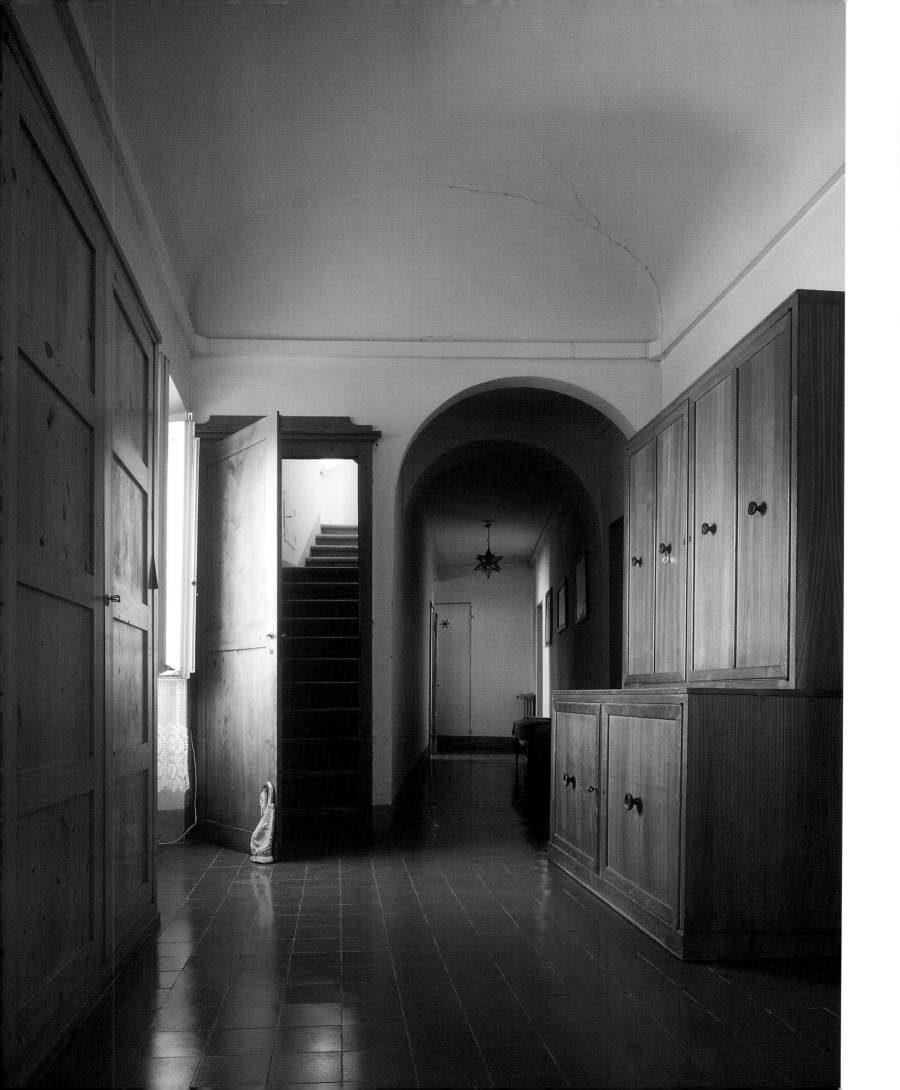

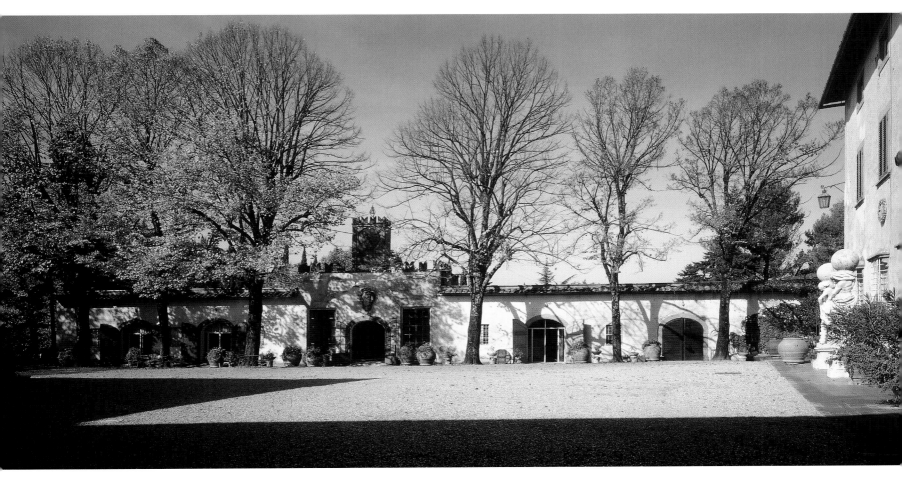

Opposite: *Large wardrobes sit in the corridor of a building between the artist's studio and the villa. The stairs lead to servants' apartments on the upper floors of the villa.*

Above: *The tree-lined courtyard outside the artist's studio. On the right is a partial view of the sixteenth-century façade of Villa of Capezzana adorned with large statues.*

Leone Contini Bonacossi lives and works in the villa located at the center of the large estate known as the "Fattoria di Capezzana," a working farm in Seano, in the province of Florence. After living in the center of Florence he decided to return to his family's villa because "here my aesthetic ideals are forced to come to terms with a historical, artistic, and family background rooted in the past, a past that I believe is impossible to set aside, even for someone who tries to make artwork that is driven by innovation." The powerful influence the villa exercises over Bonacossi emanates from the structure's spacious rooms, immense bare attics, and damp cellars with patterns on the walls traced by mold and saltpeter that fascinated him as a child. The villa's mythical past, including the family life of the artist's ancestors, seems to be present in Bonacossi's repeating, half-shadow silhouette figures.

Bonacossi's studio is located on the ground floor of the low buildings that form a courtyard in front of the villa's sixteenth-century façade. For centuries carriages and produce from the villa's farm were stored in these buildings. The interiors, with wood beams and terracotta floors, maintain the old simplicity of the space. "I decided to leave things as they were because in a certain way I feel like a guest of the past generations. I left a face painted on the wall, who knows when and by whom. That face keeps reappearing in my pictures." Memories of this place are an important factor in the artist's work, and its influence does not lead him in just one direction. He reworks the signals emanating from his surroundings, giving shape to the unseen forces that fill the studio.

"Artists are often fond of living in the midst of their own creations, but I have always been fascinated by houses that give off their own energy. Care and time are required to summon up the past, capture its traces, and listen to the stories it has to tell. The process is no different from what the human eye does when it gradually adjusts to darkness. As an artist, I feel that I am not so much a creator as a listener; the creative act is inseparable from the way one experiences one's surroundings—words, objects, people, and stories. I believe my paintings tell the stories of countless others."

Dario Bartolini

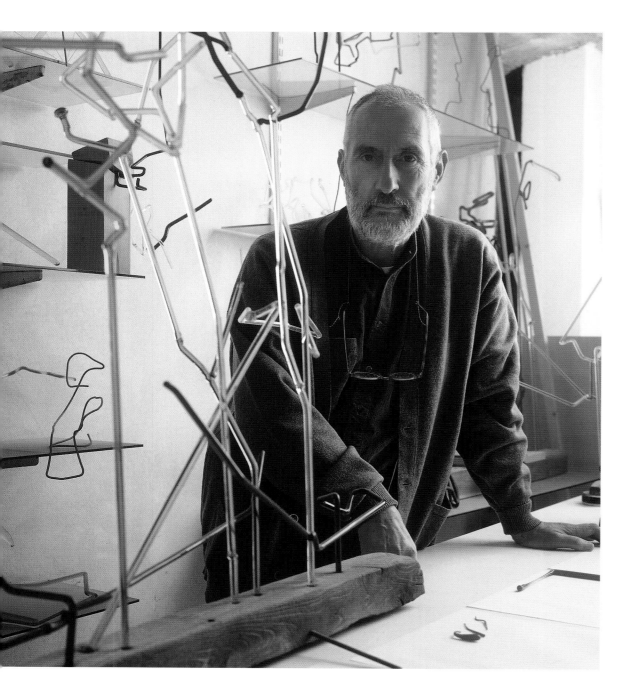

Left: *Portrait of Dario Bartolini in his studio with works from his* Cervelli *series.*

Opposite: *A pair of wire and glass* Oche *(Geese) by the artist are arranged on a table on the terrace in the front of the house.*

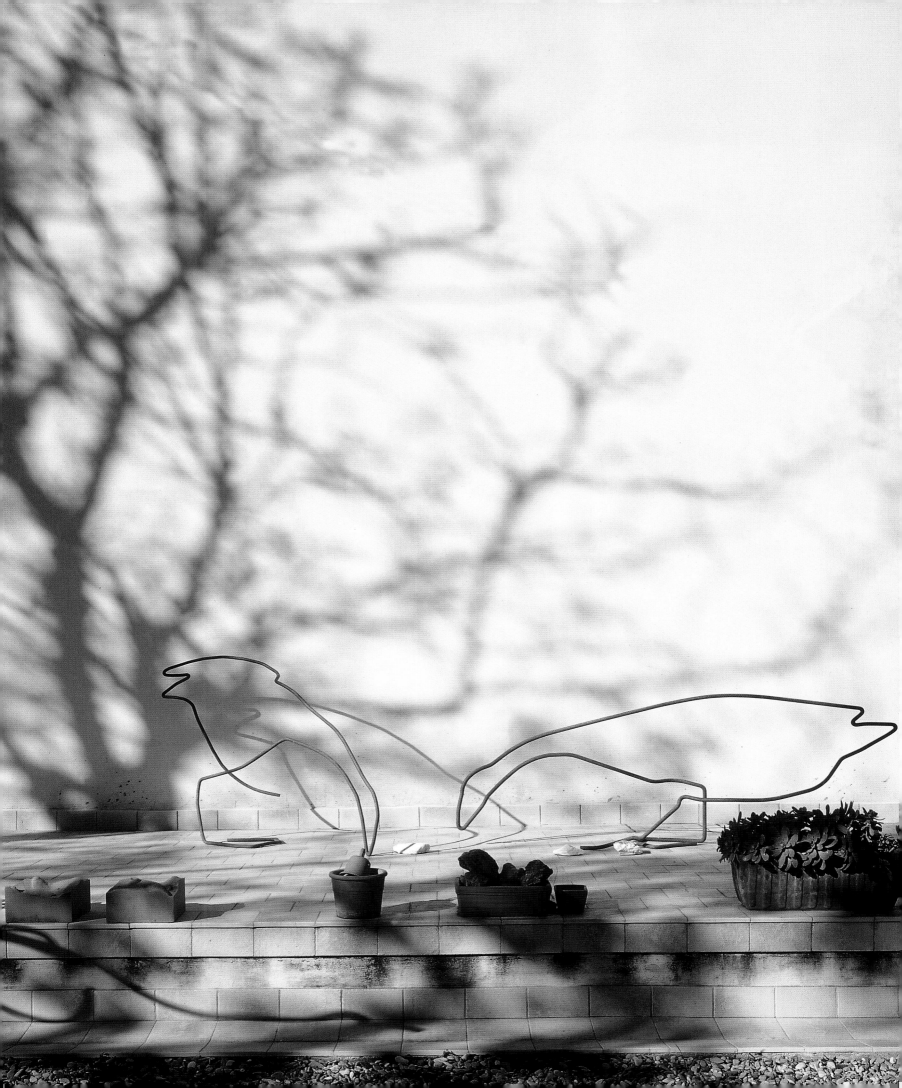

The simple two-story structure rebuilt in the seventies by Dario Bartolini and his wife Lucia Morozzi is set beside the core of an old hayloft and pigpen. The house is surrounded by olive groves and has a view of Florence in the distance. Bartolini and his wife have fond memories of their years of intense activity with the Archizoom group, a Florence-based group of radical architects. They believe that the experiences they gained by being members of this creative group strongly influence the look and vitality of their interiors. The various elements of the house—living rooms, bedrooms, work spaces—are constantly changing to adapt to different situations. Bartolini explains that as "one shifts things around, remodels, changes, adapts…one revolutionizes things in small ways, the house gets cleaned, changed, spruced up."

Bartolini and his wife are also inspired by the rigorous simplicity of modern architecture and by the clean lines of the architecture of Adolf Loos in particular. Their house is composed of stark geometric forms. At first the walls were white and bare but over the years but, despite some resistance, they have become covered with objects including works of art. According to Bartolini, "it is impossible not to show others, and yourself, what you do. The place where I live is full of useful things, things I want to have near me, and things I produced."

Above left: *The living room has a mix of antique and contemporary furniture.*

Above: *In a corner of the kitchen, the artist's plywood* Radio in scatola *sits in front of bottles of olive oil on a nineteenth-century table. On the wall is his acrylic on canvas titled* Una rana davanti a New York.

Opposite: *At the entrance of the house is a sun drenched patio that leads into the living room.*

Overleaf left: *Suspended from the ceiling of the living room is a pair of ducks flying in tandem, a work by the artist titled* I consoni *that represents the artist and his wife Lucia. The television screen shows an image of Bartolini's installation on the Lofoten Islands of Norway.*

Overleaf right: *A collection of works created by the artist for an installation in the marble quarries of Carrara sit on top of an armoire in the living room.*

Antonio Possenti

Access to the piazza where the Roman amphitheater of Lucca once stood is gained through one of four arches placed symmetrically around the elliptical piazza. A ring of houses with narrow fronts follow the perimeter of the ancient amphitheater. Their design, devoid of decoration, emphasizes the shape of the piazza. Antonio Possenti's home and studio is in this unique piazza. It consists of three wedge-shaped rooms that widen toward the street behind the piazza. Built in the Middle Ages, the rooms of the house reflect the shape of the large arena.

The amphitheater was erected by the Romans at the height of the Empire. It was later used as a fort, and then abandoned for centuries essentially becoming a stone quarry for building the medieval city. In the early nineteenth century, Marie Louise de Bourbon decided to use the space for an outdoor fruit and vegetable market. During the process of razing the buildings that stood in the center of the old arena, traces of the ancient amphitheater came to light. The arches of the amphitheater were closed and replaced by street level stalls, storage spaces, and shops with houses built above them.

This beautiful setting can be viewed from Possenti's studio window. Ever since childhood he had two wishes: to be a painter and to live in the amphitheater. Both wishes have come true when he purchased the combination house and studio in 1970. The thought of being able to experience the splendor of ancient civilization, in a lively social context, was very attractive to him. The inhabitants of the houses in the piazza gave him an immediate warm welcome that displayed their best qualities: solidarity, affection, and spontaneity. Possenti describes the piazza and its surrounding houses as being an anthropologically homogeneous and self-sufficient microcosm, with the ancient pit serving as a living room for the whole community. The residents bring chairs outside and sit down to work or chat, moving in or out of the sun according to the weather. "Lucca has always basically been a middle-class city, but this quarter was different, even though it is located in the heart of the historic center. It felt like it belonged to a different world, so that when we left the neighborhood we would say, 'I am going into town.' Others used to think that the area was somewhat disreputable and dangerous. Some would avoid passing through the piazza the same way one does not enter someone else's home without an invitation. The truth is, however, that people kept their doors unlocked; solidarity and social control created great security. The first thefts came in the early nineties when the neighborhood started to give itself airs and the people changed."

Possenti had no desire to transform the house and limited his restoration to a facelift. He opened up the three rooms, staggered on different levels, with windows overlooking the piazza in front and the street at the back, creating spatial continuity. "Everything was already laid out and had a long history behind it. It could not be altered." However he did uncover the old Roman walls built of stone and pozzolana cement, and the marble blocks that once served to anchor the capitals under the base of

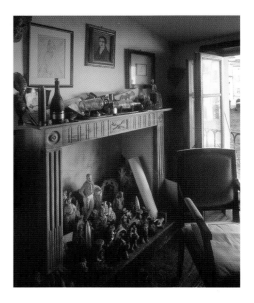

Above: *A marble fireplace houses collections of objects. Drawings by Carrà and Viani grace the wall.*

Opposite: *A balcony filled with plants overlooks Piazza Anfiteatro. A Roman amphitheater once occupied the site of this oval-shaped piazza. Stones and arches from the amphitheater are embedded in some of the houses around the piazza.*

Overleaf, left: *The studio as seen from the loft. The arch in the doorway has been raised in the shape of a triangle to allow the view overlooking the piazza to be enjoyed from the upper level.*

Overleaf, right: *Portrait of Antonio Possenti.*

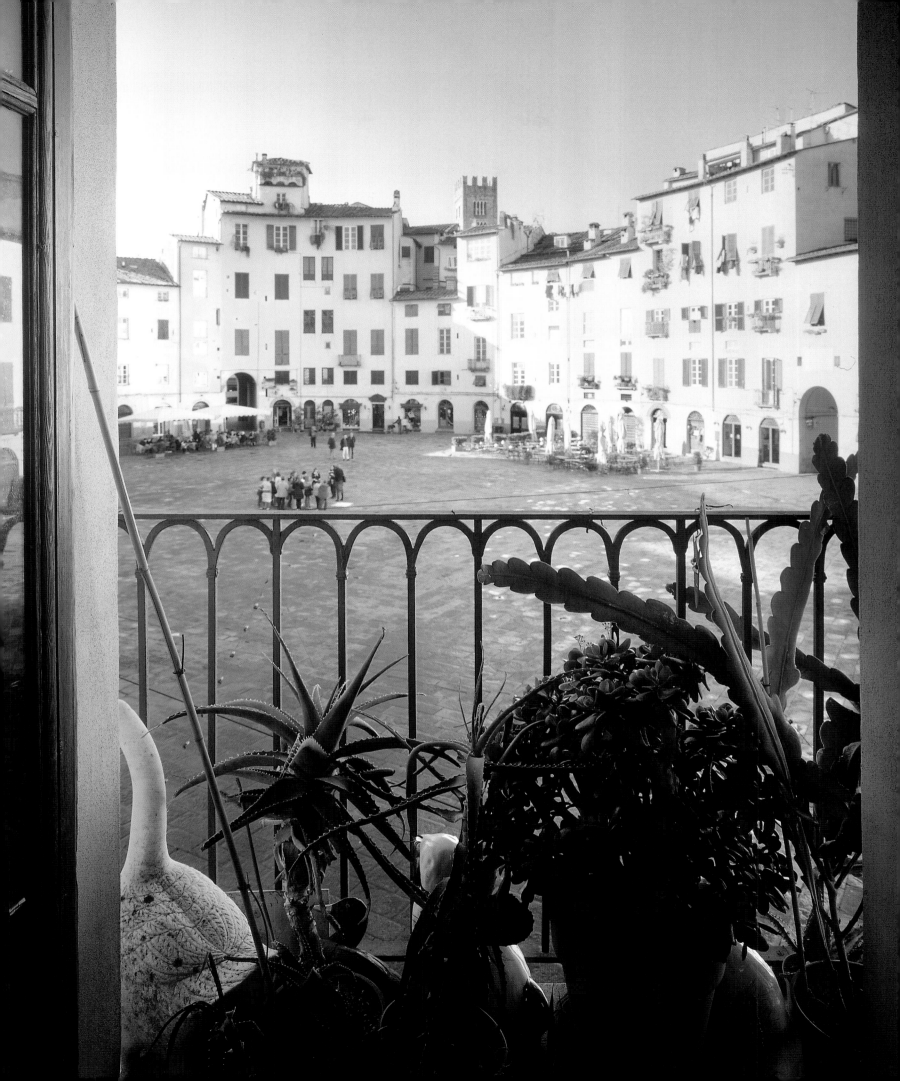

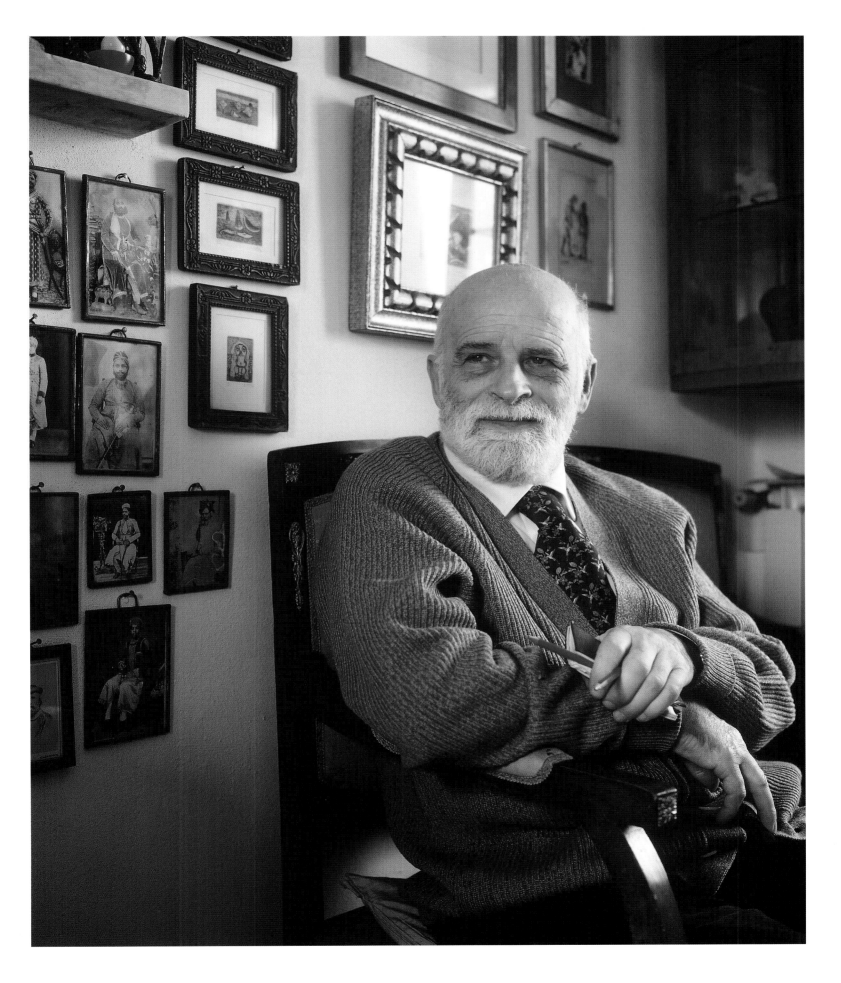

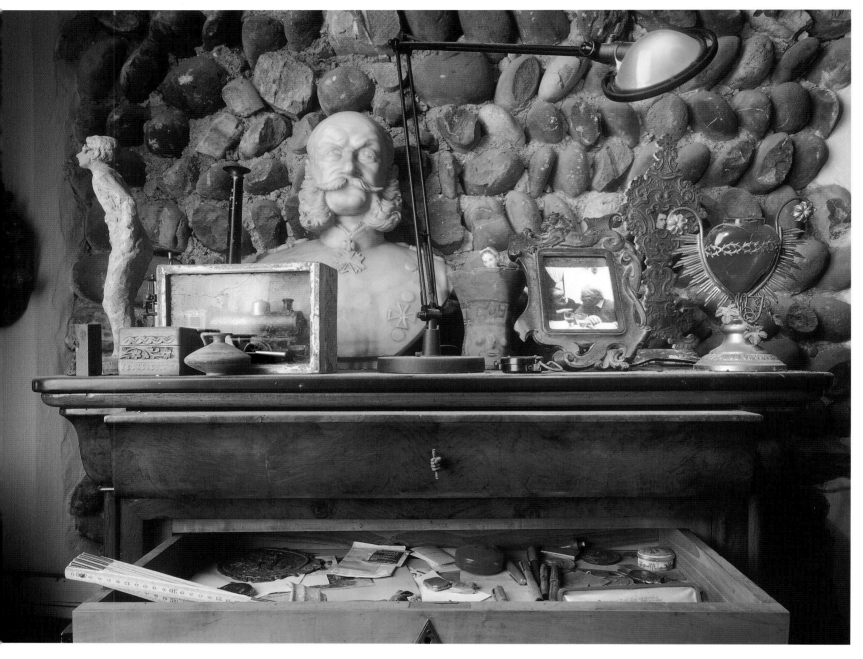

the arches. On the top floor he removed the plaster from the medieval walls to reveal their humble materials, such as pressed mud and pebbles from the river arranged with a refined sense of beauty.

The furnishings are casual, with antique furniture and nineteenth-century cases full of books, tools, black felt hats, antiques, and collections of sundry items placed on shelves, on the floor, or hung on the walls. Possenti declares, "This house represents me in a way that goes far beyond my professional life. It is an agglomeration of things in constant change; nothing is ever arranged for show. These are things that personally concern me. This is my den, where I feel at ease and love to work, because my work has never been to represent reality. Instead, I have always used my imagination to transform reality. The things I have around me are things I collect because they excite my imagination—and because they are each a tiny part of my life."

Above: *A nineteenth-century chest of drawers holds a collection of objects, including a bust of Field Marshal Radetzky.*

Opposite: *The bedroom is located in the loft of the apartment and has medieval walls that were built using economical materials. Riverbed stones were arranged in orderly rows and held in place with mud and earth.*

Overleaf, left: *A collection of porcelain dogs from Staffordshire is displayed over a French door that divides the living room/studio into two spaces.*

Overleaf, right: *The portraits on the wall are from the nineteenth century, while the picture on the sofa, titled* Insieme su un'isola, *is by Possenti.*

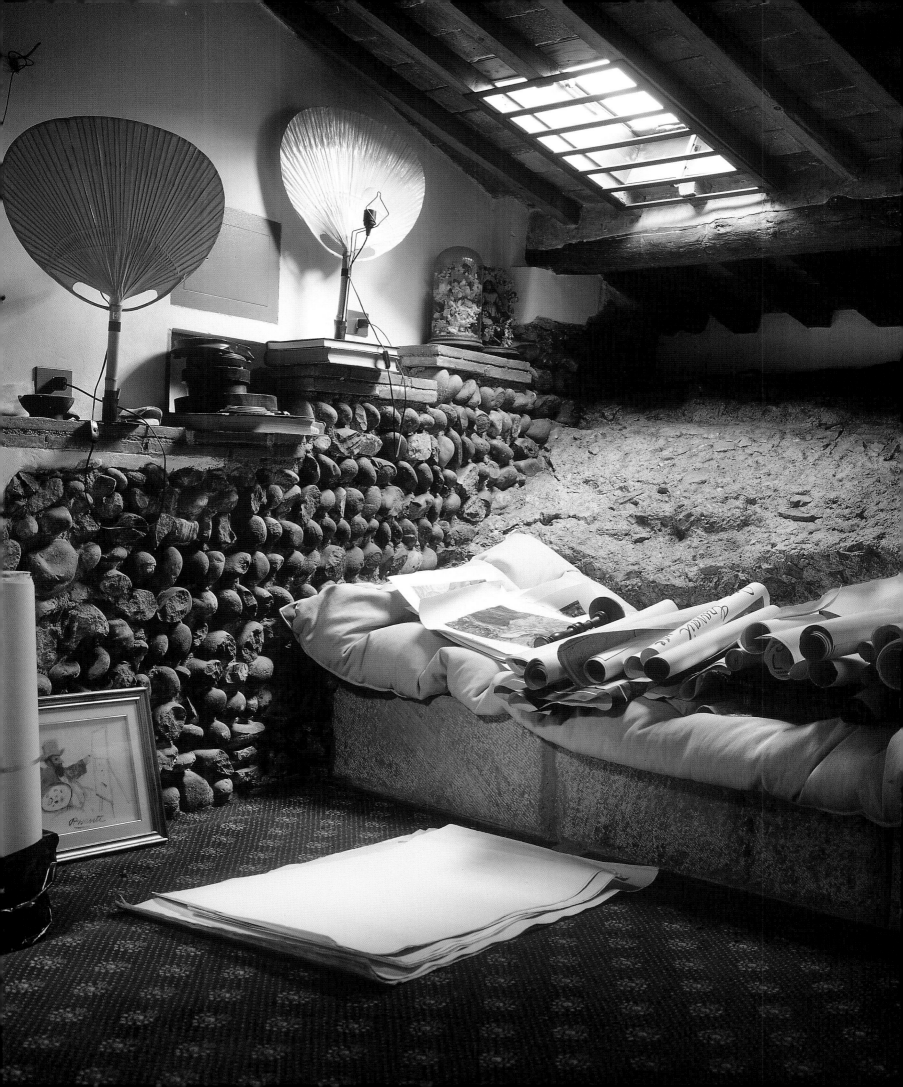

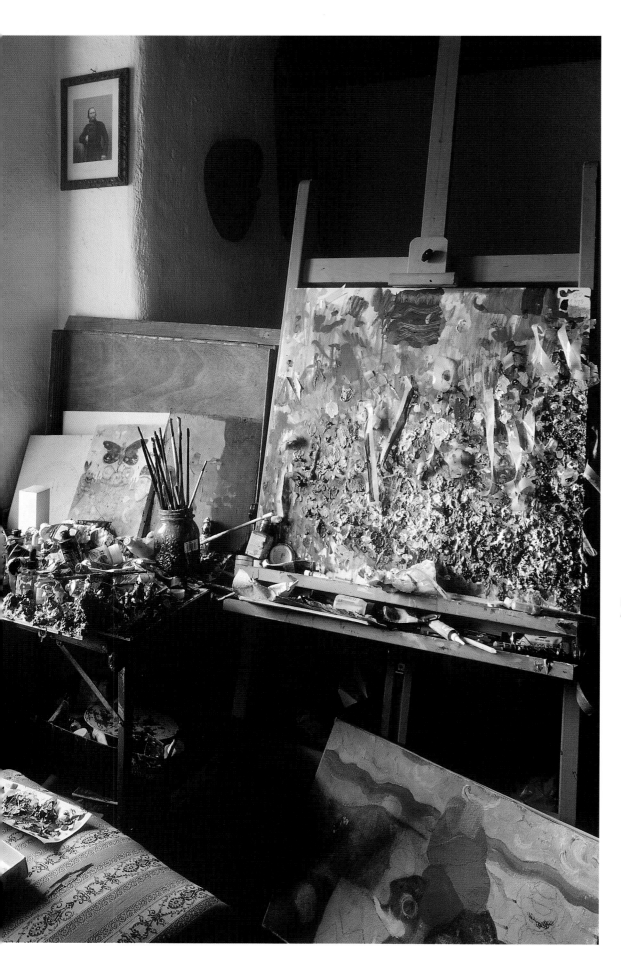

Left and opposite: *Two corners of the studio with unfinished works by the artist.*

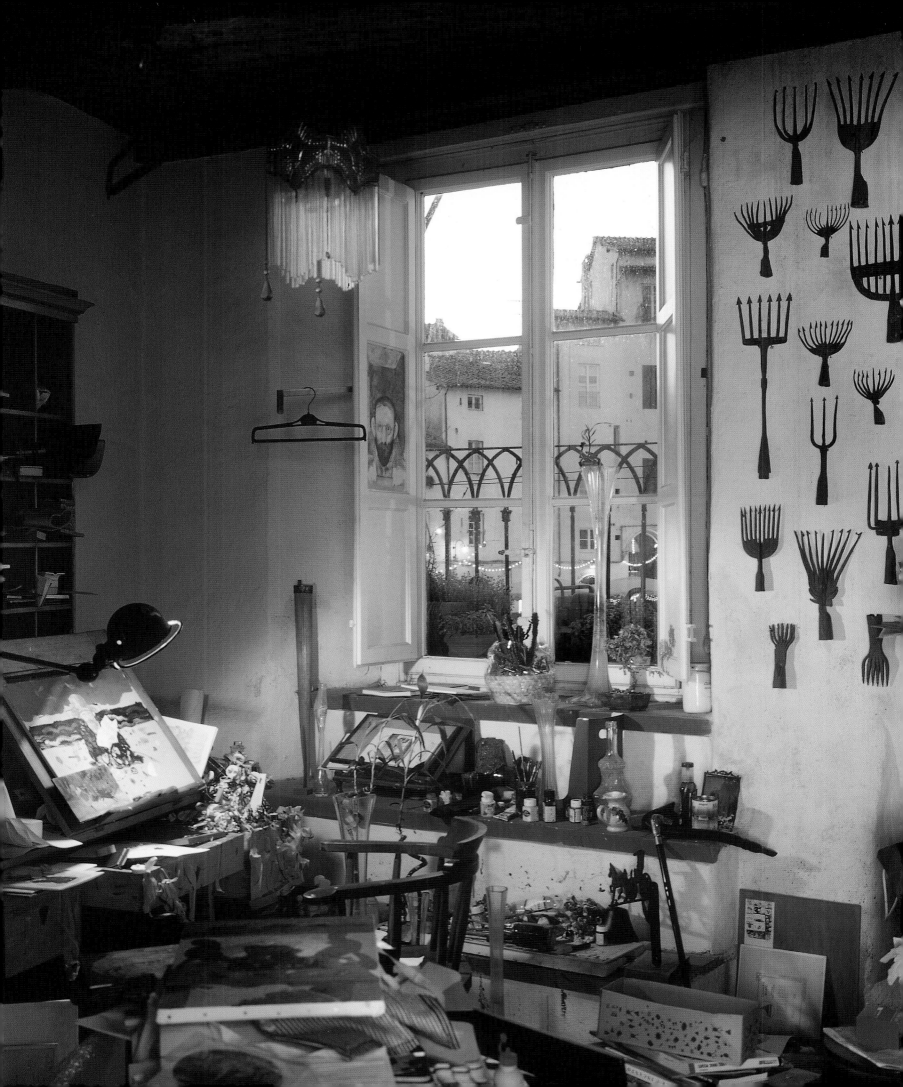

Cordelia von den Steinen and Pietro Cascella

The part of Tuscany known as Lunigiana takes its name from the city of Luni, a once flourishing Roman port city that no longer exists. With a mountainous topography that resembles territories lying farther north, the physical features of the region are completely different from those that typically come to mind when one thinks of Tuscany. A pass, cut by the Magra river, stretches through Lunigiana from the fertile plains of the river Po to the Tyrrhenian sea. Consequently Lunigiana has suffered through many defensive wars since the time of the invading Romans and Lombards. Vast protective emplacements were built, particularly by the Malaspina family that ruled the territory as a feudal stronghold from the fourteenth to the sixteenth century, giving rise to numerous picturesque castles that are still a characteristic feature of the area. Once there were more than 150 of these castles but only thirty survive today.

The Castello della Verrucola, presently the house and studio of Cordelia von den Steinen and Pietro Cascella, is one of the best-preserved castles, thanks to the restoration carried out with wisdom and loving care by the current owners. The earliest record of this structure dates from the year 1012, but it is very likely that it was built over previous fortifications. During the fourteenth century it was the residence of Spinetta Malaspina, lord of the Lunigiana, and was the political and administrative hub of the entire region for the next two centuries. During the sixteenth century the castle was converted into a convent for Augustinian nuns, and then later it was abandoned.

When the owners purchased the castle they immediately and enthusiastically attended to the enormous amount of repairs that needed to be done. At times this work was carried out with the aid of Monuments and Fine Arts Office, the body charged with the responsibility of protecting this historic monument. The owners have never deviated from their decision not to change the original layout. Even the central structure, the old keep, with its four enormous halls one on top of the other, has remained intact. Life has returned to these enormous rooms where various activities combine and overlap under twenty-foot ceilings.

Cascella admits that the decision to leave the structure intact has lead to practical problems: "The house is not necessarily a comfortable one, given the medieval stairways with their tall, tricky steps, not to mention the matter of heating…though we do have a forced-air system like the ones used in churches. The place requires constant maintenance. I have enjoyed living here, but it is very demanding and requires some sacrifice. When I bought the castle what most influenced my decision was the need for more room, since in my line of work there is never enough. The real luxury of this place is its spaciousness. Our sculptures have invaded the house and even our living room is a studio filled with sketches. Actually, we live in one enormous studio." Living in this house has changed their entire lifestyle. One thing von den Steinen notices is that having people over has become more complicated, planning is now required. Their personal relationships may have become deeper because of

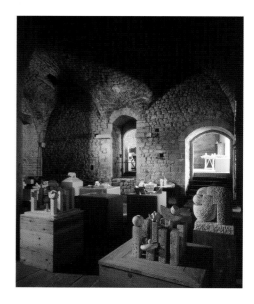

Above: *The armory of Castello della Verrucola is now used as an exhibition space.*

Opposite: *Portrait of Pietro Cascella in his studio.*

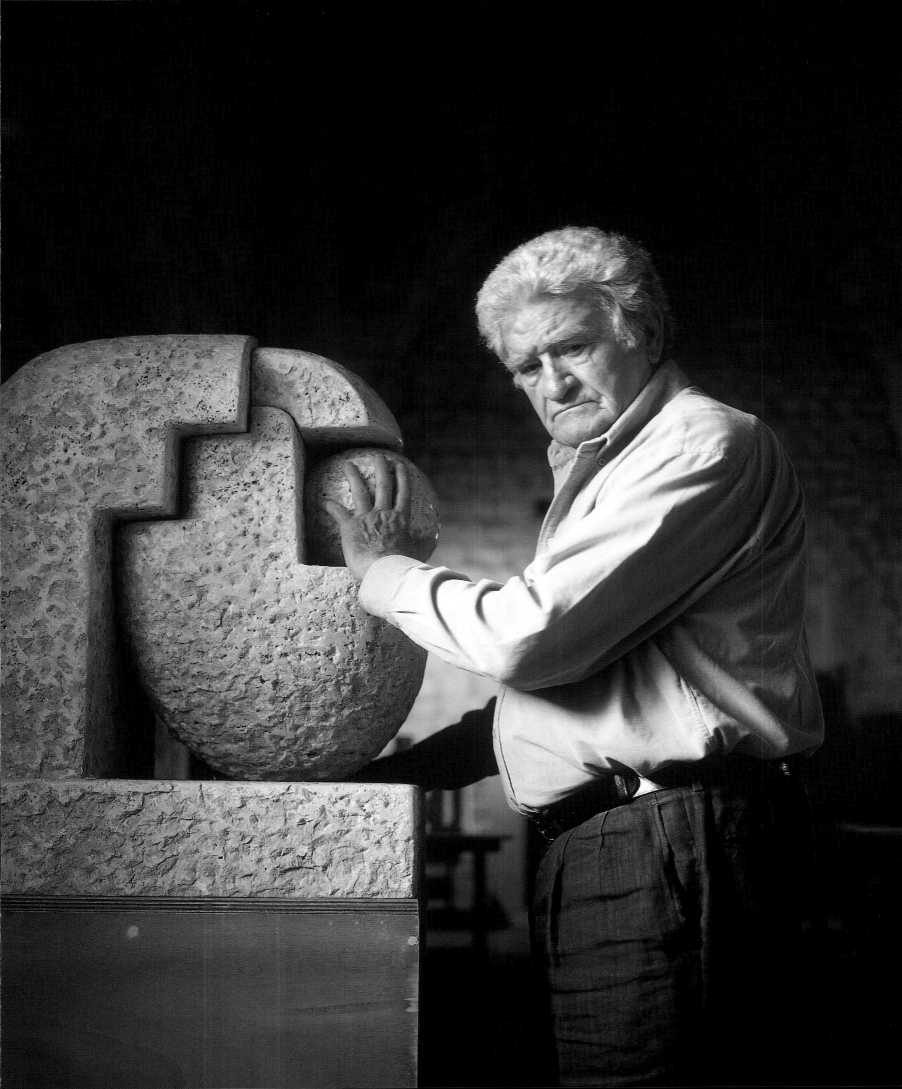

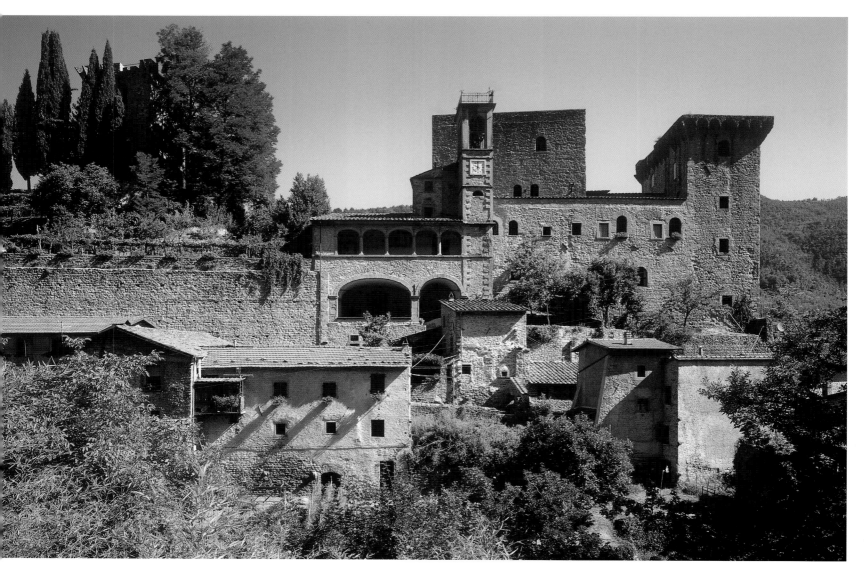

this, but a degree of spontaneity has been lost. On the other hand, loneliness is never a problem, perhaps because of the lingering presence of so many former inhabitants. "Here I have never felt alone, unlike in Milan where all I had to do to be surrounded by people is go out. Living in a tiny town helps because we all know each other. Certainly, this place has influenced our work. I have no idea what would have become of me if I had chosen to work in New York or some other big city. What I do know is that my life here is reflected in my work. This is a place of great silence, a silence that is even visual. The window by my writing desk frames a hill, which never changes except for the slow progress of the seasons. No outside element interferes. The static quality of our surroundings has clearly influenced our work, though to just what extent is hard to say, but I know it for a fact. It is an ideal place to work." Cascella stresses that this castle allows him to completely focus on his work. "This is my think tank. I believe there are powerful forces at work here, including great inner strength. It is a sort of storage battery where energy accumulates. I have lived in many other places but here is where I feel that I can work. This is truly my home."

Above: *Castello della Verrucola in Fivizzano dates from the early Middle Ages. In the fourteenth century, under the Marquis Spinetta Malaspina, it became the political and administrative center of Lunigiana, a region in the northwest corner of Tuscany. The walls of this typical stronghold housed a small hamlet.*

Opposite: *The main entrance to the castle has traces of alterations made by Augustinian nuns who lived in the castle during the sixteenth century. The frescos date from the same period. The children's carriage (on the right) dates from the nineteenth century.*

Overleaf: *The armory, with its cross vault supported by a single central octagonal stone pillar, is the best preserved part of the original medieval structure. The objects on the tables are plaster studies and finished works in stone by Pietro Cascella.*

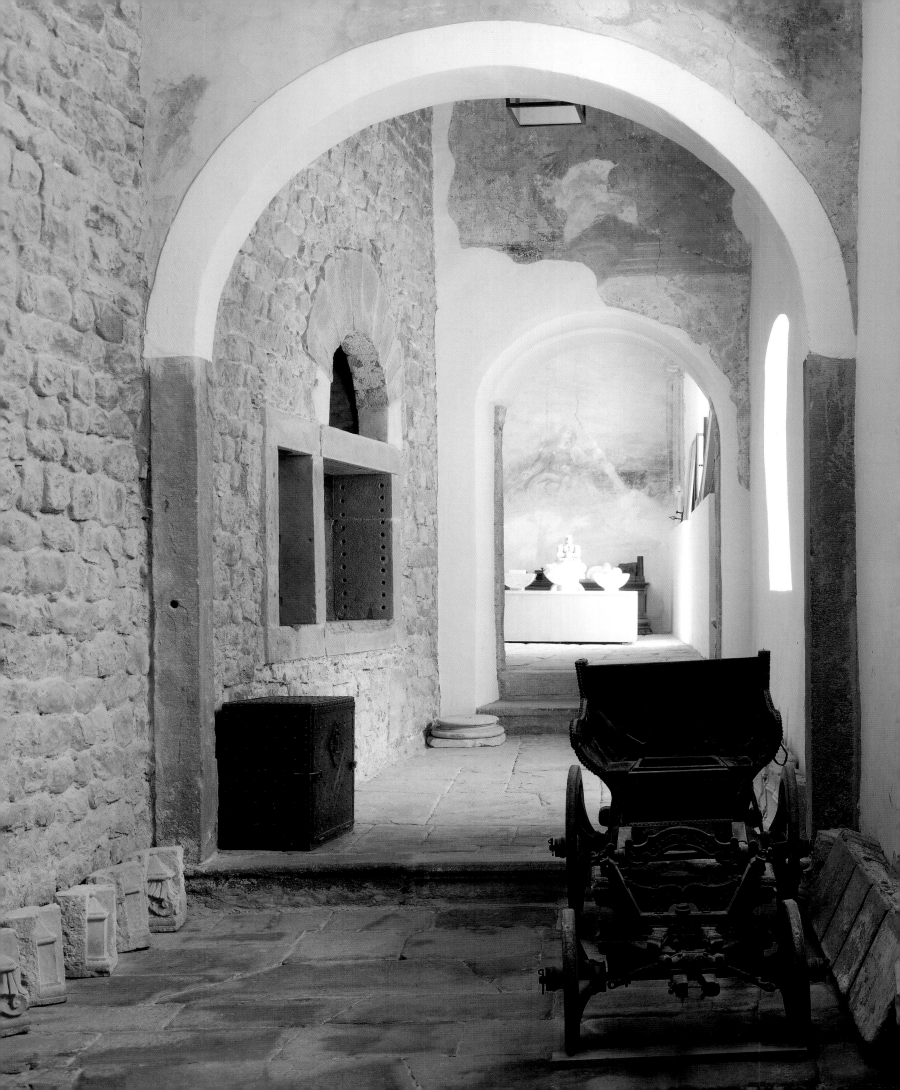

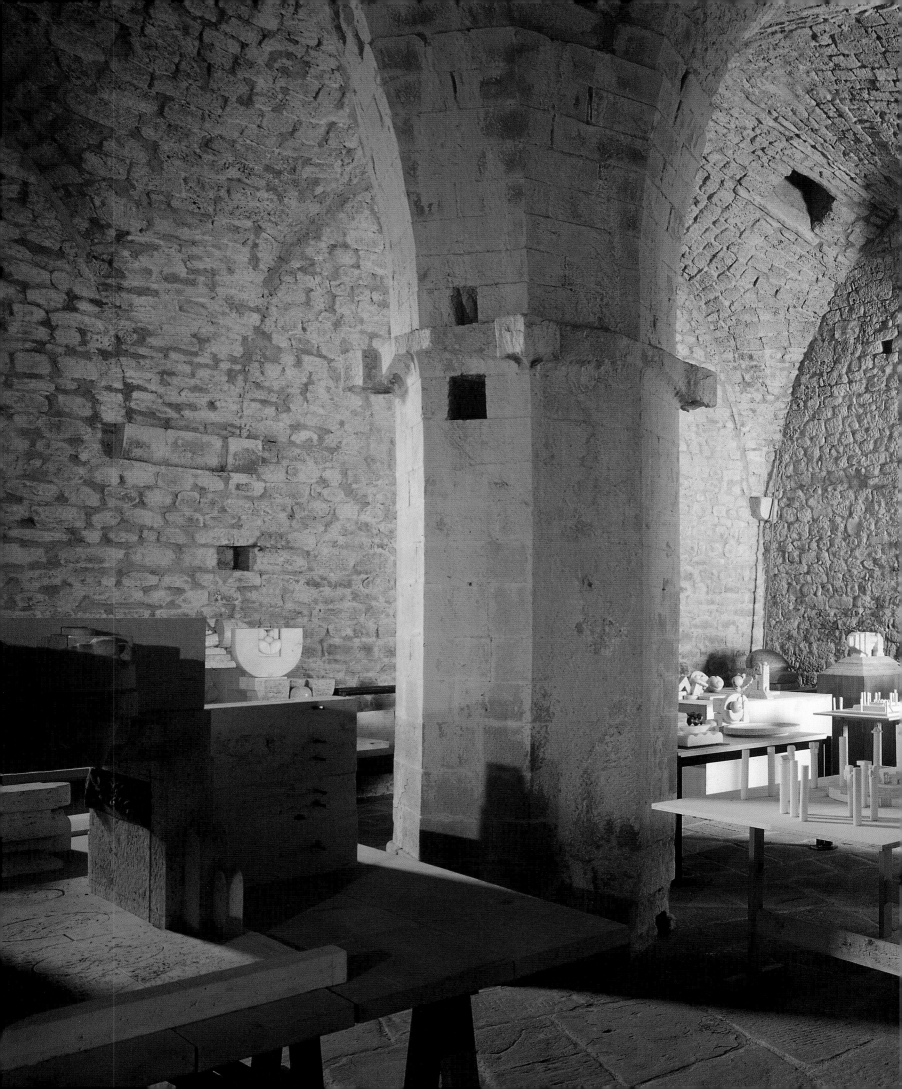

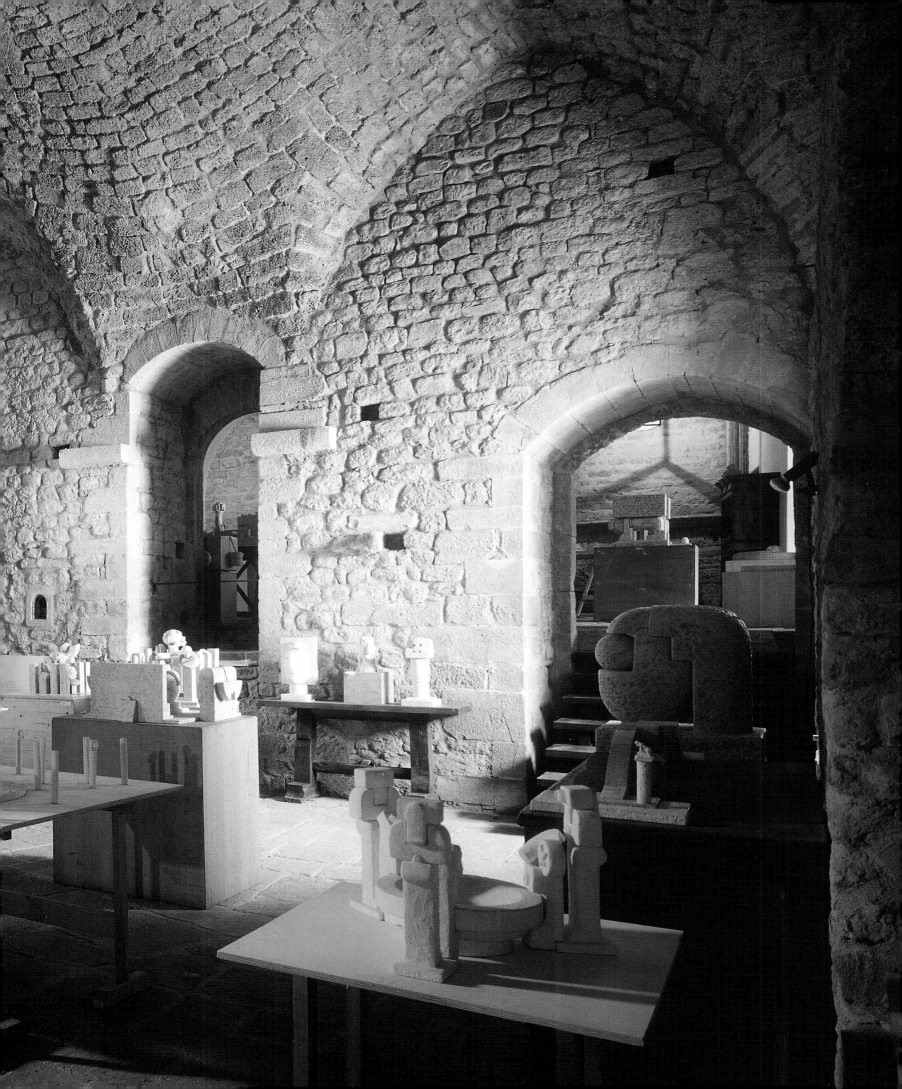

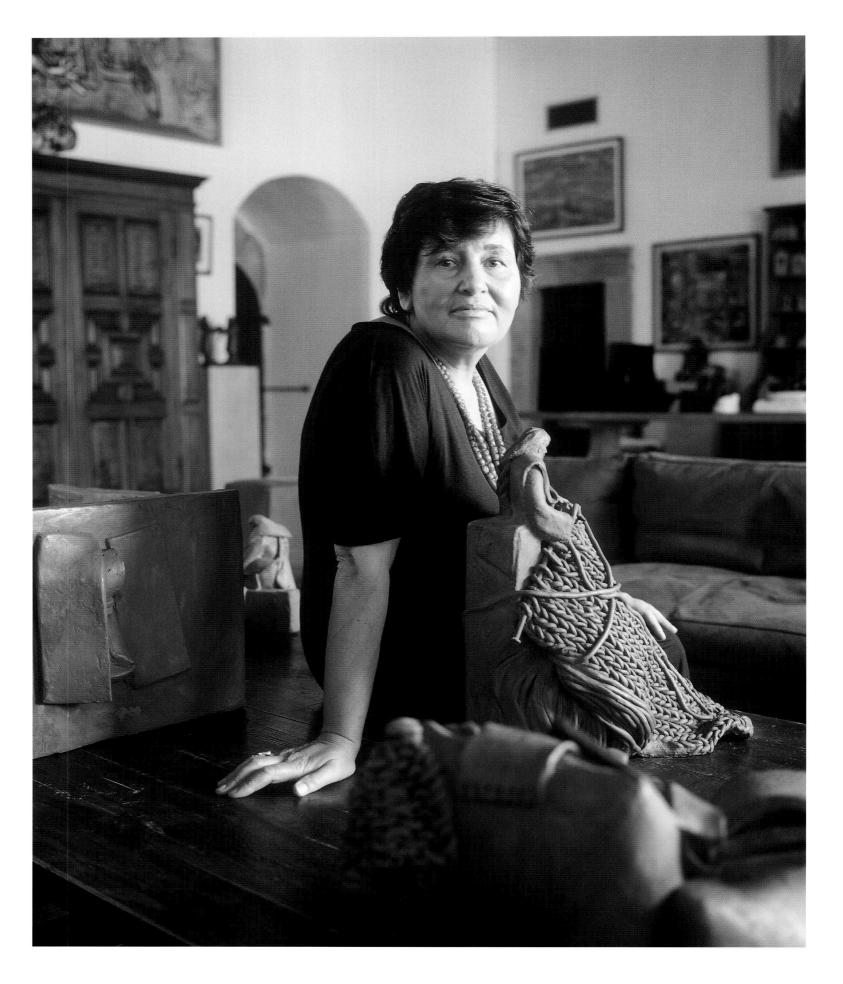

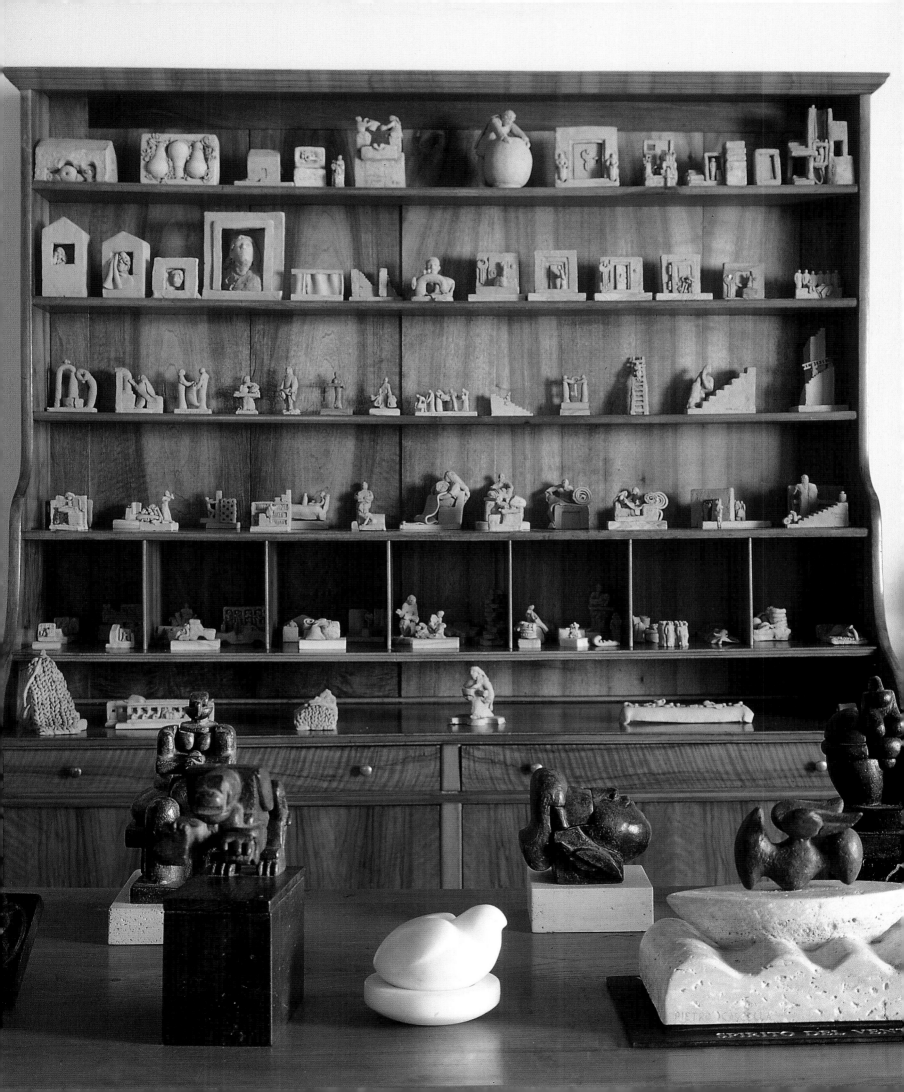

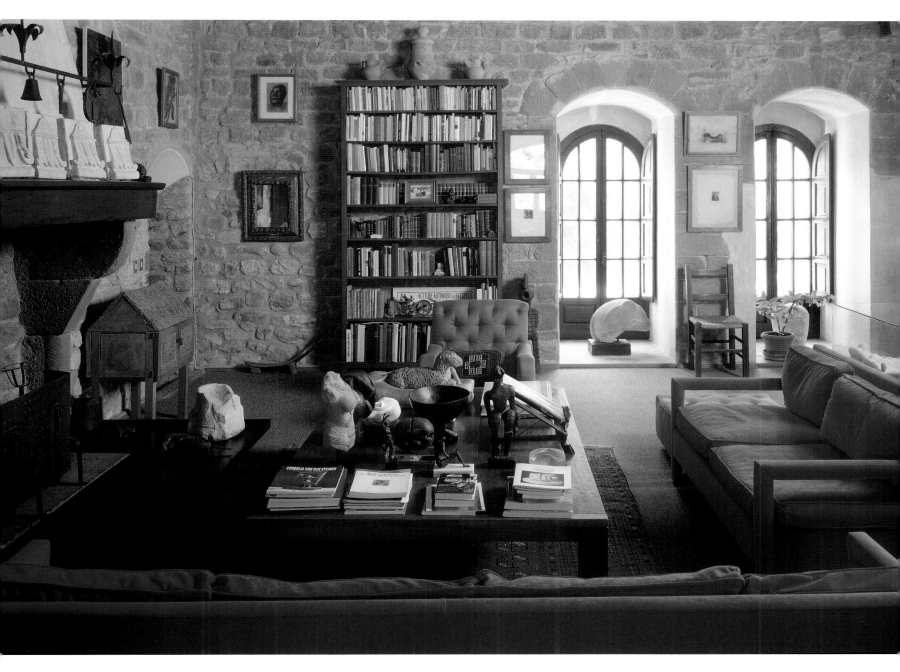

Previous pages, left: *Portrait of Cordelia von den Steinen holding one of her terracotta sculptures.*

Previous pages right: *A Swiss cabinet designed to hold prints houses an arrangement of terracotta pieces by von den Steinen.*

Opposite: *Partial view of one of the many living spaces in the castle. A writing desk is positioned in front of a window that has a view of the surrounding countryside. The wooden staircase leads to the room shown above.*

Above: *This room, high in one of the towers of the castle, has a large stone fireplace and furnishings from various parts of the world. A collection of artworks by friends displayed on the table includes a bronze bowl by Alberto Giacometti.*

Isanna Generali

Isanna Generali's plain farmhouse is not an ancient farmhouse with stone arches and dovecotes, but a rectangle planted in the middle of a valley formed by gently rolling clay hills, linked to the outside world by a narrow, unpaved road that acts as a sort of umbilical cord. The structure is typical of those built in the 1920s to house large sharecropper families, which at that time formed the backbone of Tuscany's agricultural economy.

While there are no decorative features as such, a harmonious solidity shows through a design that is the fruit of building out of necessity, where everything is dictated by ancient rules that have been refined over the centuries. The house has a typical layout: workrooms are located on the ground floor, including stalls and storage areas that Generali has made into a studio. The upper floor, reached from the outside by a narrow staircase, is devoted to family life. The first room one enters, a large kitchen with a fireplace, is the heart of the house. Doors lead to spacious bedrooms where entire families used to sleep.

Generali came to live in this house during the early nineties. She was born in an area so flat that variations on the land could only be detected from on high, such as from an airplane, bell-tower, or bridge. She later lived in the historic center of Florence, "trying to absorb everything that its history, life, and humanity could teach…the walls, streets, workshops, the know-how of the craftsmen, the life of the piazza." This choice of a new life arose from the profound inner changes she was experiencing—a need to sum up previous experience in order to find new priorities, to get away from things, to have more room for herself, and to view things from a more unencumbered perspective.

Above: *The gentle hills of the Tuscan countryside surround Isanna Generali's house.*

Opposite: *Portrait of the artist in her studio. The ceiling of the old stalls where the studio is located has small arches made of terracotta and iron. These* voltine *are a typical early twentieth-century construction technique.*

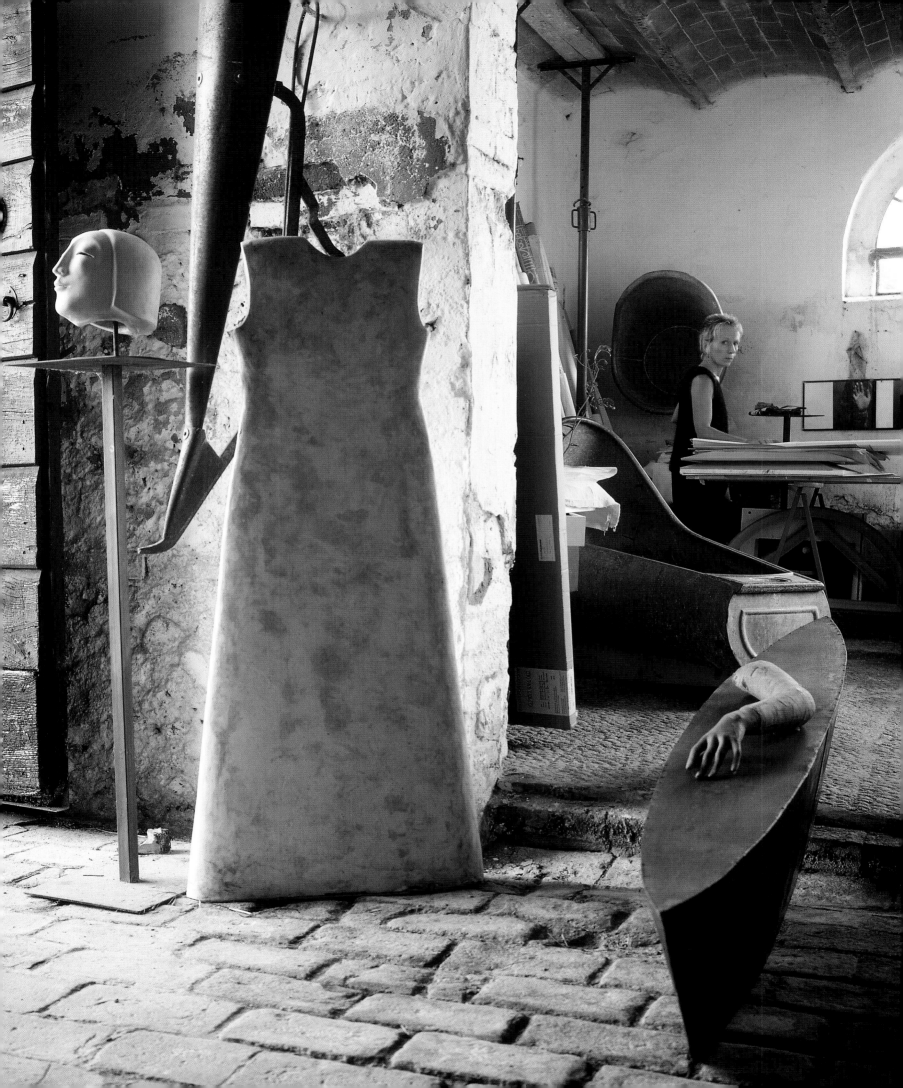

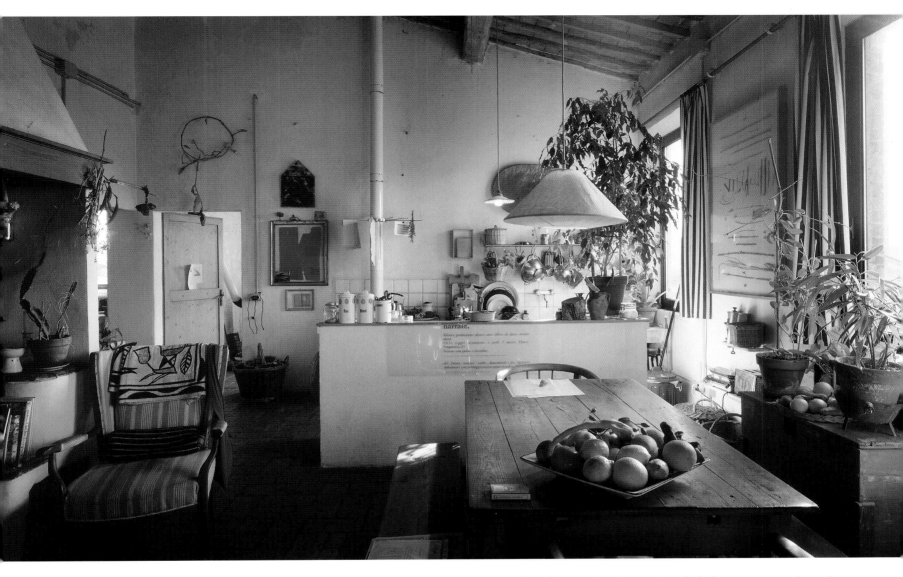

Above: *The heart of the house is a spacious kitchen and living room, a comfortable space for dining, reading, animated discussions, and silence.*

Opposite: *A small herd of sheep pasturing on a wall recalls the presence of these animals in the surrounding countryside.*

Overleaf: *The cooking area where everyday items mingle with Generali's artwork.*

"I was looking for a place and by chance I found it, standing discreetly right before my eyes at the end of a narrow road in the middle of the encircling clay hills." At the time of her arrival, the long-abandoned house was in bad condition, but it still had traces of the life that had been lived there. "The colors of the rooms—pink, sky blue, ochre—and the old bare plaster, left just as it was…the house was tired, but still alive, and spoke to me in my current state. I was still in time to do the essential things: provide myself with a workspace and satisfactory everyday living arrangements."

An effort was made to keep changes to a minimum, the idea was to conserve and put to good use what the house had to offer, which naturally entailed the utmost respect for its history. Generali brought new life to the place by bringing out the best in what was already there. This included simple acts such as the careful placement of everyday objects in harmony with both her artwork and the artwork of her friends. The house has regained its vitality and its has capacity to absorb and transmit the energy of the people who live in it.

"This house has been a friend to me, taking me in and showing me everything that might prove useful —and I have made good use of everything it has to offer. Its history really belongs to it alone, and everything proclaims this fact. My personal history is extraneous, at the moment our paths have simply crossed. We both manage to get along with our respective existences despite some tiredness on both sides. I do not know what the future holds for the house, but then again I do not know what the future holds for me. If I go beyond such petty considerations and give free rein to the echoes of

narrare,

voices from the past and the larger history that imbues these walls and this land, it seems impossible for me to come to terms with the fact that they are lost and gone forever. Everything speaks of them, and at times this 'noise' disorients me. I am something else and I cannot guarantee the continuity of what has changed so radically and paradoxically.

"The empty spaces, the rooms filled with light, the vast pleasant horizon on all sides, the precious silence are what this combination house and studio nourish me with, and what will make it difficult to detach myself from this house when the time comes. Sooner or later the time will come to go and look for another place to provide stimulation, and at the same time to take stock of myself and give an account to others about this desire, pleasure, and need of mine to produce art.

"It is difficult to make a distinction between the past and present of this house, not only because its structure has been left untouched, but also because the new things seem to be in keeping with what the house, stone by stone, was originally built for. Here the same light and sounds are perceived within, and the same silence without."

Above and opposite: *The bedroom maintains a simplicity typical of old farmhouses in Tuscany. Among objects and images held in high regard by the artist are finished works, studies, and sketches.*

Overleaf, left: *A collage on the wall above the washstand in the bedroom has traces of painting by the artist's daughter.*

Overleaf, right: *A desk and table in the bedroom are covered with books, notes, photographs, papers, and various finds.*

Second overleaf: *Details of the bedroom.*

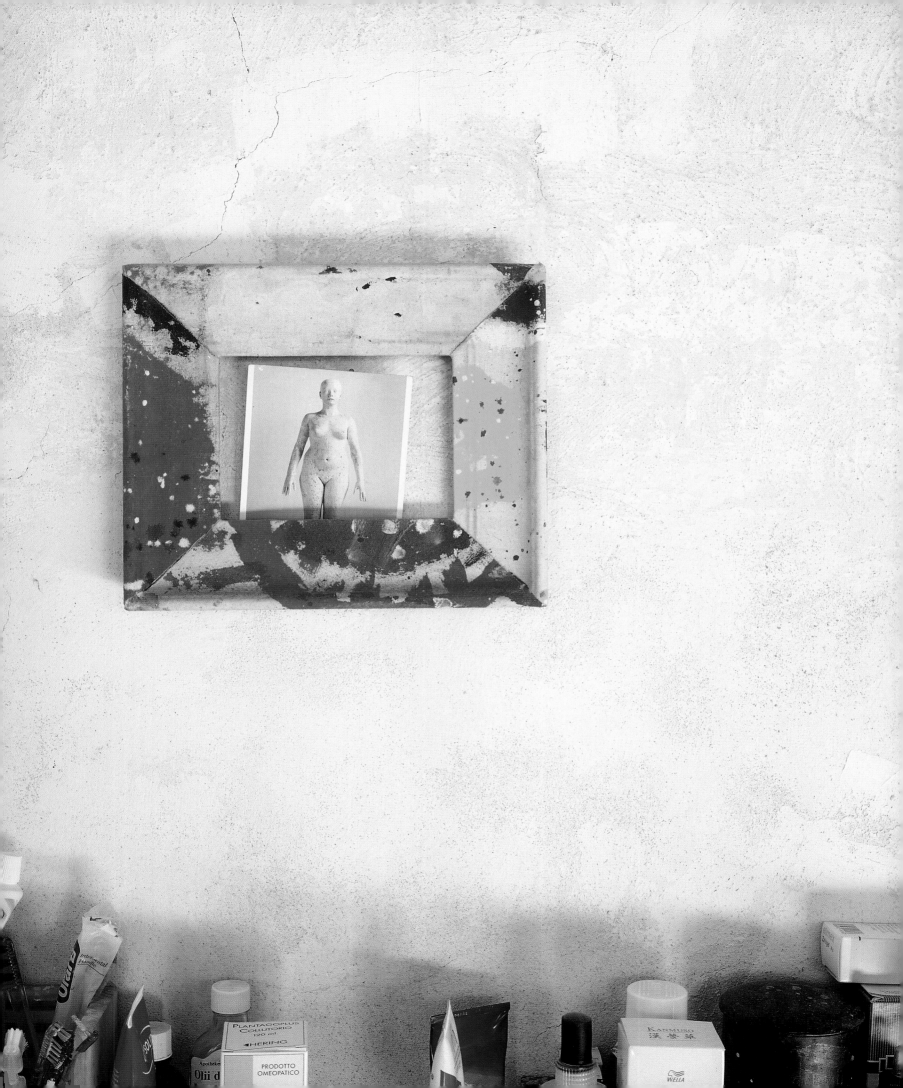

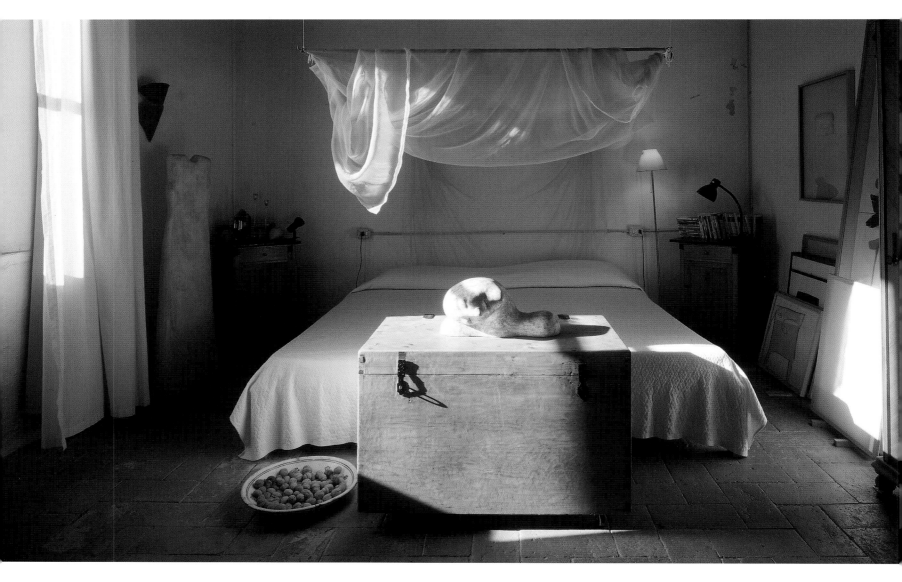

Above and opposite: *The guest room, referred to as the "white room," is illuminated by bright sunlight most of the day. It has simple, basic furnishings and is decorated with sculptures and drawings by Generali.*

Overleaf: *A simple bookcase and desk in the artist's studio overflow with books, sculptures, and other artworks. The banner in the foreground of the photograph on the left reads "Ah! si tous le communistes étaient comme toi" is a momento from the artist's days of collaboration with French graphic artists during the seventies.*

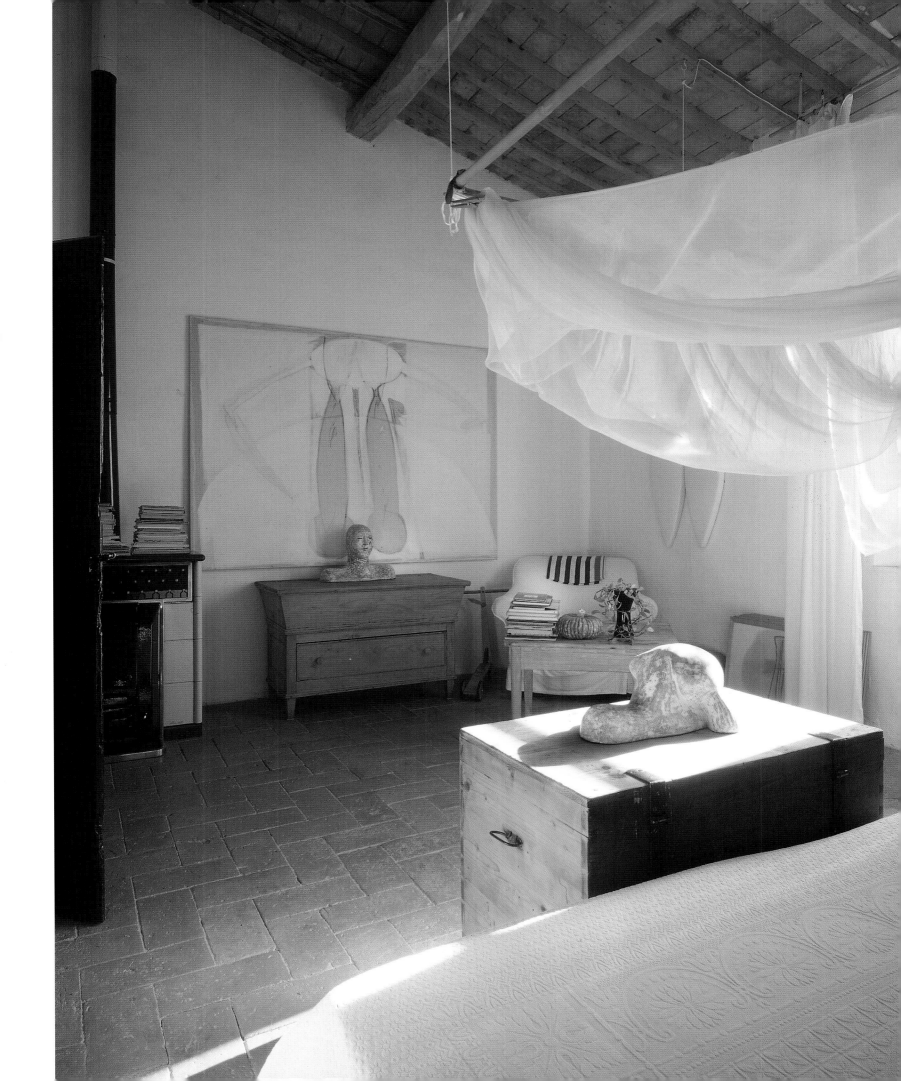

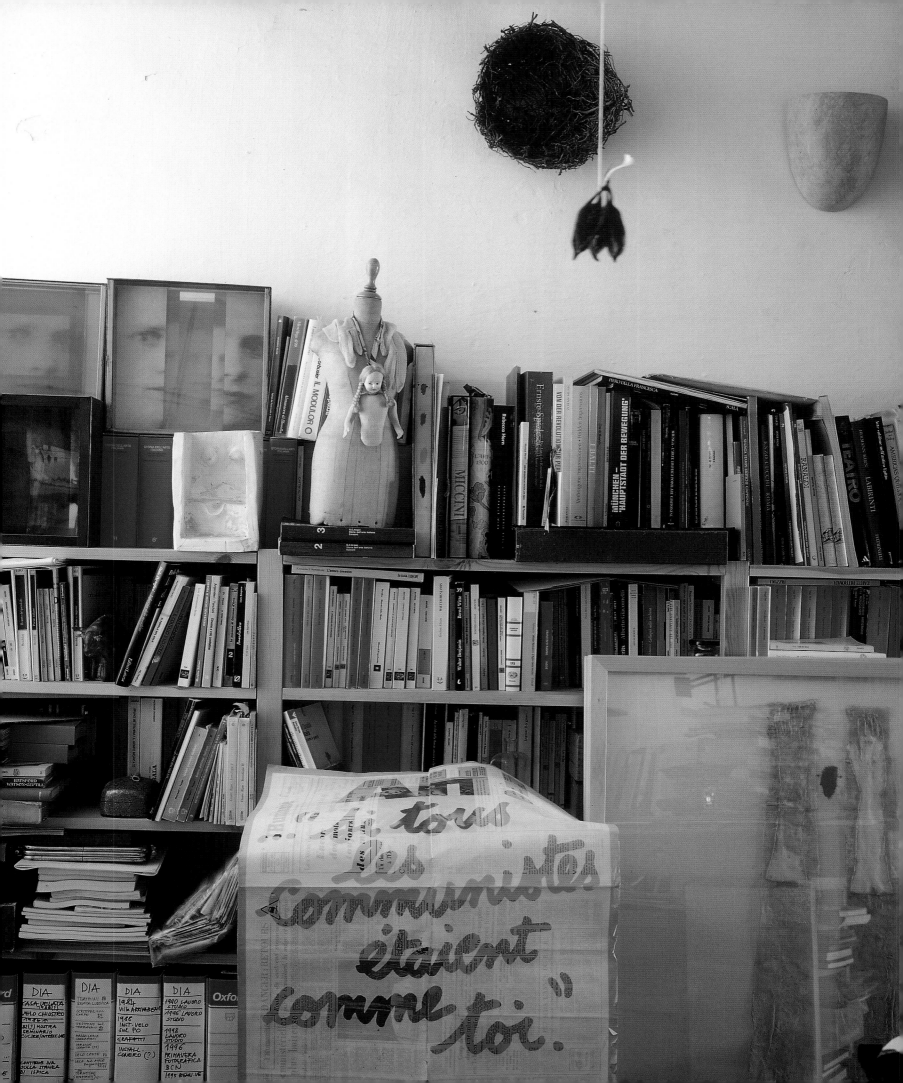

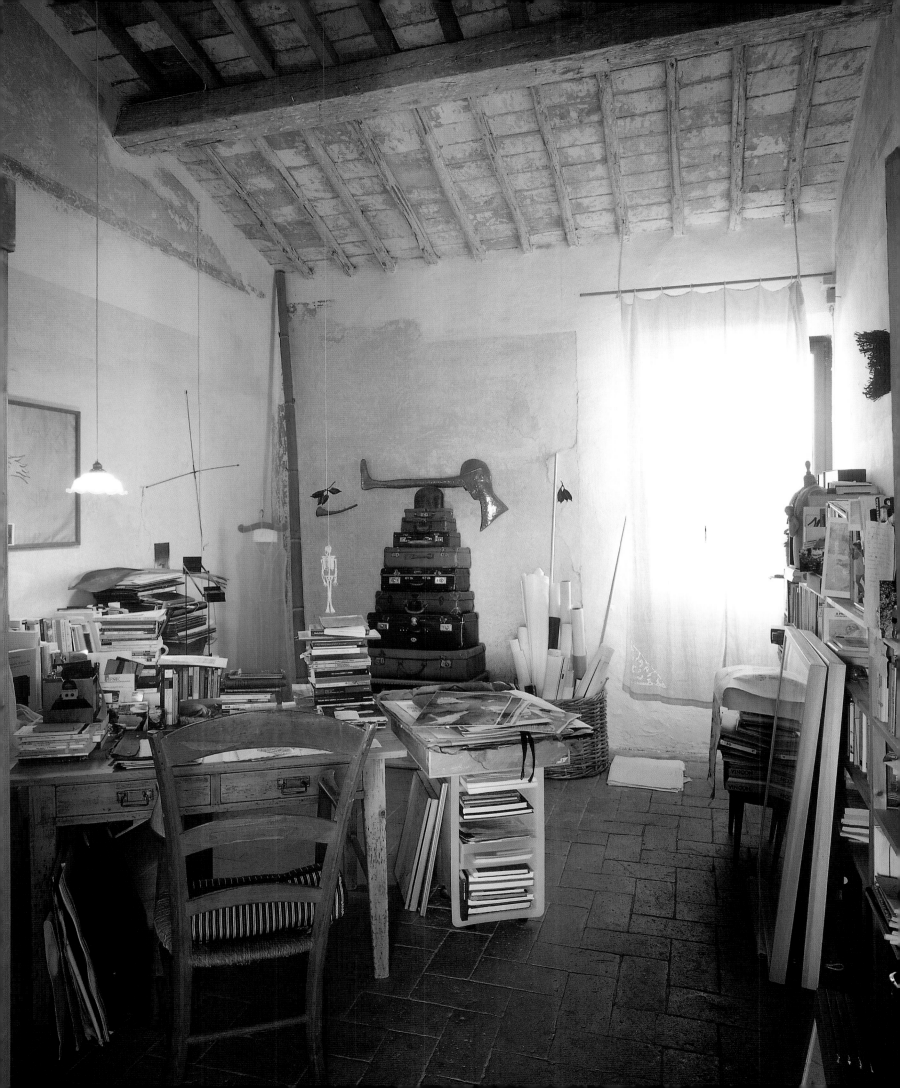

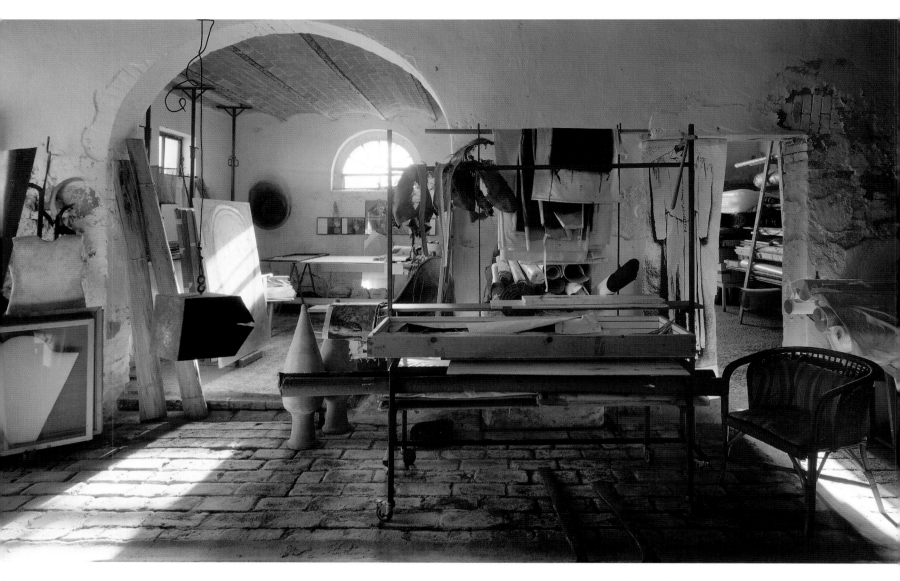

Above and opposite: *In the studio various materials accumulate in a disorderly way. Apart from the addition of Generali's work, these stalls have remained unchanged.*

Overleaf left: *This work in terracotta, titled* Annunciazione, *is from the the artist's* Dogma della verginità *series.*

Overleaf right: *An installation by the artist that includes sculptures in copper is on display in the studio.*

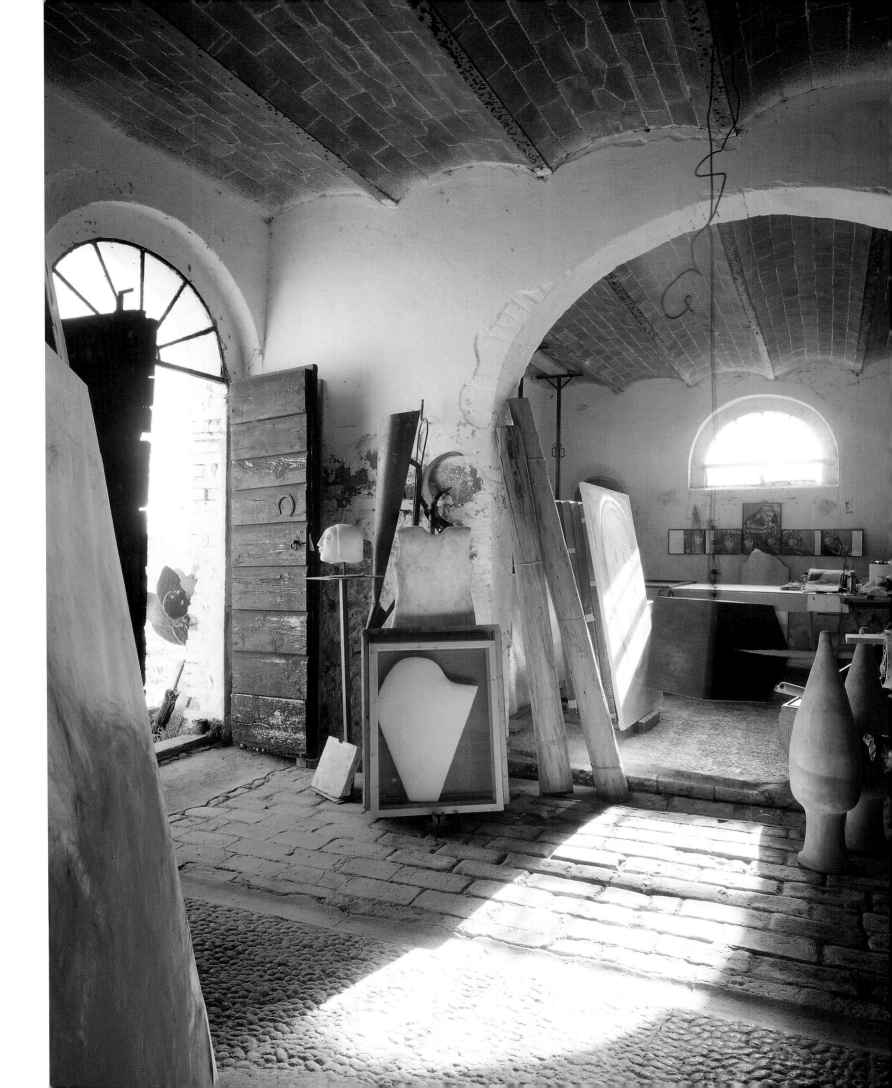

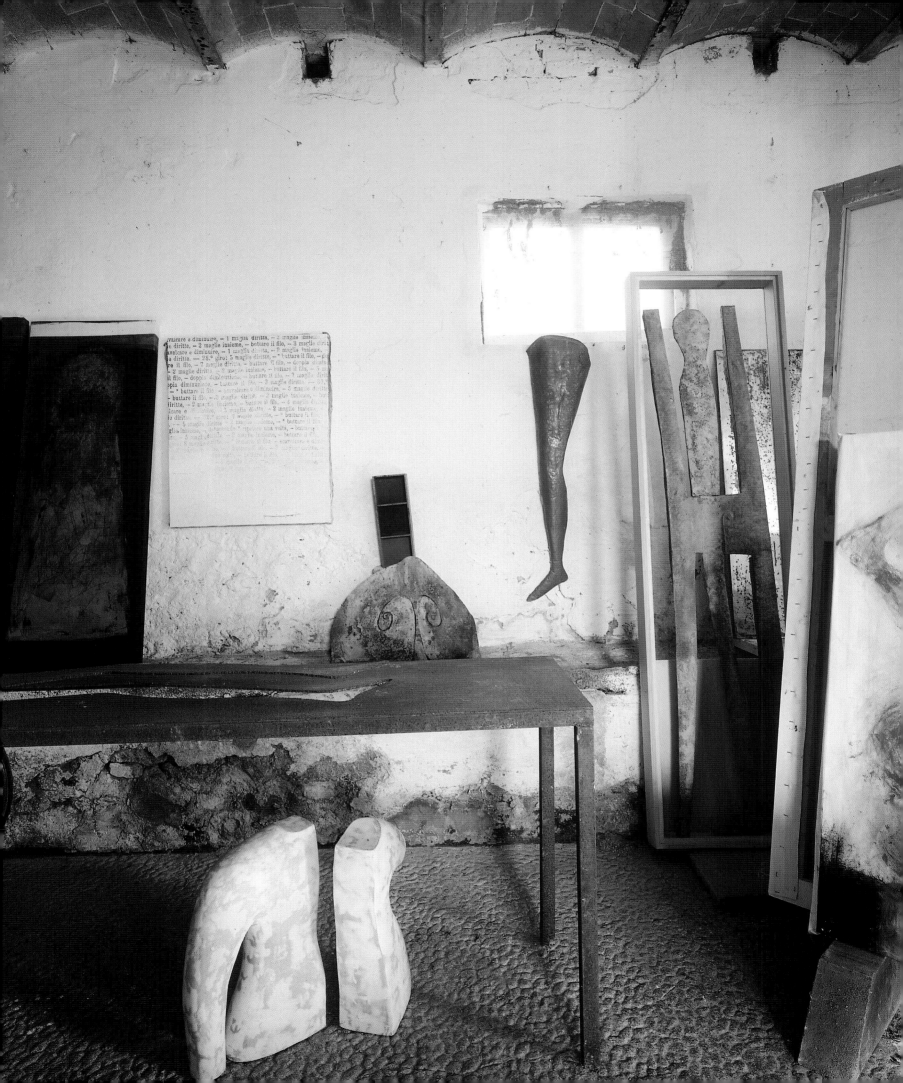

Evelien La Sud

Evelien La Sud's home is outside Barberino Val d'Elsa, in the heart of Chianti. It is an old farmhouse built around a small central tower that dates from the thirteenth century. Over time, the house underwent so many transformations that when its current owner arrived it had been reduced to little more than a heap of stones. La Sud restored it with her own hands, with the same loving care she lavishes on the crystal vases and orchids. "This house," she says, "was a ruin, completely abandoned. I fell under the spell cast by the solitude, the tangle of plants, trees, stones, and bricks. I was intrigued, any human effort is destined to lose the contest with nature."

As a matter of principle, La Sud's restoration work always utilized recycled building materials found abandoned along roads that run by old farmhouses. Most of the old farmhouses in Tuscany have either been converted into mansions or destroyed to make room for modern apartment buildings. "It really hurt me to see all that material being thrown away. I began to collect the hand-chiseled stones, handmade bricks of every size and shape, oak beams, windows, roofing tiles, flooring, and even entire ceilings. I wanted to recover and reuse material that once formed an integral part of the reality of a particular place. For me this material is not just a means to an end, it is something of interest in its own right, worthy of attention. This material holds memories and has a forgotten essence that is waiting to be rediscovered."

La Sud came to Tuscany after many years in Milan where she studied at the Brera Academy of Fine Arts. During her studies in Milan, in the seventies, the artistic and intellectual communities were immersed in a general revolt against both moral and social constraints. Artists refused to be put into traditional categories and began to discuss new theories and develop new movements. "I decided to move to Tuscany to work in natural space. It was a type of artistic experience that does not produce works of art, but involves events limited in time that leave only traces. A fundamental moment in my development was the first time I visited a small chapel by the cemetery in Monterchi and saw Piero della Francesca's fresco, the *Madonna del Parto*. In this work a pair of angels pull back the curtain of a pavilion to reveal the pregnant Madonna squarely in the middle, immobile and solitary. In that great fifteenth-century Tuscan painting I recognized the landscape that I saw out of my window. The world may have changed, but a constant thread remained: the quest of mankind, human expectations, in a whole intimately bound up with nature."

Though La Sud says that she was not consciously aware of the tumultuous exodus of peasant farmworkers in Tuscany, their history had an effect on her. "My desire to rebuild this house stems from a desire to understand the profound forces that shaped the lives of the people who worked the land and inhabited these old farmhouses. I wanted to experience the rural environment—the huge peasant kitchen, hearth, and the rooms that were demolished, then rebuilt, adapted, extended over time. Their experiences are like a hidden spring, a source of new ideas. The important heritage of the

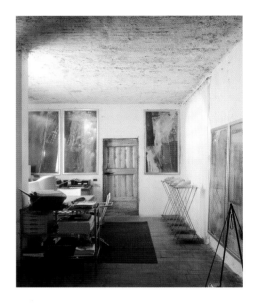

Above: *The artist's studio.*

Opposite: *Evelien La Sud in her studio.*

Overleaf: *Paintings in various mediums hang in La Sud's studio. The crystal pieces on the table in the photograph on the left are from the artist's* Orticello *series.*

Second overleaf: *La Sud added a series of large windows to a hayloft converted into a living room. The room has a spectacular view of the rolling Tuscan landscape.*

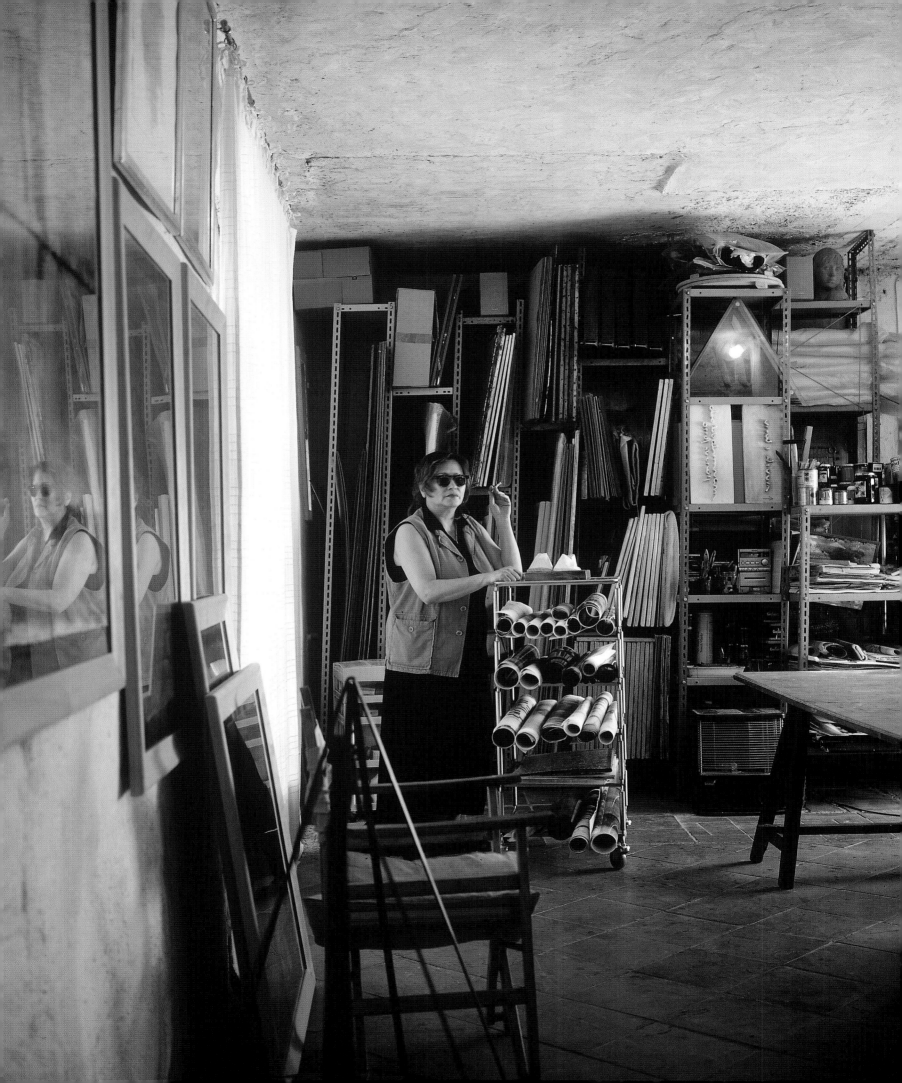

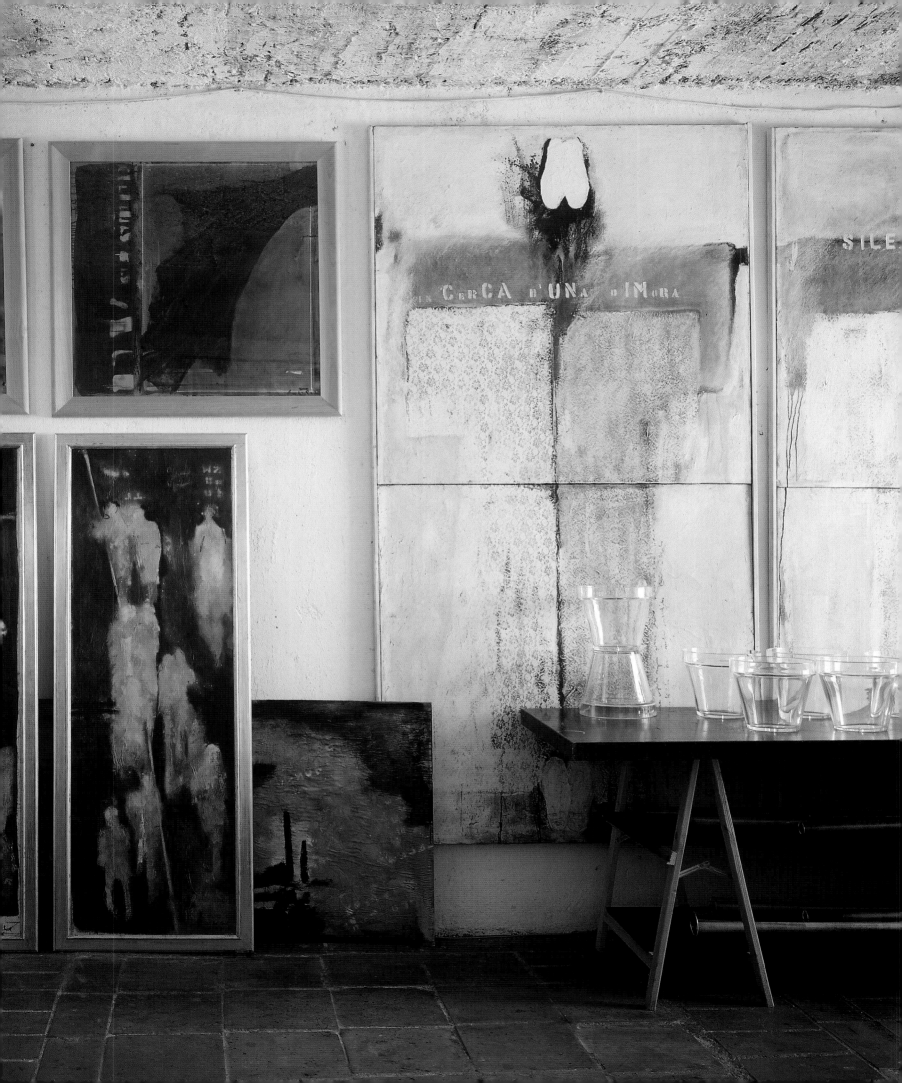

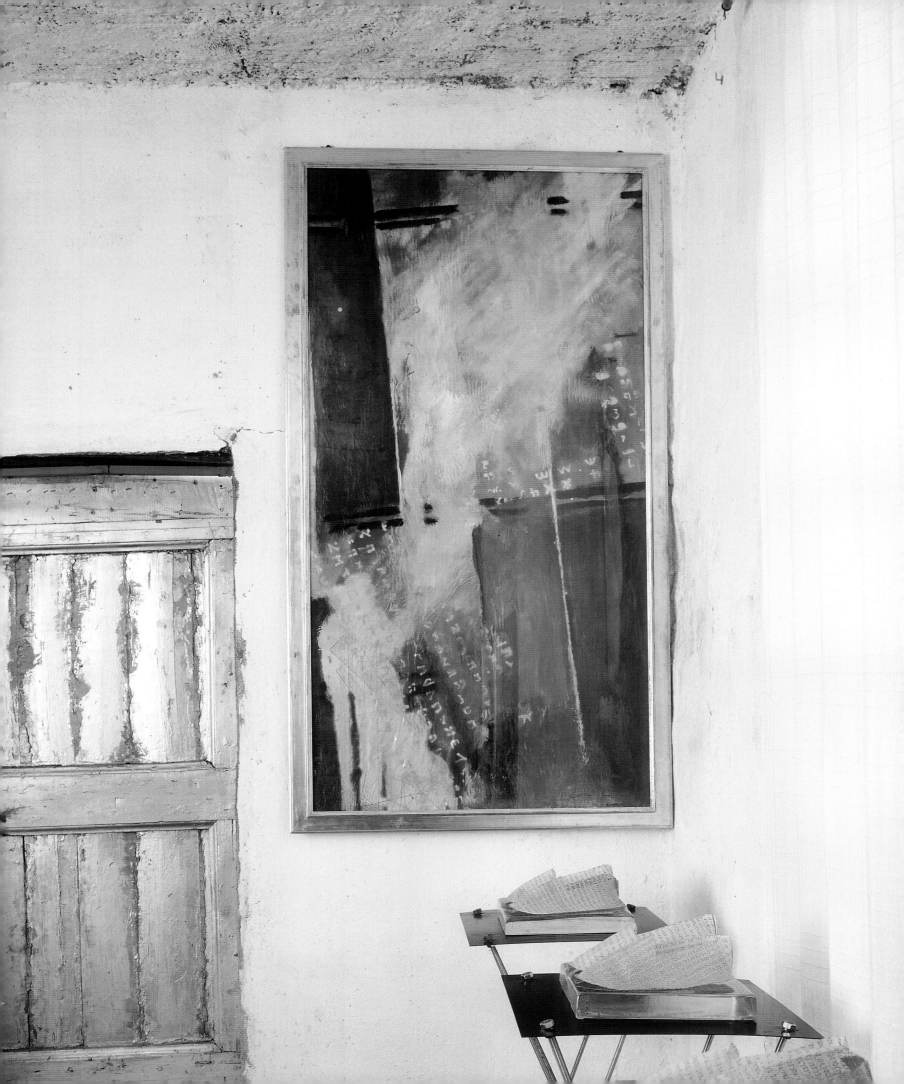

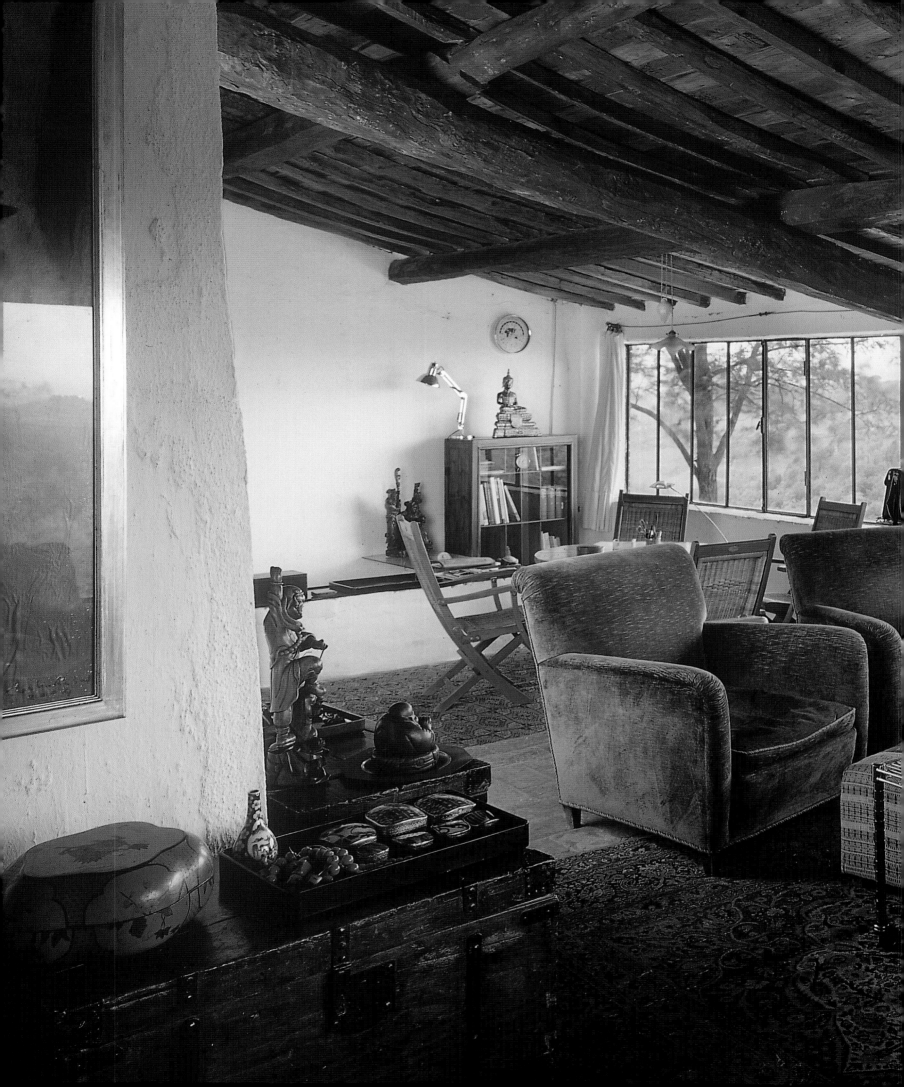

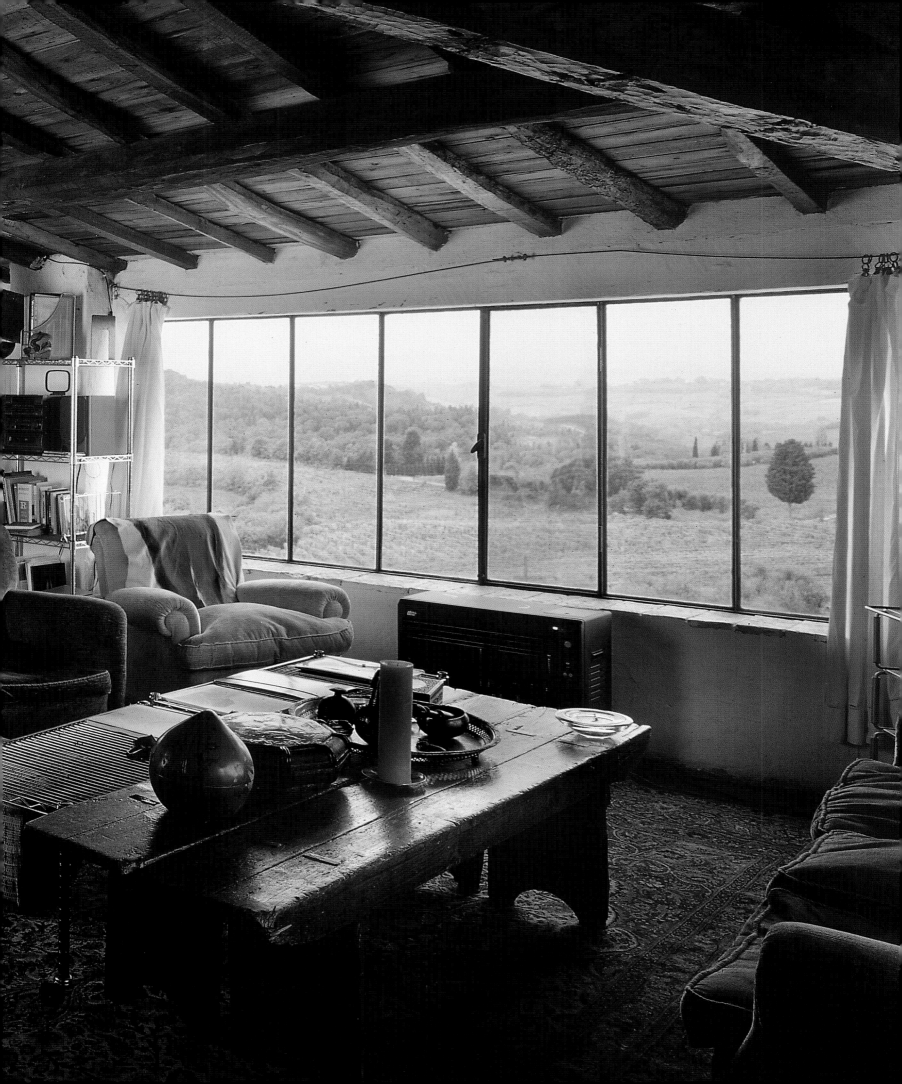

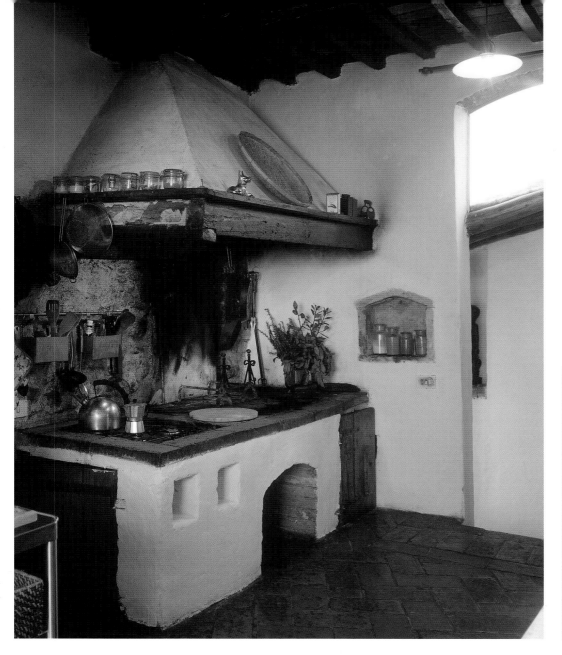

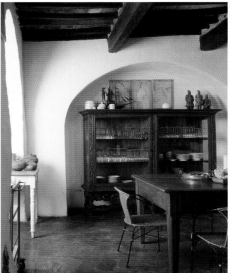

world of peasant farmworkers in Tuscany, with all its magic and mystery, is self-contained. It must be handed down to future generations so that we do not lose this unique identity. The simultaneous existence of the histories of various people—where no one part cancels out another, creating the warp and weft—gives Tuscany its sense of the eternal."

The living room is carved out of an old hayloft and is the house's main living space. It has large windows that face a striking view of the the valley and hills that surround the house. At sunset the difference between indoors and outdoors seems to be erased. La Sud says "living every day in direct contact with this landscape has made it a part of me. Natural phenomena—dawn, sunset, seasons changing—represent an energy that has become and integral part of my artistic imagination.

Above left: *La Sud has restored the traditional Tuscan farmhouse corner cooking area, with its raised hearth fireplace and large hood, without altering its original design.*

Above right: *The kitchen has nineteenth-century furniture. The small Chinese statues on top of the glass cabinet are terracotta copies of Emperor Xian's army.*

Opposite: *The padded Chinese kimono hanging in the anteroom to the bathroom is of embroidered silk. The turtle shell on the wall is a Chinese good luck charm.*

Overleaf, left: *The bathroom was once a pigpen that had three small adjoining rooms. Original building materials were used in the remodeling process. An ebony boat from Indonesia, fossils, and seashells decorate the bathtub.*

Overleaf, right: *The washbasin in the bathroom is an old stone water trough that was found on the premises.*

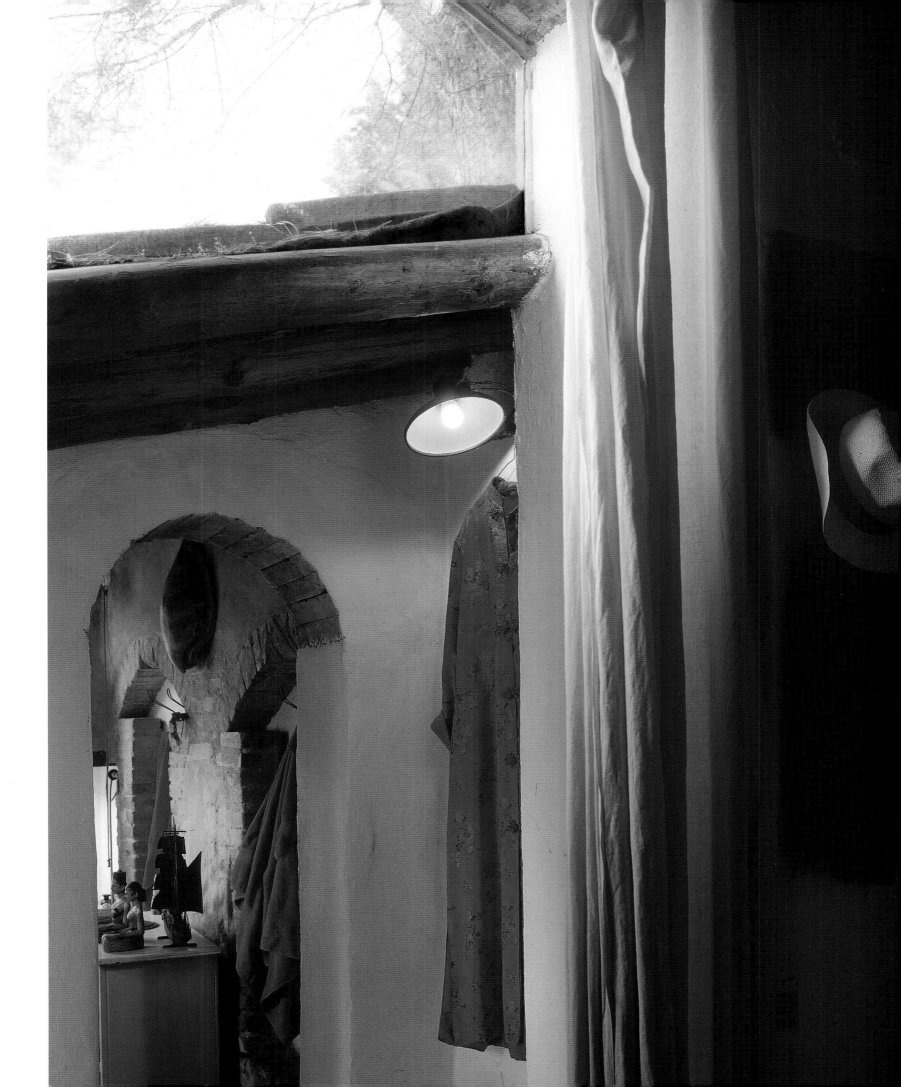

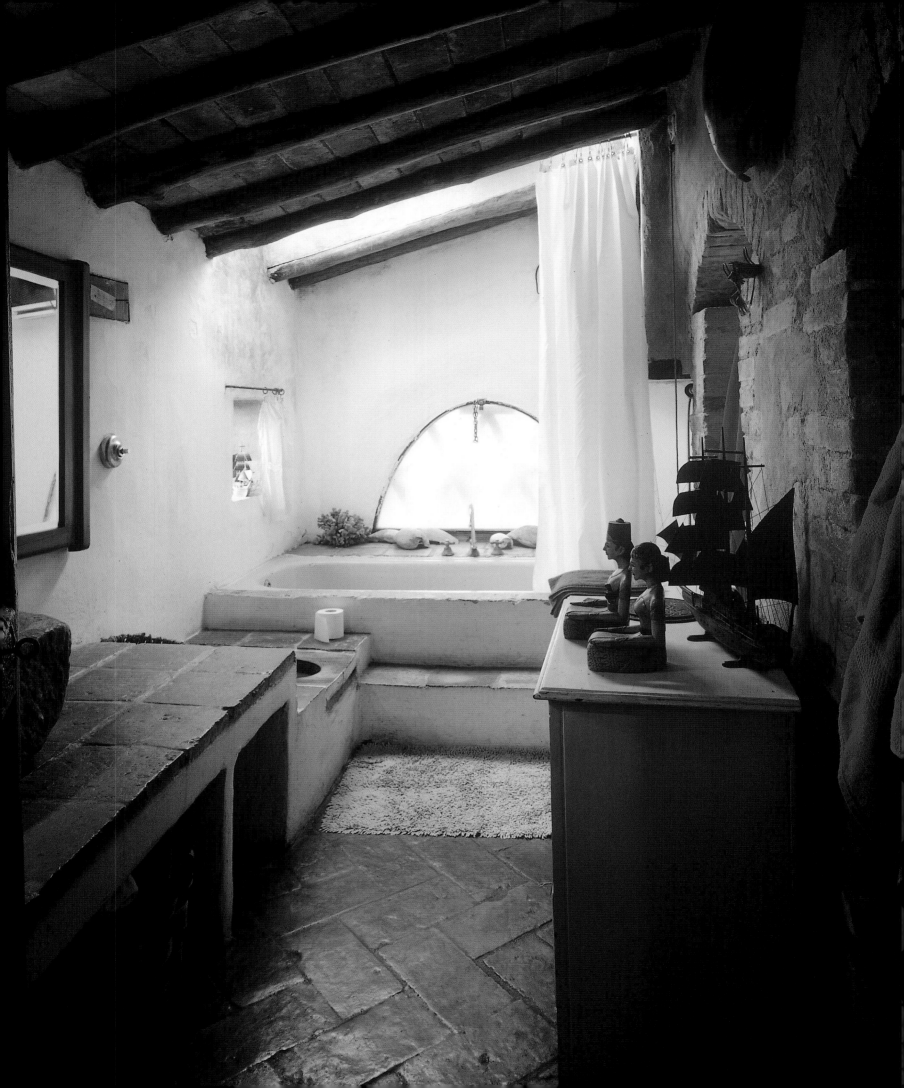

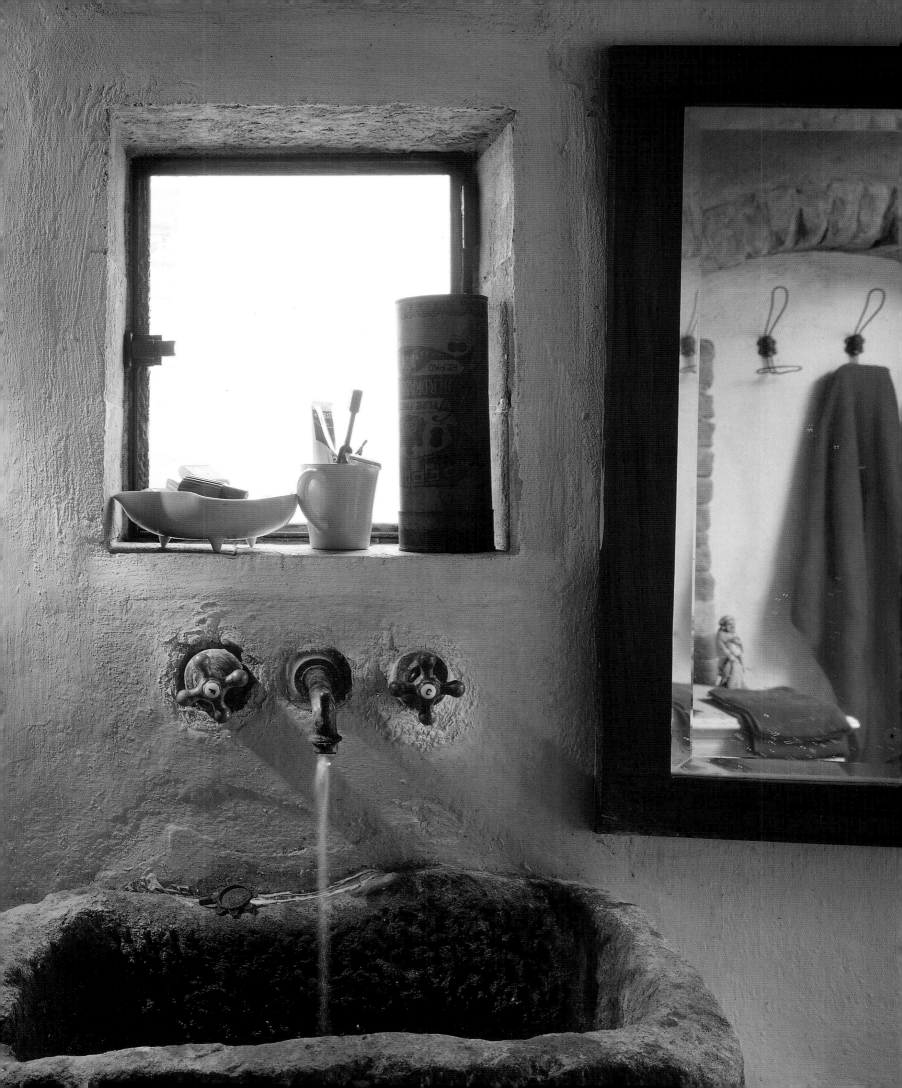

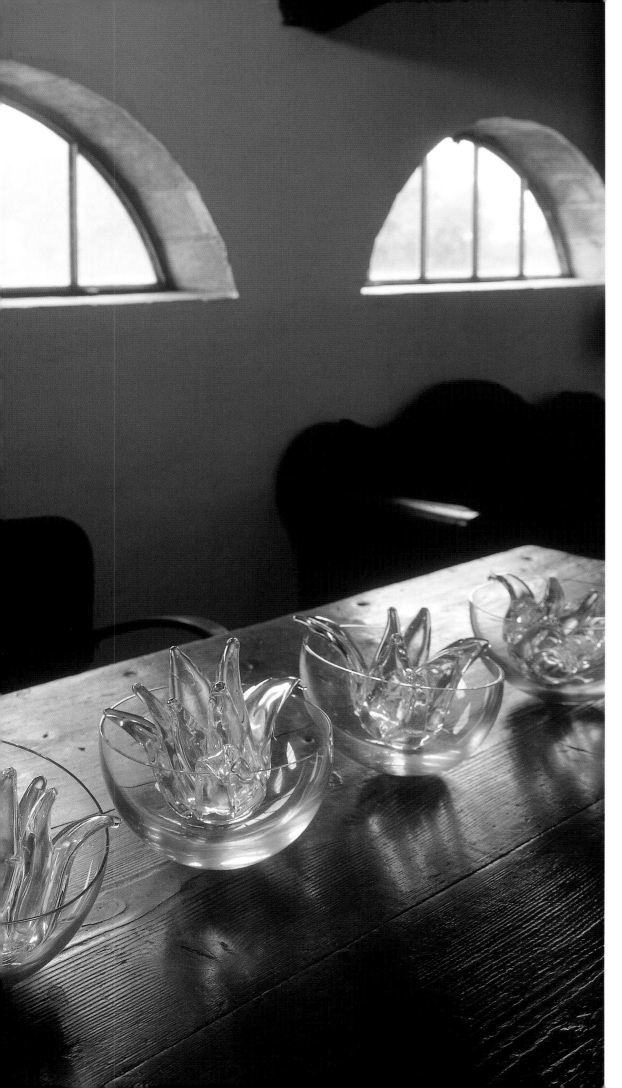

Left: *Crystal water lilies floating in crystal vases made by the artist for installation in the* Fontana di Giove *in the garden of the sixteenth-century Medici villa in Pratolino north of Florence.*

Opposite: *The artist's bedroom.*

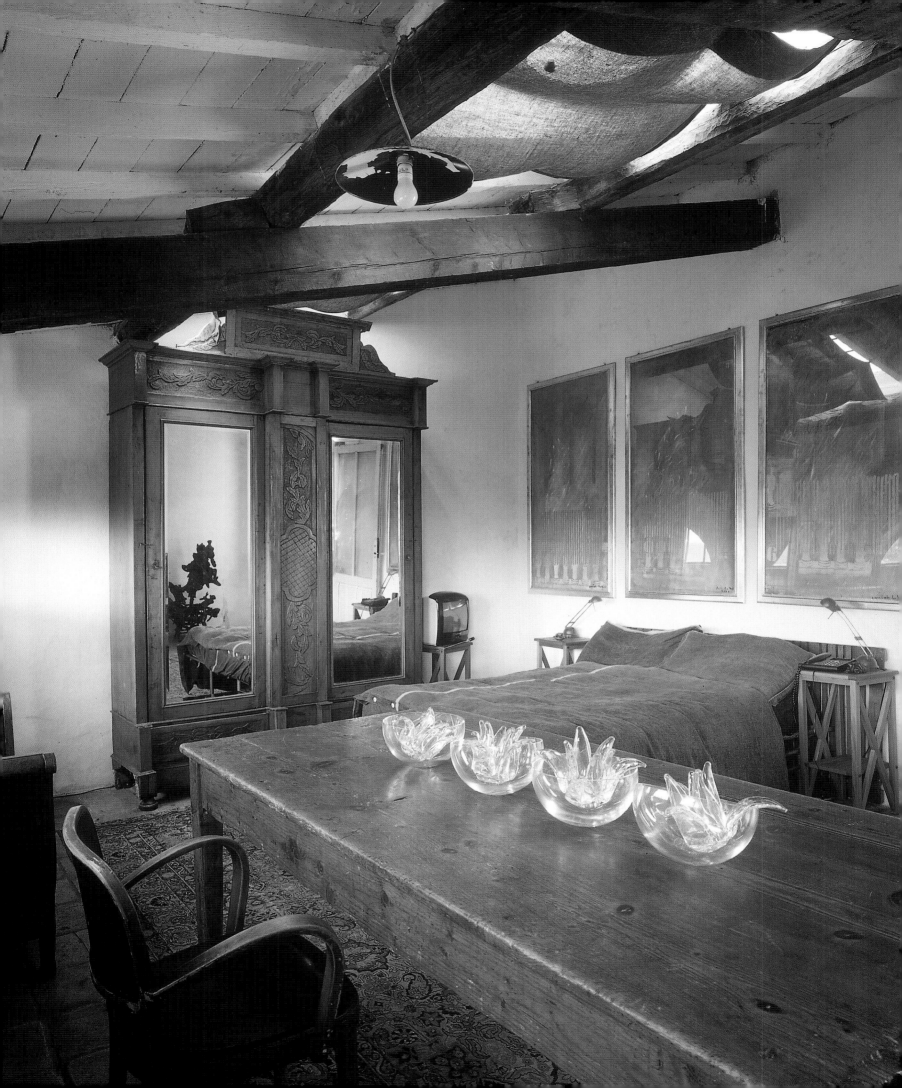

Kurt Laurens Metzler

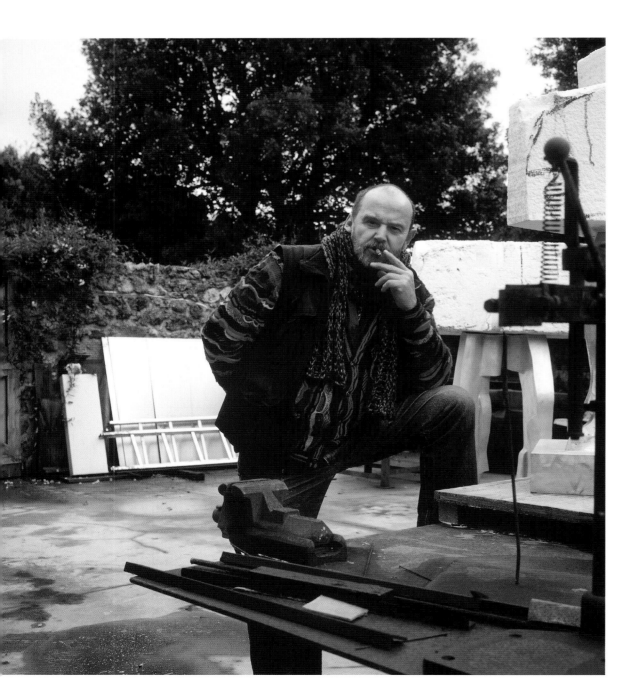

Left: *Portrait of Kurt Laurenz Metzler in the courtyard of his studio.*

Opposite: *View of the artist's studio with workbenches and various tools used for shaping iron, aluminum, and stone.*

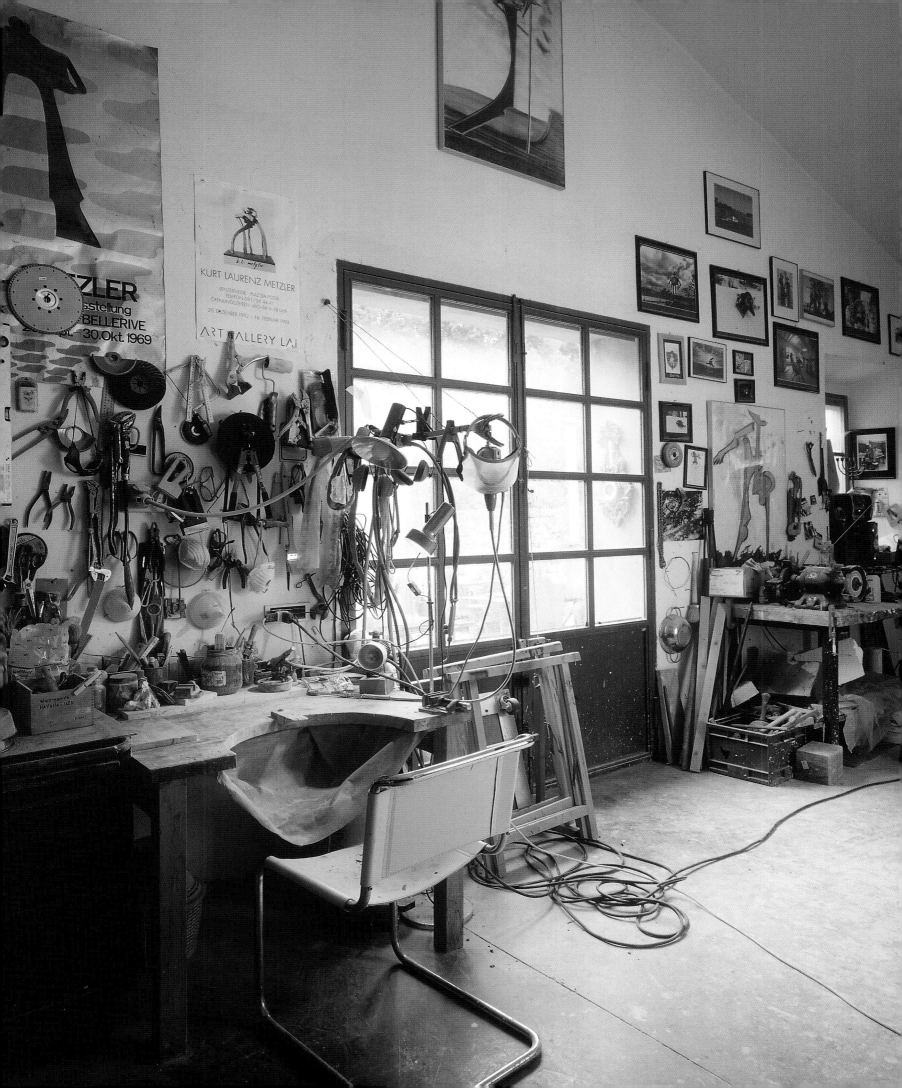

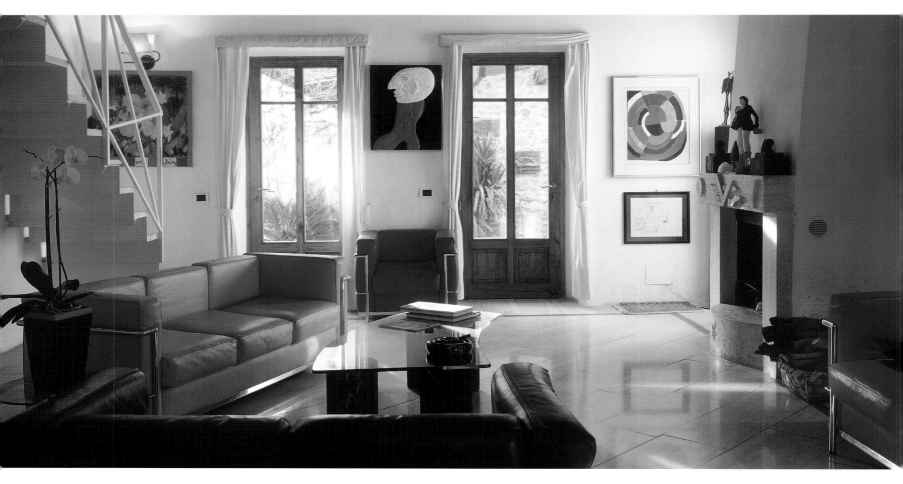

Iesa is a hamlet situated in the hills along the road that leads out of Siena toward Maremma and the sea. Kurt Laurens Metzler first went to Iesa in 1985 during a short vacation and never left. His decision to live there was motivated by his desire to have an arrangement that would enable him to reconcile the demands of working as a sculptor in a properly equipped studio with the needs of his growing family. He purchased a long abandoned farmhouse. Since the artist was determined to completely restructure the interior the restoration work lasted two long years. "I wanted it to be in keeping with my aesthetic ideals as well as simple, comfortable, and sunny. What I absolutely did not want was something pseudo-rustic." The exterior, with its original features still intact, is that of a typical Tuscan farmhouse, while the interior reflects the artist's cultural background.

The rooms have been opened up and emptied to create a spacious environment with old exposed roof beams. Spaces that were once stalls and a hayloft have been converted into a one large room, the house's living room. Simple openings made in the walls link all the various rooms and create an unbroken living and workspace. Unlike the typical Tuscan farmhouse, Metzler's home is flooded with light. French doors allow light to enter the house and create a sense of continuity with the outdoors. The color pallet of the house is bright and the modern furnishings have clean lines. Metzler explains that "in artistic matters I love to experiment and play with shapes and colors, but for the house I prefer pure, rigorous lines and powerful materials, such as marble, glass, and stone. What I love about this house is the light, the surrounding greenery, and the way my own style is reflected in the furnishings that stand in contrast to the rural reality outside. The Sienese countryside puts me at ease after I have been immersed in the hectic life of the big city. This is a place that allows me to gather my thoughts and rethink projects that may have been conceived elsewhere, and to carry them out in total peace and quiet using the most appropriate material. This is a place where I find it possible to reconcile my work with my sense of aesthetics and philosophy of life."

Above: *The living room has French doors that open on to a garden. The plain iron stairs lead to a loft space. A painting by the artist,* Il comandante *hangs between the French doors. To the right of the doors is a colorful silk-screen print by Sonia Delaunay and a drawing by Saul Steinberg. The modern style furniture includes leather Le Corbusier sofas and a small glass and marble table designed by Metzler.*

Opposite: *All the rooms on the ground floor are connected by geometric cuts in the walls. The travertine fireplace was designed by Metzler.*

Overleaf, left: *The sideboard in the dining room was designed by the artist. The three Metzler sculptures on the sideboard are titled* Signora in stivali, Uomo con il suo cane, *and* Giocatore di golf.

Overleaf, right: *An antique wood sculpture from Senegal stands in the entrance hall. The two portraits on the wall on the left are by Guenther Stillino, and the large colorful acrylic painting,* Encounter and Destiny, *is by Lambert Maria Wintersberger.*

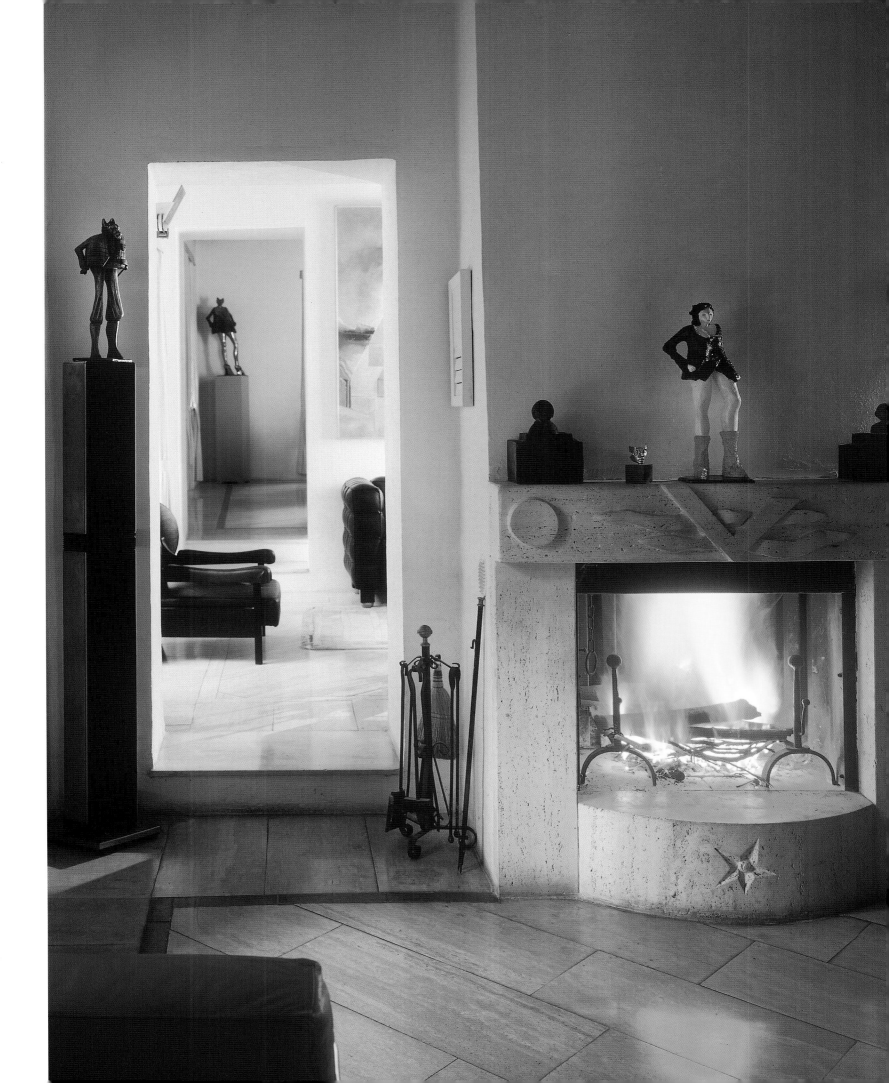

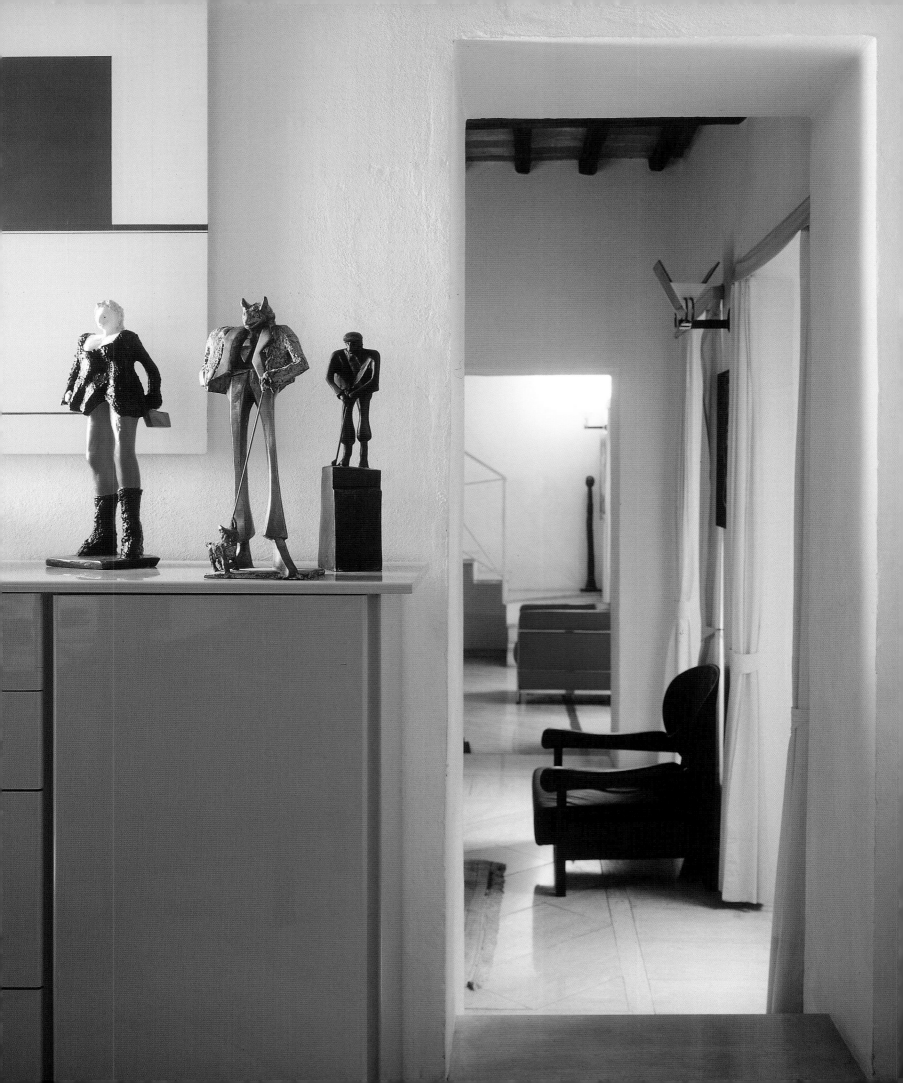

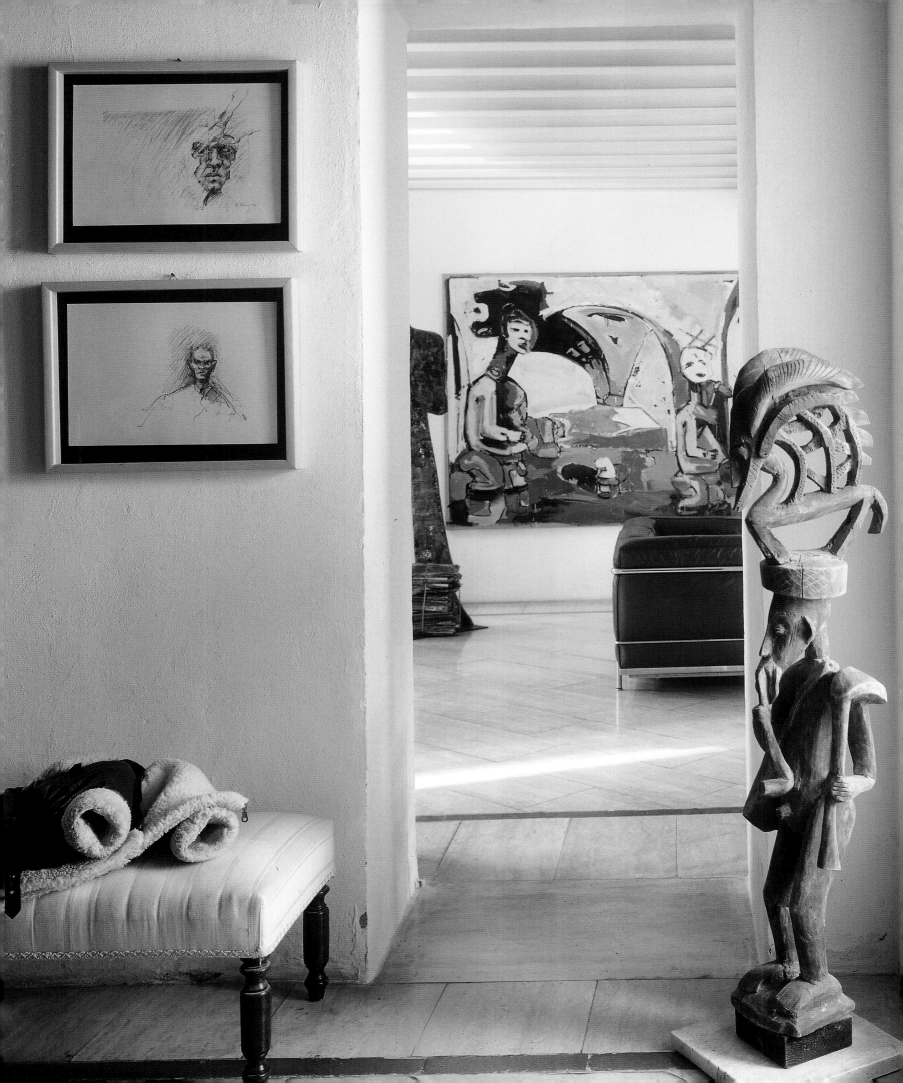

Marcello Guasti

The house where sculptors Marcello Guasti and his companion, Artemisia Viscoli, live is an old stone farmhouse that overlooks the hills and valley of Incontro on the outskirts of Florence. Its various components—stalls, haylofts, and storage facilities—are connected by stone paths covered by pergolas supporting grapevines. Guasti moved here from central Florence in the seventies. This move was a return to his roots—his ancestors were farmers, millers, and bakers. "I have always been captivated by the spirit of the country, so it is only natural for me to fit in here." The house, which originally belonged to a Church, dates from the eighteenth century. During its restoration, the date 1779 was found scratched on an old plaster wall. Given that farmworkers often added rooms to accommodate new family members, the core of the house is probably much older. When Guasti bought the house it had been vacant for fifteen years.

Guasti himself helped with the restoration work, giving the masons a hand with their hard labor. Fortunately, these masons were old-school artisans with a background in farming. According to Guasti they had "not yet been ruined by the *geometri*, who have disfigured half of Italy." Salvaged building materials were used, including old curved and flat roofing tiles and the alberese stone found in the vicinity. In Guasti's words, the idea was to "respect the original house and environment, making only those changes necessary for adapting them to my work. For instance, I made a point of keeping the old fireplace in the kitchen. In the wintertime I build huge fires and invite friends over for steak done *alla Fiorentina*." The decor of the house preserves the homespun atmosphere of an authentic farmhouse. The artist avoids ornamentation that would seem foreign to the previous inhabitants of the house. For example the utensils hanging on the wall in the kitchen do not seem to be part of a collection of period objects, rather they are simply tools in good working order waiting to be put to use again, by Guasti or by someone who cultivated the surrounding vineyards, fields, or groves centuries ago.

Guasti's immediate environment is a source of inspiration for his art. "My work receives a vital spark from the house I have built around me. It is here where my classical training and powerful curiosity about everything modern come together; the old and new live together. It is my distinct impression that everything ebbs and flows, and that ancient and modern forms come together to form a one unified whole. For me, this house represents the continuity of time. I feel like a link in a chain, a witness to an age rife with contradictions. It is an expression of the present that blends with the signs of the past…everything coincides, my contradictions subside. This atmosphere, filled with history, allows me to work serenely."

Opposite: *Portrait of Marcello Guasti in his kitchen chopping herbs to garnish anchovies. A bronze cat by the artist watches the fire. A typical farmhouse decoration, a paper* pizzo, *adorns the mantle of the fireplace.*

Overleaf: *This kitchen and living room preserves the room's original farmhouse character.*

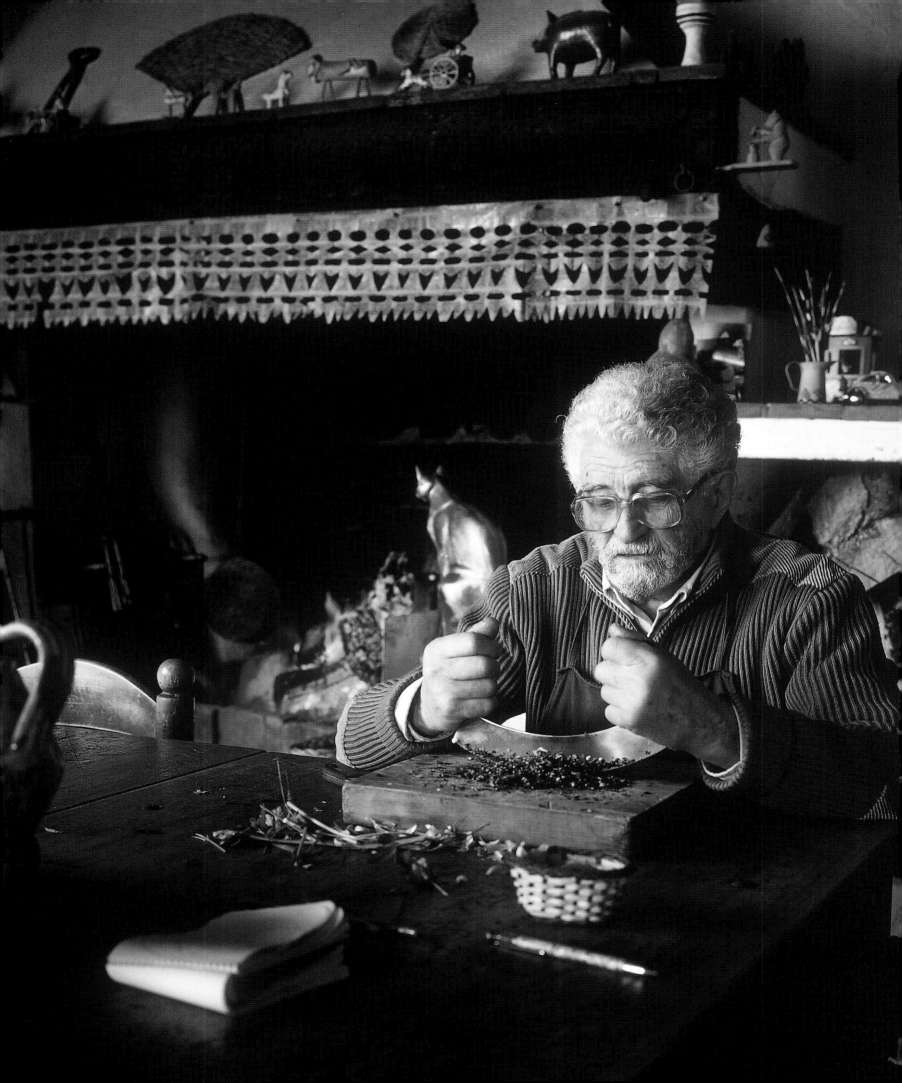

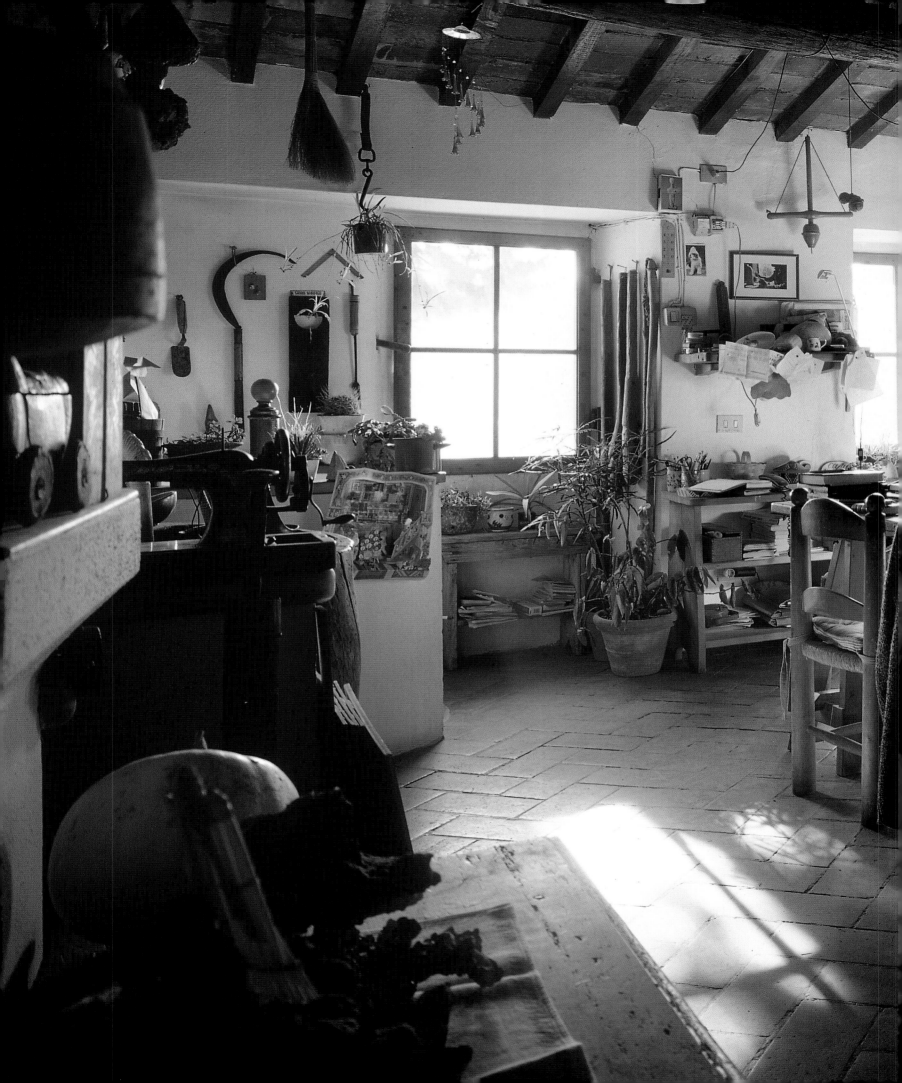

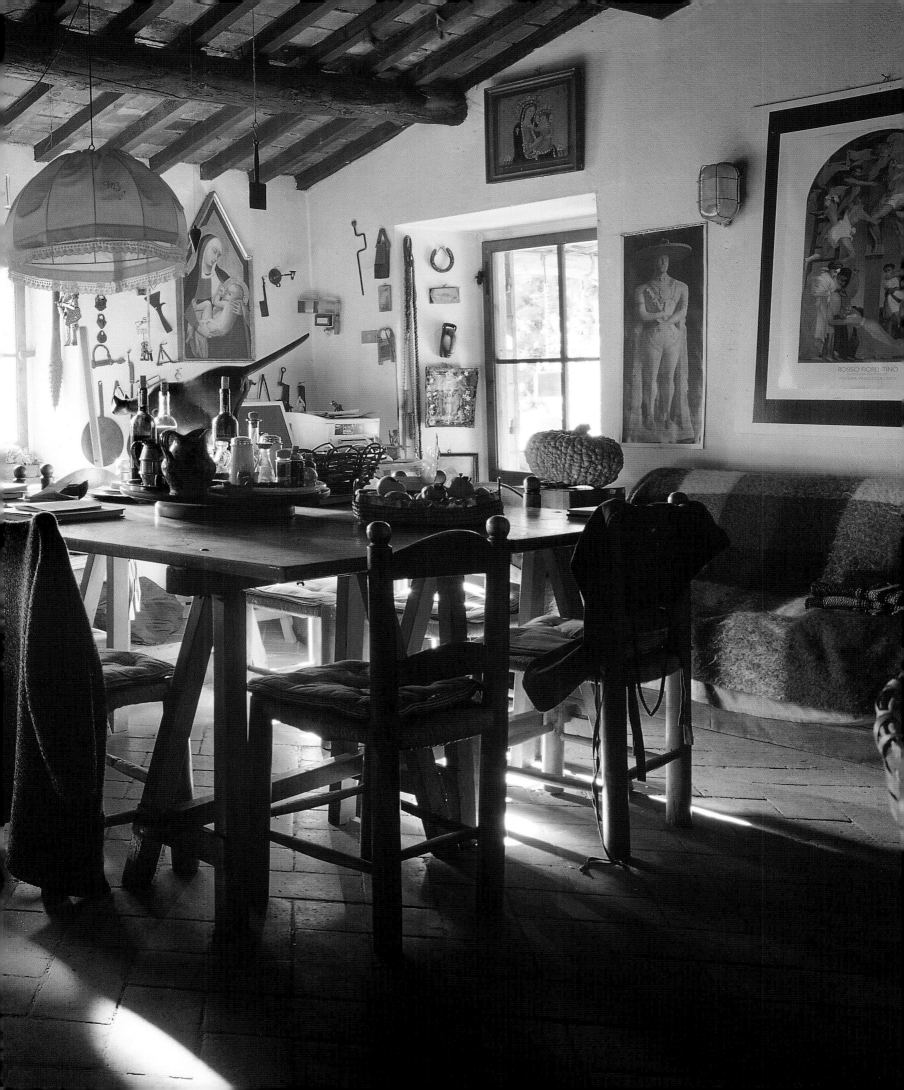

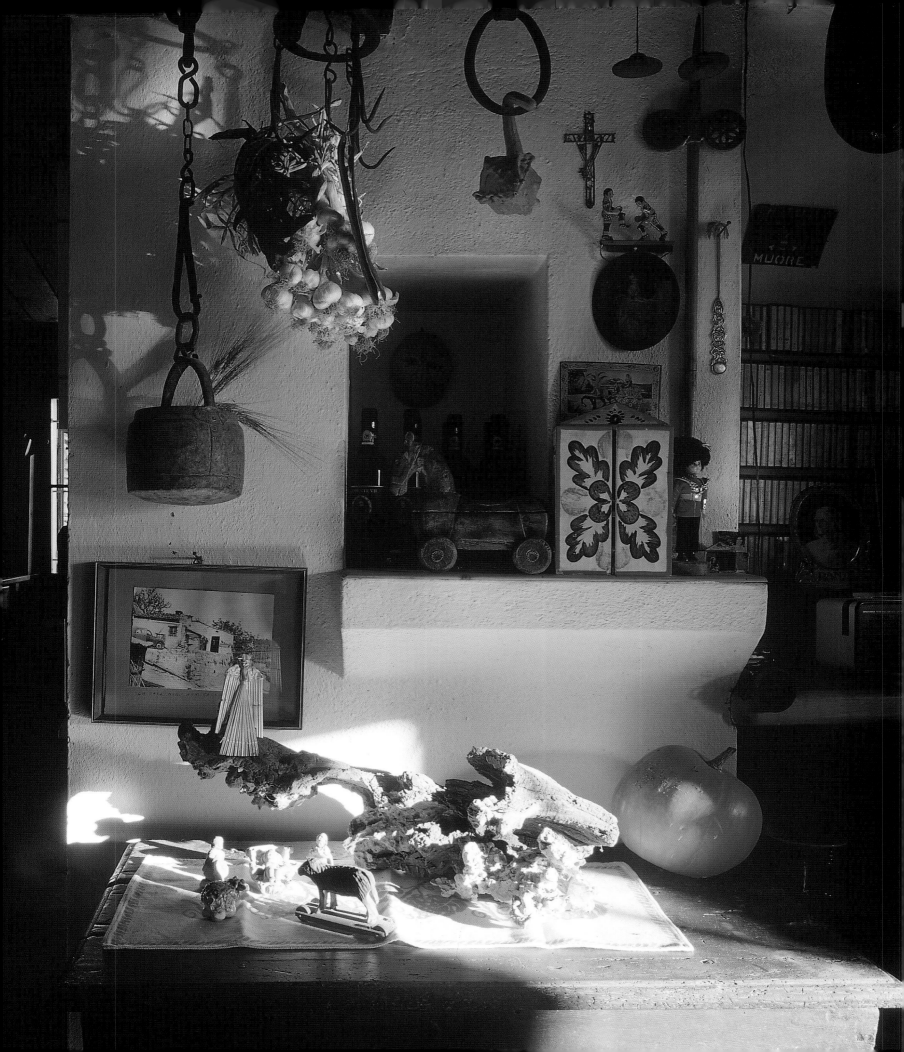

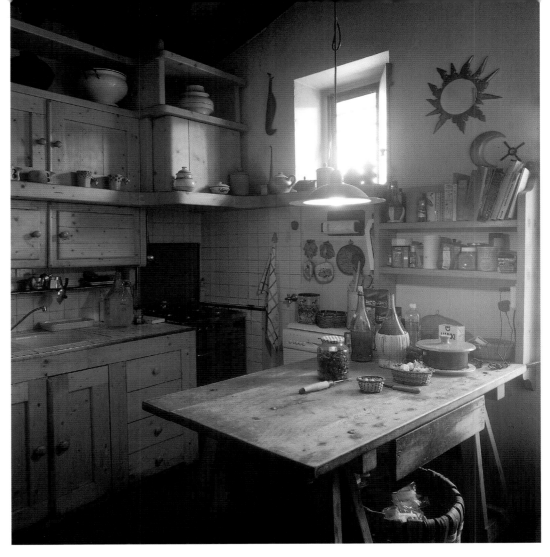

Opposite: *A corner of the room in the previous photograph boasts a small papier-maché Nativity scene.*

Above right: *The simple wood furniture in this corner of the kitchen was built by the artist.*

Below right: *The bedroom has a wall of artwork made by friends and a nineteenth-century wrought-iron bed from Naples. The sideboard with a wooden horse on top was produced in Emilia-Romagna.*

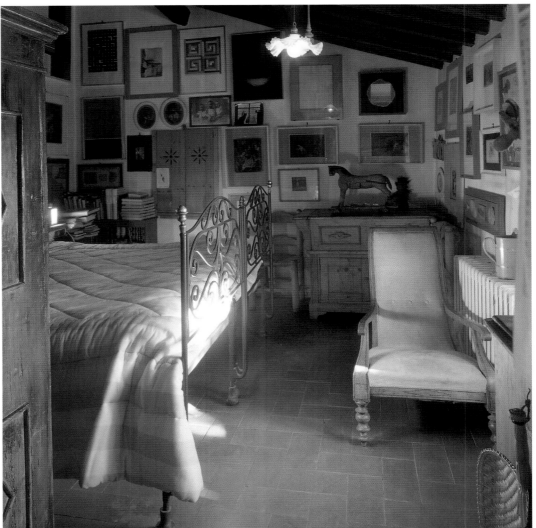

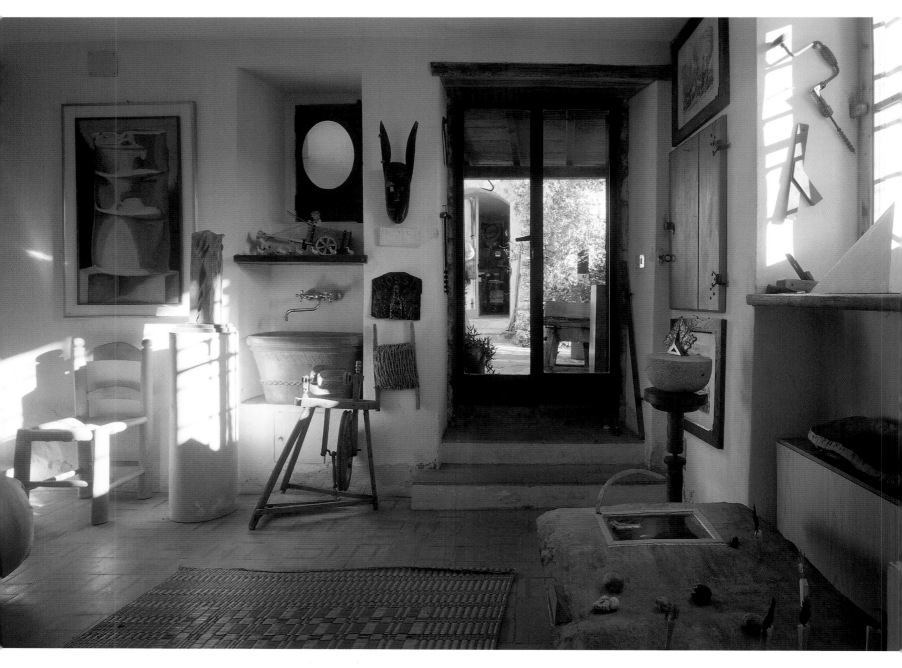

Above: *Guasti has converted the stable under his kitchen into a studio.*

Opposite: *A hayloft has been converted into an exhibition space. In the center of the room is Guasti's Sculptura n. 4. 63/64 (1964–1965) in Swedish pine.*

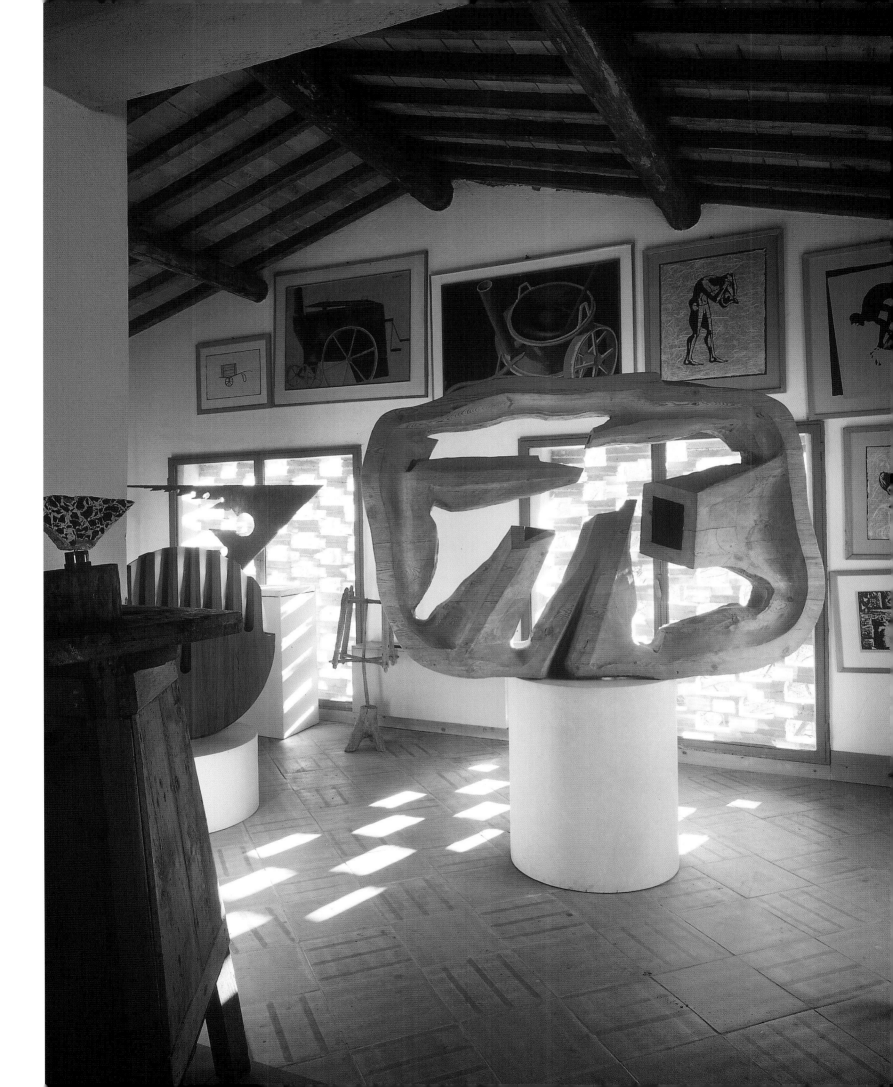

Lietta Cavalli

The house of Lietta Cavalli and her husband, Francesco Sacconi, has been enlarged over the centuries but still preserves traces of many styles and a great many memories. Its core is a medieval watchtower, the top of which was destroyed by a bomb during the liberation of Florence in 1944. Along with four other well-preserved towers, it was part of a medieval defensive system designed to prevent enemy armies from entering the Arno Valley. Traces of a Roman cobblestone road in the woods nearby seem to indicate that these fortifications may have been to an even earlier road system. In later centuries, the towers were enlarged and converted for use as a way station to shelter pilgrims on their way to Rome. One tower was once turned into a small convent. The present entrance, kitchen, studio, and cellars display typically medieval structural features. The walls were built using alberese stone and the rooms arranged in regular rows with low cross vaults. The stone blocks were set in place with a skill that has long been forgotten. Other parts of the house show signs of later renovations dating from the Renaissance: *pietra serena* cornices, corbels on the walls, and the size of the vaults. For centuries this structure was a manor house. In the nineteenth century the entire complex was enlarged and converted for use as a farm and became a center of peasant life. The ground floor became a place to keep animals and to store agricultural products. Traces this period still remain, including traces of a manger in what is now the kitchen.

The new owners' desire for a more tranquil life, close to nature, led them to purchase the property in 1986. "We used to live in downtown Florence," Cavalli explains, "and we were enthusiastic about our nineteenth-century detached house, but the traffic and noise made life difficult. We started to look around for another place, and we liked this one right away. It has good southern exposure, and with the terrace and meadow in front, and verdant valley below, the surrounding space is well-defined. To the west, the marvelous opening in the direction of the Arno Valley creates a direct link to the city. In the evening we can see the whole city gradually light up. We are only half an hour from Florence, more than 1300 feet above sea level, in the open country at the edge of a wood. In the morning we are greeted by deer and squirrel…it is a different world."

The seemingly endless remodeling work has required much time and effort. Progress continues day after day, year after year, sometimes involving small undertakings and other times major projects. One major project, the new combination studio and greenhouse, is now being completed amid the garden greenery. Here Cavalli does her weaving and exhibits her wall hangings made from rare, precious threads and yarn. The result is warm, contrasting tones patterned in unusual textures. "When it comes to making decisions about transforming the house," she says, "as is true of everything I do, I feel that my inspiration is the fruit of a culture and memory naturally arising from the life I have lived. I consider it a privilege to have been able to live in Florence, and to have absorbed, willingly or unwillingly, the Florentine spirit, which I have then re-elaborated from a modern outlook."

Opposite: *Portrait of Lietta Cavalli in her studio.*

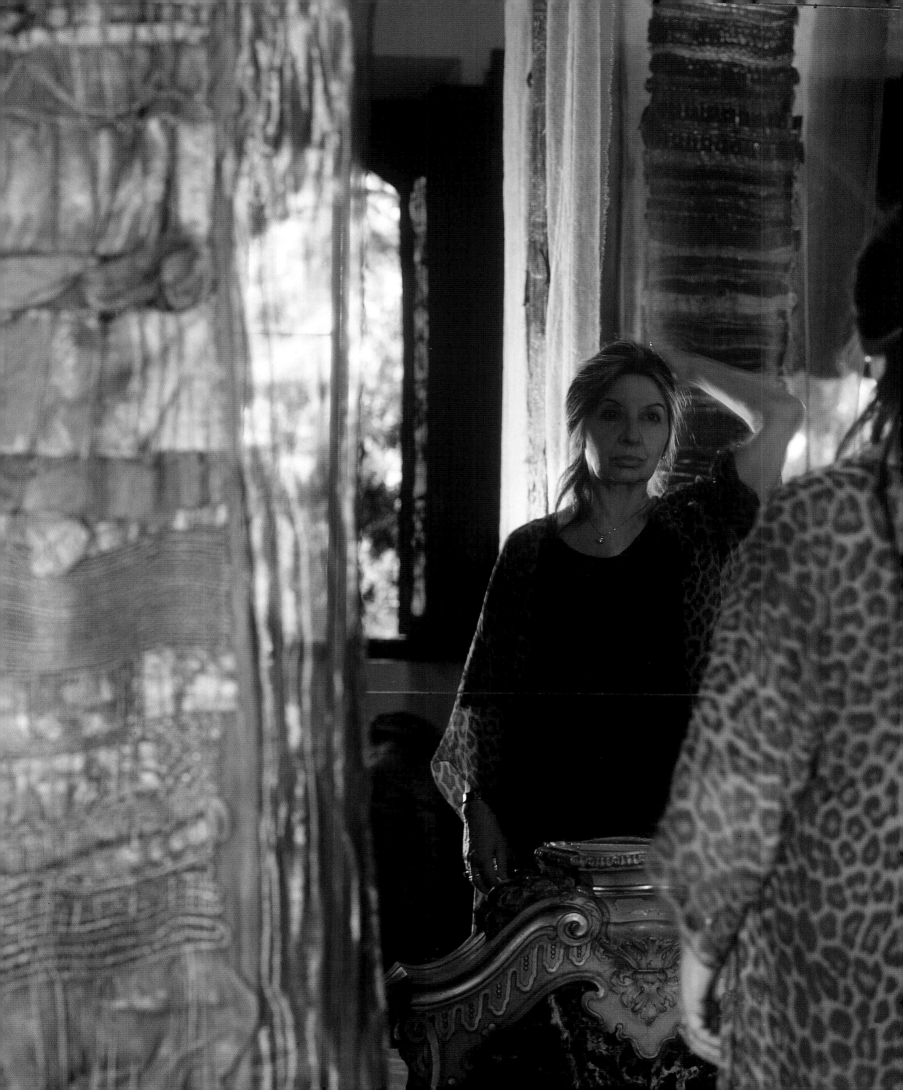

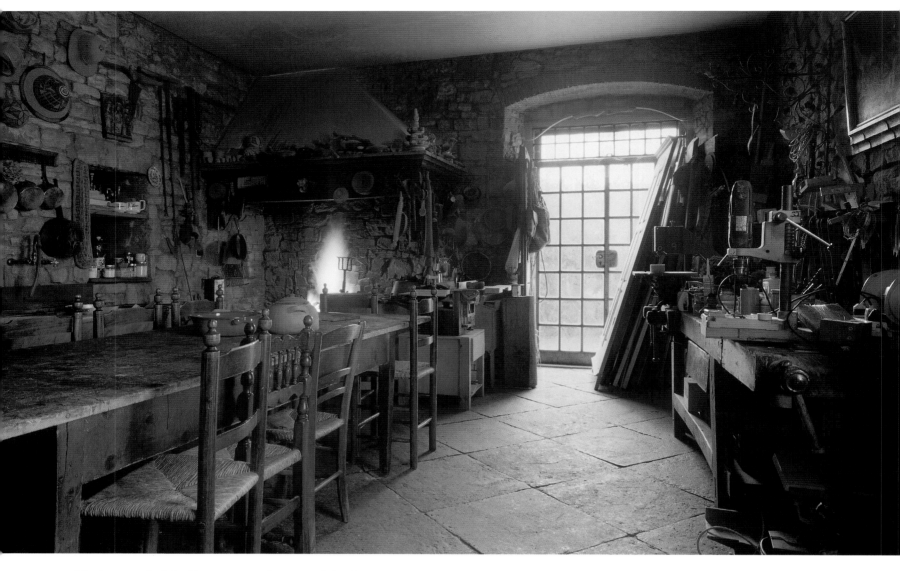

The house, which had been previously restored, has been completely renovated, as Cavalli explains, "in order to really make it our own." Original features have been preserved, like the floors and the plaster on the vaults, which was once tinted green, sky blue, and pink—the only colors available when the work was originally done—obtained using an ancient technique that involved adding powdered cinnabar, turquoise, and copper sulfate to lime.

Cavalli reveals how she haphazardly acquired the antique furnishings, guided by whim, without giving much thought to where things would go. Given her penchant for collecting, there has been a considerable increase in the number of objects. "We attach great importance to our home; in this stage of our lives it is really the fulcrum of our existence. As soon as we came to live here, we started thinking about giving up our regular jobs, and then we actually did: Francesco closed his graphics studio so that he could dedicate his time to the restoration of the house, while I gave up the fashion world to devote all my energy to my hangings. Even travel does not interest us as much as before because there are certain times of year that we hate to be away from the garden. Once when we were heading out the gate about to leave for someplace, we turned around, just so we would not miss the peonies in bloom. In July we never go anywhere because the full moon shines through our bedroom window and for several nights moonlight floods the bed. Maybe we have changed too. Living in the country, we have become more observant, we enjoy scenes that we never paid any attention to before, for example during the past few days we have enjoyed watching birds search for food in the snow."

Above, opposite, and overleaf, left: *The combination carpenter's shop and kitchen is the oldest part of the house; it is part of the tower that dates from the thirteenth century. Cavalli's husband gives free reign to his two vocations, sculptor and chef. The tools of these two trades are arranged on the workbench and hang on the walls. The floor is laid with handmade terracotta and alberese stone.*

Overleaf, right: *Cross vaults with alberese stone ribs. Shelves on the wall hold vintage wines and homemade preserves and jams. In the background, an Art Nouveau glass cabinet with polychrome panes and brass fittings stands under an arch.*

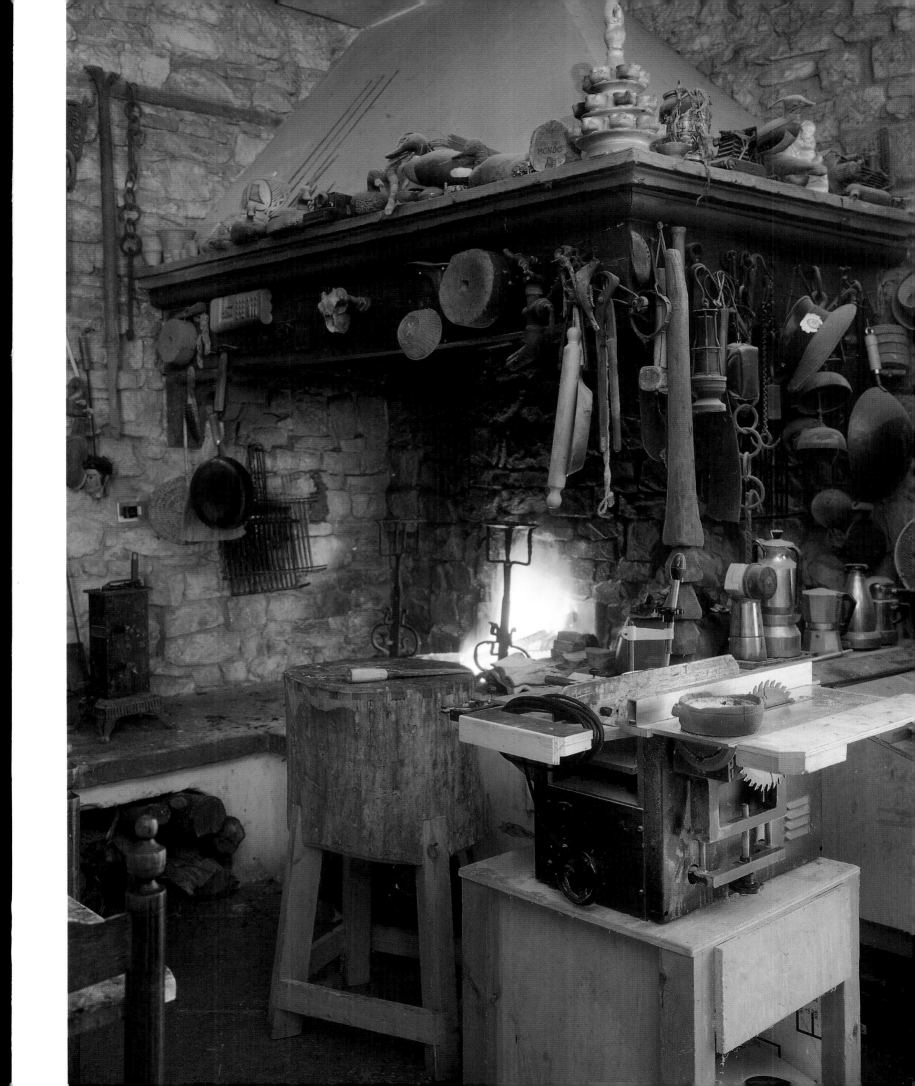

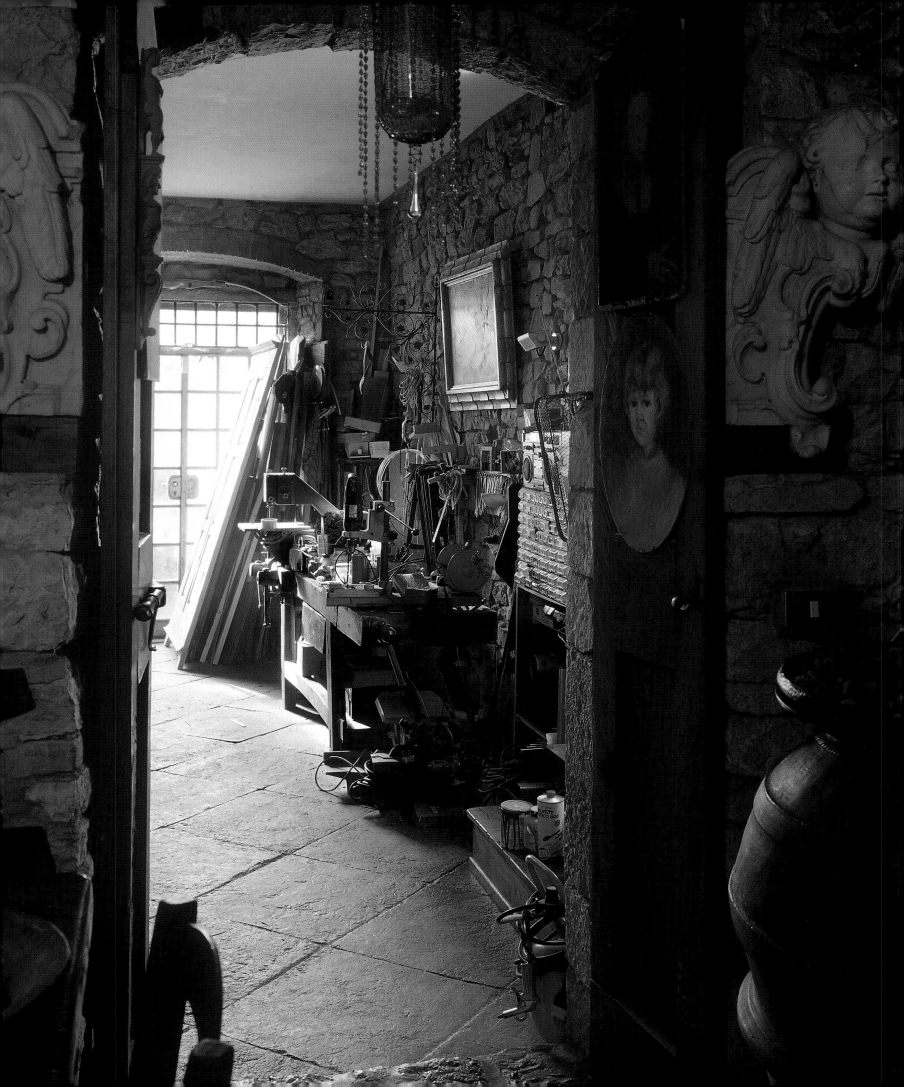

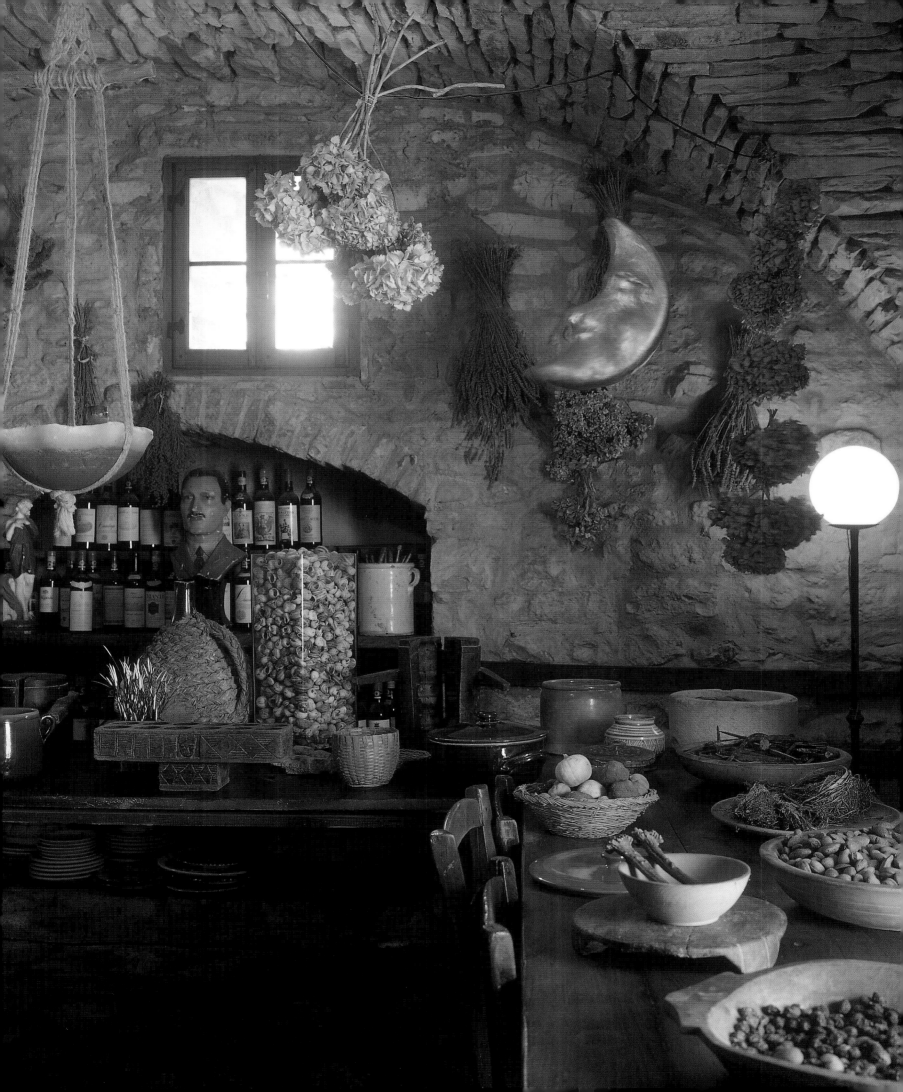

Previous pages and above: *The ground floor dining room was created by closing a sixteenth-century loggia with a ribbed vault. A collection of antique and modern blown glass is arranged on a glass table with bamboo legs.*

Opposite: *A winter garden has been created in a corner of the dining room to store plants otherwise kept in a large loggia in front of the house. Hidden among the plants are four terracotta amphorae from Puglia and a wrought-iron table with a marble top. The custom-made floor representing a sun was executed using terracotta tiles of different colors and alberese stone.*

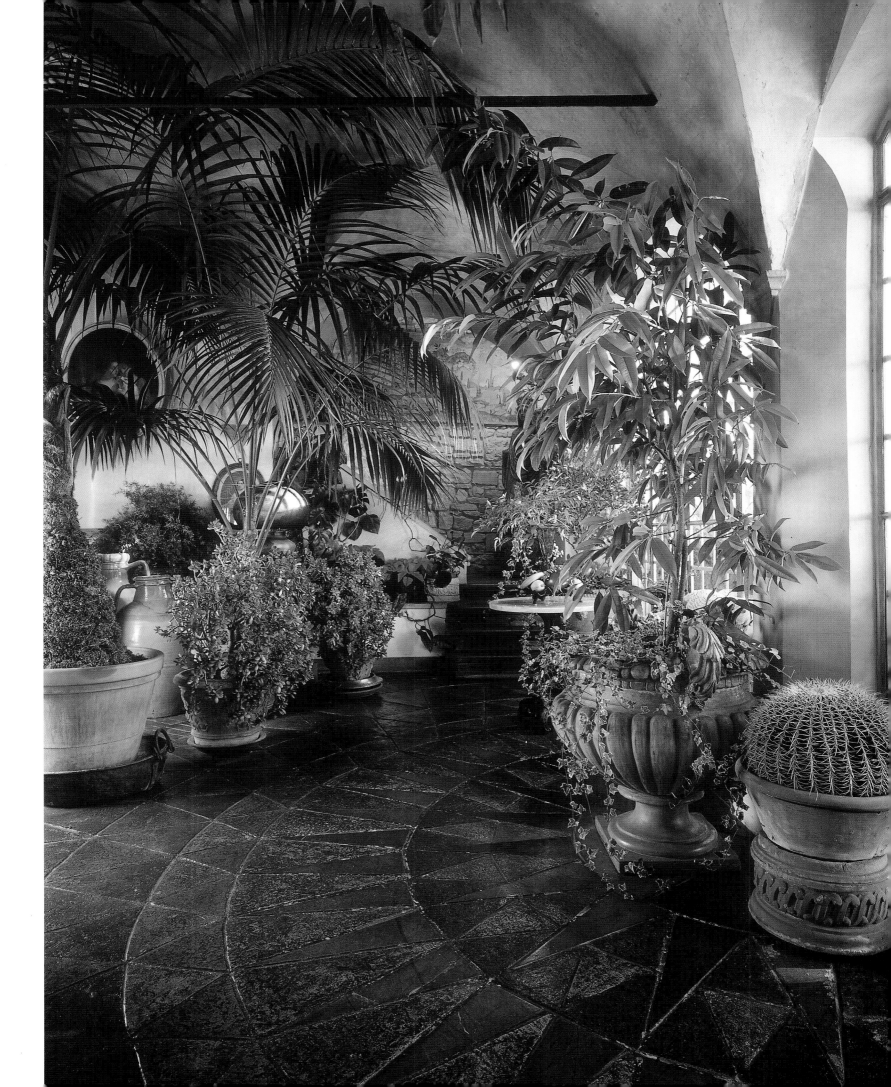

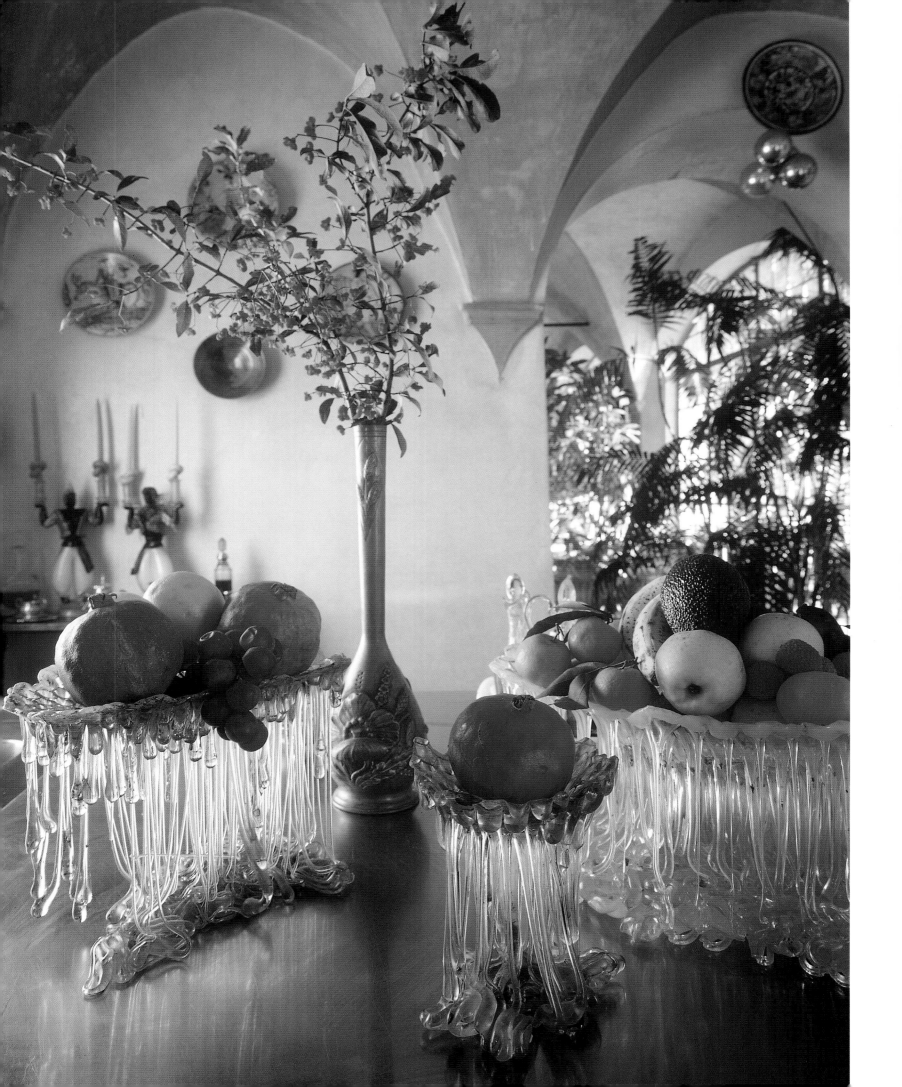

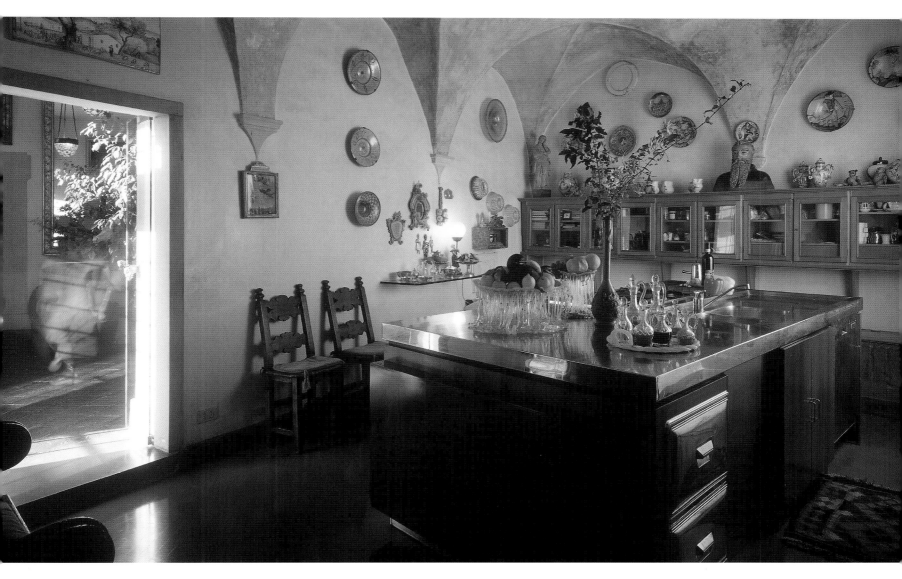

Opposite: *Glass fruit bowls fused by Daniela Forti grace a freestanding central kitchen counter.*

Above: *The kitchen, in an old stable, features a ribbed vault with original sky-blue colored plaster. The large steel and walnut cabinet in the center houses home appliances. A Majolica collection on the walls includes pieces from different periods and parts of Italy: Montelupo, Faenza, Deruta, Naples, and Caltagirone.*

Overleaf, left: *Through the doorway is a view of the room where Cavalli weaves her works on a loom.*

Overleaf, right: *Two yarn sculptures hang in the studio; on the left is* Samurai di acqua, *on the right* Samurai rosso di diaspro.

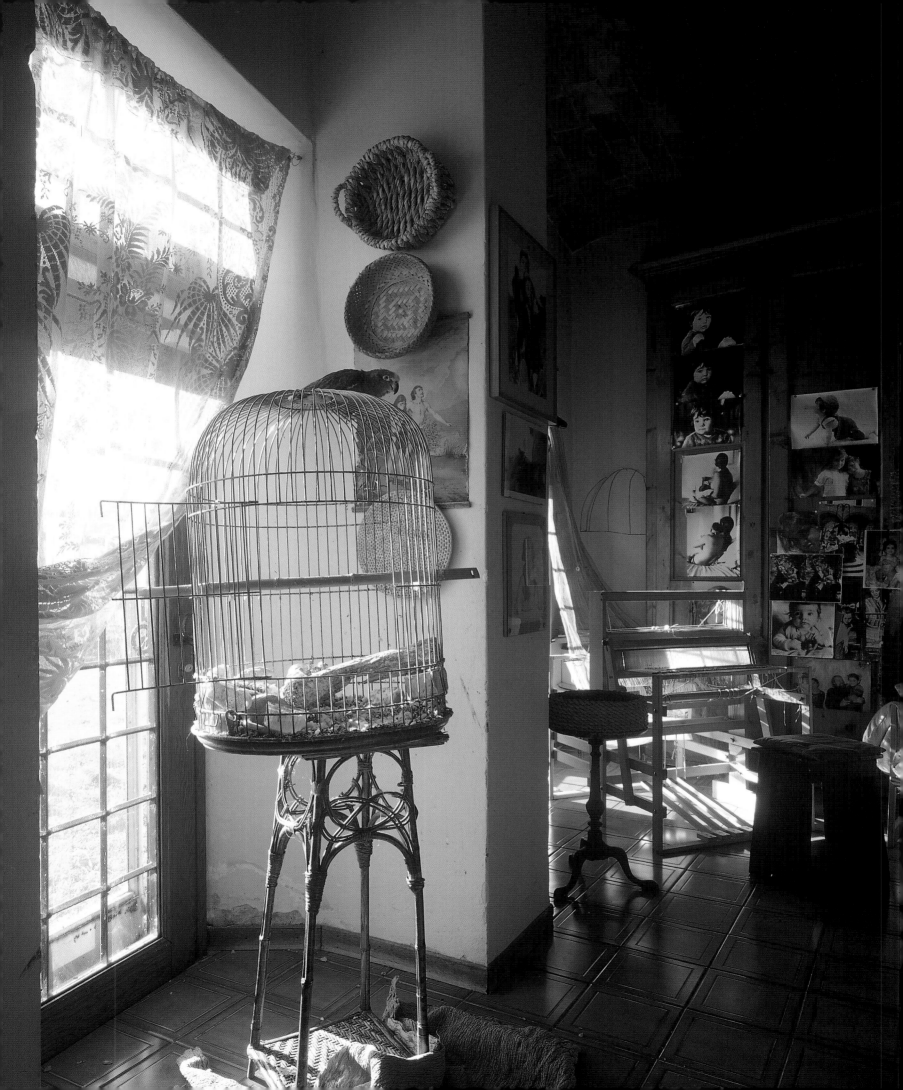

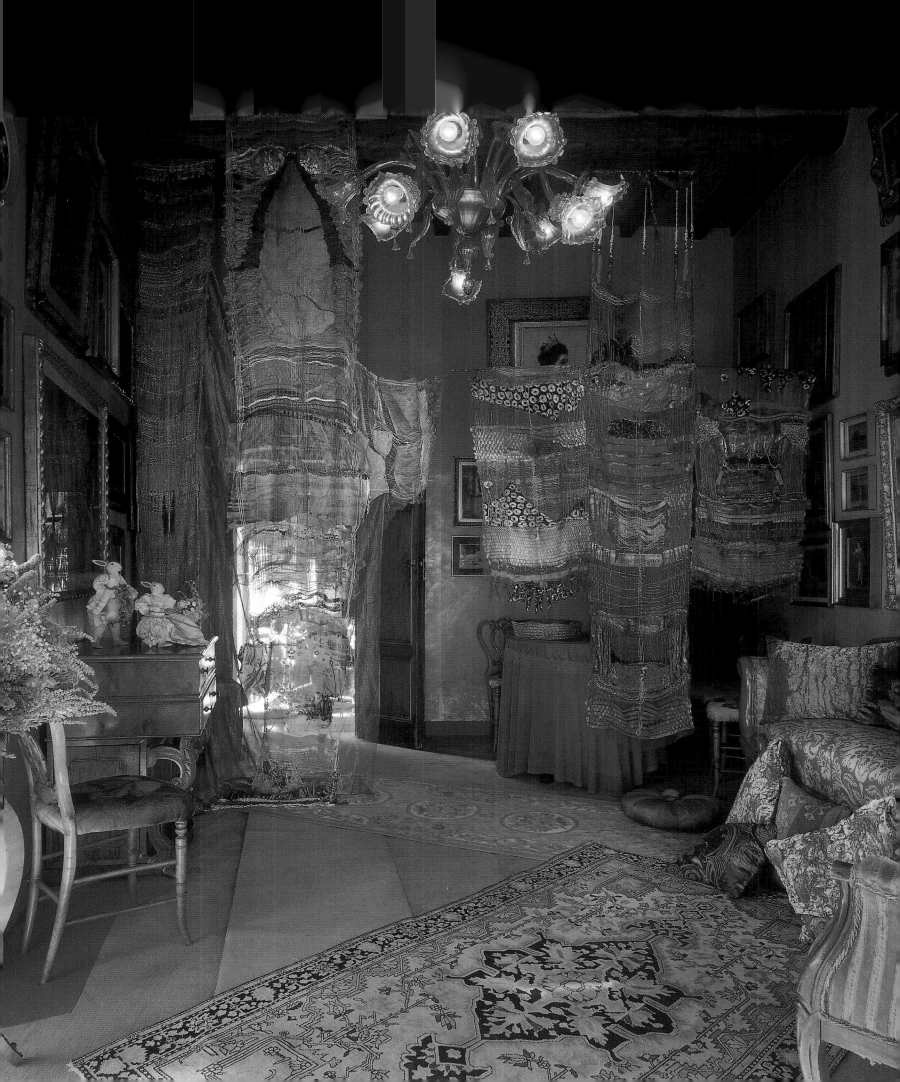

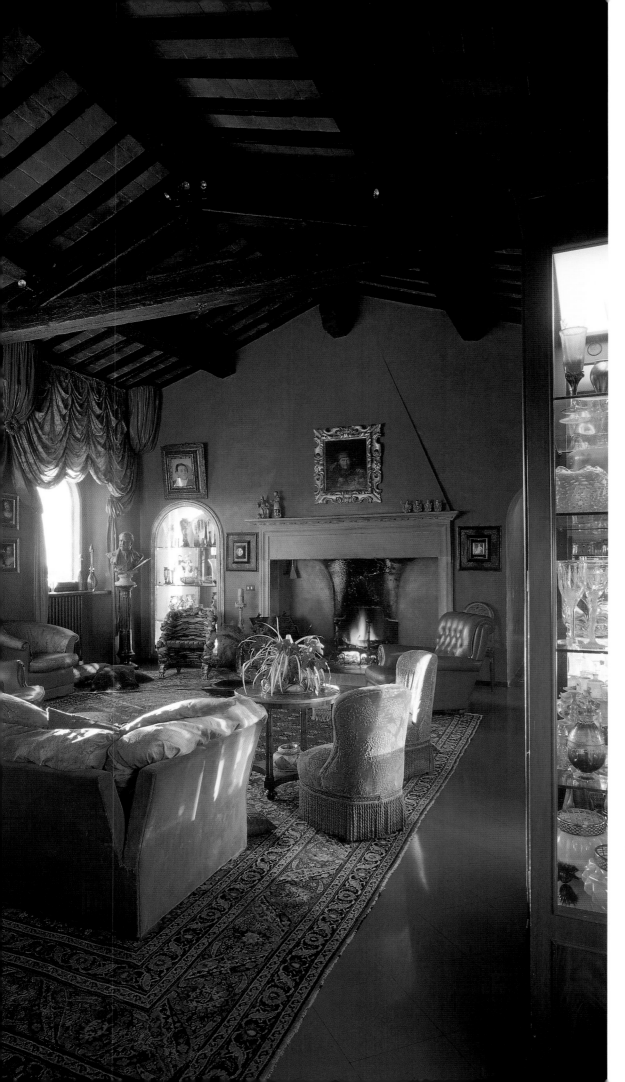

Left and opposite: *The upholstery on the sofas, cushions, and the drapery in the "Red Fireplace Room" were all designed by Cavalli. The Renaissance fireplace (left) and large alcove washbasin (opposite), both of pietra serena, are original elements of the room. The display cabinets contain a collection of ceramics and glass dating from the sixteenth to the twentieth century. The oil paintings above the washbasin are from the late eighteenth century.*

Overleaf, left: *Near the windows of the "Red Fireplace Room" are wooden angels from the eighteenth century and a showcase that houses assorted curiosities and toys.*

Overleaf, right: *Glass works from Germany and Austria sit on a windowsill.*

Second overleaf: *A life-size nineteenth-century Neapolitan mannequin inhabits the bedroom. The opalescent Murano chandelier dates from the mid-nineteenth century and the large gilded mirror is in the Empire style. Hangings in Calais lace and fabric were designed by Cavalli.*

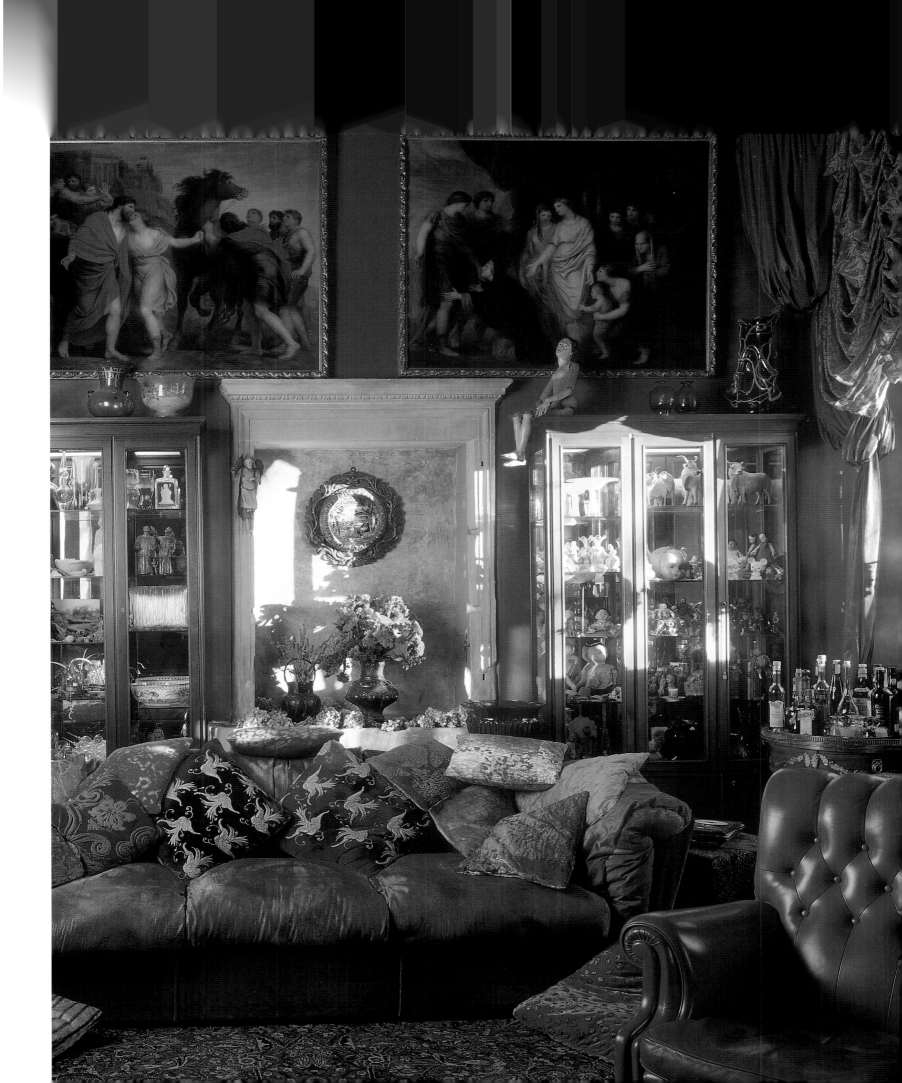

Paola Crema and Roberto Fallani

The narrow Florentine street that leads to the main gate of Paola Crema and Roberto Fallani's property is lined with tall austere buildings. Behind the gate, and through a covered passage, one is surprised to find a verdant area that extends from the back of the artists' palazzo to the medieval walls of the city. The garden, with its eighteenth-century layout, forms a romantic park planted with ilex, laurel, and centuries-old oak. It is complete with statues, water fountains, and old cast-iron and stone furniture. It was the exceptional quality of this large garden that convinced the two artists to purchase the property. "Before we lived on Via della Scala with a view overlooking the Corsini gardens. We finally tired of always having to watch the seasons change from above and at a distance." An outdoor stairway covered with wisteria leads up to a lovely terrace and the palazzo's sixteenth-century rooms, once used as a school for German nuns.

Crema and Fallani have worked together on the restoration, making a conscious effort not to substantially alter the rooms. As a result, the interior has not undergone significant structural change despite adaptation to today's requirements. What has changed radically is the spirit of the house: both sculptors work in a similar style, reinterpreting the art of the nineteenth and early twentieth century in a contemporary key. They have always been passionate collectors of works dating from the this period and have enjoyed long careers as antique dealers. The rare beauty of the pieces they managed to uncover won their gallery worldwide fame. Their house is essentially an enormous jewel box for their collection, which has been intelligently placed among their own works to create a very special overall effect imbued with charm.

A large studio has been carved out buildings that annex the palazzo. This ground floor space houses Fallani's luminous sculptures and Crema's fragile silver and crystal works. Every piece has its own well-defined identity yet the viewer is not able perceive a definite boundary between artworks and furnishings. One feels that the rooms and walls are one with the artists who have transformed them. Crema and Fallani have created a home that truly represents them.

Above: *A large garden lies behind the artists' home. The entrance is a covered passage found along a narrow Florentine street.*

Opposite: *A wisteria-covered terrace behind the palazzo blooms in May.*

Overleaf, left: *A small fountain surrounded by moss covered stones has a bronze statue in the center.*

Overleaf, right: *The terrace, which doubles as an outdoor dining area, is furnished with cast-iron table and chairs.*

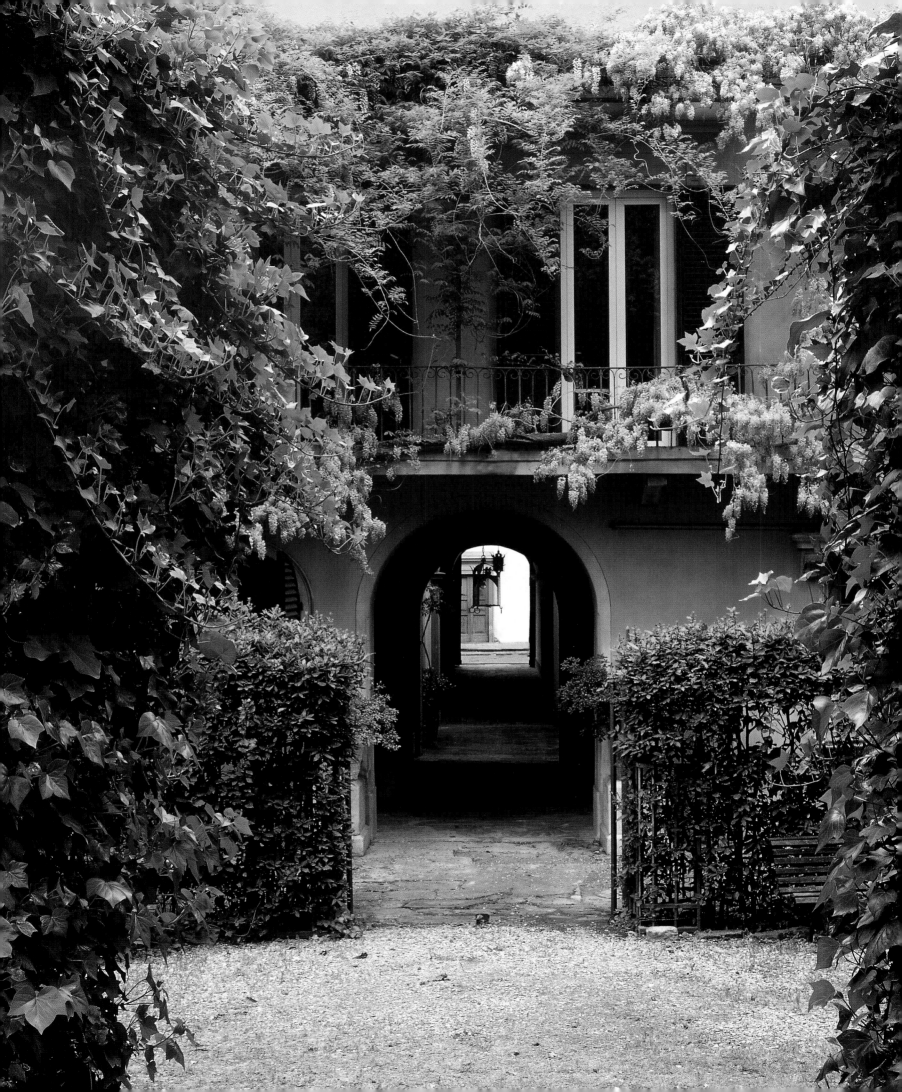

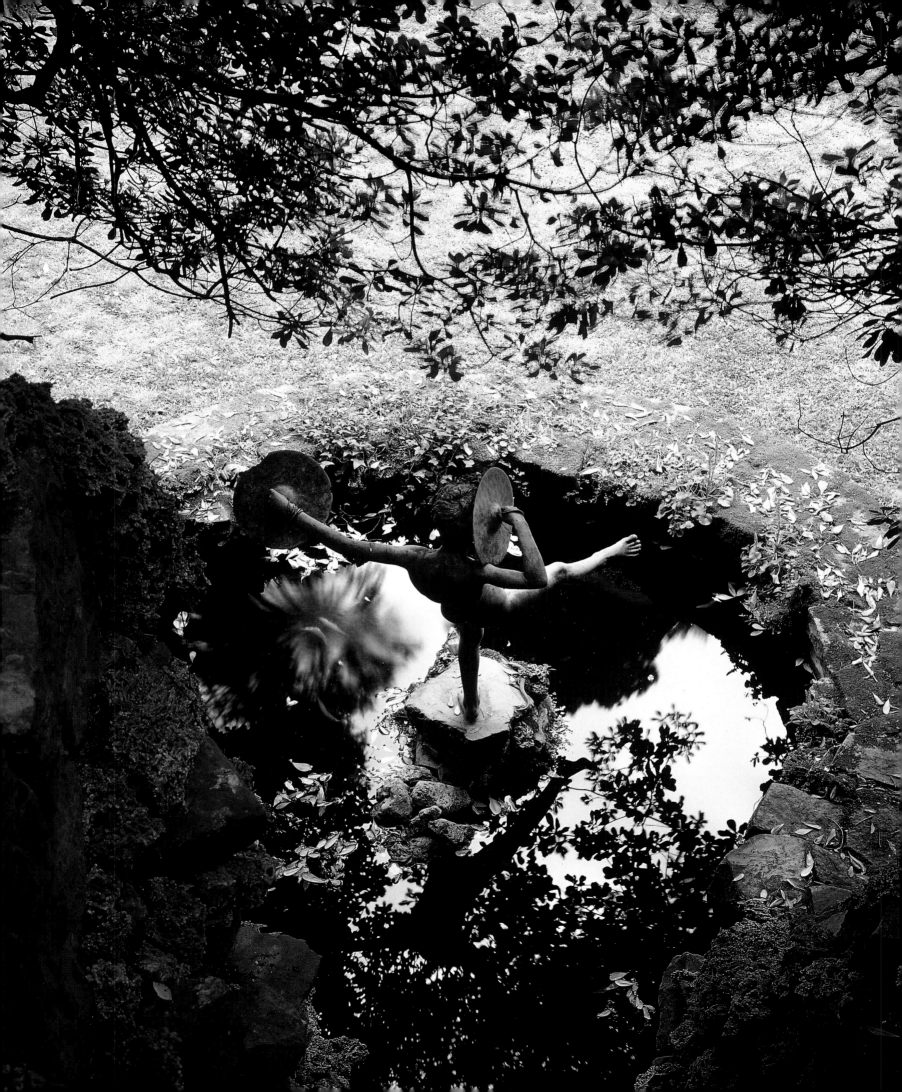

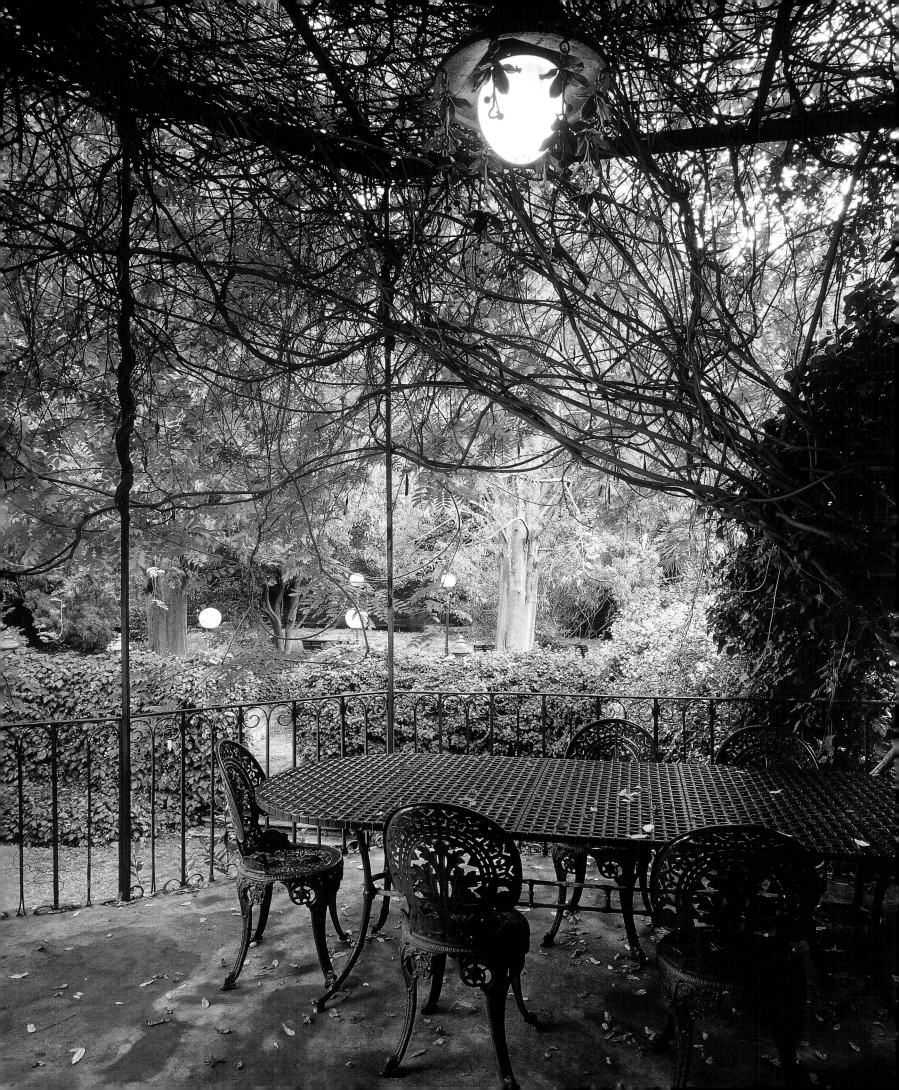

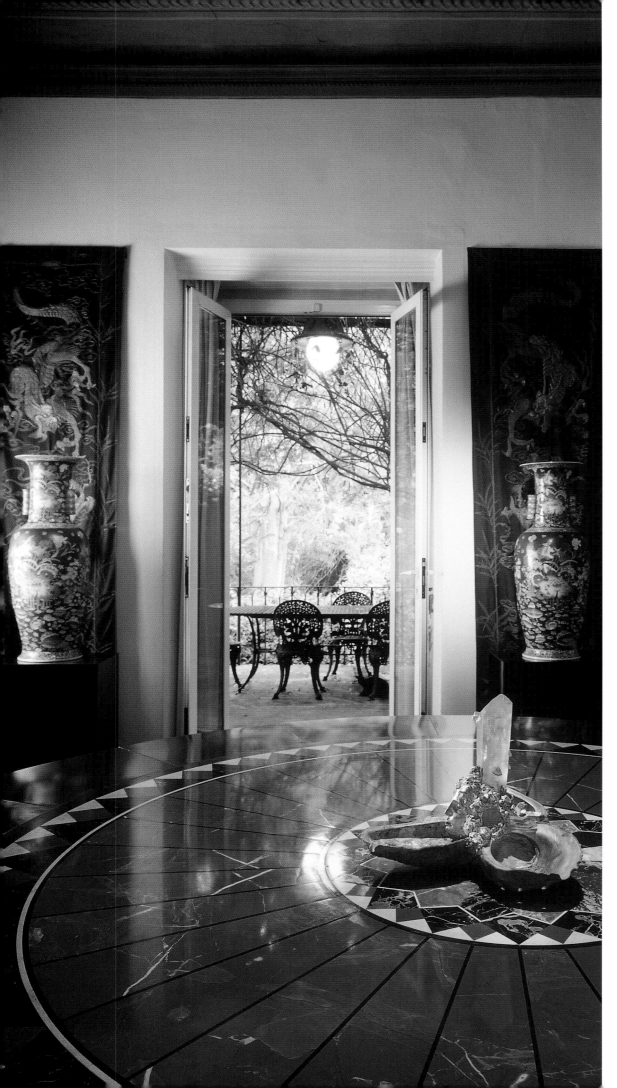

Left: *The circular dining room table was designed by Fallani; the colorful central portion utilizes various types of marble while the monochromatic outer ring is made of iron. At the center of the table is a work by Crema titled* Gioiello da tavolo, *made of rock crystal, silver, and seashells. Next to the doorway to the terrace is a pair of eighteenth-century Chinese vases in front of gold embroidered silk panels.*

Opposite: *The statue on the left,* Vittoria alata *(1902), is by Arrigo Minerbi. A screen by Galileo Chini on the back wall is mounted on an iron frame designed by Fallani. The floor, in graniglia tile, is an original feature of the house.*

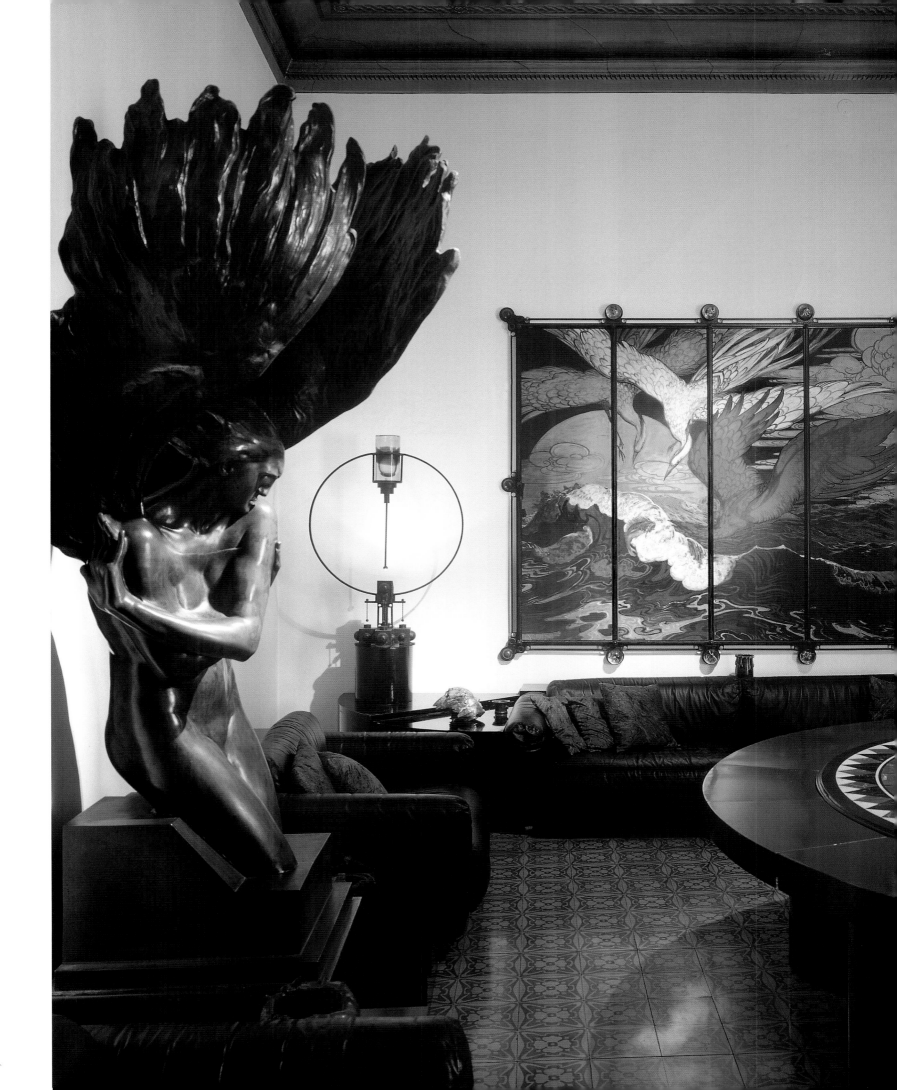

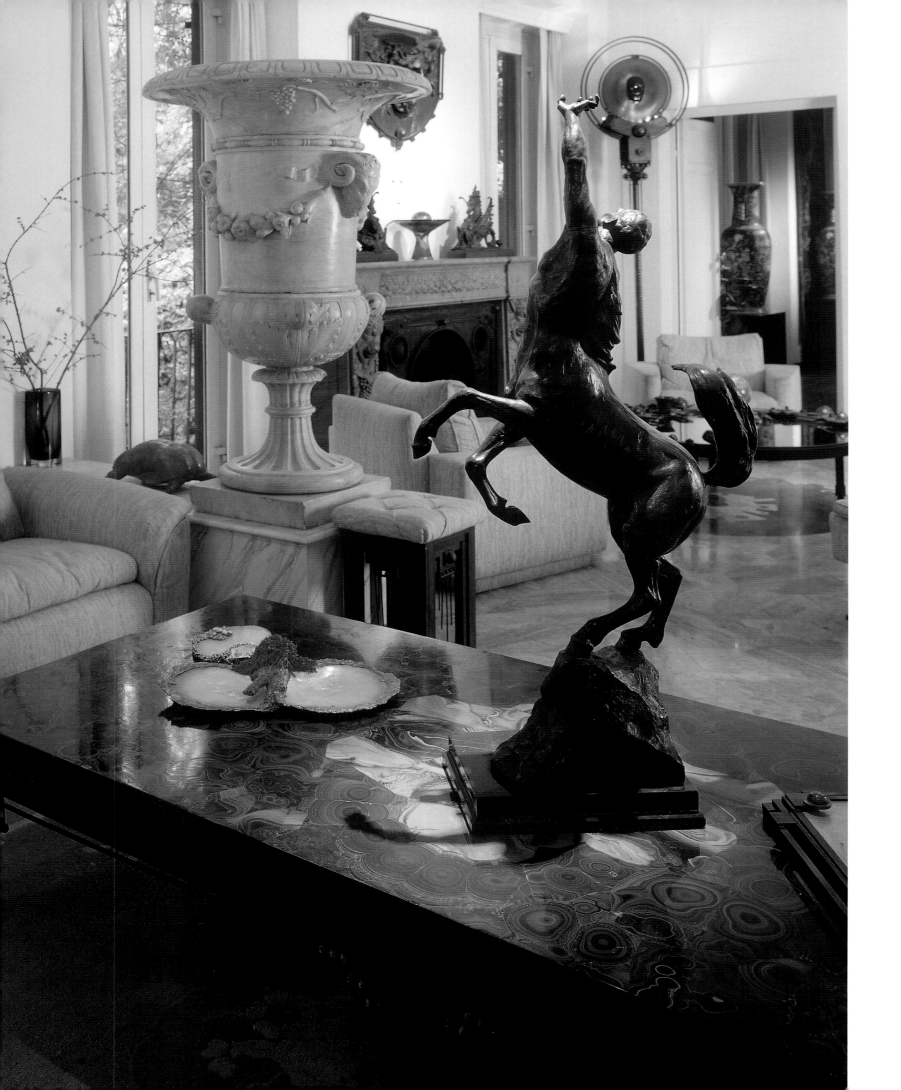

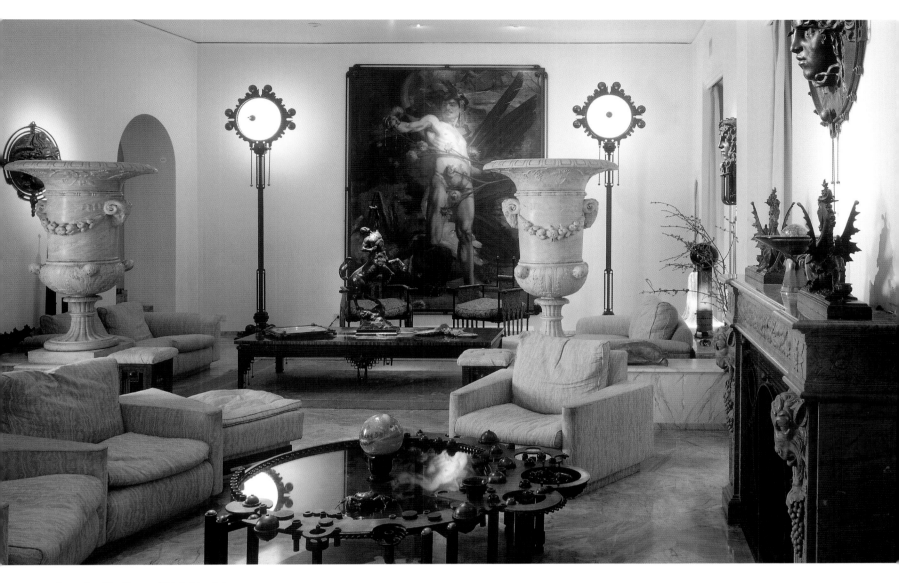

Opposite: *The "Room of Myths" is a living room with Centaurs, Medusae, Minotaurs, a Satyr, and a Siren. The Centaur is an early twentieth-century bronze. The large nineteenth-century vases are in statuary marble.*

Above: *The large late nineteenth-century canvas, titled* Giant, *is by Victor van Dich. The table in the foreground was designed by Fallani.*

Overleaf, left: *Two bronze Buddhas, copies of sixteenth-century Japanese originals, sit opposite a gilded bronze Buddha from Thailand. This corridor also houses a glass and wrought-iron sculptures by Bellotto.*

Overleaf, right: *The rooms on the ground floor are used as studios by the two artists.*

Second overleaf, left: *Portrait of Fallani and Crema.*

Second overleaf, right: *Iron and glass sculptures by Fallani. The figure in the background is made of heat-deformed polyethylene.*

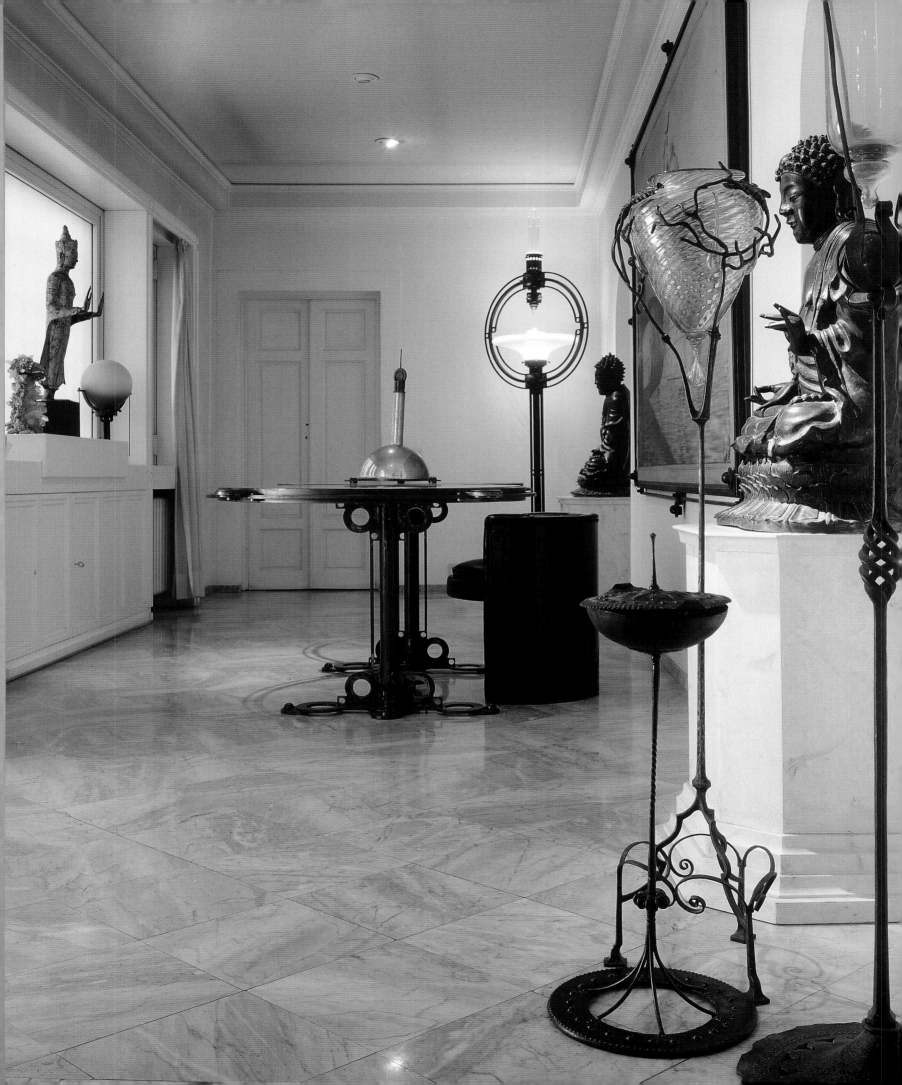

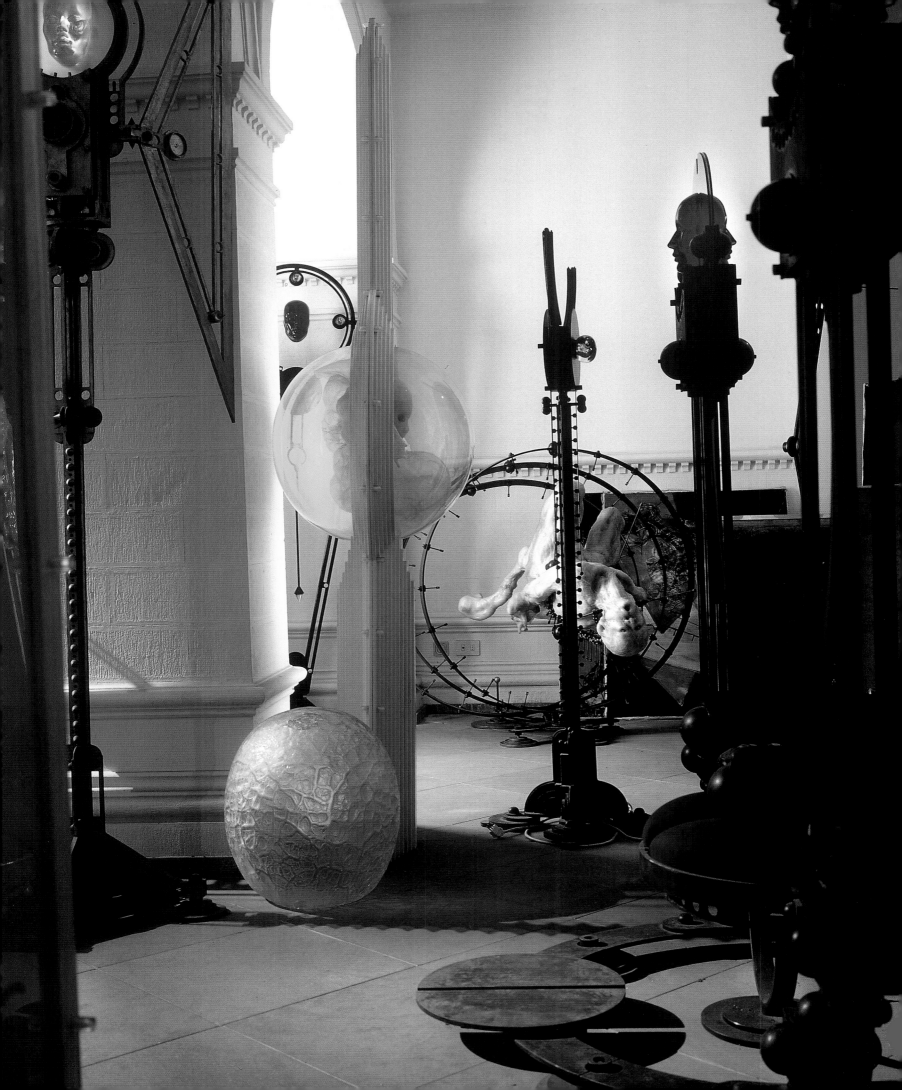

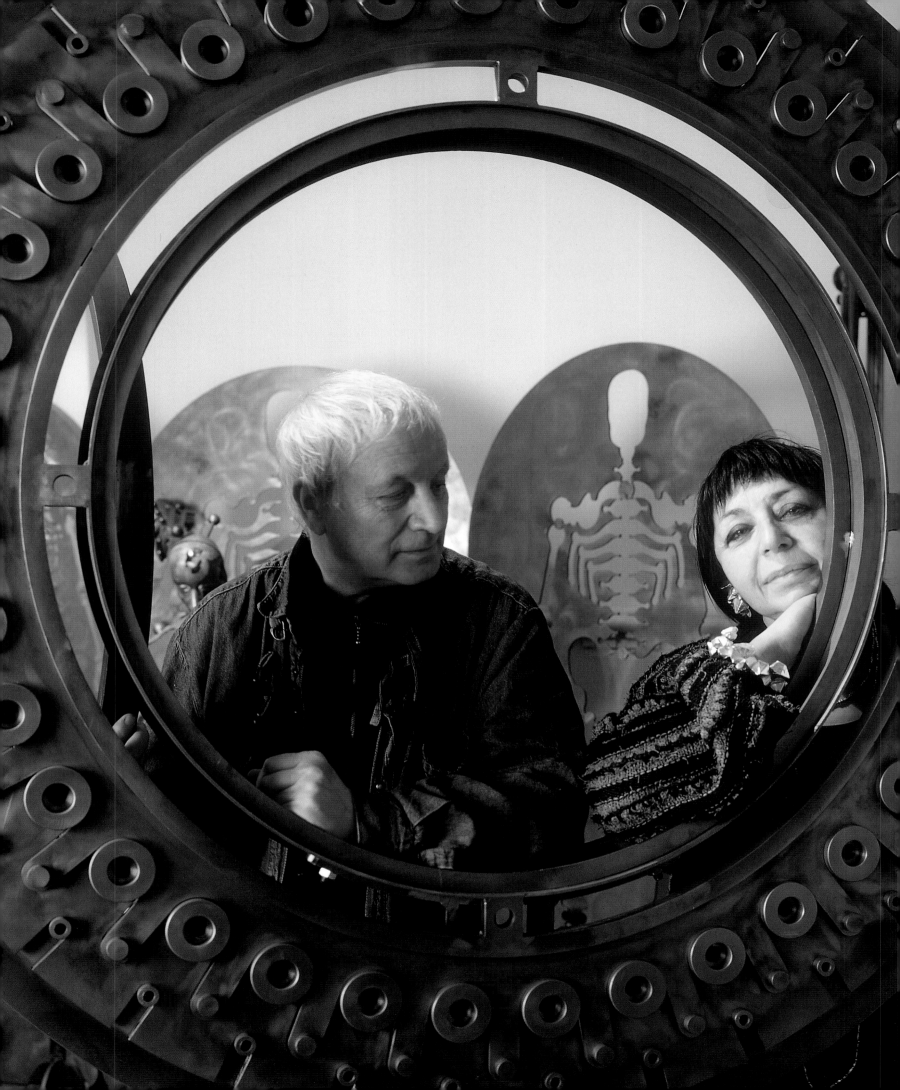

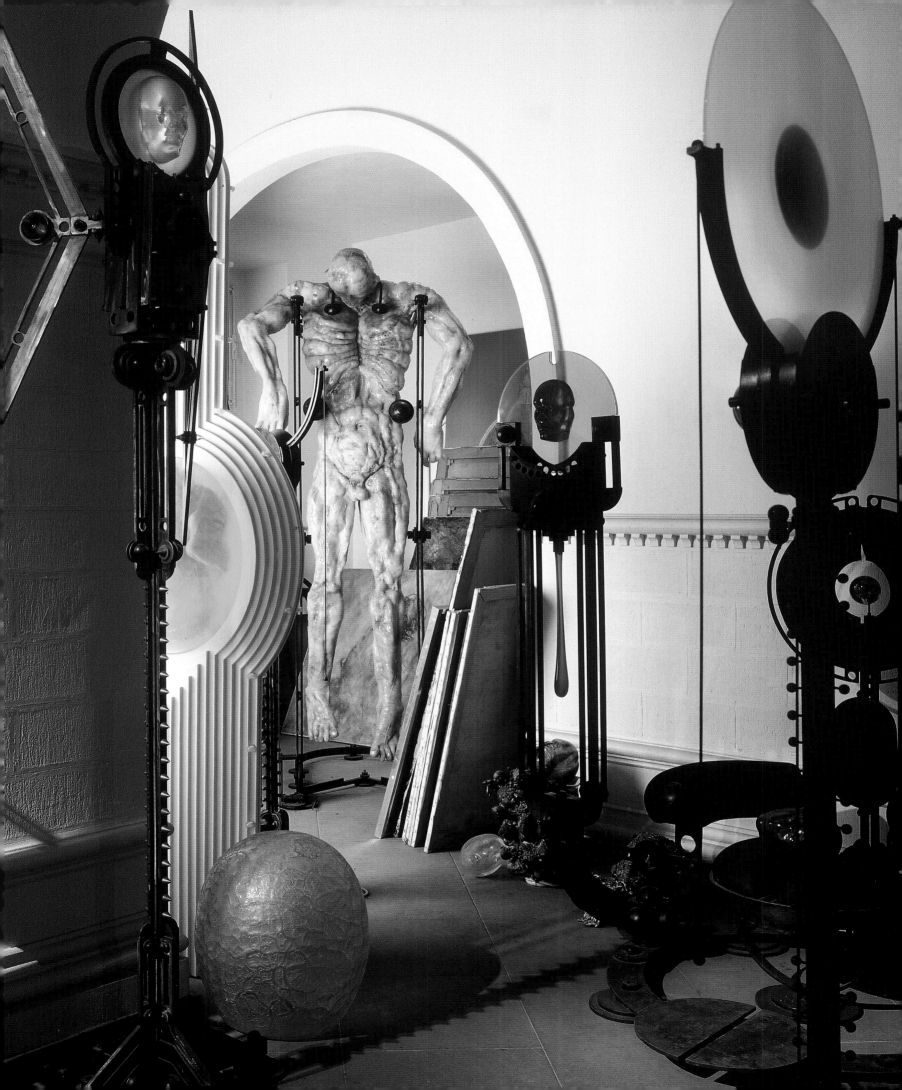

Gianni Ruffi

Left: *Portrait of Gianni Ruffi.*

Opposite: *The studio, located just outside of Pistoia, is a converted workshop with an outdoor courtyard. The work on the floor is Ruffi's* Luna di miele *(2001). Nineteenth-century industrial buildings, no longer in use, lie beyond the high whitewashed walls of the studio.*

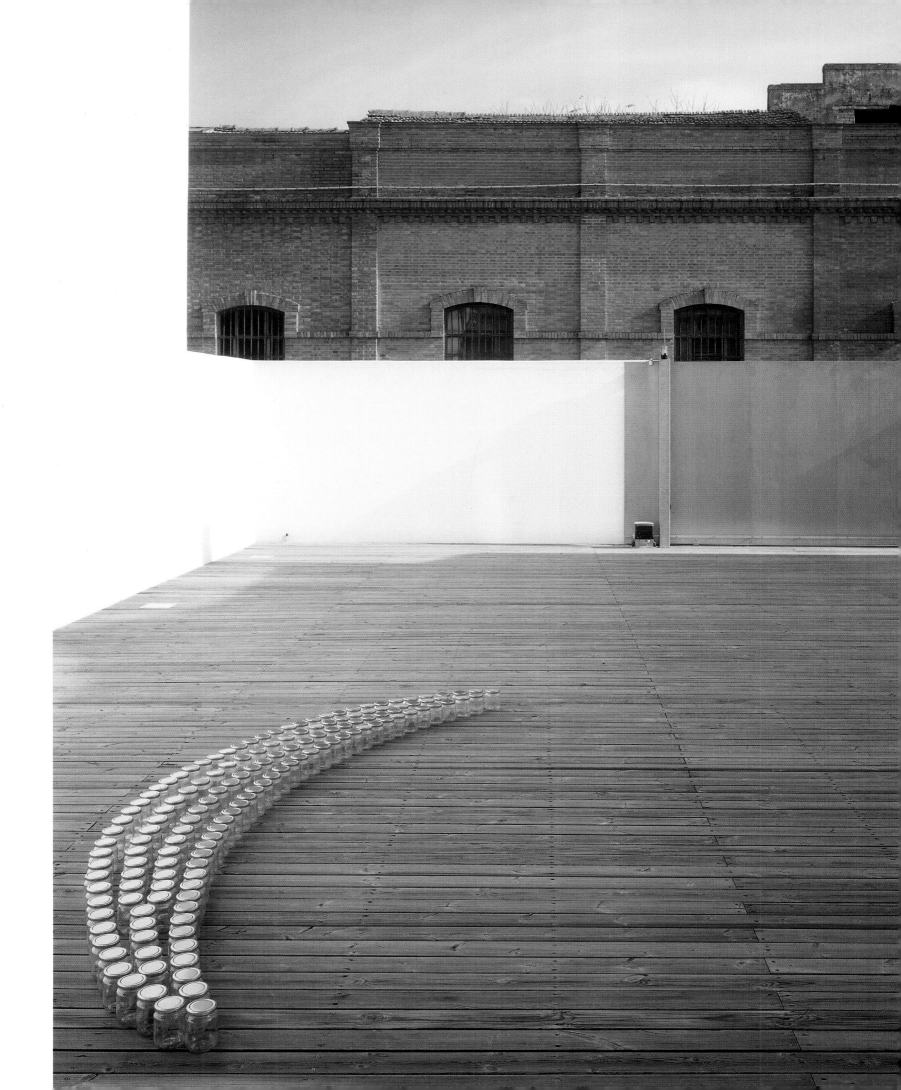

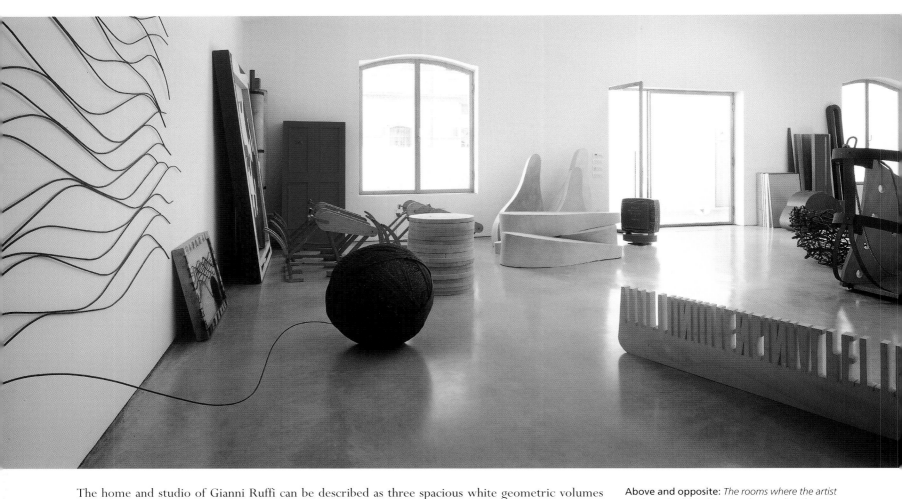

The home and studio of Gianni Ruffi can be described as three spacious white geometric volumes with plain windows overlooking a large square courtyard that is paved with planks like those on the deck of a ship. Ruffi's taste in housing and workspace is no different from that of many other artists who chose to convert obsolete and abandoned industrial buildings for their own use. Such buildings, which have a special charm all their own, are frequently found on the outskirts of provincial Italian cities. Ruffi's studio, once brick factory then used to store glass, is located on the outskirts of Pistoia. The artist's son Lapo, an architect, did the restoration very carefully. "The first time we set foot in the place," Ruffi recalls, "we found everything under the sun, including a boat; you might say I brought the sea to it." Ruffi made no attempt to influence his son's decisions and had "the privilege of entering into the picture when the work was over."

The large front rooms lead to small back rooms with low ceilings suggesting boxes covered with sheets of steel. The small rooms include the kitchen, bedroom, and bathroom, all with a view facing a yard overgrown with bamboo. Light enters through large windows and numerous skylights, striking the whitewashed walls to create an atmosphere that is perfectly suited to Ruffi's ironic and fancifully poetic works. Ruffi enjoys spending his days drawing, writing, and working in solitude in this studio. He enjoys telling visitors that he has always lived in Tuscany, and that he arrived here straight from the Moon the day he was born. "As they say around here, 'I used to be on the moon, that is why I am a lunatic.' As far as I am concerned, the house, the studio, and life are 'caso cosa casa caos' [chance thing house chaos]."

Above and opposite: *The rooms where the artist works and exhibits his artwork open directly onto the courtyard. Large windows and skylights allow natural light to flood into the studio. The refined minimalist restoration was carried out by the artist's son, Lapo.*

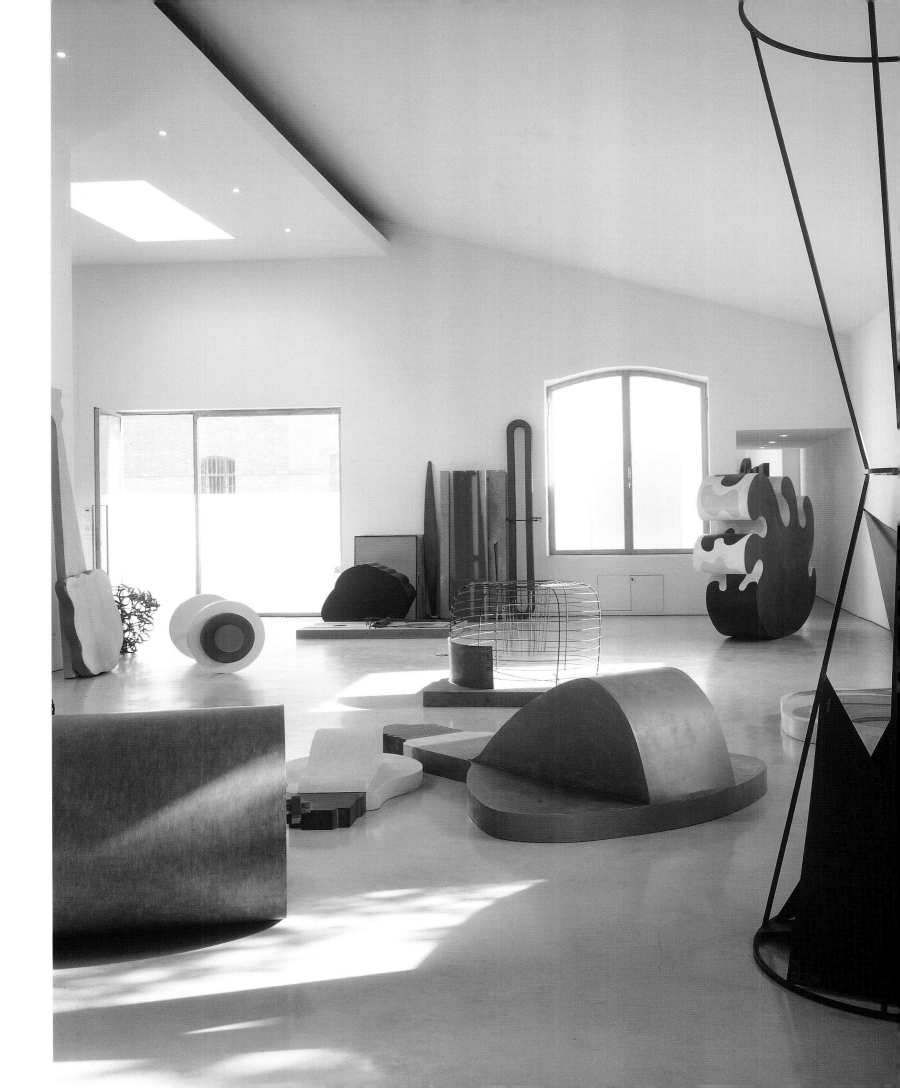

Robert Pettena

The home and studio of Robert Pettena is located on a narrow back street in one of the less elegant areas of Florence's historic center. His home is made up of spaces that were once used as storerooms and workshops connected to shops and homes located in the front of the building or on the upper floors. When Pettena purchased this property in 1999 it was cluttered with lumber and colored wax that testified to its past use as both a carpenter's and chandler's shop. Canvases hung on nails driven into the walls and sketches drawn on the walls of the loft remained from the time the space was used for storage of stage sets belonging to the Teatro Comunale, Florence's municipal theater. When the rooms were finally emptied, it became clear that at one time they had also been used as stables with a central courtyard that had been covered long ago.

Inspired by the American Minimalism of Richard Long the artist insisted on a careful restoration that avoided major changes. For instance, the rooms and loft were essentially left as they were. An old door from the trattoria *La Casalinga* was saved, including the name on the outside and a portrait of Garibaldi on the inside. Even traces of the 1966 flood were spared, including mud deposits on the wall that reminded Pettena of Alberto Burri's work. For the decor Pettena favored neutral tones that do not contrast with his artwork. Archizoom chairs, and the furnishings in general, are in harmony with the artist's "youthful memories."

The studio is divided into two parts, one filled with light and the other kept dark. Pettena explains the effect of this division: "As a result, I am always shifting back and forth. In one area I do my planning and in the other I try out my work, sort of like in a wind tunnel. I am not an atelier artist, so I do not need work space all my own. As a matter of fact, most of my work is with video, which I do elsewhere, with others."

The choice of this space for his combination home and studio was also influenced by its location in working-class San Frediano, a multiethnic neighborhood in Florence. In the evening those seeking a place to sleep for the night begin to appear in front of the "Albergo Popolare," the city's homeless shelter across the street. Pettena enjoys observing the interaction of people of various nationalities from his window. His interest in anthropological and social investigation is also evident in his work. In particular, he is fascinated by the forms of expression of young people living in underprivileged outlying metropolitan areas in Europe. The behavior patterns of the younger generations, including how they relate to architectural space, is the theme of *Flat Land Game*, Pettena's most recent show at the Museo delle Papesse in Siena.

Above: *The home and studio of Robert Pettena was once a craftsman's workshop in the center of Florence. In the entrance is an inflatable work made of red fabric, titled* Vestito da Cardinale, *by Pettena.*

Opposite: *Portrait of Pettena in the corridor of his studio.*

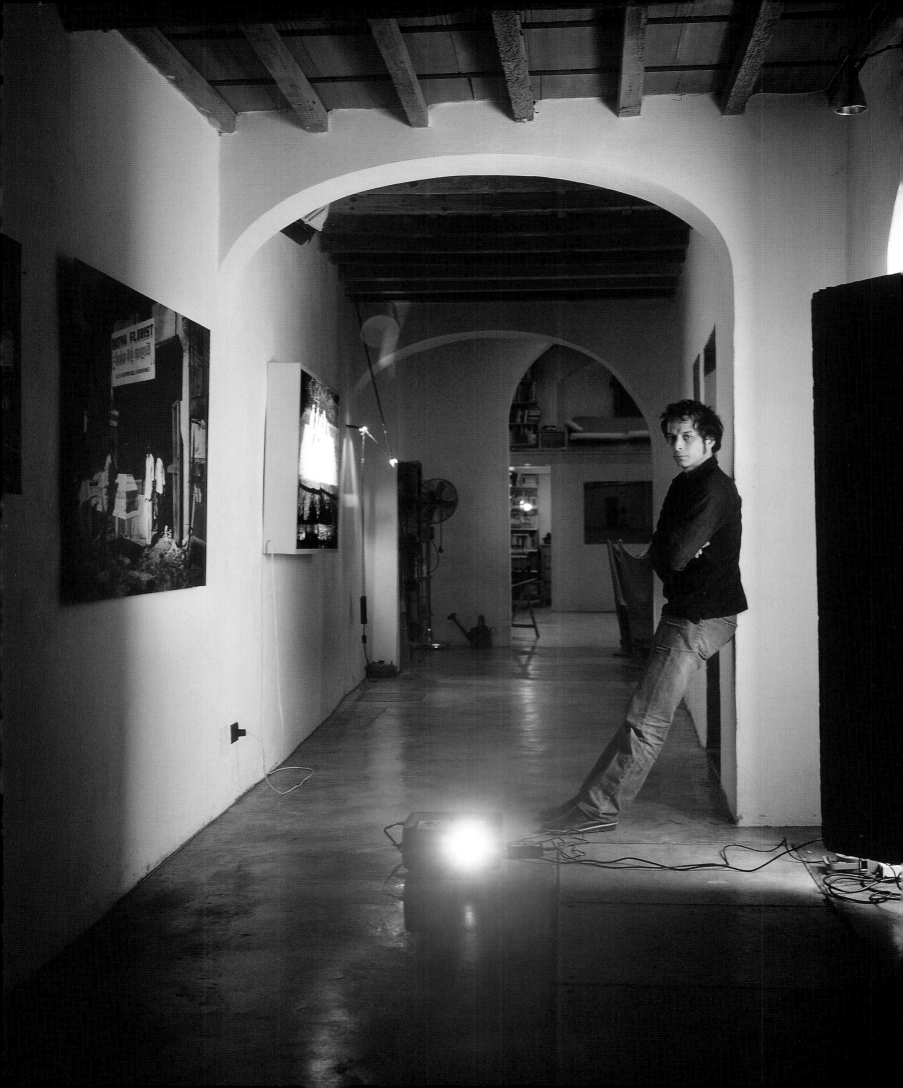

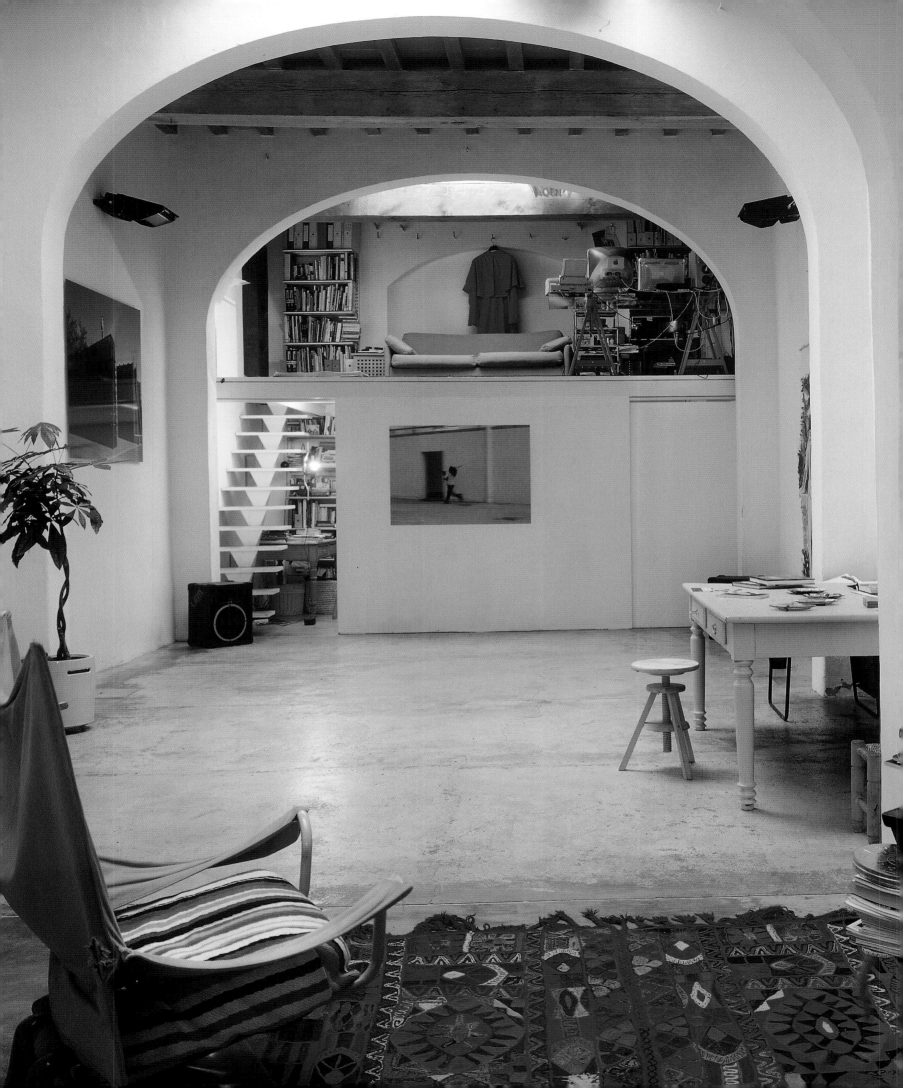

Opposite: *The largest area in the original layout was a courtyard. Now it has been closed in and skylights provide natural light. Works by the artist include* Caap plast *(2003) on the wall to the left, and* Bagpipe *(2003) on the wall below the loft.*

Right: *Opposite the former courtyard is a corridor. The wall at the end is used by the artist to plan and project his video creations, including* Flat Land Game *(2003).*

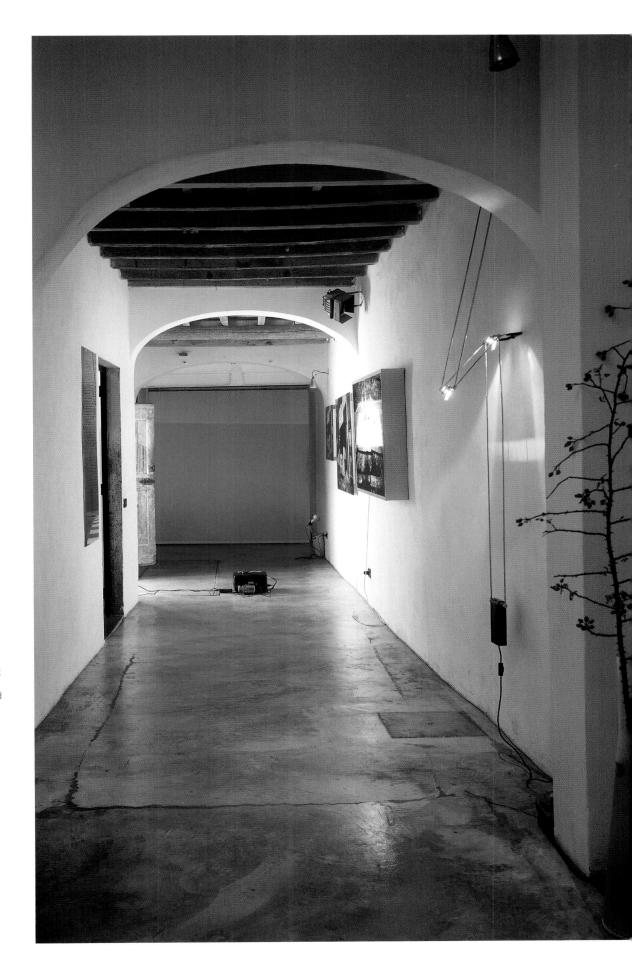

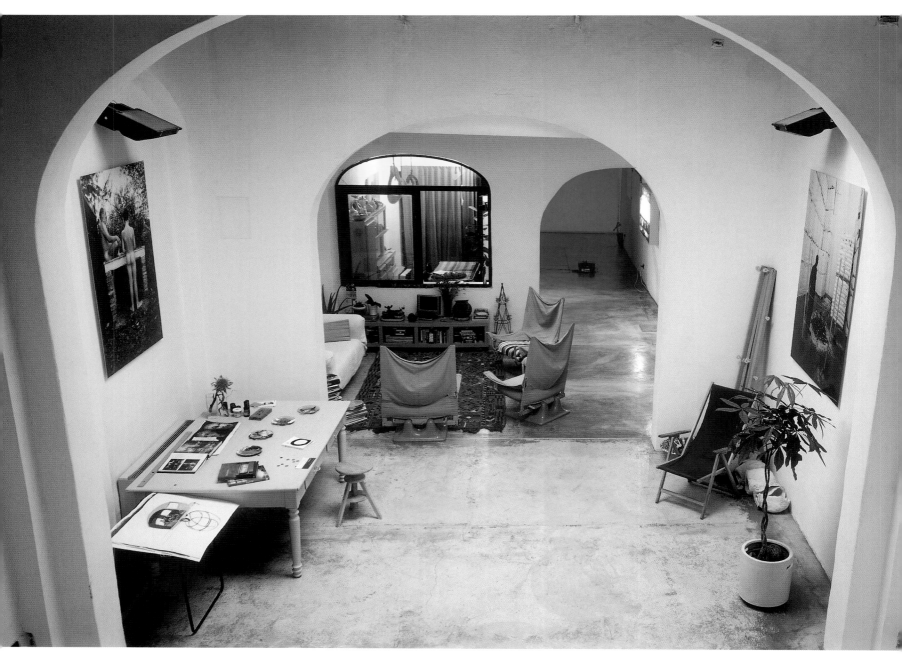

Above: *Although the space has been renovated, the artist left the basic features of the rooms unaltered. The simple contemporary furnishings include armchairs designed by the Archizoom group during the seventies.*

Opposite: *Pettena's work,* Simk House *(2001), hangs on the wall above a simple table.*

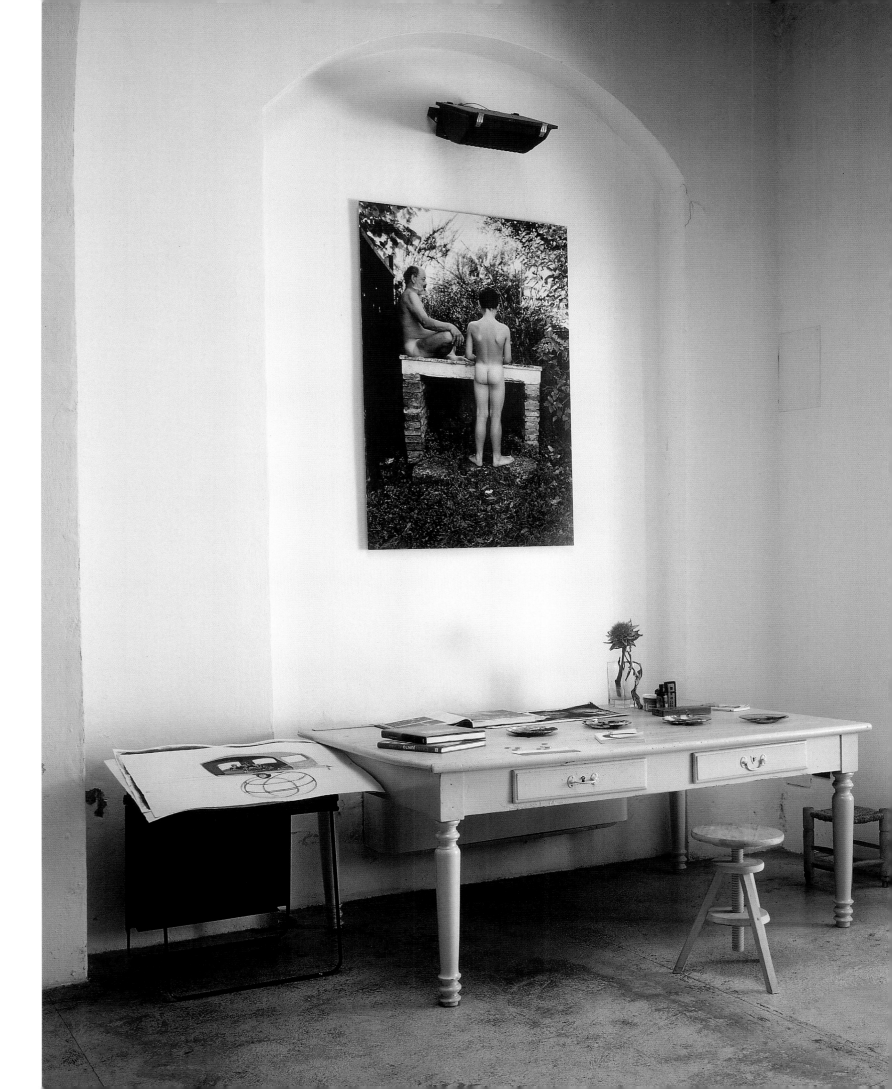

Carlo Battisti

Versilia, the birthplace and residence of Carlo Battisti, reached its greatest splendor in the early years of the twentieth century when it became the habit of the wealthy to spend vacations at the seashore. The fact that Giacomo Puccini, Gabriele D'Annunzio, Luigi Pirandello, and Rosso di San Secondo had homes here is a sign of just how fashionable a place it had become. Members of the European aristocracy and industrial elite vacationed here, as did prominent cultural figures on the international scene, ranging from Thomas Mann to Guglielmo Marconi and Eleonora Duse. This moment of great fortune left a slightly *demodé* imprint on the coast, where examples of extraordinary Art Nouveau architecture are unfortunately mixed with barrack-like buildings—the fruit of ruinous town planning executed during the post-war economic boom.

Battisti's home and studio are found on a secluded, peaceful road near the sea. Like many vacation houses built during the fifties, the architectural style is somewhat coquettish. "My wife and I were looking for a place in the area and on several occasions had noticed this frivolous little house with its stone façade, small arched windows, and wisteria-covered terrace. One day a for-sale-sign went up, and within fifteen days the house was ours." Since the building had seriously deteriorated, the immediate repairs necessary were without altering the original architecture. "We were after an uncomplicated, comfortable, airy intimacy."

A number of years later, after his family situation changed, the artist decided to move his studio to its current location. The small rooms were suited to his work, which is mainly of a conceptual nature. Following an initial period of inevitable confusion, the matter of how the different rooms would be used fell into place: one room houses printing equipment, while another is used as an archive and photo studio. There is a workshop for small-scale metal constructions. The largest and brightest room has tools for design and an informatics station for planning and producing video projections.

"Any time, day or night, I have whatever I need for my work available to me, so that life's usual division into rest, recreation, and work is one uninterrupted flow—something I really like." Battisti spends almost all of his time in these rooms, although he claims that he is unsure whether the house still represents him, as it certainly has for a major portion of his life. At times he finds the intimacy of so many little rooms disturbing, as though this fragmentation of space and its different uses has caused a fragmentation of his creative thought. "When that happens, I wonder if I would not be better off with a loft so I could cast my gaze 360 degrees. That way, I would be able see at a glance all my work in progress and reflect on it. But when I am assailed by such doubts, soon enough my strong sentimental ties to the house dissuade me from taking any initiative."

Opposite: *Carlo Battisti's work focuses on the relationships between light, sound, writing, and movement. Projected images and phrases in the artist's study search for meaning.*

Overleaf, left: *Portrait of Carlo Battisti.*

Overleaf, right: *Two of the artist's musical sculptures. The work on the right has a pipe that plays "Smoke Gets in Your Eyes." Ottorino Respighi's "Nightingales," is played by eight nightingales.*

Joseph Kosuth

The house of Joseph Kosuth is part of a typical farm complex called Podere Pian del Frassino located in the San Casciano dei Bagni area, in the province of Siena. Here the countryside has low hills facing a verdant valley of olives and coppice. The infrequent stone houses on the ridges seem long abandoned, creating an impression of total isolation. Down in the valley a small dam built across a marsh to form a large artificial lake has altered nature, creating an unusual landscape in this generally parched terrain.

When Kosuth purchased the house from the town butcher back in the sixties it had been vacant for two decades. It was essentially a ruin, but Kosuth took up residence there all the same, making a mental association between this new experience and the works he was in the process of creating at that time. The house had no electricity, but the artist solved this problem with a small generator for domestic use. To organize his shows, he relied on a fax which sometimes produced curious results. When he was in the process of arranging a show at the Brooklyn Museum in New York, the power did not always suffice for all his needs. Occasionally he was forced to read fax messages from the curator by candlelight. Kosuth took an enthusiastic view of the situations created by the curious mix of what he calls "a lack of modernity" and the outer world. He began to feel a special relationship with this new reality so far removed from his previous experience.

Over time the house has been made increasingly more comfortable to accommodate a growing family. The addition of stairs from the dayroom leading up to the bedrooms, carved out of former stalls, is just one example. Still, the lack of disturbing additions has preserved the architecture's bare, essential nature. Of all the houses the artist has owned, this is the one that he has kept the longest. This does not mean, however, that this is his 'home' in the usual sense of the word. Kosuth associates all the places he has lived in with special moments in his life and work, so that each is important to him in its own way for its association with a particular mood or psychological moment.

"The concept of home is extremely important for me, including from a psychological standpoint, because I consider architecture to be the art form that most closely reflects the psychology of people. Architecture often enters into my own work. When I choose a home, I like to step back and analyze the things that are really important for me to get out of it. For instance, my New York loft is a typical New York loft. It is located in the middle of Soho and covers an entire block. At one time it was a shirt factory, and its basic layout is still the same as before, although I have obviously made a few changes to the interior to turn it into my studio. Another place I live and work in is on the island of Tiberin in Rome, in a house with a view of the river on all four sides. It is a very particular place, with a special charm all its own. I also have an apartment in Venice where I teach, with a completely different view and type of architecture—very Venetian, as it should be. I live in all these places and each one of them gives me something different. And, in its own way, influences my vision of the world and my work."

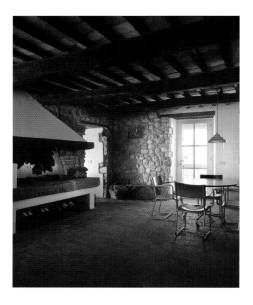

Above: *The kitchen, located where the stables once were, has maintained its original layout. The old stone wall stands in contrast to the white ceramic tiles.*

Opposite: *The artist's farm complex is set in verdant hills that surround a lake in southern Tuscany.*

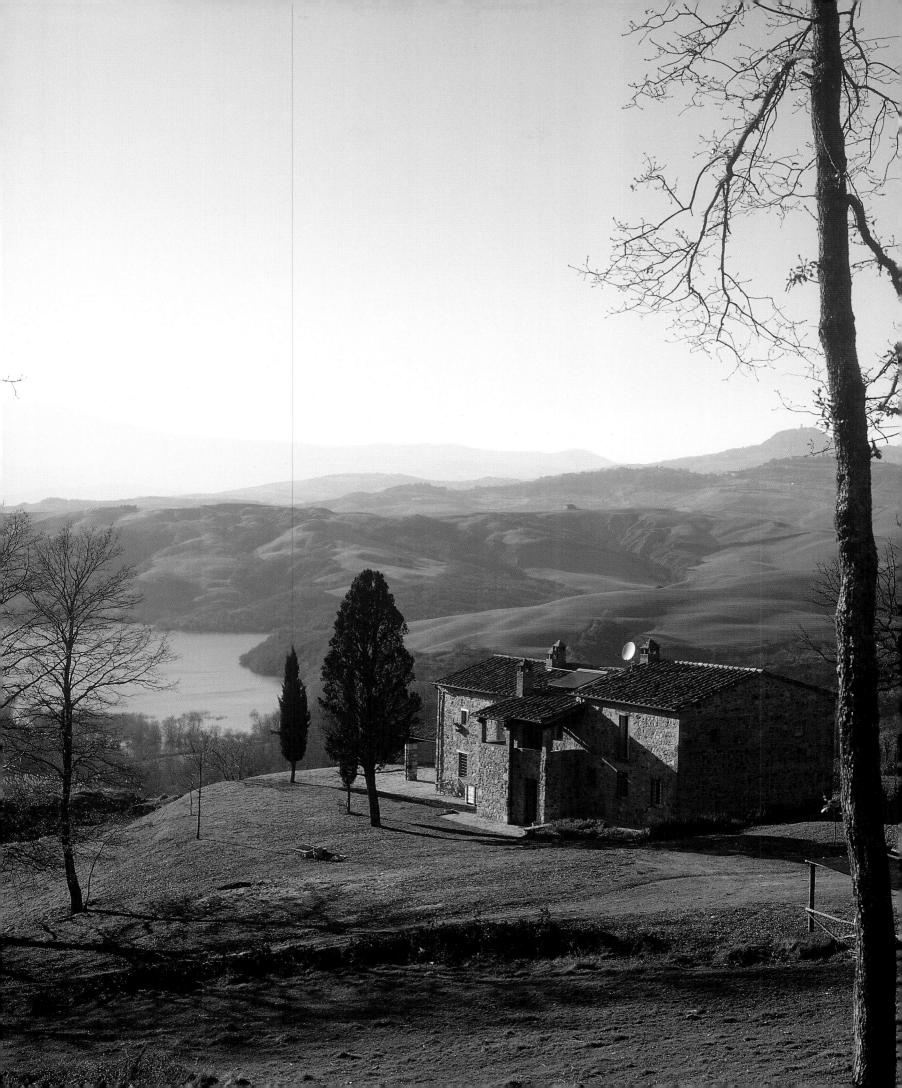

Sandro Poli

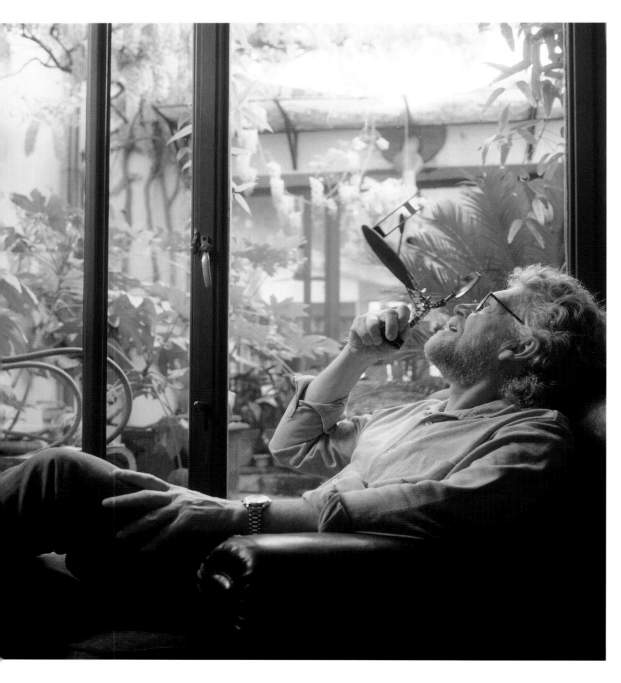

Left: *Sandro Poli in front of a window facing a small patio outside his studio.*

Opposite: *In the entryway a pietra serena and marble shelf holds decorated vases dating from the early twentieth century and works by the artist, including an assemblage of terracotta vases and links of wrought-iron.*

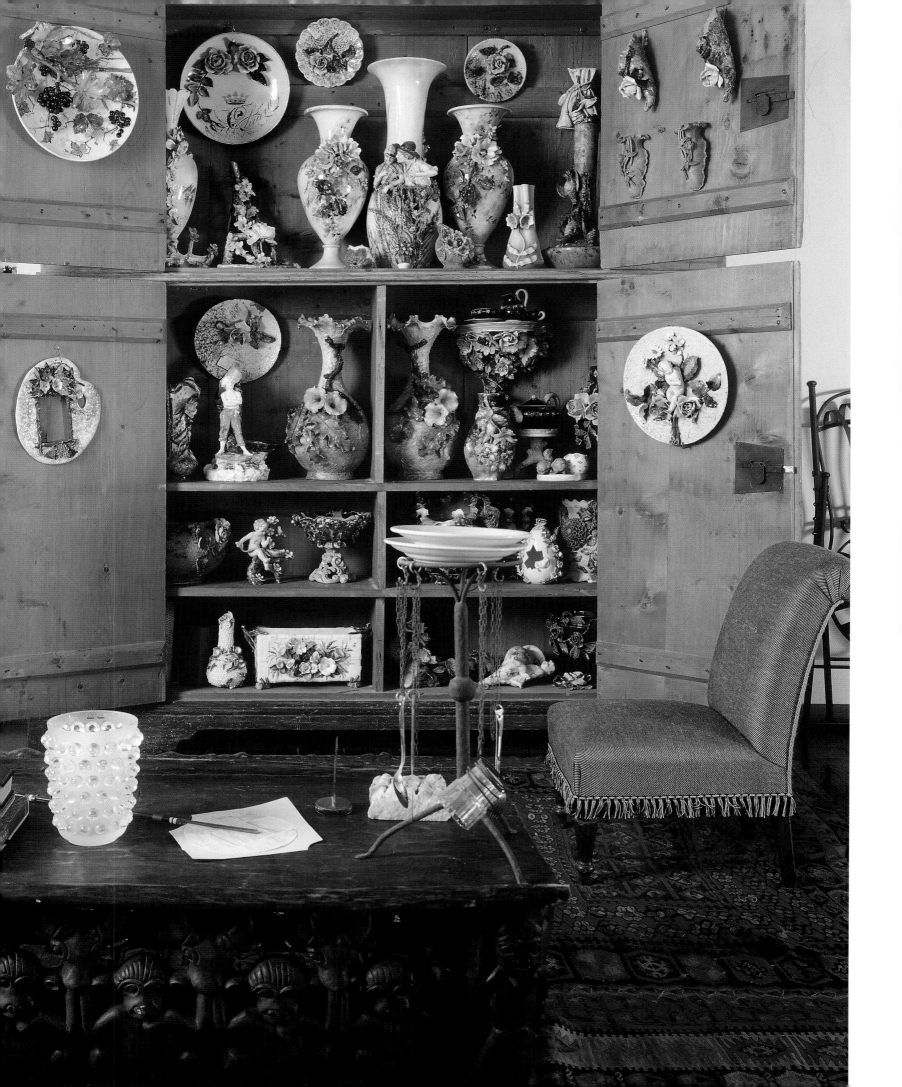

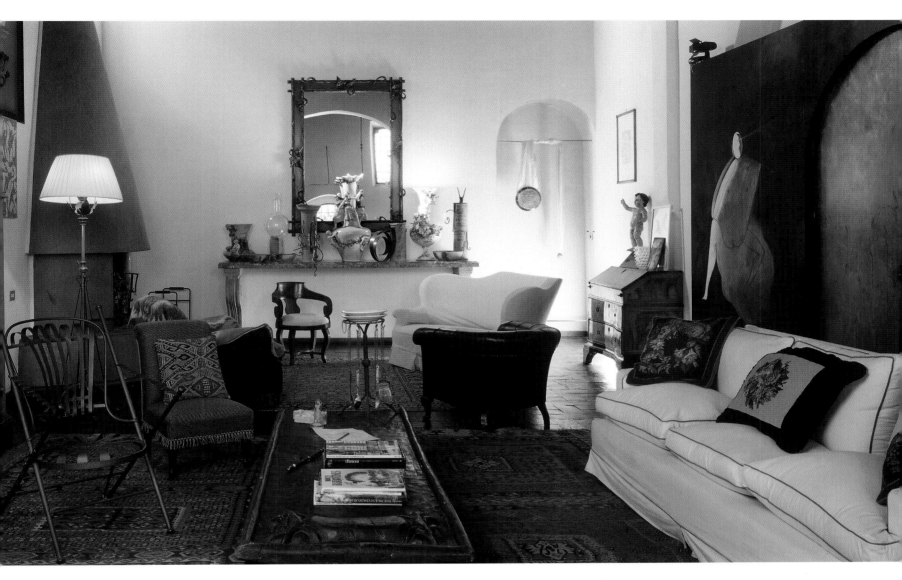

Opposite: *A wooden wardrobe in the living room houses a collection of late nineteenth-century ceramics. A crystal vase by Lalique and* Tavolo singolo *by Poli rest on a table that has been made from an African bed.*

Above: *The entrance and living room space once housed an olive oil press. On the left is a conical fireplace designed by Sandro Poli. A large mirror with an Art Nouveau frame hangs on the wall at far end of the room. The clock in the niche, made with aluminum and linen, is titled* Suspended Day *by Poli. On the right is a panel painted by Vittorio Tolu titled* Annunciation: Night Announces Day.

History has woven the villas, farmhouses, and related buildings in the countryside around Florence into an intricate fabric with ongoing ties to the city. For centuries these properties, once owned by the aristocracy, played their originally intended dual role of country house and working farm. Social and economic changes during the fifties led to a decline in the application of this dual role and opened up the possibility of adapting these structures to different purposes. One example of this process of adaptation is Sandro Poli's "Arcipre ssi" villa and farm located in the heart of the large estate of Marchese Ridolfi, just outside Florence. A farm surrounded a building that dates from the eleventh century, which was partially destroyed as the result of a failed plot against the Medici in 1359. Farm life thrived for centuries until the great agricultural crisis of modern times when the farm was no longer able to function as before. Poli explains: "In the eighties three large rooms formerly used for the granary, vats, and olive oil press were remodeled to become my family's home. The evident state of neglect only increased its charm. Light streaming into the lofty rooms from the glassless windows and holes in the roof illuminated the remains of old farm machinery, presses, carriages, and the rows of vats that all stood witness to the structure's past functions."

"Even though we were not doing a completely faithful restoration, and we were certainly changing the structure's function, we wanted to preserve the emotion and atmosphere of the place by emphasizing all the traces and changes produced by usage and time. A fundamental point was to avoid changing the natural light, so none of the original windows and doorways were changed. The rooms

have the same subdued lighting, and shadowy areas, that they always have had. It is impossible to see the entire panorama of the surrounding countryside all at once; one has to be content with partial views framed by the aperture of the original windows.

"In the beginning we kept the spacious rooms bare, which is the way we would have liked them to remain. But instead they filled up with furniture, different objects, and works of art. All of these things came from homes that no longer exist; they are not furnishings conceived to form a coordinated decor; the rooms were not designed for it, nor did the idea interest us. At one time these rooms acted as containers for storing what the countryside produced; now they have become the place to house us, our personal history, and our work."

Above and overleaf: *This space, formerly a granary, is now used as a living and dining room. Among the period and contemporary furnishings are a long walnut worktable and leather armchairs by Tobia Scarpa, small leather armchairs and a table designed by Josef Hoffmann.*

Opposite: *A collection of pieces in terracotta produced in Impruneta.*

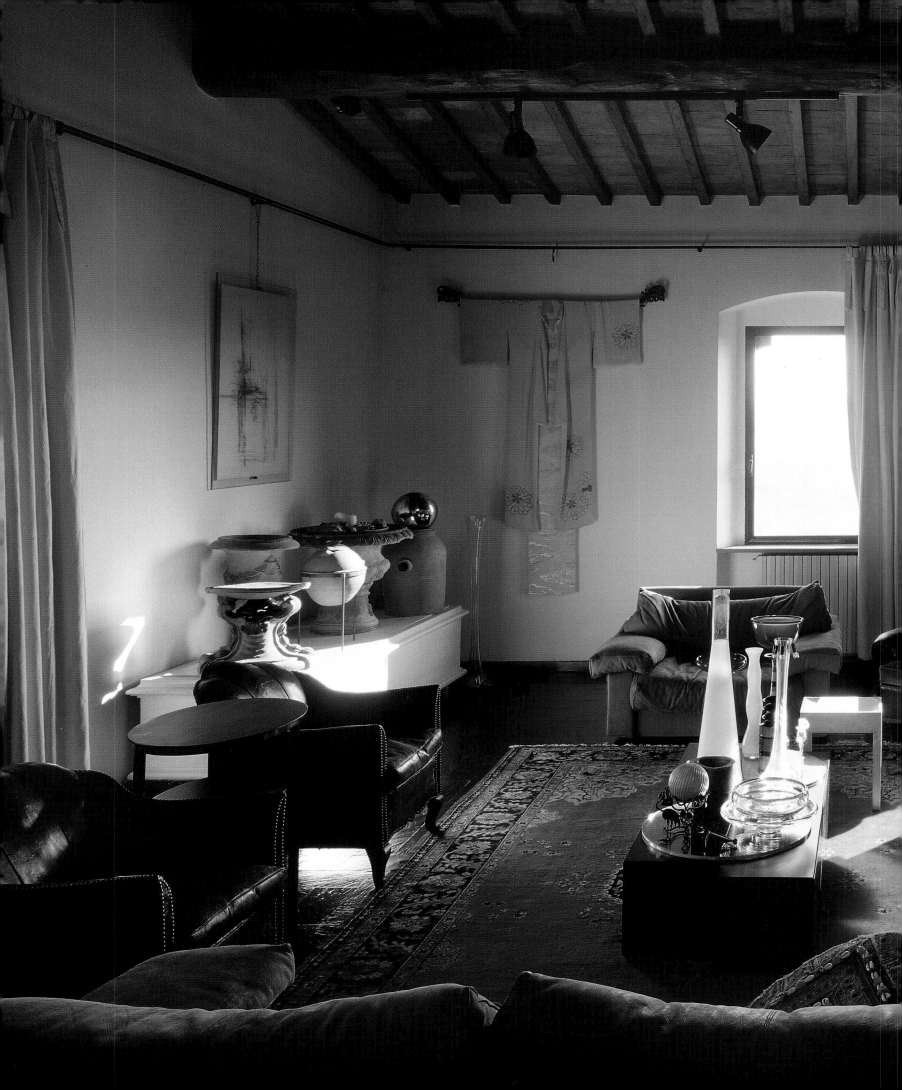

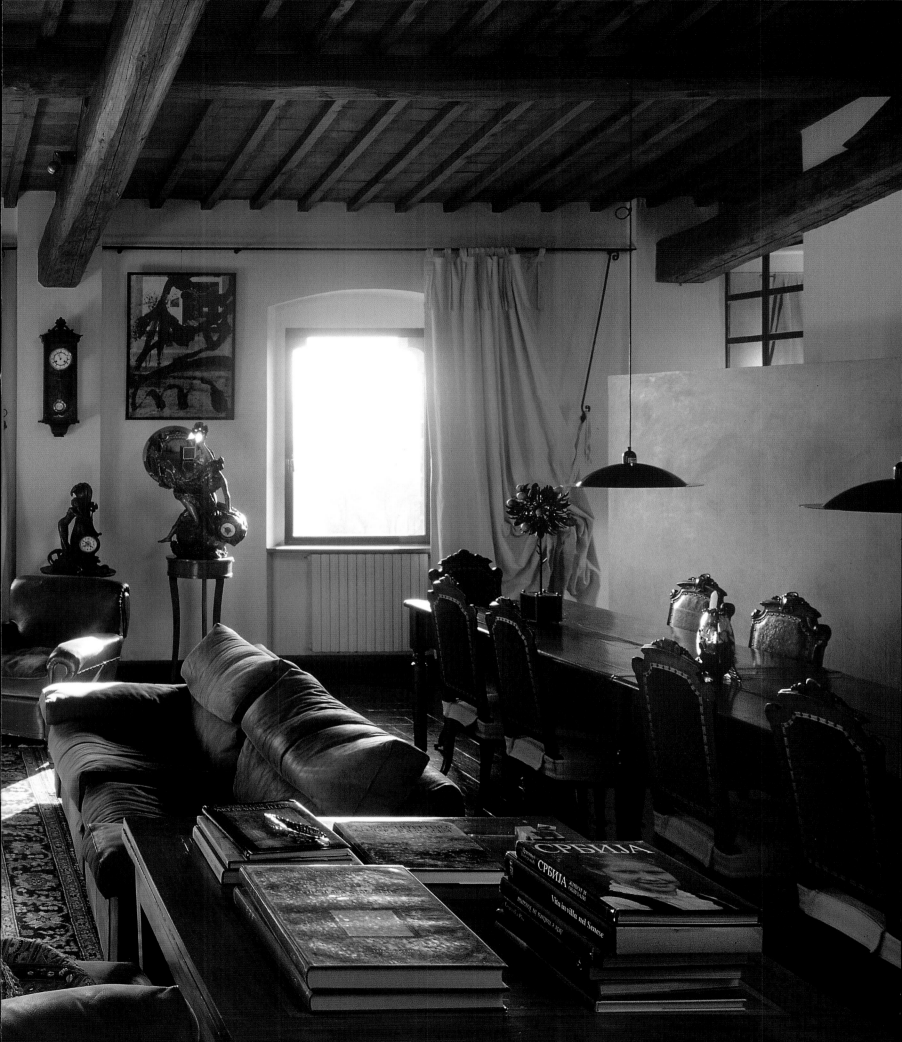

Frances Lansing and Sheppard Craige

The large farmhouse where Frances Lansing and Sheppard Craige live is set in the middle of a vast flat meadow in the clay hills near Siena known as Le Crete. From the house one can see the Asso and Orcia valleys all the way to San Quirico and Montalcino. In this corner of Tuscany the predominant feature of the panorama, which swiftly changes with the passing hours and seasons, is the special brightness of the sky. With steep hills that suddenly end in gullies and clay soil that makes even road construction difficult, the land is mostly used as pasture. The houses reflect the hard lives of their original inhabitants. At one time they were completely isolated, making self-sufficiency essential for survival—as evidenced by the numerous wells for collecting precious rainwater. People who have lived in these houses are unlikely to forget the suffering caused by the extremely hot and cold conditions and by the solitude.

Lansing came to live in Tuscany on a permanent basis in 1995; her husband Craige was already a resident. "When he was living in New York, long before coming here, Sheppard used to paint landscapes very similar to those that depict Le Crete. During a trip to Tuscany he realized that his paintings were simplified versions of the landscape around Siena. In a way Sheppard chose this house as a result of his spontaneous identification with the landscape. For me it was a matter of wanting to be with him. I was struck—and I still am every day—by the beauty of this place, but I had a feeling of absolute solitude. Before I really felt that the place was my own, I had to study it, make some changes, smooth the edges…try to enter into a dialogue with it."

The ancient heart of the house probably dates back to the fourteenth century; the changes it has undergone over the years are a reflection of the fortunes of those who have lived in it. "Before I arrived Sheppard had already restored the structure, opening the lovely loggia along the front where the old oven is, but he left the interior practically unchanged. The decision to live here year round made additional work necessary. We wanted a house that was unpretentious but not Spartan. We were not after 'design' but an informal and flexible place that could open onto the garden in summer and close to keep us warm around the fireplace in the winter. Sandro Poli lent a helping hand by interpreting our desires and mediating our different needs. It is no easy task for two artists to make a place they can both identify with. There may be more of Sheppard in this place than there is of me. The simplicity of the landscape and house are consistent with his paintings and the gardens he creates here. I identify more with the objects that I tend to accumulate or the details that I add little by little, the colors, the different textures. We had no clearly defined aesthetic standard; there are special territories, such as art, where the rules differ from the rest of the world. For us, life and creative work are one, so our home must not be too finished or well defined. Our life is here. Sheppard loves his studio window facing north on a landscape that looks just like one of his pictures, while for me the studio in the old hayloft is essential. Just the other day I noticed a plaque hidden by an old plum tree. The hayloft was finished on the exact same day that my father was born."

Above: *The brick and stone farmhouse lies in the center of a wide plateau with a sweeping view of the Asso and Orcia valleys.*

Opposite: *Portrait of Frances Lansing and Sheppard Craige.*

Left: *The large loggia at the entrance to the house was originally used to store carts, agricultural products, and farm equipment.*

Opposite: *One entrance to the house leads to a dining room furnished with plain farm furniture. The large sculptural vase on top of the armoire is the work of Betty Woodman.*

Overleaf, left: *The kitchen's white Carrara marble countertop is supported by terracotta brick columns. The portraits and scenes of family life painted on the ceramic tiles above the countertop are by Lansing.*

Overleaf, right: *The kitchen is also furnished with old farm furniture.*

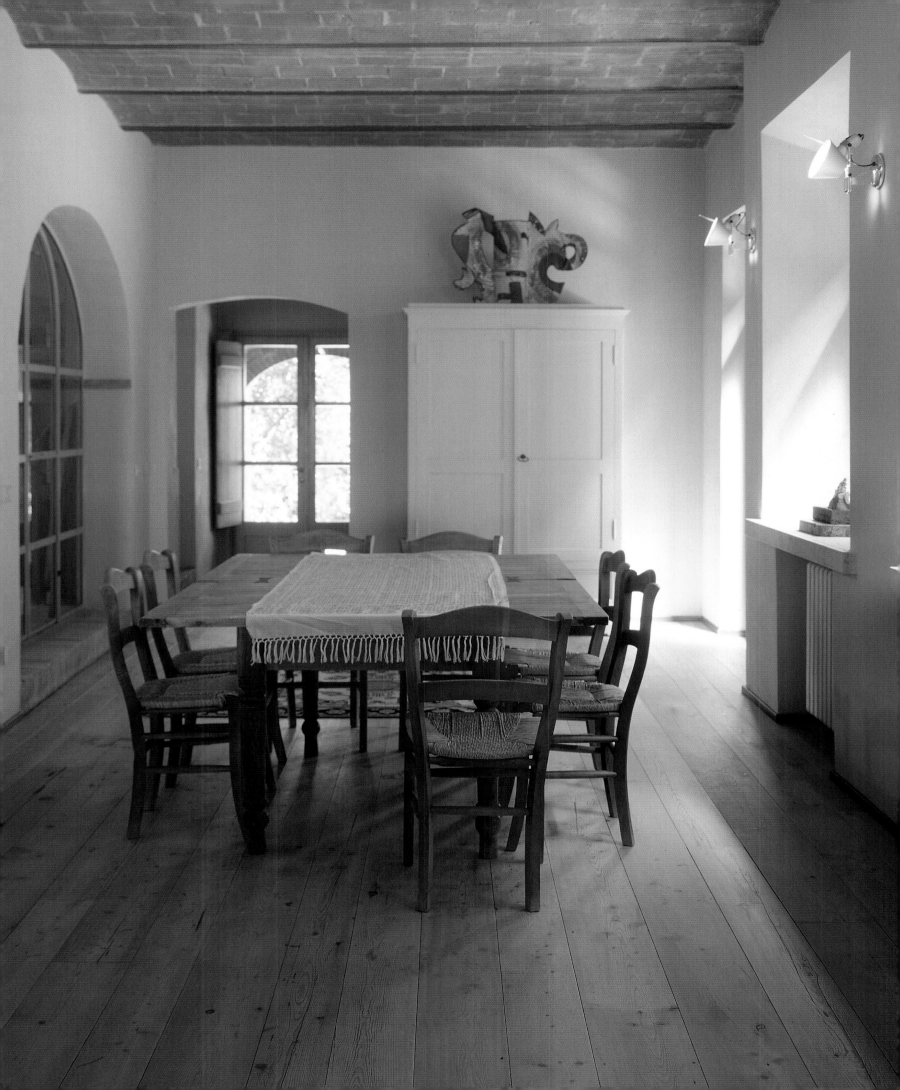

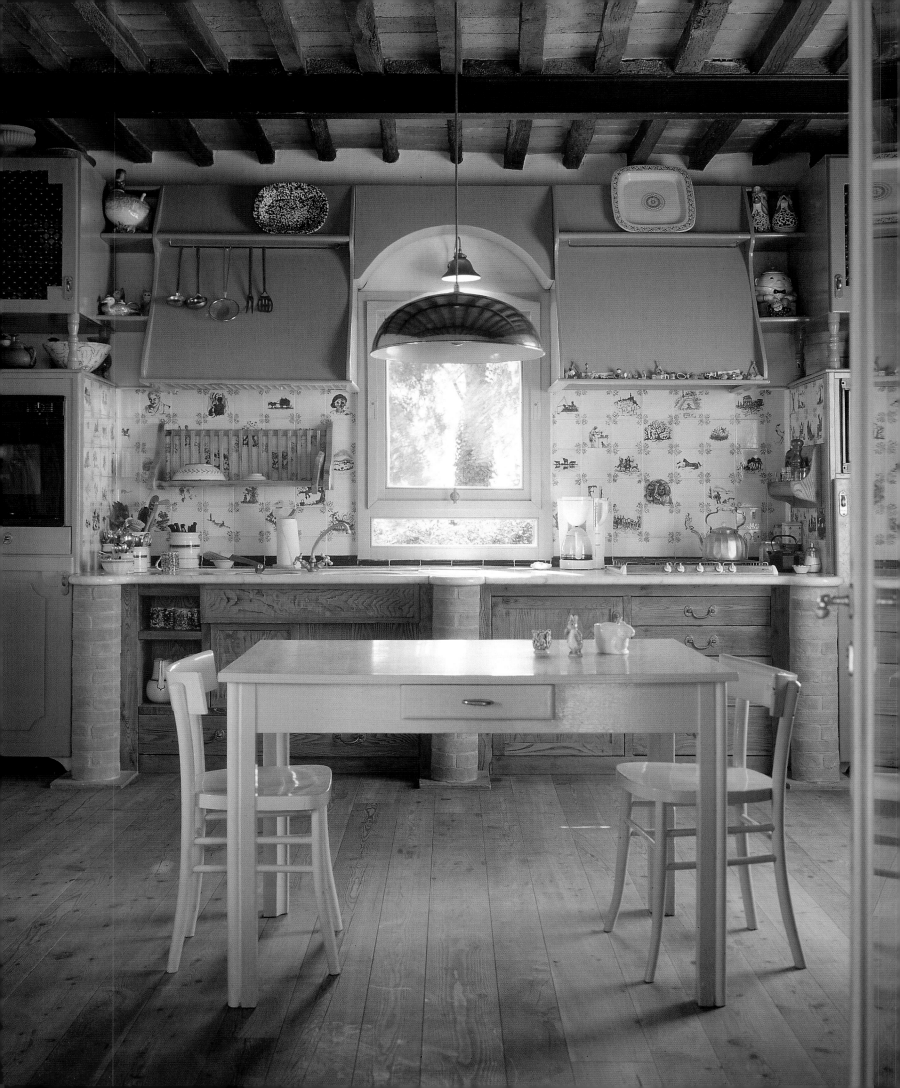

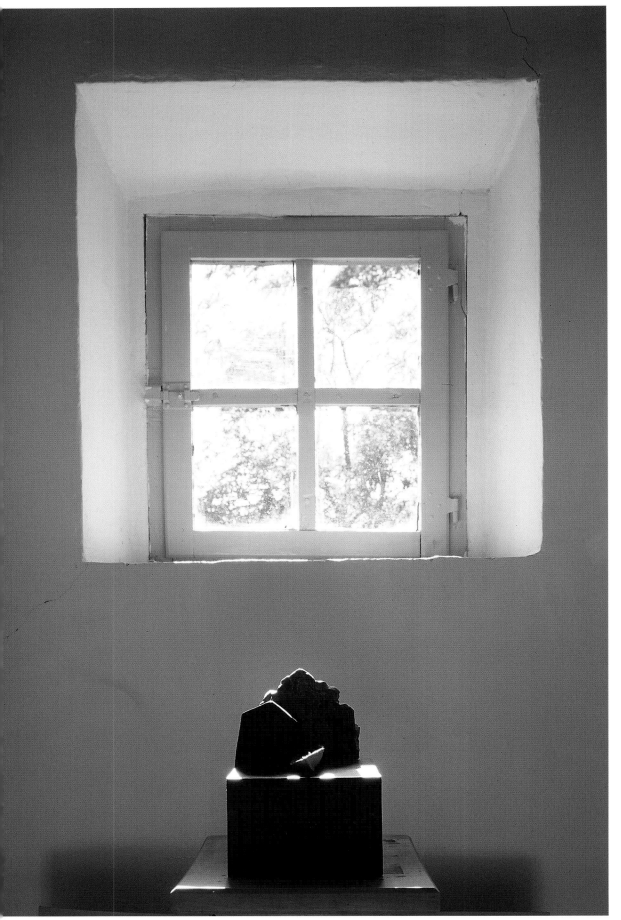

Left and above: *A long corridor leads to a bedroom on the second floor. A ceramic sculpture, Lo Monte (1980), by Giuseppe Gattuso rests on a high stool in front of a small window overlooking Le Crete, the picturesque hills south of Siena.*

Opposite: *Detail of a stairway with a wrought-iron handrail designed by Sandro Poli. An oil painting by Eugene Le Roy, titled* Portrait, *hangs on the wall.*

Overleaf: *The living room and study on the second floor has a writing desk that is Craige's preferred place to work; the panoramic view of the countryside inspires his paintings. The large oil painting on the wall (in the photograph on page 212),* Montelandi (1990), *was exhibited during a protest against a proposed garbage dump in Tuscany.*

Right: *Lansing's studio was once a hayloft; the structure of the building has been left unaltered. A large wax and oil landscape is leaning against the wall and an unfinished work rests on an easel.*

Janet Mullarney

Janet Mullarney's house is surrounded by a meadow located on a plateau between the mountains and the broad Arno Valley. Next to the house is a separate hayloft; both structures are square and lack the classic Tuscan farmhouse exterior embellishments—stairs, loggias, entrance halls, stone construction. Mullarney came here from her native Ireland in the mid-seventies. After completing her studies at Florence's Academy of Fine Arts, she decided to remain in Italy to do restoration work and to carve furniture, as she puts it, "to live art...or perhaps flee from it." She kept moving from place to place, as was true of many young people at the time who were interested in experiencing communal lifestyles. Several years later she began living in her current home, a manor dating from the eighteenth century. When she first saw the house it was vacant and had fallen into disrepair, but to her it appeared very promising. In earlier times, it had been full of life, with perhaps as many as twenty-seven people living there, all in the employ of the descendants of the original owner, Prince Corsini.

The first task she faced was the considerable undertaking of reclaiming the structure without altering the original configuration. The artist's aesthetics invariably led her to choose simple solutions in an attempt to preserve the soul of the house and its unique commanding presence. This approach also governed the renovation of the hayloft that became her studio. Only essential changes were made, adding large windows, white cement floors, and opening up a large workspace.

"The house has represented me right from the start, but I have taken care not to transform its *genius loci*. It knows that it is loved and appreciated in an old fashioned way. For me, the primary thing is where I live. I find this vitally important, especially when I am traveling and stay for extended periods in India or Mexico. When I am away, I make myself at home by looking for local products in the marketplace, whether they be curious decorations, unusual handcrafted items, or something else. This hunt for objects has become a large part of my work. My life is at one with creating art: I attach the same importance to producing works of art, gardening, or looking after the house."

The memory that has most influenced her restoration of this house is that of her childhood home in Ireland, an old mill where she lived with her father, mother, and eleven brothers and sisters. Mullarney explains that it was a chaotic home, but full of life: "My mother loved colors, art, the garden. She enjoyed decorating the house in an eccentric manner all her own. My father instead used to fill it with books, although he also had a great gift for finding small handcrafted items or toys from the Eastern countries back in the days before there were global markets. I have brought this whole world with me, perhaps this is why the lack of creature comforts has never frightened me."

Every year, when the seasons change Mullarney devotes herself to transforming the house. In the summer she sees to it that everything is white and cool, curtains and even some of the doors are removed, while in winter she prefers bright colors, heavy warm curtains, and many more objects on

Above: *Janet Mullarney's farmhouse is nestled in the hills of Valdarno. Next to the house is the old hayloft that the artist uses as a studio.*

Opposite: *A stairway has been decorated with a plaster sculpture hanging from the ceiling and a small bronze dog fixed to the wall, both are works by the artist.*

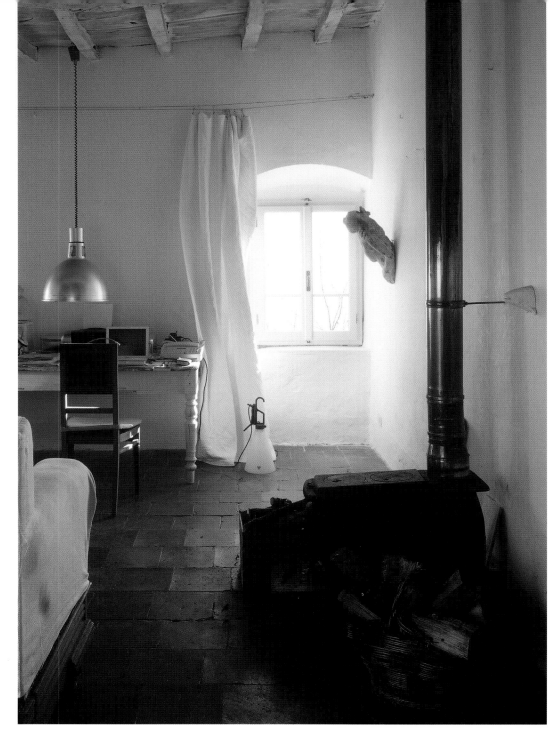

display. In recent years she has been spending half of her time in Ireland. When she returns to Tuscany she feels a need to do something to reclaim the house. "I change everything around. The lighting gets switched around or I bring in new lamps, the furniture gets pushed from place to place until I strike a new balance. However the sculptures demand a place all their own. You can turn them or shift them around, but they usually end up back where they were in the beginning. Without my creations the house seems bare to me. My most recent work always gets a place of honor. They are almost like members of the family; at times I even give them a passing caress. At any rate, they too get marched around the room whenever there is a change in the furnishings, or get carted off to some show, sometimes never to return…but then some new ones always appear to take their place."

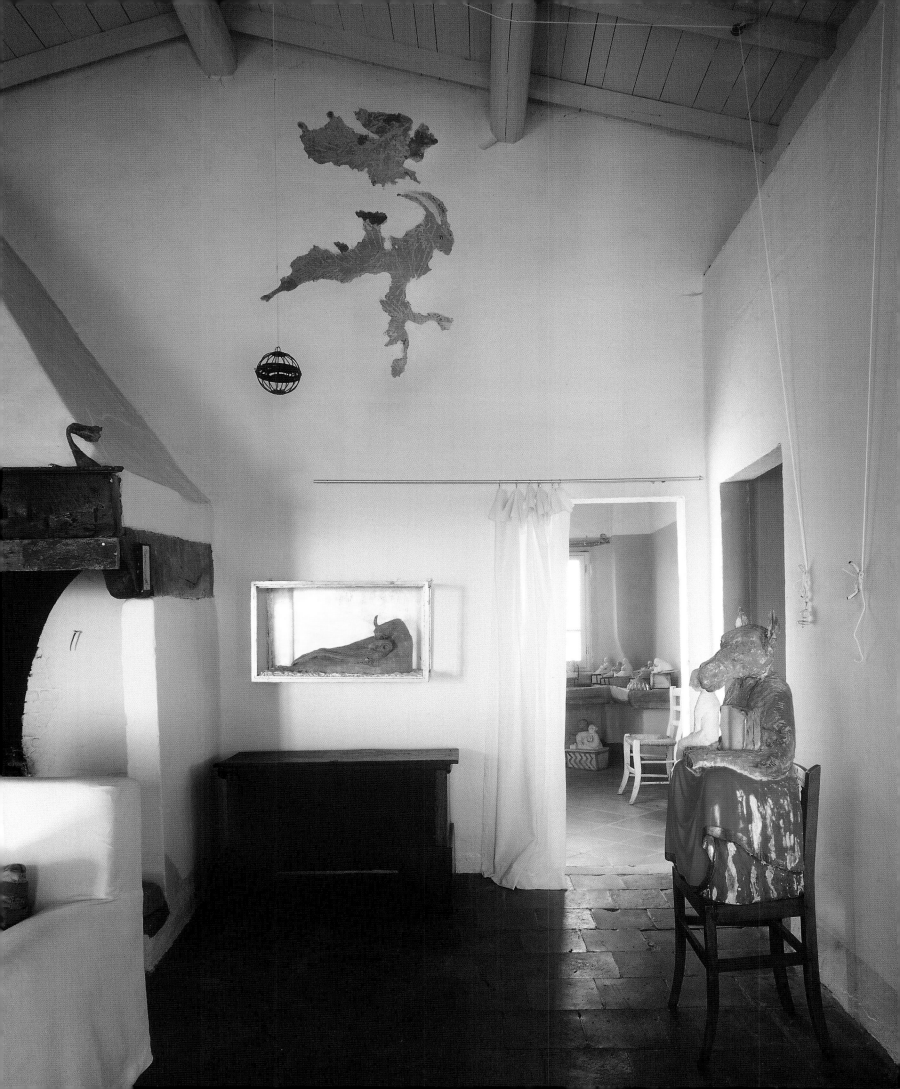

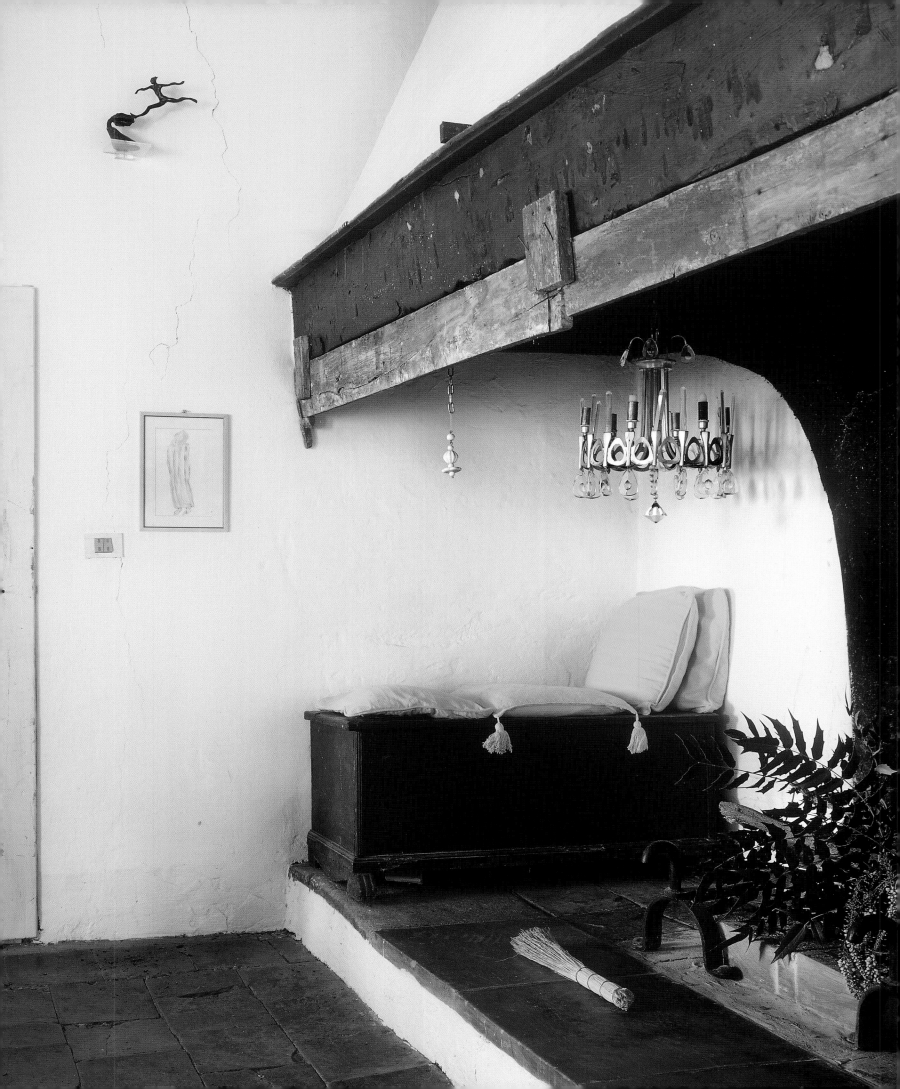

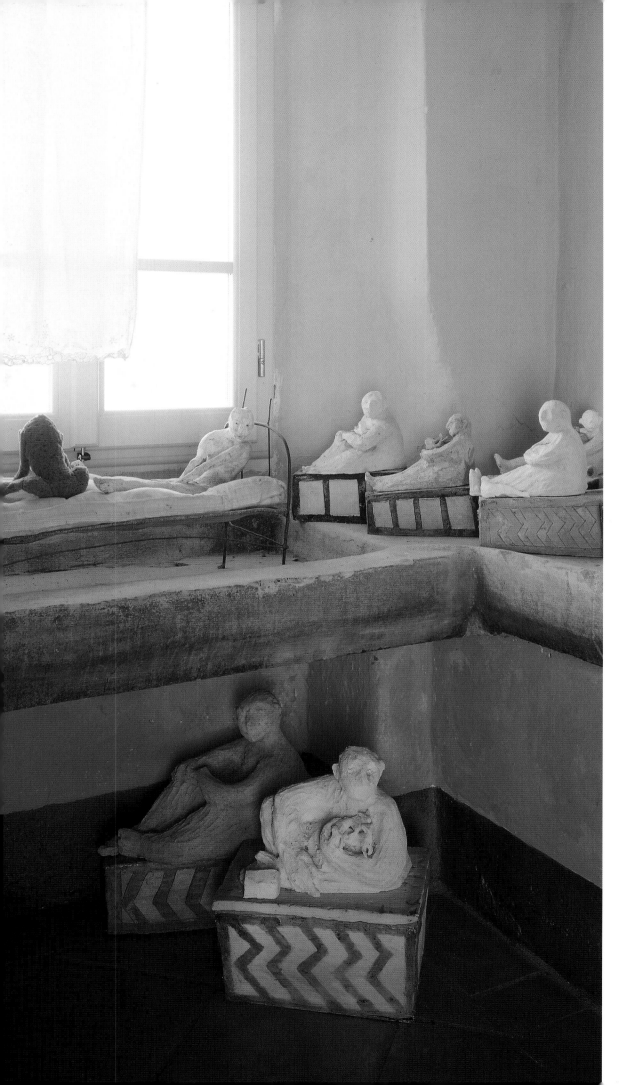

Left: *A collection of terracotta sculptures sit on a stone basin in the house's old kitchen.*

Opposite*: Sponge puppets cut by the artist hang from the ceiling of the bathroom.*

Overleaf, left: *A detail of the bedroom includes a piece of wood furniture—made by the Mullarney's sister—was inspired by art of Ravenna.*

Overleaf, right: *The statue in middle of the bedroom was originally part of a group of sculptures created by the artist.*

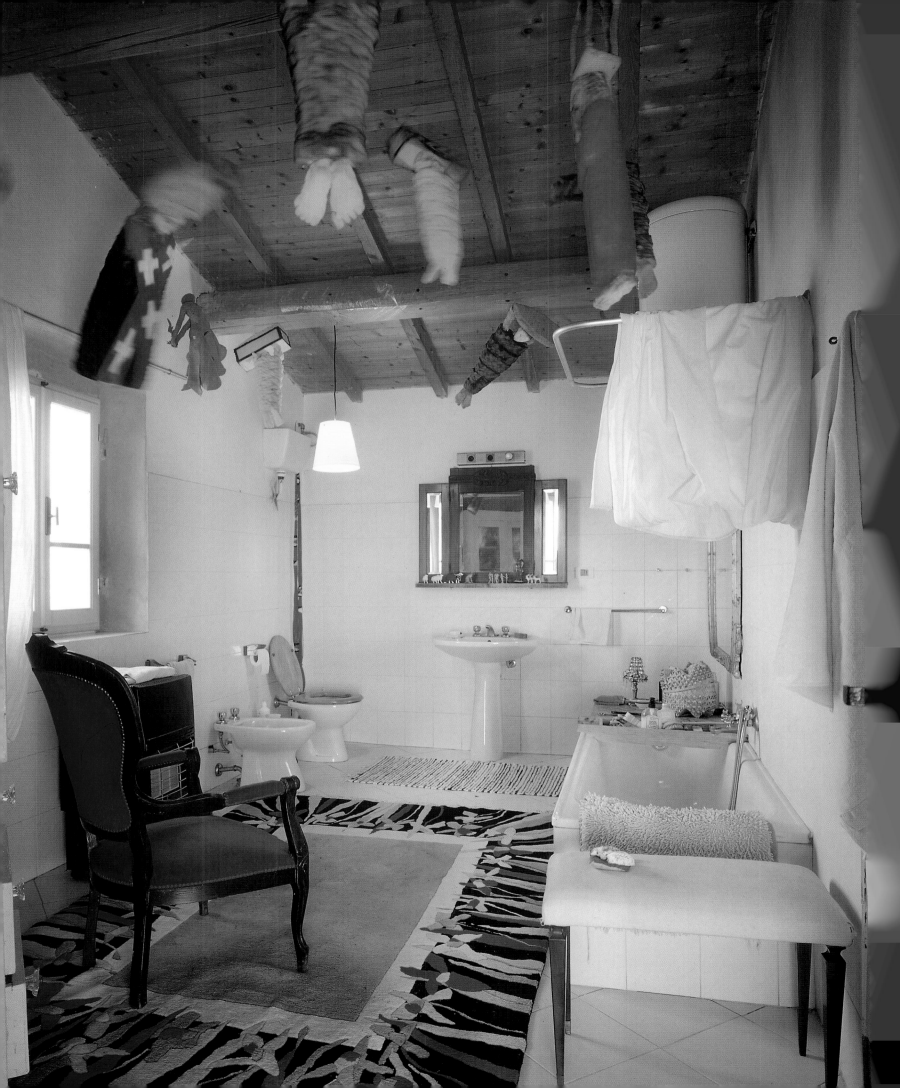

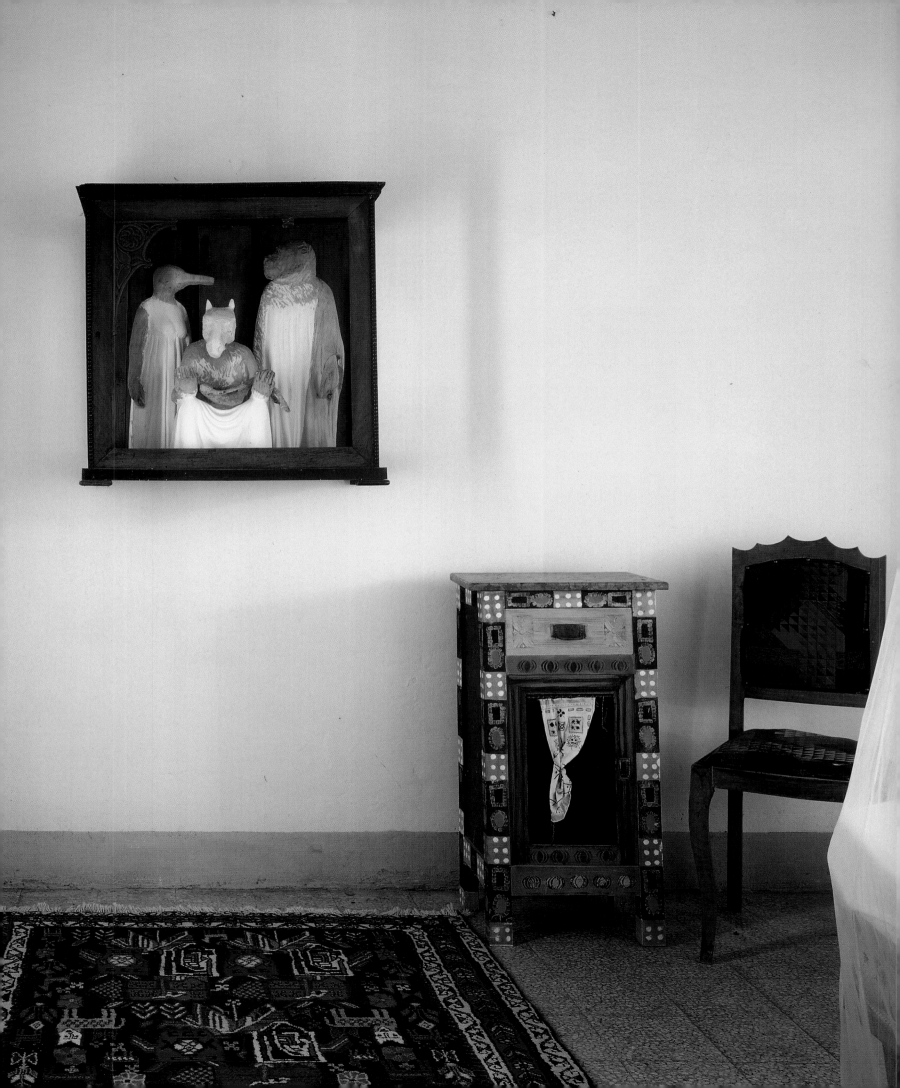

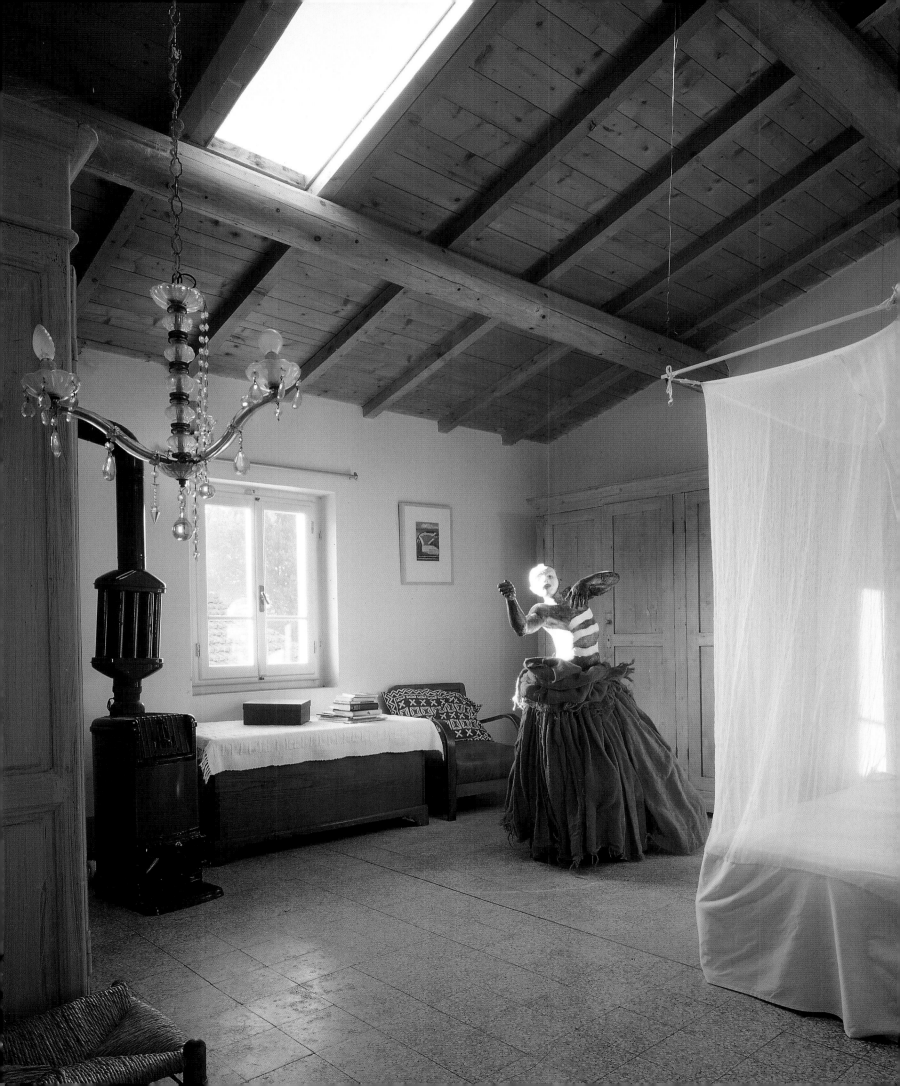

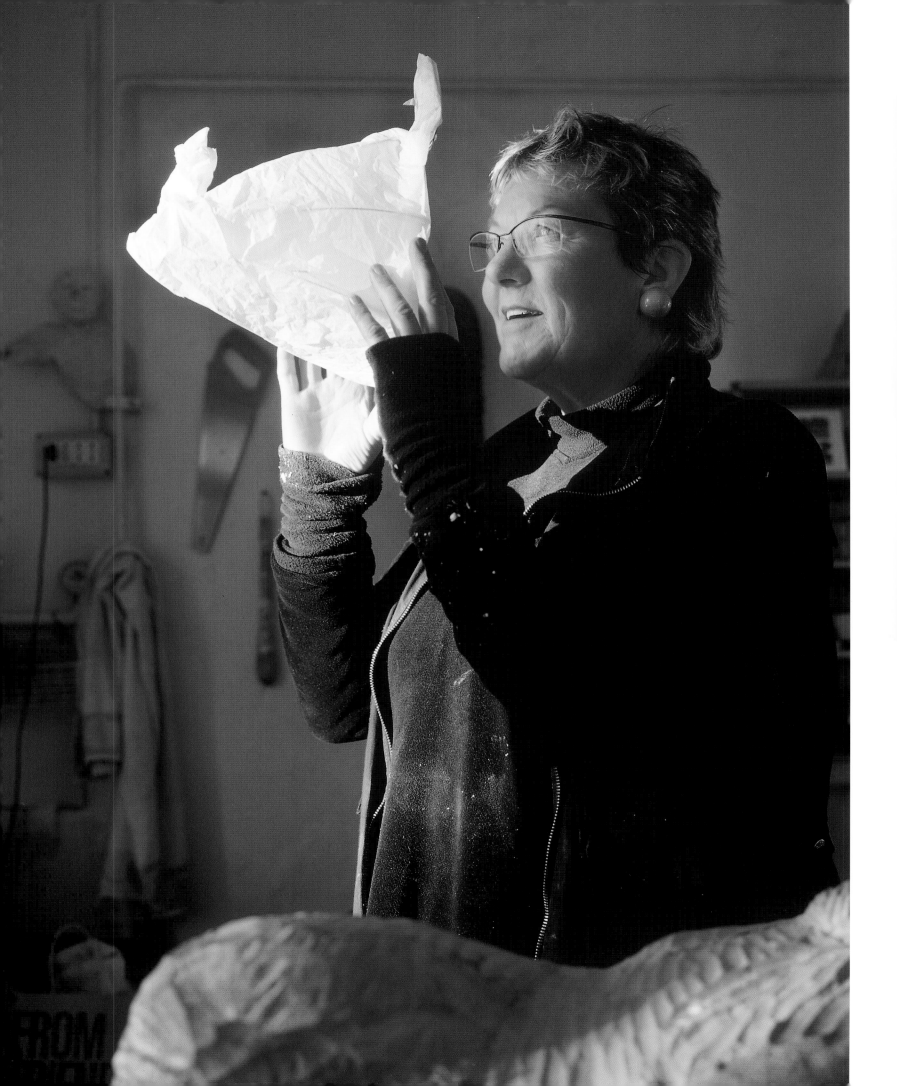

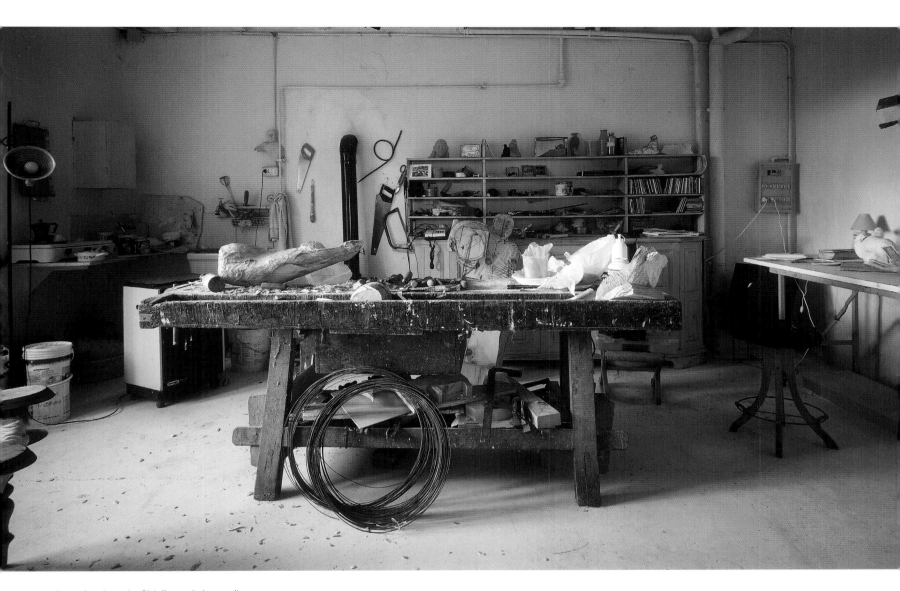

Opposite: *Portrait of Mullarney in her studio.*

Above: *A woodworking bench in the artist's spacious studio.*

Artists' Biographies

Dario Bartolini

Carlo Battisti

Dario Bartolini was born in Trieste in 1943. An architect and designer, he was a member of Archizoom from 1969 to 1973. Like other such groups of the time, Archizoom's declared aim was to revise the traditional language of architecture, in some instances by integrating innovative currents in the visual arts. He was invited to take part in two major shows, the New Domestic Landscape *at the Museum of Modern Art in New York and* Vestirsi è facile (Getting Dressed is Easy) *at the Milan Triennial in 1973. During the seventies and the eighties he continued his artistic development while developing new approaches to teaching.*

Although his artistic expression in the early nineties mainly took the form of painting, in early 1992 he began working with iron rods, producing his first "filiform," three-dimensional sculptures that would become the focus of his subsequent artistic production. Bartolini creates these sculptures directly on their intended permanent site or, if this is not possible, he creates them with specific destinations in mind. Arriving at these sites presupposes a journey in stages that comprises part of the work. This concept gave rise to a number of itinerant projects, including Pellegrini (Pilgrims) *and* Acque Meridiane (Meridian Waters) *in 1998. A major project in 2000 involved a trip from Florence to Norway following Europe's central meridian. Another noteworthy project is the 1997 installation* Stretto a sé un profumo di rose (Clenched a Scent of Roses), *placed in a courtyard of the historic center of Àrola (Verbania). In 1999 Bartolini created a series of works titled* Orizzonti nei Parchi (Horizons in Parks) *for the parks of Val di Cornia.*

Carlo Battisti was born in 1945 in Versilia, a region that many artists have made their home. When Battisti was a young boy the surrounding art world piqued his curiosity. He has vivid memories of youthful visits to see Henry Moore's studio, from the outside. He was also fascinated by the huge bronze sculptures by Jacques Lipchitz sitting on the grounds of a foundry in Pietrasanta waiting to be shipped to faraway cities in America.

After studying sculpture at the Pietrasanta Art Institute and a brief stint at the Florence Academy of Fine Arts in stage design, he developed his artistic work mixing various forms of expression. In the sixties Battisti began creating sculptures that incorporated sound effects, and natural materials such as wood, stone, and cane. He often abandoned his finished work along the side of the road for the benefit of those who happened to pass by.

A lively interest in words—and the infinite possibilities for manipulating and distorting them—prompted Battisti to turn to visual concrete poetry, with sound effects. For nearly three decades, using the languages of Fluxus, mail art, neo-Dada, and conceptual art, he has produced artistic books, innumerable gadgets, and talking sculptures. Battisti's current artistic output is focused on projected and video texts in large installations. A vein of irony is a constant feature of his work.

Leone Contini Bonacossi Pietro Cascella Lietta Cavalli Sandro Chia

Leone Contini Bonacossi was born in Florence in 1976. Drawing and painting have been his preferred means of expression since childhood. In 1992 he began to study oil painting on his own. He subsequently had more formal training at the Restauro Santa Trinità restoration studio at the Florence Academy of Fine Arts. Bonacossi has supplemented his study of artistic techniques and art history with travels throughout Europe, including frequent trips to Southern Europe and the Balkans. In addition to artistic research, he has also cultivated an interest in philosophy and anthropology. Bonacossi has always been fascinated by primitive art, religious art, and by what could be described as a "choral approach."

In 1997 he began to exhibit his work for the first time. It was shown in both one-man and group exhibitions in Milan, Florence, and Prato. Japanese aesthetics, especially in connection with traditional painting, have profoundly influenced his style. In 2004 he had three one-man shows in Japan, in Morioka, Aone-Kawasaki, and Tokyo. He currently lives and works near Florence in Capezzana.

Pietro Cascella was born into a family of artists in Pesaro in 1921. His interest in painting was apparent since early childhood and his father was his first teacher. He moved to Rome in 1938 where he studied at the Academy of Fine Arts. He participated in Rome's Quadriennale Art Exhibition in 1943 and at the Venice Biennale in 1948. In the years that followed, together with his brother Andrea and ceramicist Anna Maria Cesarini, he opened a sculpting and ceramics studio and began creating large works. The sculpture-paintings from this period evoke surreal themes inspired by Sebastian Matta.

Cascella's wide acclaim can be linked to his work Auschwitz Monument crafted in 1967. This work is a stone memorial executed on the spot where a railway track reached its final destination and where the prisoners ended their journey. His monument-sized artwork and aesthetic lead Cascella to work with solid materials like marble and stone. A sense of force and restrained energy is conveyed by his female figures with their sinuous and rounded curves. Since the seventies his large scale work has often combined urban sculpture projects with social commitment. In the mid-sixties he married Swiss sculptor Cordelia von den Steinen and in 1977 he moved to the castle of Verrucola, in Fivizzano in the province of Massa-Carrara, where he is currently living and working.

Lietta Cavalli was born in Florence into a family of artists and artisans; her grandfather, Giuseppe Rossi, was an acclaimed painter of the Florentine School and her mother was an established stylist. She graduated from the Institute of Arts in Florence when it was considered the city's benchmark for artists. She began her career in the world of fashion with her brother Roberto, and from the start she proved to possess a gifted and strong personality. This trait led her on an exploratory journey and has resulted in truly innovative projects. Unlike her brother, she was not a fashion designer at heart but an artist with a keen passion for artifacts and unique pieces crafted by mixing different materials. Her creations result from the combination of her originality and creativity and blend the distinctive cultural flavor of Florentine handicraft that emerges in every detail.

Cavalli designs her work by researching color nuances and fabric combinations obtained by blending the most diverse coloring and printing techniques and fusing different materials together. In 1982 her artwork was presented at an exhibition-event organized by Alessandro Mendini in the Palazzina Reale in Florence. Mendini defines Cavalli as "an atemporal designer of body objects." The Cosmesi catalogue is a synthesis of her works exploring the world of body makeup. In 1990 her constant dedication to research and continuous experimentation led her to walk away from the hectic world of fashion. This move has enabled her to concentrate solely on the creation of the so-called Pieces, unique handicrafts stemming from the research of complex tones and original textile weaves that give a new value to imperfection, error, and scraps.

Sandro Chia was born in Florence in 1946 and attended the city's Art Institute and Academy of Fine Arts. After an extensive period of traveling that took him across Europe, India, and Turkey he stopped in Rome in 1970 and made the capital his place of residence. The following year the Art Gallery La Salita hosted his first solo exhibition titled L'ombra e il suo doppio (The Shadow and Its Double). During this period his artistic interests led him toward conceptual, environmental, and action art. In the mid-seventies his work shifted to explore figuration. He participated in the exhibition Aperto 80 at the Venice Biennale 1980 and became known as one of the protagonists of "Transavanguardia," a term used by art critic Achille Bonito Oliva to define the work of artists like Chia, Mimmo Paladino, Enzo Cucchi, Francesco Clemente, and Nicola De Maria.

The artist's poetics sway with lightness and at times with irony; they adopt different forms of expression and blend a remote pictorial heritage with a technique that intensifies design and color. Chia recovers the sensuality of color by adopting vivid and contrasting tones and recouping figurative imagery from the old Italian pictorial tradition. Artists like Tintoretto and Scipione remain the inspirational bases of his expressive art. His paintings of mythological subjects and his first sculptures date back to the beginning of the eighties. In 1982 he spent some time in New York where his artwork was shown in several galleries. During the eighties and nineties Chia was devoted solely to his artwork. His work has been presented in many galleries and museums and has been exhibited in important international collections worldwide. He now lives and works in Rome, New York, and in Montalcino in the province of Siena.

Sheppard Craige Paola Crema and Roberto Fallani Isanna Generali

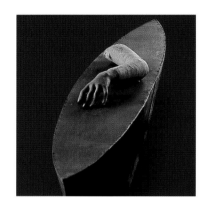

Sheppard Craige was born in Virginia in 1942. After completing his studies in History of Philosophy at Johns Hopkins University, he focused his energy on art, especially painting, and on showing his work in Europe and the United States. He came to Tuscany in 1980 and began to spend more time living in the region. In 1997 he acquired a woodland property in the Asso Valley and began the largest project of his life—the creation of the Park of the Ragnaia *has been the highest expression of his creativity and the synthesis of his interest in nature, philosophy, and art. In 2004 he finished the first phase of the project's development and published a book describing the work. At present he is working on the second phase that will probably require another three or four years of work.*

Roberto Fallani was born in Siena, but lived there only one year before his family moved to Florence, where he received his education. During his university years he met Paola Crema and they have been together ever since. Sharing cultural and professional interests, they have worked together in the fields of interior design and furnishings.

Fallani works in the world of design, creating both one-of-a-kind pieces and numbered series of works. He also is active as a sculptor, with a preference for large works made from unusual materials, such as plastic shaped by heat and joined to iron or steel. The different themes expressed in his work are sometimes disquieting, such as genetic manipulation and cloning.

Paola Crema has a long-standing interest in antique dealing, which has been rewarded by success. For many years she has run her own gallery, Fallani Best, specialized in late nineteenth and early twentieth century art and furnishings. She also creates outsize jewelry that she calls "table jewels." Her favorite materials are bronze, silver, and gold set with semi-precious stones, seashells, and mother-of-pearl. The general theme of her work, with its almost dreamlike quality, is "The rediscovery of finds of Atlantis."

Isanna Generali was born in Modena in 1947. She studied Pictorial Decoration at the Art Institute of Modena and in 1965 she decided to make Florence her home. She attended the College of Art Education and began perfecting her skills in graphic arts. Her first working experience was in interior design and decorating but over time her interests shifted. In the sixties she was actively involved in teaching theater and began to devote more of her attention to women's and children's issues. She taught Pictorial Arts at the State Institute of Arts in Florence for over twenty years.

Her first exhibition, Populart Conversazioni di Carta *(Populart Conversations of Paper), was held in Barcelona in 1981. Her artworks can be seen in collections all over Europe. Her preferred form of art is sculpture and she creates evocative installations by artistically adopting a varied range of materials that include anything from iron to rubber. Generali strives to unveil past memories in her work by exploring the metamorphosis of different materials. Since 1993 she has made Radi, a town near Siena, her home and workplace.*

Gigi Guadagnucci Marcello Guasti Joseph Kosuth Evelien La Sud

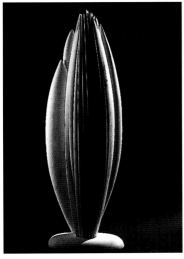

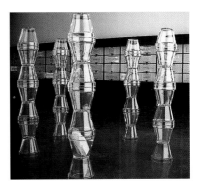

Gigi Guadagnucci was born in Castagnetola, in the Province of Massa-Carrara, in 1915. In keeping with family tradition, as a young child he began to learn the art of working marble. In 1936, forced to leave Italy for political reasons, he settled in Grenoble. There he managed to become a self-taught expert in the history of art and design, thus broadening his knowledge of great classical sculpture. After the war he decided to remain in France, making his new home Paris, where he had the opportunity to frequent the most advanced, vital cultural milieus. This led to his becoming acquainted with Gino Severini and important sculptors, including Alberto Giacometti and Ossip Zadkine, as well as young avant-garde artists César, Yves Klein, and Jean Tinguely. At the same time he began showing his work in major Paris galleries, winning popular and critical acclaim.

During his years in the French capital it was already evident that Guadagnucci's sculpture, while not unaffected by innovative contemporary art, never lost sight of the tradition and examples set by the classics. Beginning in the sixties, Guadagnucci was a regular presence at the most important salons of Paris, in addition to exhibiting his work at the major international events featuring sculpture. During the mid-sixties, Guadagnucci began to return to his native Tuscany on a regular basis. He participated in the International Sculpture Biennial of Carrara in 1967, 1969, and 1973. In 1977 he was awarded the Bourdelle Prize. He continued to execute monumental works, mostly in France, but also in Tokyo and Kenya. He also created works for two municipal buildings, the Palazzo Comunale and the Palazzo Ducale, for the city of Massa. During the nineties Guadagnucci was based in his home and studio in Bergiola and began dedicating himself to the production of bas-reliefs and jewelry that reflect the forms of great marble works.

Marcello Guasti was born in Florence in 1924. He received a degree in Graphic Arts from the State Institute of Arts in Florence and was taught by the masters Pietro Parigi and Francesco Chiappelli. He was also close to established artists like Ottone Rosai and Corrado Cagli. In the forties he applied himself to learning the technique of etching, rigorously in black and white. His early work seems to have been influenced by a call to primitivism traceable to works by Paul Gauguin, Pablo Picasso, and to German Expressionism, especially the work of Ernst Ludwig Kirchner. A particularly striking feature is the artist's modern interpretation of Italian Classical Renaissance masterpieces by Paolo Uccello and Piero della Francesca. The forties were also years when he was actively engaged in sculpting and he enjoyed experimenting with different morphologies and materials. His characteristic artistic trait is to work along formal themes and reinterpret them in their material differences by using a wide range of materials ranging from silver to wood, marble to plexiglass, and adding aluminum, lead, antimony, and natural or colored cement.

His first solo exhibition was held at the Indiano Gallery in Florence in 1955. Since then he has participated in several major exhibitions both in Italy and abroad. His works were exhibited at the Venice Biennale in 1948; at The Parker Exhibition of Contemporary Italian Painting, a touring exhibition in the United States in 1959; and at the eighteenth Salon des Réalités Nouvelles in Paris in 1973. Numerous public artworks bear his name, including: the International Sculpture Park in Horice, near Prague (1967); the Soest Park in Soest, Westphalia, Germany (1974); the fountain-sculpture Earth, Wind, Water, and Fire at the Firenze-Certosa motorway exit (designed in the years between 1992 and 1995). He is presently living and working in Terzano, a small town in the countryside outside Florence.

Joseph Kosuth was born in Toledo, Ohio in 1945. His early studies were at the Toledo Museum School of Design and the Cleveland Art Institute. He also took private lessons from the Belgian painter Line Bloom Draper. Before continuing his formal education, he took time off in 1965 to broaden his knowledge of Europe and North Africa through travel. He attended the New York School of Visual Arts from 1965 to 1967. These were the years when he put his knowledge of language theory to good use in his own work, particularly Wittgenstein's philosophy which explored the relationship between art and language. Kosuth viewed art as a mental process and the essence of an idea, rather than the result of a special artistic skill in the traditional sense.

In 1967 he founded the Museum of Normal Art of New York. In 1969 he organized a personal show titled Fifteen Locations, which took place simultaneously in fifteen museums and galleries scattered around the world. Major retrospective exhibitions of his work include shows at the Kunstmuseum Luzern (1973) and the Staatsgalerie Stuttgart and Kunsthalle Bielefeld (1981). Kosuth currently lives and works in New York, Belgium, and Italy. He is considered the father and leading theoretician of Conceptual Art.

Evelien La Sud was born in Holland. She studied at the Epson and Ewell School in England and at the Kunst Akademie St. Joost in Holland. In 1968, after having seen Mantegna's Dead Christ, she decided to enroll at the Brera Academy of Fine Arts in Milan. She remained in the city for ten years, working in the field of advertising, while also showing her artwork at the Galleria Angolare. In the late seventies, attracted by the charms of its nature and countryside, she relocated to Tuscany. In 1980 she purchased an abandoned farmhouse, which would become her home and studio.

Throughout the nineties, she participated in a variety of cultural events in Tuscany. One project involved the creation of a permanent installation in the main square of Pelago, in the province of Florence. In 2001 she took part in a show titled Sindrome d'Oriente (Syndrome of the East), held at the Palazzo Pubblico of Siena, with curators Jade Vlietstra and Mauro Civai. In 2003 she participated in Sindrome d'Oriente 2, an event that took place at the Fondazione Mudima in Milan.

Frances Lansing Massimo Lippi Luciana Majoni

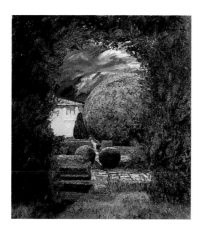

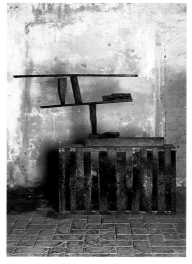

Frances Lansing was born in New York in 1945. She graduated from the University of Virginia and then studied painting at Carnegie Mellon in Pittsburgh and at Villa Schifanoia in Florence where she received a Masters degree in Fine Arts. She moved to Tuscany in 1973 and taught design at Syracuse University in Florence.

During the seventies she concentrated her activity on the technique of intaglio printing, producing a series of large format color works on copper. Since then she has dedicated her time to painting, experimenting with techniques of her own invention.

She participated in various shows with a group known as the Etruscans, who were promoted by Philippe Daverio. Her works are present in numerous private collections in the United States and in Europe. She lives near Siena with her husband, painter Sheppard Craige.

Massimo Lippi, poet, sculptor, and painter, was born in Ponte a Tressa, in the province of Siena, in 1951. He studied at the Academy of Fine Arts of Siena under painter Virgilio Carmignani and earned his degree in literature at the University of Siena under Giuliano Briganti. In 1982 Lippi published his first book of verse as part of Einaudi's series titled Nuovi poeti italiani *(New Italian Poets). In 1991 Scheiwiller published a collection his of lyric poems,* Non popolo mio *(Not my People), including a foreword by Franco Fortini. Lippi was a finalist in the prestigious Viareggio Prize literary competition with another collection of poems published in 1999 as part of the same series,* Passi il mondo e venga la Grazia *(Let the World Pass away and Grace Come).*

In 1993 Lippi was commissioned to paint the banner for the Palio di Siena. His most memorable Italian shows include L'Orma del Fuoco *(The Trace of Fire), held at Santa Maria della Scala in Siena in 2000, and* L'Albero della Vita *(Tree of Life), held at the Palazzo della Regione, the regional government building in Bergamo, in 2001. His work is displayed in various international museums, among them the Metropolitan Museum of Tokyo. Lippi lives and works in Siena, where he has his studio in the "grancia di Cuna," a farm formerly owned by Santa Maria della Scala. He also teaches sculpture at Buffalo University in Siena and at the Carrara and Macerata academies of fine arts.*

Luciana Majoni was born in Cortina d'Ampezzo, in the province of Belluno, where she attended the Art Institute. In 1972 she moved to Florence to further her education at the Academy of Fine Arts, graduating from the school of painting. During these years she also took up photography as a means of expression, with a particular interest in documenting the artistic activities present in the city at the time. She also began to exhibit her work in group and individual shows in Florence (at Spazio Zona in 1978 and at Galleria Schema from 1980 to 1993), thus advancing her research in the field of the photographic image. Over time she developed a passionate interest in a variety of themes, such as nature in its more mysterious and metaphysical aspects, classical statuary, and the human figure, particularly the female face. In 2004 she participated in a group show in Florence titled Col segno di poi *(With the Mark of Afterwards) at the Palazzo Pitti, as well as a retrospective held at the Museo Marini.*

Kurt Laurens Metzler Igor Mitoraj Janet Mullarney Robert Pettena

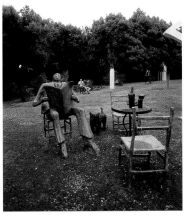

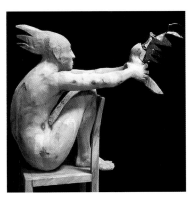

Kurt Laurenz Metzler was born in Balgach, Switzerland in 1941. In 1963 he graduated from the art school in Zurich. During the seventies he worked in the United States, participating in the 1976 edition of the International Sculpture Congress in New Orleans. As early as the sixties he began showing his work in galleries in Switzerland, the United States, and Italy, in addition to taking part in a number of international fairs, among them the fairs held in Basel and Düsseldorf.

Metzler's first sculptures were made of stone and executed in a traditional style, but during his American sojourn in the seventies he discovered new materials, such as polyester, and began to produce more experimental work in the form of human figures, both male and female. The figures are treated with a special irony and subtle sense of humor; in them, the viewer frequently finds something of a portrait of him- or herself.

The most notable of his recent major shows in Tuscany were those held in 1997 at Siena's Magazzini del Sale at the Palazzo Pubblico and in the Piazza del Duomo. In 1995 his contribution to Forme nel verde (Forms in the Green) in San Quirico d'Orcia was also well received.

Metzler owns studios in New York and Zurich and in 1989 he purchased a third studio in Iesa, in the province of Siena. He divides his time between the United States, Switzerland, and Italy.

Igor Mitoraj was born in Oederan, Germany, in 1944. His Polish parents met under tragic circumstances: his mother was deported to Germany and made to do forced labor and his father was an officer in the French Foreign Legion. After the bombing of Dresden in 1945, Mitoraj and his mother returned to Poland where he spent his childhood and adolescence. He attended the Fine Arts Academy in Cracow and studied painting with Tadeuz Kantor. Following the success of his first exhibition in Cracow in 1967 he was encouraged to move to Paris and study at the Ecole Nationale Supérieure des Beaux-Arts. In the mid-seventies he traveled to Mexico and explored Aztec art, then visited Greece and discovered its classic statuary. He opened his studio in the French capital in 1976 and started to sculpt in terracotta and bronze. In 1979, he spent a great deal of time in Pietrasanta, near Carrara, learning the art of sculpting marble.

Mitoraj's sculptures fuse the artist's singular reinterpretation of formal post-modern styles with classical myths resulting in busts without heads or arms, or faces or with truncated profiles. The perfection of classic forms is thus transformed into imperfection in modern times.

His work has toured the world and has been included in many notable group exhibitions both in Europe and in the United States. Mitoraj, with Carlo Maria Mariani, has been a part of the movement known as Citazionismo Anacronistico (Anachronistic Citation). His work is also present in the permanent collections of major museums, and a number of public sites, around the world. The Boboli Garden in Florence houses an imposing bronze mask that was left in place after a retrospective exhibition of his work. Since 1987 his studio in Paris and his house and studio in Pietrasanta have been his two places of work and residence.

Janet Mullarney was born in Dublin in 1952. She attended the Academy of Fine Arts in Florence from 1971 to 1974 and decided to devote her time to art restoration. This activity enabled her to deepen her understanding of woodworking and wood itself—a material she has loved ever since her childhood. Wood remains her preferred medium for her sculptures, though at times she also uses other materials including chalk, foam rubber, bronze, and fabric.

Mullarney's first solo exhibition, titled Roots, was held in 1989. It brought her broad recognition not only in Italy but also internationally. Her work has been shown in numerous exhibitions in Italy, Ireland, and other European cities, as well as in India and in Mexico. In June 2003, she participated in a group exhibition titled Il Palazzo delle Libertà (The Palace of Liberties) hosted at the Palazzo delle Papesse in Siena. Her artwork can be seen in many public and private collections including: the Irish Museum of Modern Art in Dublin, the Waagstraat Project in Groningen, Holland, and the Patrick J. Murphy Collection in Dublin.

Much of her time is spent traveling. The different costumes, rituals, objects, and art pieces Mullarney comes across during her travels have become an important source of inspiration for her creativity. She is currently living and working both in Ireland and in Italy. A tiny town near Arezzo called Castelfranco di Sopra has become her preferred home.

Robert Pettena was born in Penbury, England in 1970 and lives and works in Florence. He uses his skills in video and photography to create installations and video works. He also stages performances that frequently involve paradoxical situations that challenge common sense and distort "normal" reality. His preferred artistic themes involve the investigations of the relationship between the human body and space, between "inner" and "outer" phenomenas. His one-man shows include Once Again in Your Bones, held in 2000 at the lemon-house of Villa Vogel in Florence under the auspices of Centro Pecci, and Cronaca (Chronicle), involving video and non-video installations, held in 2002 at Palazzo Strozzi in Florence. Pettena has also participated in numerous group exhibitions, among them the 1997 International Triennial of Istanbul; Contro la pena di morte (Against the Death Penalty), held in 2000 at the Fortezza da Basso in Florence with V. Masini as curator; Abitanti arte in relazione (Inhabitants Art in Relation) held in 2001 at the Palazzo Fabroni of Pistoia; the 2003 edition of the Video Festival at the Museum of New Art of Detroit; and Il Palazzo delle Libertà (The Palace of Liberties) held in 2003 at the Palazzo delle Papesse in Siena.

Sandro Poli Antonio Possenti Renato Ranaldi

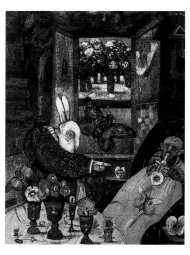

Sandro Poli was born in Fiesole, outside of Florence, in 1941. He has a degree in architecture from the University in Florence. His thesis, titled "Urban Park in Modena," was published in 1970 in A.D., The Supersensualist. He was involved in Supestudio and adhered to the Radical Architecture Movement. In 1972 he took part in the exhibition Italy—The New Domestic Landscape at the Museum of Modern Art in New York. Poli also taught at the department of architecture at the University in Florence and was involved in research on "Extra-urban Material Culture" addressing the issue at the Venice Biennale with a work titled La coscienza di Zeno (The Conscience of Zeno).

Poli alternates between architectural projects and personal artistic work that focuses mainly on design and jewelry making. His work has been shown in both solo and group exhibitions. In 2001 his work was included in an exhibit called The Art of Jewelry that was presented at the Museo degli Argenti, in Palazzo Pitti, Florence, a show he also curated.

Antonio Possenti was born in 1933 in Lucca. After graduating from law school, he practiced and taught law for several years. His natural ability as a draftsman and illustrator led him to become a self-taught painter. Since 1960 he has completely dedicated himself to painting. Possenti's painting has developed within the framework of a poetic and fantastic world. His original artistic language is partly derived from growing up in a literary and cultured family environment. Possenti is inspired by the literature and art of both the classical and modern worlds. In numerous works he displays a particular fondness for polymorphous representations of the fantastic.

Possenti's works are exhibited in a number of galleries both in Italy and outside of Italy. He also participates in a number of national and international art events, among them the Fiera d'Arte in Bologna, Art Basel, the Los Angeles Art Fair, and the Arco of Madrid. His works are included in many collections throughout the world. Critics, writers, and intellectuals such as Dino Buzzati, Enrico Crispolti, Alfonso Gatto, and Giorgio Soavi have written about Possenti's art. When he is not away on one of his many extended journeys, he can be found in his home and studio in the Piazza Anfiteatro in Lucca.

Renato Ranaldi was born in Florence in 1941. Upon graduation from the Academy of Fine Arts, he devoted himself to oil painting and the graphic arts, with a special interest in children's drawings and music. His acquaintance with Andrea Granchi and Sandro Chia sparked the Teatro Musicale Integrale experience, from 1967 to 1969. During this period Ranaldi's first one-man show, curated by Claudio Popovich, was held at Florence's Galleria la Zattera. At the time Ranaldi's work was decidedly outside the artistic currents then in vogue (Minimal Art, Pop Art, Land Art). His highly personal style contains distant echoes of painting and sculpture in the grand classical tradition. He made his first bronze cast in 1979, many more followed, some of them of considerable size. In addition to bronze, the artist also experimented with rolled sections of zinc, copper, and brass, frequently anchored to wood supports, suggesting a "sculpted painting."

Throughout his artistic career, Ranaldi has displayed a steady interest in drawing. The majority of his works shown at a retrospective exhibition, titled Parusie and held at the Il Ponte gallery of Florence, were drawings on paper. In 1988 Ranaldi was invited to participate in the Venice Bienniale, where a room was dedicated to his work. He has taken part in many other public and private shows. Ranaldi's works are in the permanent collections of museums and galleries in Italy and abroad.

Gianni Ruffi Daniel Spoerri Ivan Theimer Cordelia von den Steinen

 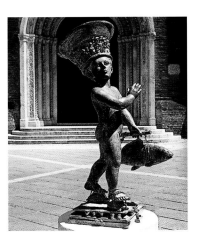

Gianni Ruffi was born in Florence in 1938. During his adolescence he had a close friendship with Roberto Barni. Both had a common interest in Action Painting and they were part of the "School of Pistoia" along with Umberto Buscioni. Each artist used his particular talent to shape a new and original Italian brand of international Pop Art. His first exhibition was held at the Numero Gallery in Florence in 1962. The Zoom Studio exhibition in Pistoia in 1965 included Ruffi's "windows." Exploring new themes, these "windows" were colorful landscapes designed with a very basic and synthetic style influenced both by the second Italian Futurist Movement, in particular by the work of artists Giacomo Balla and Fortunato Depero, and certain types of Japanese graphics. These works are significant because they anticipate "exiting the painting" and a move toward a more free articulation of colored forms in space. This approach emerges in Ruffi's two dimensional and three dimensional work as illustrated by Moto Ondoso (Wave Motion), 1967 and Messaggio dal Mar Nero (Message from the Black Sea), 1967. Ruffi's artwork has since evolved toward a more mature expression of sculptures made by adopting strikingly bright colors and cartoon style strips that completely separate this art from framed paintings.

Ruffi's recent works are crafted around linguistic games and become "sculptural rebuses" as illustrated by his works: Ri-corda (Re-member), 1976–1986; Dipanare il mare (Unravel the Sea), 1988–1990; Via Lattea (The Milky Way), 1989; and Luna di Miele (Honeymoon), 2001. His work is included in private collections in Europe and in the United States. He is presently working in his studio in Pistoia and living in a farmhouse on a hillside in Serravalle.

Daniel Spoerri was born into a Jewish family in Galati, Romania in 1930. He lived in Switzerland with his stepfather who worked at the University of Zurich. After completing his studies, Spoerri devoted himself to dance. In 1952 he moved to Paris and befriended artists Eva Aeppli and Jean Tinguely. From 1954 to 1957 he was the lead dancer in the Berne theater. During these years he was also involved in Concrete Poetry and contributed to the magazine Material. In 1959 he founded Edition Mat (Multiplication d'Art Transformable) with the Niki de Saint Phalle, Christo, Marcel Duchamp, Fernando Soto, Victor Vasarely, Karl Gerstner, Jean Arp, and Tinguely. One year later, he was among the signers of the Manifesto du Nouveau Réalisme organized by critic Pierre Restany. These associations brought him closer to the Fluxus Movement and to Roland Topor and Robert Filliou.

In 1990 the Centre Pompidou in Paris held a retrospective exhibition of Spoerri's work. Since then, he has been living in Seggiano on Mount Amiata, in the province of Grosseto, where a foundation bears Spoerri's name.

Ivan Theimer was born in Olomouc, Moravia in 1944. He attended the Academy of Fine Arts until 1968, when he decided to leave his native Czechoslovakia and move to Paris to complete his studies. In 1973 he exhibited his work at the Paris Biennial, and at the Venice Biennial in 1978. In 1978 he also participated in a group show dedicated to architectural design at the Pompidou Center.

Since the early eighties Theimer has had numerous one-man and group shows in Europe, mainly in France, Italy, Switzerland, and Germany. In 1996 a major retrospective dedicated to his work was mounted at the Belvedere of the Castle of Prague. Theimer has created many sculptures for public spaces. France boasts many of these works including three bronze obelisks for the façade of the Palais de Elysée, a bronze relief for the façade of the National Archives and a monument at Champs-de-Mars, in Paris, and a fountain for Place de la République in Poissy. He has also done work in Germany (for the cities of Kassel, Marburg, Hamburg, Fulda, and Gelsenkirchen) and in Italy. Theimer currently divides his time between Paris, Pietrasanta, and Venice.

Cordelia von den Steinen was born in Basel in 1941. After attending the School of Art and Trades in Basel, she moved to Milan to complete her studies at the Brera Academy of Fine Arts under the guidance of Marino Marini. Though her main interest is sculpting in terracotta and in bronze she has also designed furnishings, jewelry, and costumes for the theater. Her work has been exhibited in many galleries and public spaces. Large sculptures designed for the outdoors figure prominently in her work. Since her marriage to sculptor Pietro Cascella, she has lived and worked in the castle of Verrucola in Fivizzano, in the province of Massa-Carrara.

Acknowledgments and Credits

This book is a natural result of the research done for Tuscany · Artists · Gardens. *Each time I met with an artist to discuss his or her passion for creating a garden, I was struck by the richness and originality of their home.*

I wish to give special thanks and gratitude to all the artists who opened their homes for this book and also to those artists who, because of limited space, could not be included in this volume.

Also very special thanks to Adriana Tramontano for her support and advice on the text.

All of the photographs in this book were made by Mario Ciampi especially for this volume. With the exception of some of the images of the homes of Igor Mitoraj and Pietro Cascella, that were previously published in "Casamica" RCS Periodici, none of these photographs have been published before.

The images that appear with the artists' biographies were graciously supplied by the artists, except for the photographs that accompany Battisti, Bonacossi, Cascella, Crema, Fallani, Generali, Kosuth, Lippi, Metzler, Mitoraj, Pettena, Spoerri, and von den Steinen that were made by Mario Ciampi.